BUTLER LIBRARY
Corpus Christi College

DATE DUE BACK

........................

........................

........................

........................

....................

....................

....................

....................

Up to ten books may be borrowed
for two weeks. Fines for late return
are 10p per book per day.

Maps of Medieval Thought

THE HEREFORD PARADIGM

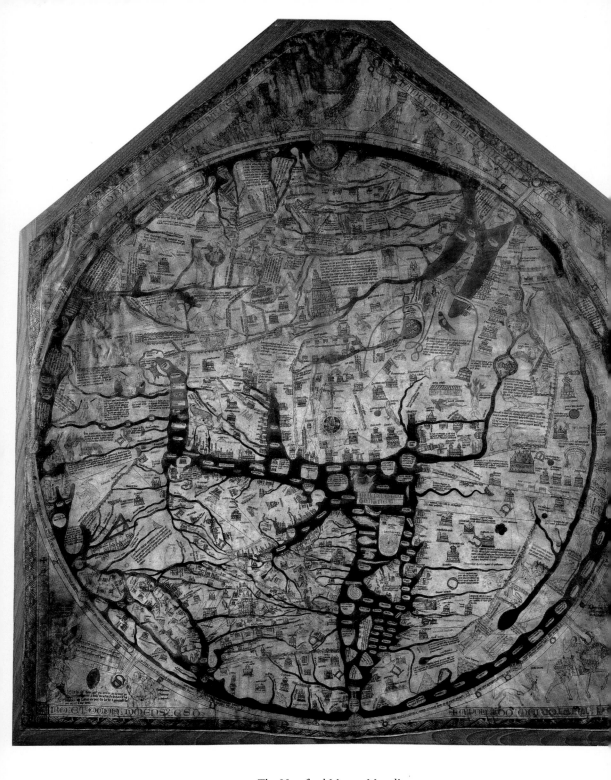

The Hereford Mappa Mundi
By kind permission of The Dean and Chapter of Hereford Cathedral and the Hereford Mappa Mundi Trust

Maps of Medieval Thought

THE HEREFORD PARADIGM

Naomi Reed Kline

THE BOYDELL PRESS

First published 2001
The Boydell Press, Woodbridge

ISBN 0 85115 602 9

Publication of this book has been aided by a grant from
the Millard Meiss Publication Fund of the College Art Association

The Boydell Press is an imprint of Boydell & Brewer Ltd
PO Box 9, Woodbridge, Suffolk IP12 3DF, UK
and of Boydell & Brewer Inc.
PO Box 41026, Rochester, NY 14604–4126, USA
website: http://www.boydell.co.uk

A catalogue record for this book is available
from the British Library

Library of Congress Cataloging-in-Publication Data
Kline, Naomi Reed.
 Maps of medieval thought : the Hereford paradigm / Naomi Reed Kline.
 p. cm.
 Includes bibliographical references and index.
 ISBN 0–85115–602–9 (alk. paper)
 1. Geography, Medieval – Maps. 2. Cartography – History – Maps.
 G89.5 .K54 2001
 912'.094'0902 – dc21 2001025737

This publication is printed on acid-free paper

Printed in Great Britain by
St Edmundsbury Press Ltd, Bury St Edmunds, Suffolk

CONTENTS

To Sam and James

ILLUSTRATIONS

ACKNOWLEDGMENTS

I fondly remember visiting Hereford Cathedral for the first time in 1993. By then, I had undertaken a reasonable amount of research, had developed an extensive bibliography and database, and had written a preliminary draft with which I came armed. My dear friend Jill Adels had read the draft and sent me off with words of encouragement. I thus carried my early model of a Macintosh Powerbook (with great trepidation I might add) to England. It is remarkable now to think that less than ten years ago it was relatively rare for scholars to travel with a computer. My 'magical box' contained amongst other things the database of the inscriptions and translations for the Hereford and Ebstorf mappae mundi, which represented a good deal of work by Thomas McCormick, Preston Shea, and John Chandler. They were jointly and consecutively involved from the earliest glimmer of this undertaking and I am most grateful to them for their efforts and friendship.

On arriving in Hereford, I was graciously received by the Very Reverend Robert Willis, Dean of Hereford, Canon John Tiller, Master of the Library, Joan Williams, Librarian, Dominic Harbour, Exhibition Manager, and Meryl Jancey, Archivist. Betty Breyer, a loyal friend of the Cathedral, took me under her wing and kindly drove me around Herefordshire where we delightedly visited related sites and monuments. A brief stay in London followed the whirlwind Hereford visit. It was at the British Museum that I first met with Peter Barber and Catherine Delano Smith who were most welcoming to an art historian who presumed to join the world of cartographic scholarship. I have learned that map people are a wonderfully inclusive group.

Following that trip, there were other trips and more good people to whom I owe thanks. Over the years I have greatly and most especially profited from the advice and support of Paul (P. D. A.) Harvey. He has been a friend and mentor from the moment we met by arrangement in a busy train-station café where we discussed maps over the loud background of rock music. From that time onward he has been most gracious and generous in many ways, including having read and commented on this manuscript when it was a work in progress. Evelyn Edson also read the manuscript in an earlier form and her comments were equally valuable. Finally Marcia Kupfer, as a great favor to me, read the 'penultimate' version and once again I was the recipient of intelligence and insight abundantly offered. I am deeply grateful to these three fine scholars who have made insightful and substantive comments which have considerably strengthened my work. I admit however, there are sections where I stubbornly followed my own course, despite their good advice, so any weak arguments or errors are mine alone.

The Hereford Cathedral Chapter has seen to the reinstallation of the map in its magnificent new museum building. In the summer of 1999 a historic conference on the

Hereford mappa mundi was held in Hereford. I was honored to be invited and to share ideas with that select group of scholars, some of whom I knew by then, and others whom I had the good fortune to finally meet there, such as David Woodward, who for years had been receptive to my calls, and always unfailingly helpful, as well as scholars whose publications were familiar to me insofar as we were all on the same wavelength. I await with great interest the collection of papers to be published as a result of that conference. I have particularly taken into account the evidence provided by Nigel Morgan and Malcolm Parkes that conclusively dates the map to *ca.* 1300. And so, all in all, the Hereford Cathedral Chapter has with elegance and grace provided a new home for the map and a haven for its scholars in years to come.

In the course of research I called upon a number of people who responded to a variety of substantive queries. I especially thank Arthur Baynes-Cope, Andrew Scheil, Elizabeth Sears, Rudolf Simek, Anne Stanton, and Susan Ward. And to those who provided me with otherwise unavailable photographs I thank Jill Adels, Jonathon Cooter, Christopher de Hamel, Debra Hassig, Randall Hoyt, Jean O'Gorman, Maureen Pemberton, Virginia Raguin, and Mary Shepard. As to the libraries in which I worked, I would like to thank the staffs of the Bodleian Library, Oxford; the British Library, London; the Bibliothèque Nationale, Paris; The Fogg Library, Cambridge, Massachusetts; Hereford Library; Hereford Cathedral Library; Hereford Museum Library; Houghton Library, Cambridge, Massachusetts; the Lamson Library, Plymouth, New Hampshire; and the Widener Library, Cambridge, Massachusetts.

At Plymouth State College, this project has involved a number of people. Through the years there have been numerous students who have explored the map and learned a great deal from it. I especially remember Jennifer Goulet who doggedly pursued an early interest in the Ebstorf map and Annie Robinson who years later did independent research on the Hereford map. Fearful of leaving someone unmentioned, I would like to thank the many students who have over the years been involved with this map. I have also received generous support from Computer Services: Randall Hoyt, Steve Burrell, Jeannie Poterucha, and Wally Stuart have provided much appreciated help with setting up the database, and all computer-related needs. My colleague Joan Bowers of the English Department was kind enough to edit yet another version of the manuscript.

I would like to thank everyone at Boydell & Brewer, especially Dr Richard Barber, Caroline Palmer, Elspeth Ferguson, Vanda Andrews, Pru Harrison and Helen Barber, for their kindness and patience. Dr Clive Tolley's scholarly and sensitive final editing was of inestimable value.

And finally, I am indebted to my dear friend Howard Dinin, who generously designed the schematic diagrams of the map that precede the chapters of the 'worlds'.

I began this work because I believed that a contextual understanding of the Hereford mappa mundi could substantially add to our knowledge of medieval art and thought. I have been most fortunate to receive grants from foundations that have encouraged me to pursue this subject and have provided me with the necessary support . The research and publication of this book was made fiscally possible by The Marion and Jasper Whiting Foundation which provided me with the funds to make

that first trip to England a seminal opportunity. Through the years, I have received several faculty development grants from Plymouth State College to defray the cost of library privileges at Harvard University. For that I am especially indebted to Robin Bowers, then Dean of the College, who was always supportive of this work. And finally, the Millard Meiss Publication Fund made it financially possible for this book to appear with illustrations.

Material in this book also appears on the CD-Rom 'A Wheel of Memory: The Hereford Mappa mundi', by Naomi Reed Kline (Ann Arbor: The University of Michigan Press). I am grateful to The University of Michigan Press for permission to use it here.

Naomi Reed Kline
New Hampshire

INTRODUCTION

It is obvious then, that memory belongs to that part of the soul to which imagination belongs. . . . The stimulus produced impresses a sort of likeness of the percept, just as when men seal with signet rings. . . . Just as the picture painted on the panel is at once a picture and a portrait, and though one and the same, is both, yet the essence of the two is not the same, and it is possible to think of it both as a picture and as a portrait, so in the same way we must regard the mental picture within us both as an object of contemplation in itself and as a mental picture of something else. Insofar as we consider it in itself, it is an object of contemplation or a mental picture, but insofar as we consider it in relation to something else, e.g. as a likeness, it is also an aid to memory. (Aristotle)[1]

THE HEREFORD MAPPA MUNDI (*ca.* 1300), part of a long cartographic tradition, is the only surviving complete example of a large wall-scale 'world map' of the Middle Ages (Frontispiece). I wonder, in light of Aristotle's words, how this map, full of images and texts, was perceived and remembered in its time as a picture and then as a portrait of the world people lived in. In other words, how did the viewer in the Middle Ages see, learn, and digest the bits and pieces of information on the map in order to bring personal meaning to it? With its many images and texts the map, which presents the world as a picture painted on a single piece of vellum, suggests now and no doubt suggested then a different 'portrait' of the world to each onlooker.

Much has been written about the Hereford map; scholars have considered it from a number of perspectives. My task, as an art historian, is to begin to uncover how this map, and by extension others like it functioned as objects of art in their own time. In examining in detail the possibilities of how the map was viewed and understood, questions of literacy and oral tradition, of artistry and textuality, become the recurrent themes. I believe that memory, recollection, and association, concepts well known in the Middle Ages, afforded the viewer an experience of the map's meaning. The map could be explored as a 'picture' of the world and also as a 'portrait' of one's own conception of the world – that is, it can be considered within the personal context of artistic memory and of medieval thought.

Maps are known to have existed for centuries, but it was in the Middle Ages in mappae mundi like the Hereford map that images and texts came to fill most spaces between and beyond the geographical interstices. The lack of measured distances between sites suggests that these were abstract representations of the world not meant

[1] The translation is based on Aristotle's *Parva naturalia* in which he treats the subject of memory and recollection. See Aristotle, *On the Soul, Parva Naturalia, On Breath*, trans. W. S. Hett, Cambridge, MA, 1935: *Parva Naturalia: On Memory and Recollection*, 450a, 451a (pp. 285–7). Aristotle notes that this concept reiterates ideas considered in *De anima* III: vii–viii, 174–81. Also see Richard Sorabji, *Aristotle on Memory*, Providence, 1972.

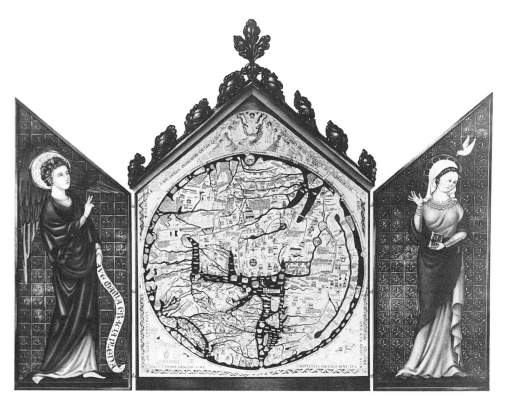

Fig. 1 A reconstruction by Hargrave Hands of the Mappa Mundi Triptych,
including the Annunciation panels, 1990
By kind permission of The Dean and Chapter of Hereford Cathedral
and the Hereford Mappa Mundi Trust

to help the viewer gauge distances in terms of actual travel. Distortions exist because
the conceptual overrides the practical in most instances.

The Hereford map consists of a single sheet of vellum: on this is depicted the
circular image of the world beyond which are five corners that fill the natural shape of
the vellum. These painted corners I shall hereafter refer to as the 'pictorial frame'. On
the Hereford map, the earthly realm with all its wonders is oriented to the east, and is
enclosed within a circular format surrounded within by the Great Ocean and
surrounded without by a ring that contains the winds. Christ the Judge surmounts the
painted pictorial frame that encompasses the entirety. The Hereford map thus connects
the timeless realm of the Last Judgment to the worldly realm of geography, natural
history, events, and peoples. The items depicted and described on the map derive from
multiple sources, linked to one another by models, copies, and webs of transmission –
textual, imagistic, and oral. To 'read the map' as a medieval picture requires that we
employ visual methods of separating this mind-boggling assortment of information
into some of its component parts. The geometry of the circle: its center, radii, diame-
ters, and perimeter function as the stage upon which a geographical theater-in-the-

round presents itself. As in much medieval art, there is an imbedded visual hierarchy that brings order to what at first appears disorderly and thus becomes an aid to memory and association. It is those associations that personalize the viewer's understanding of the world.

The continents, cities, and countries are named and marked by boundaries within which architectural and geographic symbols are drawn. Arteries of blue waterways (except for the red of the Red Sea) provide ways for viewers to navigate through the geography. Nevertheless, it is, and probably was to the medieval viewer as well, difficult to comprehend without a good deal of effort and some instruction. The overwhelming number of images and texts strewn about confuse the geographical 'structure'. The images and texts do not derive from a consistent narrative or textual source. However, the commonly employed pictorial hierarchical conventions of medieval art such as ascending and descending order, radiating lines of images, and signifiers such as size, color, and style, assisted imagination and memory.

Recall also that the medieval audience was largely composed of people who could not read but nevertheless esteemed the authority of the written word. For them, reception depended upon visual memory and oral communication. Their understanding of texts often relied on explanations provided by others. Pictorial images and conventions reinforced received knowledge. In that manner, the non-literate viewer could interpret the material without being able to read the texts. And for the rare literate viewer who was able to read the inscriptions in Latin and Anglo-Norman, who perhaps even helped others make connections, the narrative of the description was pedagogically personalized. The map presented its information in a non-linear way, and hence extracted narratives depended on viewers' differing capacities for making associations. The story must have changed each time it was invented or told. As Walter Ong points out, oral narratives lack climactic plots.[2] Information may be told in any order using the building blocks to fit into the structure that is imposed upon the information by the actively involved viewer-participant. In this case, though, the pictorial frame with its privileged statement of the Last Judgment firmly planted above the disjunctive narrative makes the plot's climax universally understood. However the map was 'read', the story must always end with the Last Judgment, a theme that permeated the medieval imagination.

The map was, I believe (though the matter is open to debate), displayed in Hereford Cathedral soon after its completion in the recently rediscovered Gothic wooden framework. The 'wooden framework' (as opposed to the 'pictorial frame') was composed as a triptych. Its Gothic spires carved in wood provided an architectural container fitted to a church interior. The mappa mundi was nailed to the central panel; the panel on the left was reportedly painted with an image of the angel Gabriel, the right panel with an image of the Virgin Mary. The flanking paintings together depicted the Annunciation. The juxtaposition of the side panels of the Annunciation to the central and topmost image of the Last Judgment on the map reinforced the predilection to inter-

2 Walter J. Ong, *Orality and Literacy: The Technologizing of the Word*, London, 1982, 139–47.

pret the map through the filter of Christianity. As an ensemble, the key elements of Christian time were introduced: the Incarnation on the panels and the Last Judgment on the map. I also believe that the triptych was likely installed in a recently completed chapel that contained the mortal remains of the sainted Bishop Cantilupe whose tomb was rapidly becoming a magnet for pilgrims and a broad spectrum of folk, who worshipped at his tomb and prayed for miracles.

But clearly the way the viewer would approach the material provided on the map depended upon his or her store of knowledge. Texts in Latin or Anglo-French could only be read by the learned few, possibly aloud to others. For most people, however, the visual and oral traditions were the primary aids to deciphering, distilling relevance, and constructing meaning from this extraordinary object.

To help the reader understand the rationale for the portrait of the map I am about to create, I shall follow the lines of inquiry broadly outlined. The book begins (Part I) with a general discussion of the centrality of memory and associations to medieval thought with emphasis on the circle as a medieval container of concepts made visual, a circular map being only one of many circular forms of distilled information. Part II focuses specifically on the Hereford map and its painted pictorial frame. The images and inscriptions on the pictorial frame provide information about the donor, his intentions for the map, its historical and contextual sources, and possible ways of understanding the pictorial frame as a conceptual device that enriches the meaning of the world depicted within. A separate chapter considers the audience for the map. Part III follows with chapters discussing the 'worlds' within the world – meaning the categories of subject matter selectively chosen to be included on the map. Visual and textual sources are considered to provide clues to their understanding. There follows a last chapter (Part IV) that mirrors Part I insofar as it too is a general overview of medieval conceptual enclosures; this time, it is a consideration of the Hereford map as a paradigm for deciphering the painted pictorial frames of related maps.

I hope that an appreciation of the many ways of considering the vast amount of information presented on the Hereford map will provide a guide for looking at and deconstructing other medieval maps and artifacts. However, I am aware that what seems exhaustive is only a stab at trying to use today's tools to try to recapture memory and imagination of time past. If the Hereford mappa mundi can truly be considered a paradigm of medieval thought, I hope that some of the possibilities I suggest here will resonate with other scholars who choose to follow related paths.

Part I

The Circle as a Conceptual Device

1

THE COSMOLOGICAL WHEEL

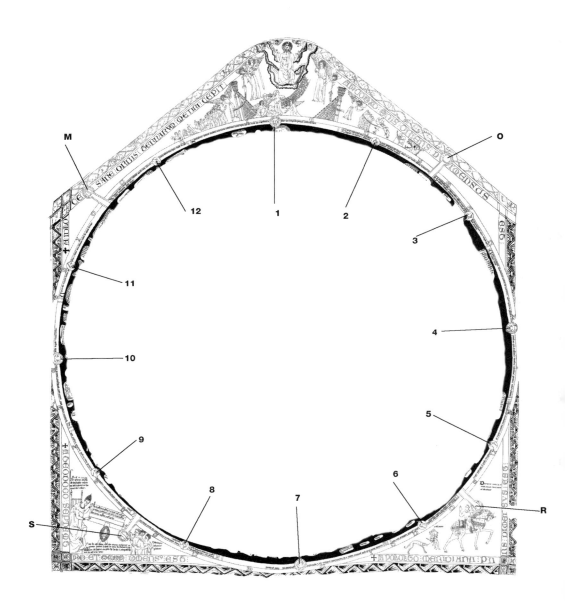

THE WINDS (clockwise)

1 **Subsolanus** (East Wind): Inscription: *Subsolanus uentus · occidenti contrarius · subsolanus dictus: quia sub sole oritur · qui et appollites [=Apheliotes] dicitur · qui temporales pluuias latissimas facit ·* (Subsolanus, the opposite wind to Occidens is called Subsolanus as it rises beneath the sun and is also called Apheliotes; it makes widespread seasonal rains.)

2 **Eurus** (Eurus): Inscription: *Eurus contrarius choro · a sinistro uolans Subsolani · ideo dictus eurus: eo quo [quod] morbo afficiat · homines mergendo in mortem · et extremam [=extremum] · orientem nubibus irrigans ·* (Eurus is the opposite of Chorus, flying in from the left of Subsolanus. It is called Eurus because it brings men sickness and plunges them into death. It waters the far east with its clouds.)

3 **Eurus Nothus** (Eurus-Nothus): Inscription: *Eurus nothus · flat a dexris austri · callidus nimis et aqua [aquam] ex marmore fluere facit · et irrigat aquis omnia · et dissoluit contrarius circio: dictus nothus: eo quod facit amictus ·* (Eurus-Nothus blows from the right hand of Austrus. Excessively warm, it makes water flow out of marble. It moistens and melts everything. It is opposite to Circius. It is called mixed or bastard ('nothus') as it comes mixed [with Eurus].)

4 **Auster** (South Wind): Inscription: *Auster contrarius septemtrioni · uocatus ab hauriendis aquis · quarum profusione terram mundat · qui est callidus et humidus · fulmineus · generans nubes · et pluuias · et soluit flores ·* (Auster is the opposite wind from Septentrio. It is so called because by bringing forth waters in profusion it cleanses the earth. It is warm and moist, lightning-bearing and producing clouds and rain. It sets free the flowers.)

5 **Austeraffricus** (Auster-Affricus): Inscription: *Austerafricus · contrarius aquiloni · dictus est austeraffricus: quod per affricam currit* (Auster-Africus, the opposite of Aquilo, is called Auster-Africus because it runs through Africa.)

6 **Affricus** (Affricus): Inscription: *Affricus · qui et lipsis dicitur · generans tempestates · et pluuias latissimas facit · sonitus tonitruum et fulgurum nisum impulsus ·* (Africus is also called Lipsis. It produces storms and widespread rain. The sounds of thunder and lightning are the striking of its pressure.)

7 **Favonius** (West Wind): Inscription: *Fauonius dictus est · eo quod germina foueat · et ad maturitatem perducat · hic et zephirus rigore [rigorem] hiemis relaxat · flores producit ·* (Favonius is the name of that [wind] which germinates seeds and leads them to maturity. This [wind] and Zephirus relax the harshness of winter and produce flowers.)

8 **Chorus** (Chorus): Inscription: *Chorus qui et agrestis [=Argestes] flans · in oriente nubilosus · in yndia serenus · ideo dictus chorus est : quod omnium uentorum spiritus concludat ·* (Chorus, which is also called Argestes, blows cloud-bearing in the east. But in India it is mild. It is called Chorus for this reason: it encloses the breaths of all the winds.)

9 **Circius** (Circius): Inscription: *Circius · qui et traceas facit nubes · et grandinum coagulatione[s] dictus est circius: eo quod in circulo iungitur cum choro ·* (Circius, which is also called Traceas, makes clouds and frozen hail. It is called Circius because it is joined in a circle with Chorus.)

10 **Septemtrio** (North Wind): Inscription: *Septemtrio · a septem stellis nomen accepit · qui frigidus et siccus est · et facit arida frigora · et siccat nubes ·* (Septentrio, which is cold and dry and makes [the land] dry and cold and dries out the clouds, takes its name from the seven stars.)

11 **Aquilo** (Aquilo): Inscription: *Aquilo · qui et boreas dicitur · gelidus et siccus · non discutit nubes · set [sed] aquas stringit ·* (Aquilo, which is also called Boreas, is icy and dry. It does not scatter the clouds but wrings out their water.)

12 **Wlturnus** (Vulturnus): Inscription: *Wlturnus [Vulturnus]: qui et caleas [Caecias] dicitur · dissoluit cuncta · atque desiccat · dictus wlturnus: quia flans in alto · habet potestatem quasi wltur [Vultur] ·* (Vulturnus, which is also called Caleas, breaks up and dries everything out. It is called Vulturnus because blowing up high it has power like Vultur.)

FOUR 'HANDLES' (clockwise from north-east)

M O R S
Death

IN THE TWELFTH AND THIRTEENTH CENTURIES the world was widely believed to be a sphere, an idea that was early understood by the Greeks and reinterpreted by the early Church fathers. It is believed that the Roman preference for depicting the world as a disk lastingly influenced medieval maps.[1] Medieval maps and schemata were flat, generally circular images. Representations of the world as flat reflected, of course, technical difficulties in depicting the third dimension, but, more importantly, revealed the primary function of maps as conceptual enclosures for stored information. Medieval images of God as creator often showed him compass in hand, in the process of creating a circular world (Fig. 1.1).[2] And world maps of the Middle Ages, known as *mappae mundi*, that contained the image of the world within such a circular ring, became conceptual enclosures for stored information relating to all of creation. The circle was considered an ideal form to visually encompass Platonic and Aristotelian cosmological theories as understood by medieval scholars and encylopedists whose task was to reconcile knowledge of the physical world with Christian beliefs.[3]

The mappae mundi under discussion here functioned in a way that was similar to medieval *rotae*, flat, circular wheels that made understandable, in a simplified graphic manner, concepts that explained the way the world worked. In the Middle Ages, complex theories that dealt with the essence of the relationship between human beings

[1] For a comprehensive survey of medieval world maps and bibliography, see David Woodward, 'Medieval Mappaemundi', in *The History of Cartography*, 1: *Cartography in Prehistoric, Ancient, and Medieval Europe and the Mediterranean*, ed. J. B. Harley and David Woodward, Chicago, 1987, 286–370. For discussion of Roman maps, see O. A. W. Dilke, 'Maps in the Service of the State: Roman Cartography to the end of the Augustan Era', in *The History of Cartography*, 1: 201–11, esp. 207–9; David Woodward, 'Reality, Symbolism of Time, and Space in Medieval World Maps', *Annals of the Association of American Geographers*, 75, 1985, 510–21; for discussion on the world as a sphere or 'flat', see Jill Tattersall, 'Sphere or Disc? Allusions to the Shape of the Earth in Some Twelfth-Century and Thirteenth-Century Vernacular French Works', *Modern Language Review*, 76, 1981, 31–46; Jeffrey Burton Russell, *Inventing the Flat Earth: Columbus and Modern Historians*, New York, 1991, esp. 13–26.

[2] The Creation, God as Architect in Bible Moralisée, Vienna, Ost. Nat. Bibliothek, MS 2554, f. 1r, thirteenth century, France. For bibliography, see A. de Laborde, *La Bible moralisée illustrée, conservée à Oxford, Paris et Londres*, 5 vols., Paris, 1911–27, esp. 143–54. For discussion of the compass, see John Block Friedman, 'The Architect's Compass in Creation Miniatures of the Later Middle Ages', *Traditio*, 30, 1974, 419–29. As possible sources for iconography, Friedman suggests rabbinical commentaries on scripture that refer to the compass and circle respectively in Isaiah 44: 13 and Proverbs 8: 27.

[3] For bibliography and introduction to medieval cosmology and distinctions between Platonic twelfth-century theories and Aristotelian features introduced in the thirteenth century, see David C. Lindberg, *The Beginnings of Western Science*, Chicago, 1992, 244–61. For a short introduction to medieval cosmology, see Edward Grant, 'Cosmology', in *Science in the Middle Ages*, ed. David Lindberg, Chicago, 1978, 265–302. For discussion on the continuity of Platonic tradition, see Raymond Klibansky, *The Continuity of the Platonic Tradition during the Middle Ages*, London, 1939, 13–47. For relevant translated selections from Duhem's ten volume, *Système du monde*, see Pierre Maurice Duhem, *Medieval Cosmology*, ed. and trans. Roger Ariew, Chicago, 1985, 3–178. Also see M. D. Chenu, 'Le Cosmos symbolique du XIIe siècle', *Archives d'histoire doctrinale et littéraire au Moyen Age*, 28, 1953, 31–81.

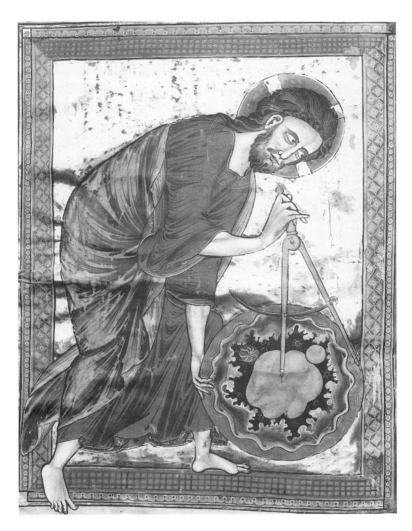

Fig. 1.1 The Creation, God as Architect. *Bible moralisée*, Vienna, Österreichische Nationalbibliothek, MS Cod. 2554, f. 1. Late 13th century, France

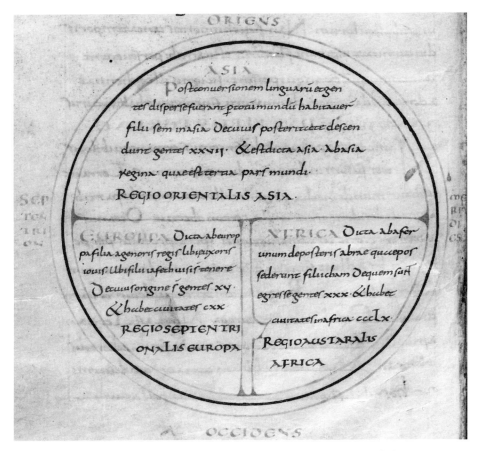

Fig. 1.2 T-O Map. Isidore of Seville, *De natura rerum*, Burgerbibliothek Bern, cod. 417, f. 88v. Late 9th century

and the natural world were often abstractly translated into circular formats of explication.[4] The Hereford, Ebstorf, and Psalter maps, and other related examples of medieval mappae mundi of the twelfth, thirteenth, and early fourteenth centuries, functioned not only as cartographic documents but also as family members of the larger category of cosmological *rotae*. As in numerous other circular cosmic schemata particularly favored in monastic teaching, ideas were presented in an encyclopedic manner. There was little attempt to rely on any single authority but rather to provide a compendium of ideas gleaned from various sources that were compiled and edited for the specific

4 For background on the concept of the wheel as a cosmic metaphor and as a schematic framework for cosmological themes in the Middle Ages, see Jurgis Baltrusaitis, 'Cercles astrologiques et cosmographiques à la fin du Moyen Age', *Gazette des beaux-arts*, 21, 1939, 65–84; Jurgis Baltrusaitis, 'L'Image du monde céleste du IXe au XIIe siècle', *Gazette des beaux-arts*, 20, 1938, 137–48.

purpose of the individual work.[5] In effect, medieval mappae mundi share with medieval *rotae* the circular format as containers of diverse information. Our consideration of medieval mappae mundi is based upon the idea of the circle as a shorthand device for assisting learning and memory and situates medieval mappae mundi within the medieval realm of wheels of memory.

Isidore of Seville

In the Middle Ages, circular formats were employed didactically in numerous ways. Much of scientific knowledge about the natural world was organized to fit these models in order to make the information more understandable. Encyclopedic knowledge gleaned from earlier sources, compiled and edited from the Carolingian period onward, was available in cosmologies that worked as medieval school treatises on natural science. As early as the seventh century, Isidore of Seville (560–636), in his encyclopedic treatise on nature *De natura rerum* (from between 612 and 615) and his *Etymologiae sive origines* (from between 622 and 633), introduced a number of *rotae* to explain geographical and cosmological theories, amongst them a visualization of the world in tripartite division known as a T-O map. Although the T-O map was not actually invented by Isidore (it was present in classical literature), Isidore's works contain some of the earliest images of T-O maps known. The original Isidorian seventh-century T-O scheme did not survive. However, it is assumed that it was frequently copied by later authors.[6] As the example in Fig. 1.2 shows,[7] the world is divided by the 'T' of the Great Sea, believed by medieval scholars to be composed of the Tanais (the river Don) which separated Europe from Asia, the Nile, which separated Africa from Asia, and the Mediterranean Sea which separated Europe from Africa. The four cardinal directions are also given: *Septentrio* (north), *Meridies* (south), *Occidens* (west) and *Oriens* (east). East is given prominence by being placed at the top of the map and marks Asia as the largest continent. Also noted is the biblical division of the world amongst the three sons of Noah (Genesis 10): Shem, Ham, and Japheth. The 'T' of the Great Sea is surrounded by the 'O' of the Great Ocean, which encircles the entire earth.

Isidore is also credited with using the circular scheme as a didactic device for a variety of cosmological explanations. The *rotae* or wheels of Isidore assumed the function of visual memory devices required by medieval schoolmen who often selected texts with the accompanying schemata in mind. These wheels were especially employed in monastic schoolbooks as cosmological diagrams, which helped explicate theories of divine order and harmony. For instance, seven *figurae* were called for in

5 Harry Bober, 'An Illustrated Medieval School-Book of Bede's *De natura rerum*', *The Journal of the Walters Art Gallery*, 19–20, 1956–7, 65–97.
6 Woodward, 'Medieval *Mappaemundi*', 301–2.
7 Isidore of Seville, *De natura rerum*; Bern, Burgerbibliothek, Codex 417, f. 88v, ninth century. For background, see Jacques Fontaine's edition of Isidore of Seville, *Traité de la nature*, Bordeaux, 1960. I am grateful to Evelyn Edson for this reference.

Isidore's *De natura rerum*, six of which were *rotae*:[8] wheels of the months (Fig. 1.3),[9] seasons (Fig. 1.4),[10] planets (Fig. 1.5),[11] zones of the earth (Fig. 1.6),[12] winds (Fig. 1.7),[13] microcosm–macrocosm (Fig. 1.8).[14] The examples given here are from early manuscripts that date from the eighth to the tenth centuries. Scholars have commented on the graphic conception of Isidore's work, noting the frequency of references to diagrams such as the notation *haec figura est* that appears above the image of the wheel

8 For discussion of seven *figurae* called for in Isidore's *De natura rerum*, see John E. Murdoch, *Album of Science: Antiquity and the Middle Ages*, New York, 1984, 52–5, 340–5, and 356.

9 Isidore, *De natura rerum*, Paris, Bibliothèque Nationale, MS lat. 4860, f. 99v, tenth century. The center of the wheel has the letters MENSES representing its function, *rota mensium*. According to Murdoch, this *rota* shows the months, number of days in each, date of the first of each month of the Roman calendar (kalends). Because the wheel is meant to reconcile the Roman calendar with the Egyptian calendar, Isidore indicates how the first day of each Egyptian month precedes the kalends by a varying number of days; see Murdoch, *Album of Science*, illustr. 46 (p. 52).

10 Isidore, *De natura rerum*, Paris, BN, MS lat. 4860, f. 100r, tenth century. This *rota* is the second wheel in the manuscript. The center of the wheel has the letters ANNUS representing its subject, and the year is divided into seasons. The four cardinal points are matched to the seasons: *oriens–ver* (east–spring); *occidens–autumnus* (west–autumn); *septentrion–hiemps* (north–winter); *meridies–aestas* (south–summer). Each season is shown opposite its contrary season. The seasons next to one another share climatic descriptions: *humidus* (wet), *calidus* (hot), *sicca* (dry), *frigidus* (cold). Explanations for connections between the cardinal points and the months are not in Isidore's *De natura rerum* but are provided in his *Etymologiae*; see Murdoch, *Album of Science*, illustr. 46 (p. 53).

11 Isidore, *De natura rerum*, Paris, BN, MS lat. 4860, f. 103v, tenth century. This is the fifth *rota* in Isidore's *De natura rerum*. The center of the wheel has the letters TERRA representing earth. This *rota* shows the times of the orbits of each of the planets around the earth. For instance, *Saturnus* (Saturn) completes its orbit in thirty (XXX) years; Phaeton (Jupiter, here spelled *Feton*) in twelve (XII) years; *Vesper* (Mars, the name *Vesper* is usually meant for Venus as evening star) in fifteen (XV) years; followed by *Sol* (Sun) in nineteen (XVIIII) years; *Lucifer* (meant for Venus) in nine (VIIII) years; Mercury in twenty (XX) years and *Luna* (Moon) in eight (VIII) years, see Murdoch, *Album of Science*, illustr. 48 (p. 54).

12 Isidore, *De natura rerum*, Paris, BN, MS lat. 6649, f. 8v, tenth century. Outside the wheel are the four cardinal points (*oriens, occidens, meridies, septemtrio* [sic]) and the Latin names of the zones. On the interior are five petals, each with the name of the zone in transliterated Greek, and its character and habitability. Reading clockwise the first is *articus*, uninhabitable due to extreme cold; second is *therminus*, temperate and habitable; third (middle zone) is *isemerinus* (equinoctial), uninhabitable because it is extremely hot; fourth is *exemerinus*, temperate and habitable; fifth is *antarticus*, uninhabitable because it is extremely cold. According to Murdoch, the wheel is meant as a mnemonic device based on the five fingers of the hand; see Murdoch, *Album of Science*, illustr. 279 (p. 340).

13 Isidore, *De natura rerum*, Paris, BN, MS lat. 6413, f. 27v, eighth century. According to Murdoch, Aristotle introduced the concept of a wind diagram in *Meteorology*, II, Chapter 6. This, however, is the first known medieval diagram of the winds. The Latin names of the winds are given as well as the Greek (with many misspellings). In Isidore's description, each of the four major winds is flanked by subsidiary winds. In the diagram *Septentrio/Aparctias* is flanked on the left by *Circius/Thrascias* and on the right by *Aquilo/Boreas*; *Subsolanus/Apeliotes* by *Vulturnus/Caecias* (left) and *Eurus/Eurus* (right); *Auster/Notus* by *Euroauster/Euronotus* (left) and *Austroafricus/Libonotus* (right); and *Pauonius/Zephyrus* by *Africus/Lips* (left) and *Corus/Argestes* (right); see Murdoch, *Album of Science*, illustr. 280 (pp. 343–5).

14 Isidore, *De natura rerum*, Paris, BN, MS lat. 6413, f. 5v, eighth century. In the center of the diagram are the words MUNDUS ANNUS HOMO ('world, year, man'). According to Murdoch, the image is based on Aristotelian theory. The image repeats the organization and information given in the Wheel of the Seasons (names of seasons: *Aestas, Ver, Hiemps, Autumnus*; climates: *calidus, humidus, frigeda* [sic]. To this are added the four humors: *colera* (red bile), *sanguis* (blood), *humor* (phlegm), and *melancolia* (black bile). The humors refer to the realm of *homo*, man considered as microcosm, while *mundus* and *annus* refer to the macrocosm; see Murdoch, *Album of Science*, illustr. 286 (p. 356)).

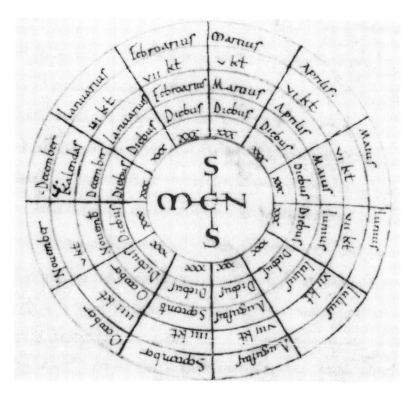

Fig. 1.3 Wheels of the Months. Isidore of Seville, *De natura rerum*, Paris, Bibliothèque Nationale, MS lat. 4860, f. 99v. 10th century

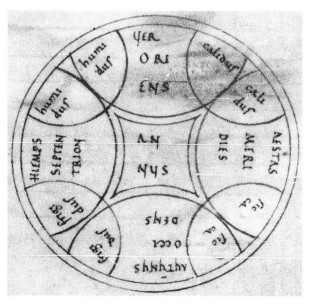

Fig. 1.4 The Seasons. Isidore of Seville, *De natura rerum*, Paris, Bibliothèque Nationale, MS lat. 4860, f. 100. 10th century

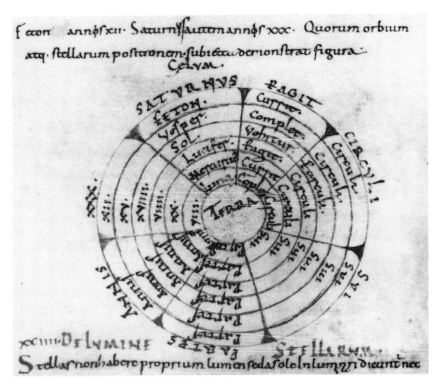

Fig. 1.5 The Planets. Isidore of Seville, *De natura rerum*, Paris, Bibliothèque Nationale, MS lat. 4860, f. 103v. 10th century

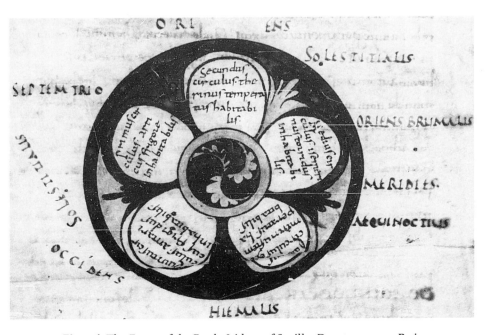

Fig. 1.6 The Zones of the Earth. Isidore of Seville, *De natura rerum*, Paris, Bibliothèque Nationale, MS lat. 6649, f. 8v. 10th century

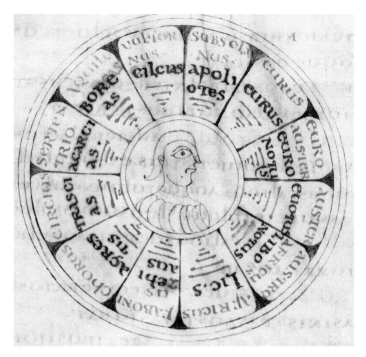

Fig. 1.7 The Winds. Isidore of Seville, *De natura rerum*, Paris, Bibliothèque Nationale, MS lat. 6413, f. 27v. 8th century

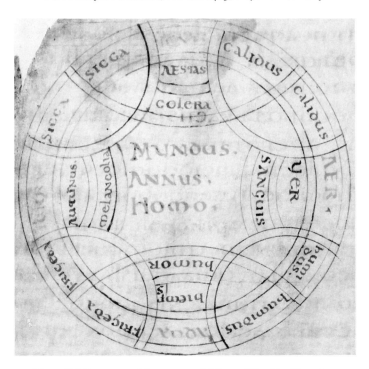

Fig. 1.8 Microcosm–Macrocosm. Isidore of Seville, *De natura rerum*, Paris, Bibliothèque Nationale, MS lat. 6413, f. 5v. 8th century

of the seasons (Fig. 1.4).[15] The concepts and visual images found in these early works were transmitted to clerics through the centuries, in illustrated schoolbook compendia of natural history.

Memory Systems

Memory systems and memory diagrams were an important aspect of medieval learning. Most memory training of the Middle Ages was based on the concepts of *Rhetorica Ad Herennium*, a textbook of rhetoric written by an unknown teacher in Rome, compiled *ca.* 86–82 BC. The book, supposedly based on earlier Greek texts, was believed to have been written by Cicero and had great prestige during the Middle Ages.[16] It was widely known in its original as well as in a variety of later forms, especially through Martianus Capella's allegorical form.[17] Rhetorical systems of memory training were known in numerous versions. We have already seen a most simple form in one of the earliest Isidorian *rotae*, the zones of the earth (Fig. 1.6) in which the five petals were matched to a memory system based on the fingers of one's hand.[18]

Schoolbooks: *Rotae*

Much like mappae mundi, schoolbooks were compilations of learning in which shared beliefs about the nature of the universe were depicted in diagrammatic form. The stationary earth, composed of the four elements, sat at the center of the God-created universe. Revolving around the earth was a series of spheres, including the moon, sun, remaining five planets and the fixed stars. Beyond this existed the empyrean of God, which according to Aristotle consisted of a different substance from the earth and was composed of a series of concentric circles to enclose the heavenly intelligences.[19] Key to

[15] Murdoch, *Album of Science*, 53. Bober makes a similar point, citing the words *Haec itaque ne confusa minus intelligantur, subjecta expressi pictura* ('And so, to prevent these things being less well understood through confusion, I have portrayed them in the figure inserted below') from the medieval schoolbook, Baltimore, Walters Gallery, MS W. 73; see Bober, 'Illustrated Medieval School-Book', 73.

[16] For background and description of *Rhetorica Ad Herennium*, see Francis Yates, *The Art of Memory*, Chicago, 1966, esp. 1–17.

[17] Martianus Capella's *De nuptiis Philologiae et Mercurii*, a fifth-century encyclopedia of the seven liberal arts, was well known in the Middle Ages and was important in preserving the ancient educational system of the seven liberal arts. In his section on rhetoric, Martianus Capella briefly discusses artificial memory; see Yates, *Art of Memory*, 20–1, 63–5, 68; David L. Wagner, *The Seven Liberal Arts in the Middle Ages*, Bloomington, 1983.

[18] Murdoch, *Album of Science*, 340. In this case, the circle in which the petals are enclosed, although the cardinal points are noted, is divorced from its symbolism as earth.

[19] Lindberg, *Beginnings*, 250–1. For discussion of the Christian interpretation of the empyrean, beginning with the Church Fathers, see Grant, 'Cosmology', esp. 275–80.

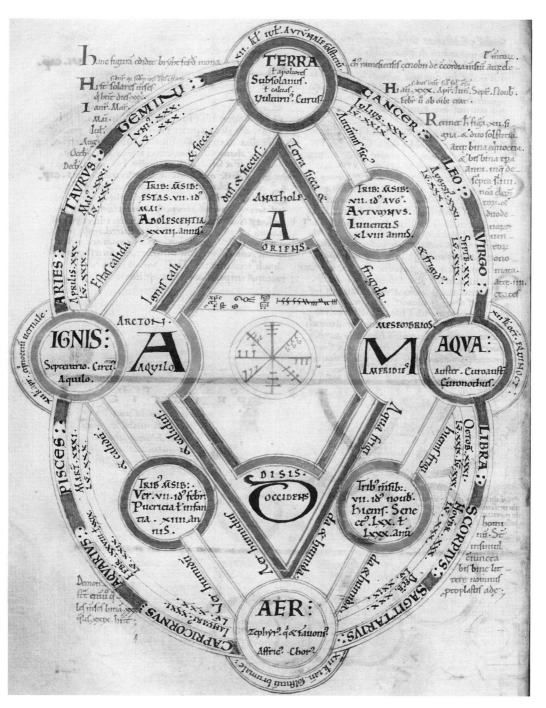

Fig. 1.9 Microcosm and Macrocosm. Byrhtferth's *Computus* (the *Ramsey Computus*), Oxford, St John's College, MS 17, f. 7v. *ca.* 1110.

medieval Aristotelian and Neo-Platonic interpretations of the nature of matter was an insistence that everything existed in a vast hierarchy in relationship to God.[20]

England had a particularly lively tradition of illustrated schoolbooks dating from Carolingian times under the influence of Abbo of Fleury who directed instruction at Ramsey Abbey before he returned to France in 988.[21] Abbo's compendium was largely based on Bede's *De natura rerum*, and heavily influenced by Isidore's works, especially his treatise of the same title. Isidore, in turn, depended upon Pliny and other classical writers. Whereas Abbo's student Byrhtferth introduced an idiosyncratic variation on Abbo's derivative schema in his assembled *Natural Science Textbook* (Fig. 1.9),[22] later English schoolbooks, compilations of Abbo's accumulated knowledge, may be considered exemplars of the durability over centuries of Abbo's schematic devices. An example of this genre in which *rotae* diagrams are used to help explain the order and unity of creation is a medieval textbook in the Walters Gallery (Baltimore, Walters Gallery, MS W.73). Accompanying the text is a rich variety of schematic diagrams, many of them circular, which, according to Bober, indicate the long-lasting influence of the Isidorian *rotae* as transmitted into the twelfth century 'within the circumscribed sphere of monastic learning, formed and consolidated out of the Bede tradition, reflecting his derivation from Isidore and, at the same time, bearing the stamp of their passage through the Abbey of Fleury'.[23] Note for example, the *rota* of the Harmony of the Year and Seasons, and the *rota* of the Harmony of the Elements, Seasons, Humors (Fig. 1.10)[24] and how closely these images resemble the earlier Isidorian *rotae* we have

20 Frederick B. Artz, *The Mind of the Middle Ages A.D. 200–1500*, Chicago, 1980 (3rd edition, revised), 234–5.
21 Harry Bober, 'Illustrated Medieval School-Book', 74–5.
22 Oxford, St John's College, MS 17, f. 7v, *ca.* 1110. This manuscript contains a number of separate works, one of which is Byrhtferth's *Computus*, or the *Ramsey Computus*. This folio (7v) describes in diagrammatic form the astrological signs and their calendric months, cardinal points, four fundamental elements of the world and their qualities as they relate to the calendar and to the ages of man and twelve winds. In the center are the inscribed letters ADAM that also stand for the initial letters of the parts of the world in Greek (in the somewhat corrupt forms *Anathole, Disis, Arcton,* and *Mesembrios*). For further discussion and bibliography, see *English Romanesque Art, 1066–1200*, George Zarnecki, Janet Holt, and Tristam Holland, London, 1984, 104; J. J. G. Alexander and Elzbieta Temple, *Illuminated Manuscripts in the Oxford College Libraries, the University Archives and the Taylor Institution*, Oxford, 1984, cat. no. 5, p. 3; Madeline Harrison Caviness, 'Images of Divine Order and the Third Mode of Seeing', *Gesta*, 22, 1983, 107; Murdoch, *Album of Science*, 365; Claus Michael Kauffmann, *Romanesque Manuscripts 1066–1190* (A Survey of Manuscripts Illuminated in the British Isles, 3), London, 1975, 56–7; Harry Bober, '*In Principio*: Creation Before Time', in *De Artibus Opuscula XL, Essays in Honor of Erwin Panofsky*, ed. Millard Meiss, 1961, I: 13–28, esp. 21. Sears considers the diagram in detail with special emphasis on tetradic cosmology; see Elizabeth Sears, *The Ages of Man: Medieval Interpretations of the Life Cycle*, Princeton, 1986, 33–5, 23–5, nn. 113–15 (bibliography).
23 Bober identified the manuscript as containing a variety of texts from authors as diverse as Isidore of Seville, the Venerable Bede, Abbo of Fleury, Pliny, Hyginus, Ptolemy, Varro, and Virgil. He argues convincingly that the manuscript is English and dates between 1190–1200. According to Bober, the manuscript's content is mainly based on Bede's *De natura rerum* with supplements from Isidore of Seville (*De natura rerum, Etymologiae*) and Abbo of Fleury; see Bober, 'Illustrated Medieval School-Book', 65–97.
24 Baltimore, Walters Gallery, MS W. 73, f. 8r. The first *rota* (above), the *rota* of the Harmony of the Year and Seasons, has its central subject, ANNUS, and includes the calendar, the seasons and their duration, and the cardinal points. The lower *rota*, that of the Harmony of the Elements, Seasons, Humors, provides similar information but the elements, seasons, and humors are linked. These two *rotae* are close in conception to the Isidorian early models of figs. 4 and 8.

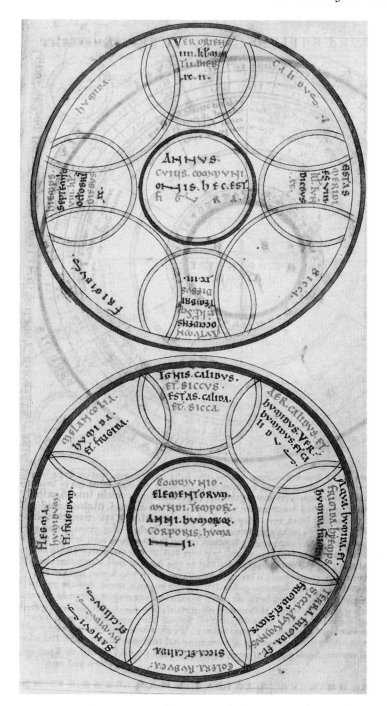

Fig. 1.10 The Harmony of the Year and the Seasons (above); the Harmony of the Elements, the Seasons, the Humors (below). The Walters Art Gallery, Baltimore, MS W.73, f. 8r. *ca.* 1190–1200

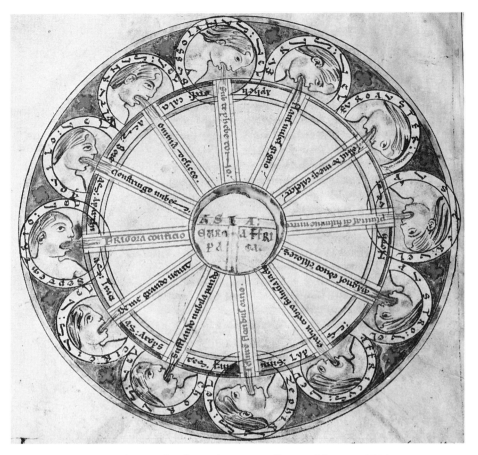

Fig. 1.11 The Winds. The Walters Art Gallery, Baltimore, MS W.73,
f. iv. *ca.* 1190–1200

previously considered, especially Figs. 1.4 and 1.8. In the *rotae* of Winds (Fig. 1.11)[25]
and of Wind Names (Fig. 1.12), we find inserted into the constructs elaborations based
on the earlier Isidorian *rotae*. The centers of all of these *rotae* contain maps in a variety
of forms from zonal to schematic T-O map of the world in which Asia, Europe, and
Africa are clearly delineated. In some wheels, the twelve winds are depicted as animal
heads.[26] In Fig. 1.11 they are depicted with human faces, and the winds themselves,
aimed at the earth, are depicted by band-like spokes that contain words of description,

25 Murdoch, *Album of Science*, illustr. 280 (p. 343). Bober notes that although the *rota* may be based on
 Isidore's *De natura rerum*, Abbo of Fleury chose to rely on Isidore's text on the winds from *Etymologiae*
 XIII: 11 because it was more informative and didactically clearer than similar sections in either Isidore's
 or Bede's *De natura rerum*. Bober repeatedly makes the point that selections of texts and images were
 based on pedagogical requirements and preferences; see Bober, 'Illustrated Medieval School-Book', 73.
26 For instance see Isidore, *De natura rerum*, Leiden, Univ. B., Cod. E Leg. Periz, f. 2, thirteenth century. See
 *Mappemondes A.D. 1200–1500: Catalog preparé par la Commission des Cartes Anciennes de l'Union
 Géographique Internationale*, ed. Marcel Destombes, Amsterdam, 1964, 68, pl. D.

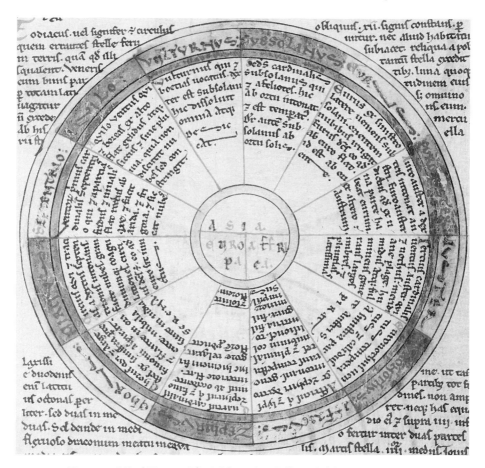

Fig. 1.12 Wind Names. The Walters Art Gallery, Baltimore, MS W.73,
f. 2r. *ca.* 1190–1200

an idea that is further developed in Fig. 1.12. In the latter examples, the wheel is turned so the eastern wind, Subsolanus, is at the top, an orientation that reinforces that of the T-O maps within. In these images we have the concentric circles of the earth and the winds aligned in eastern orientation, a key schematic organizing principal of the Hereford and related mappae mundi.

The encyclopedic nature of these schoolbooks made them well suited to be teaching devices in the context of the monastic tradition of learning systems. In fact, Bober specifically shows that the texts of the Walters schoolbook were chosen specifically for didactic effectiveness, as was common practice. The circular diagrams that were included in the manuscript were particularly well suited as visual and mnemonic devices to help the reader distill and memorize the textual information. Although many of these diagrams were known as early as the ninth century, given their value as learning and memory devices they continued to be used by the clergy. By the thirteenth and fourteenth centuries, circular schemata of tables of winds, tides, the zodiac,

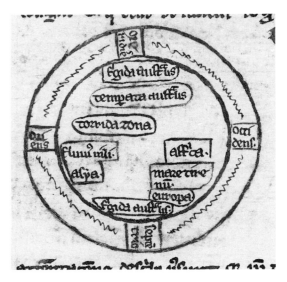

Fig. 1.13 Zonal Map. William of Conches,
Summa Magistri Wilhelmi de Conches, Oxford,
Bodleian Library, MS Digby 107,
f. 30v. (?) 14th century
© The Bodleian Library, University of Oxford

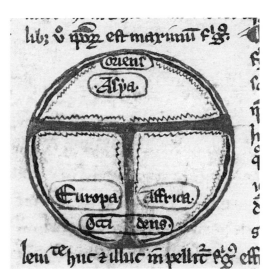

Fig. 1.14 Mappa Mundi. William of Conches,
Summa Magistri Wilhelmi de Conches, Oxford,
Bodleian Library, MS Digby 107, f. 35v.
(?) 14th century
© The Bodleian Library, University of Oxford

consanguinity and calendrical calculations found their way into a great variety of manuscripts. The diversity of texts accompanying such diagrams indicates how multivalent the images had become. They continued to be found in Latin manuscripts that were largely the province of the religious and scholastics of the universities,[27] and extended into manuscripts that contained texts in both Latin and the vernacular. For instance, in approximately contemporary manuscripts, one finds a similarity between the *rotae* in several appended pages to the *Dragmaticon,* a Latin manuscript on natural philosophy by the scholastic philosopher William of Conches (Oxford, Bodl. Lib., MS Digby 107)[28] and those accompanying Gauthier of Metz's vernacular *Le Romaunce del ymage du monde,* an encyclopedia of miscellaneous moral and scientific lore[29] (Oxford, Bodl. Lib., MS Selden Supra 74).[30] Apparently the cosmological wheels once limited to monastic and clerical usage were transformed and adapted to accompany the more readily accessible vernacular works that were becoming increasingly available to clerics and lay people alike.

The effectiveness of the wheel as a memory device had already proved itself in its use in early schoolbooks, a use which continued for centuries. For instance, the copy of

[27] William A. Wallace, 'The Philosophical Setting of Medieval Science', in *Science in the Middle Ages,* ed. David C. Lindberg, Chicago, 1976, 91–119. Wallace considers the period of between 1250 and 1350 as key to understanding high and late-medieval science grounded in the predominantly Aristotelian teachings of the universities. For discussion of universities, see Pearl Kibre and Nancy G. Siraisi, 'The Institutional Setting: The Universities', in *Science in the Middle Ages,* ed. David C. Lindberg, Chicago, 1976, 120–44.

[28] William of Conches, *Summa magistri Wilhelmi de Conches super naturalibus questionibus et responsionibus,* Oxford, Bodl. Lib., MS Digby 107, fourteenth century (?), England. The bibliography for this manuscript is relatively limited; see Murdoch, *Album of Science,* illustr. 250 (pp. 286–7), illustr. 276 (pp. 335–6), illustr. 287 (pp. 357–8). Also see Destombes, *Mappemondes,* no. 41.9. William of Conches (d. *ca.* 1159) was a prominent member of the school of Chartres, presumably a pupil of Bernard of Chartres. He taught at Chartres and Paris and was tutor to Henry (later Henry II of England) and Geoffrey, sons of Geoffrey Plantagenet. The *Dragmaticon* is concerned with philosophy and astronomy. For discussion of William of Conches, see Lynn Thorndike, *A History of Magic and Experimental Science,* New York, 1923, II: 50–65. For lists of surviving manuscripts of the *Dragmaticon,* see ibid. 65; A. Vernet, 'Un remaniement de la *Philosophia* de Guillaume de Conches', *Scriptorium,* 1, 1946–7, 243–59. Other scholars have noted schematic devices in works by William of Conches; see, for example, Sears, *Ages of Man,* 27–9, fig. 7; Murdoch, *Album of Science,* illustrs. 132, 253, 274, 285, 289.

[29] Gauthier (or Gossuin) of Metz's *Le Romaunce del ymage du monde* was a popular didactic poem influenced by Latin texts such as *Imago mundi* (twelfth century) of Honorius Augustodunensis. It was written *ca.* 1250 for laymen, and often illustrated; see Joseph Victor le Clerc, 'L'Image du monde, et autres enseignements', *Histoire littéraire de la France,* 23, 1856, 287–335. For discussion of other versions of the poem by Gauthier of Metz in French manuscripts, see Gustav Haase, *Untersuchung über die Reime in der Image du Monde des Walther von Metz,* Halle, 1879.

[30] Gauthier of Metz, *Le Romaunce del ymage du monde,* Oxford, Bodl. Lib., MS Selden Supra 74, thirteenth century, England. The text of *L'Image du monde* begins on f. 60. For general reference to this manuscript, see M. B. Parkes, *Scribes, Scripts and Readers,* London, 1991, 284. The manuscript, which includes other works besides Gauthier of Metz's *Le Romaunce del ymage du monde,* is also cited by Jeffrey and Levy for its inclusion of diverse Anglo-Norman lyrics. Three selected lyrics are given as examples, two attributed to Simon, an Augustinian canon of Carmarthen in south Wales and one from Bozon's *Proverbes de bon enseignement;* see David L. Jeffrey and Brian Levy, *The Anglo-Norman Lyric. An Anthology,* Toronto, 1990, 150–5, 205–8, 219–22; *English Lyrics of the XIIIth Century,* ed. Carleton Brown, Oxford, 1932 (repr. 1950), 1; Destombes, *Mappemondes,* no. 45.11.

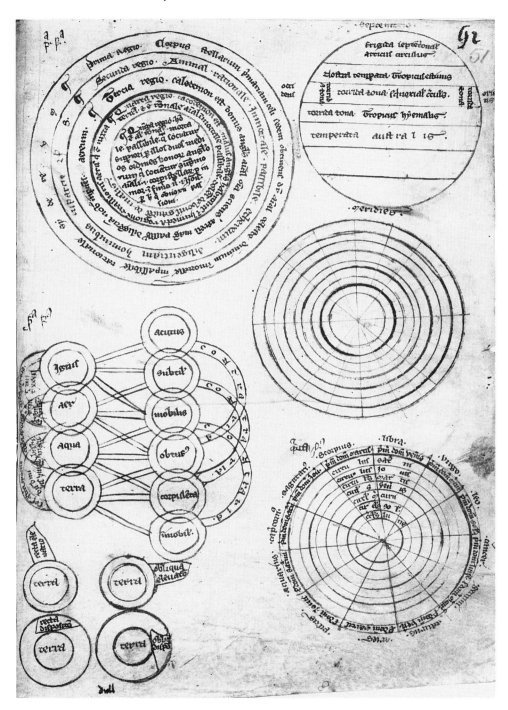

Fig. 1.15 *Rotae.* William of Conches, *Summa Magistri Wilhelmi de Conches*, Oxford, Bodleian Library, MS Digby 107, f. 51r. (?) 14th century
© The Bodleian Library, University of Oxford

William of Conches's *Dragmaticon* or *Summa* illustrated here is an example of a Latin schoolbook that contains a zonal map (based on the Macrobius model) in which the zones are incorporated into the circular form which clearly reads as a map rather than a memory wheel (Fig. 1.13),[31] a mappa mundi (Fig. 1.14),[32] and a number of interspersed circular diagrams relating to the text. At the end of the book as visual summation are four pages of additional diagrams unaccompanied by texts and bound together. Each page is filled with circular images of varying complexity; the use of red and black ink makes the pages remarkably attractive. However, not organized by subject, the pages present a confusing array of information. For instance on one page are six diagrams (Fig. 1.15)[33] that visually schematize the world and its physical aspects. Some of the diagrams are left incomplete; some repeat those in the body of the manuscript.[34] On f. 52r[35] is a similar array of charts of elements, eclipses, and cosmological diagrams of the earth's shape and strata including the composition of the empyrean. These last four pages function as visual summaries of cosmological data. Having no explanatory texts apart from the abbreviated information on the diagrams themselves, it is to be inferred that the reader was familiar with the preceding texts and might rely on the images as memory refreshers not unlike a contemporary 'pie chart' of governmental spending that accompanies a budget report.

Vernacular Literature: *Rotae*

As noted earlier, suitably adapted, many of these diagrams found their way into the popular domain through vernacular literature as well. For instance, the thirteenth-century manuscript mentioned earlier (Oxford, Bodl. Lib., MS Selden Supra 74) containing a copy of *Le Romaunce del ymage du monde* and its accompanying diagrams was a miscellany of French and Latin pieces, with vernacular works that included, among others, Walter of Henley's treatise on husbandry, Walter of

[31] Oxford, Bodl. Lib., MS Digby 107, f. 30v, fourteenth century (?). The map is oriented with south at the top; the lower half of the map contains Asia and the Nile in the east; in the west, Europe is separated from Africa by the Mediterranean; at the bottom (north) of the map is a *frigida* zone; the upper half (south) of the map encloses three areas from south to north: *frigida* (cold), *temperata* (temperate), and *torrida* (hot); the world is surrounded by a wavy line that represents the Great Ocean. For discussion of zonal mappae mundi, see Woodward, 'Medieval *Mappaemundi*', esp. 296–7, 353–5.

[32] Oxford, Bodl. Lib., MS Digby 107, f. 35v, fourteenth century (?). The map is oriented to the east following the basic divisions of a T-O map.

[33] Oxford, Bodl. Lib. Digby 107, f. 51r, fourteenth century (?). Top left: the shape and strata of the universe; middle left: Platonic theory of the elements; lower left: eclipses; top right: zonal map; middle right: incomplete; Lower right: orbs of the planets, incomplete. For discussion of comparative images, see Murdoch, *Album of Science*, esp. 276–301, 328–64.

[34] For instance, other versions of zonal maps are provided as explications of the texts on fs. 30v and 34r.

[35] Oxford, Bodl. Lib. Digby 107, f. 52r, fourteenth century (?). Top left: elements; middle left: two diagrams of the world as quadripartite; lower left: Platonic theory of elements / great chain of being; top right: two diagrams of eclipses; middle right: shape and strata of the universe; bottom right: shape and strata of the universe including the angelic spheres of the empyrean. For discussion of comparative examples, see Murdoch, *Album of Science*, esp. 276–301, 328–64.

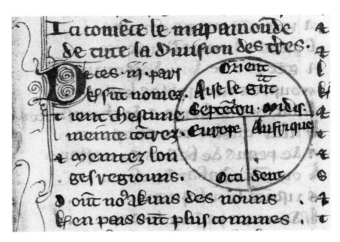

Fig. 1.16 Mappa Mundi. Gauthier of Metz, *Le Romaunce del ymage du monde*, Oxford, Bodleian Library, MS Selden Supra 74, f. 75r. 13th century, England
© The Bodleian Library, University of Oxford

Bibbesworth's treatise on learning the French language, the morally improving work, *La Desputasion du cors et de l'âme* and Bozon's *Proverbes de bon enseignement*.[36] According to Parkes, this kind of collection was 'designed to improve the reader's soul, or to multiply his accomplishments and to increase his stock of useful, even cultural information. It reflects the pragmatic taste of the middle-class reader, and his desire to rise in the world.'[37]

Sprinkled through the text are familiar images such as the earth surrounded by the four elements (f. 72r). There is a T-O map that accompanies the section that begins: 'La commence le mapamonde de cute la division des tres' which introduces information regarding geographical areas with relevant plant and animal lore (f. 75r, Fig. 1.16). In the same manuscript is a diagram of an eclipse of the sun, and a variation of the diagrammatic schema for the shape and strata of the universe (f. 101v, Fig. 1.17).

The final image of this series, taken from another manuscript of *Le Romaunce del*

36 See above, n. 30.
37 Parkes, *Scribes, Scripts*, 284. According to Clanchy, history and romance were closely connected in the lay reader's mind. Walter of Bibbesworth and Walter of Henley were typical of educated English gentlemen who acted as stewards and managers for royal and baronial enterprises for whom French was the language of management and lordship. They were also familiar with Latin because it was the language of schoolmen and of older branches of the royal administration, see M. T. Clanchy, *From Memory to Written Record*, Cambridge, MA, 1979, 112–13, 197–200. Nicholas Bozon, a Franciscan friar, active in the early fourteenth century, according to Jeffrey and Levy, most likely studied in Oxford and was probably a member of the Franciscan friary at Nottingham. He is one of the three most prominent names connected to Anglo-Norman lyric poetry of the period *ca.* 1225–1325. The name Bozon is possibly related to the Bohuns of Hereford, although the connection is largely conjectural; see Jeffrey and Levy, *Anglo-Norman Lyric*, 14. On Bozon and Bibbesworth, also see M. Dominica Legge, *Anglo-Norman Literature and Its Background*, Oxford, 1963, 281–3, 348–9.

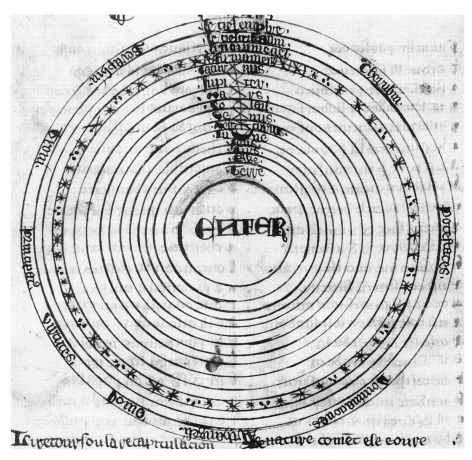

Fig. 1.17 The Shape and Strata of the Universe. Gauthier of Metz, *Le Romaunce del ymage du monde*, Oxford, Bodleian Library, MS Selden Supra 74, f. 101v. 13th century, England
© The Bodleian Library, University of Oxford

ymage du monde, shows how the earth was visualized in its relationship to the empyrean, a theme that captured the imagination (Fig. 1.18).[38] Diagrams of this nature, that combine the earth and heavens into a single visual statement of concentric or

[38] Miscellany containing *Le Romaunce del ymage du monde*, Paris, Bibliothèque de l'Arsenal, MS 3516, f. 179r, *ca.* 1268, Northern French. Folio 179r is at the end of the manuscript. Its diagram is labeled in the manuscript's table of contents, as 'L'ymage du monde et le mapemonde'. The diagram consists of two *rotae*. The lower *rota* has as its center hell with concentric circles radiating outward including the earth, sun, moon, planets, and heavenly bodies leading to the empyrean of God. The upper *rota* contains ANNUS in its center. The interior small circles contain information regarding the number of months, weeks, days and hours in the year. The larger circles that mark the cardinal points include seasons, zodiacal signs, humors, and four ages of man. Inscriptions are a mixture of Latin and French, see Sears, *Ages of Man*, 114, fig. 54. Sears cites Henry Martin, *Catalogue des manuscrits de la Bibliothèque de l'Arsenal*, 3, 1887, 395–405, which indicates that f. 156v 'Le table de le mapemonde' begins, 'Qui veut oir et entendre si se traie . . .' (a text

connecting circles, continued to be widely disseminated in texts relating to the art of memory and can be found in printed editions dating to the Renaissance.[39]

As Parkes suggests, at first the holy orders were the repository of learning and cosmologies, and their texts and images belonged to the category of 'literacy of the professional reader'. However, 'with the dissemination of literacy in its multiple forms, including developments in vernacular literature for the cultivated reader there entered the "literacy of recreation" '.[40] The example of *Le Romaunce del ymage du monde*, a vernacular text that applied a moralizing religious gloss to traditional scientific material, gives us a glimpse of the didactic dimension of recreational literacy and its appropriation of images traditionally tied to the literature of the professional.

In spite of the growing dissemination of vernacular texts for an educated reading public, Latin cosmological documents were still generally limited to churchmen and scholars. And although debate raged amongst scholars regarding the shape of the earth, by the thirteenth century the majority of scholars writing in Latin agreed upon the spherical nature of the earth. Nevertheless, other theories, even that of the square world, continued to fuel theoretical debate.[41] However, apart from the highly educated, the cultivated reader was more likely to be influenced by vernacular literature than by Latin cosmological texts. As a result, they probably visualized the world as a flat circle, which may or may not have conjured the image of a sphere for them. Examples from twelfth and thirteenth-century vernacular narrative literature in which the world was described are generally brief and ambiguous. In spite of the didactic

similar to that on the Hereford map). Gauthier of Metz's *Le Romaunce del ymage du monde* begins on f. 160r; see le Clerc, 'L'Image du monde', esp. 326–7; Ellen J. Beer, *Die Rose der Kathedrale von Lausanne*, Bern, 1952, 36–9, fig. 10.

39 The spheres of the universe specifically used as a memory system is known from the appendix titled 'Ars memorativa', of a printed version (1482) of the *Oratoriae artis epitome* by Jacobus Publicius. Another copy of the *Oratoriae* including the 'Ars memorativa' is also known to have existed in England in manuscript form, supposedly copied in 1460 by a monk at Durham. Yates suggests that the location of the memory sections as appendices indicates a connection to earlier thirteenth-century memory treatises in which the Art of Memory sections were also positioned at the end of the work and were occasionally detachable; see Yates, *Art of Memory*, 117–19. For a comprehensive study of memory in the Middle Ages, see Mary J. Carruthers, *A Book of Memory: A Study of Memory in Medieval Culture*, Cambridge, 1992 (reprint); Mary J. Carruthers, *The Craft of Thought: Meditation, Rhetoric, and the Making of Images, 400–1200*, Cambridge, 1998.

40 According to Parkes, 'Apart from the ecclesiastical prose produced in England in the tenth or at the beginning of the eleventh century, the written literature of this early period was in Latin: the learned literature of a closed circle of scholars and savants. . . . The turning-point in the history of lay literature came in the twelfth century.' See Parkes, *Scribes, Scripts*, 276.

41 Beer discusses the concept of the square earth and the circular world as interchangeable ideograms for cosmological data with the rose window incorporating both (see below, nn. 43–5). For instance, Beer notes that already Cassiodorus (*ca.* 490–585) had proposed a correlation between the circle and the square, describing the earth as a square within the circular cosmos. By Carolingian and Ottonian times, the circle and square were supposedly still considered interchangeable. Beer suggests that as late as the thirteenth century theoreticians continued to challenge the circle as the sole ideogram for the earth, as for instance proposed by Vincent of Beauvais in *Speculum maius*. Perhaps the persistence of this argument rested upon the relationship of the square to the cross, which suggested a Christian dimension to the visualization of cosmology; see Ellen Beer, 'Nouvelles réflexions sur l'image du monde dans la cathédrale de Lausanne', *La Revue de l'art*, 10, 1970, 58–62, esp. 60–2.

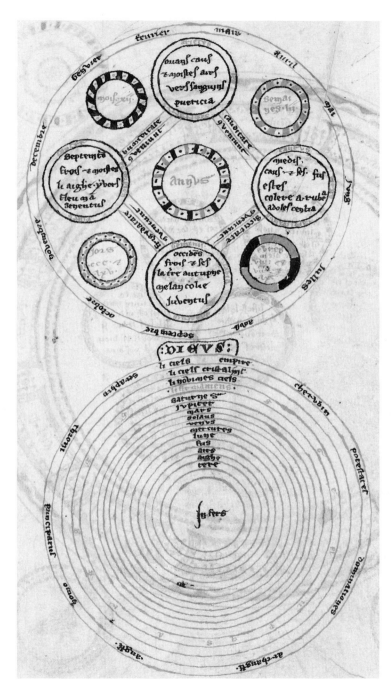

Fig. 1.18 *Rotae.* Gauthier of Metz, *Le Romaunce del ymage du monde*, Paris, Bibliothèque de l'Arsenal, MS 3517, f. 179. *ca.* 1268

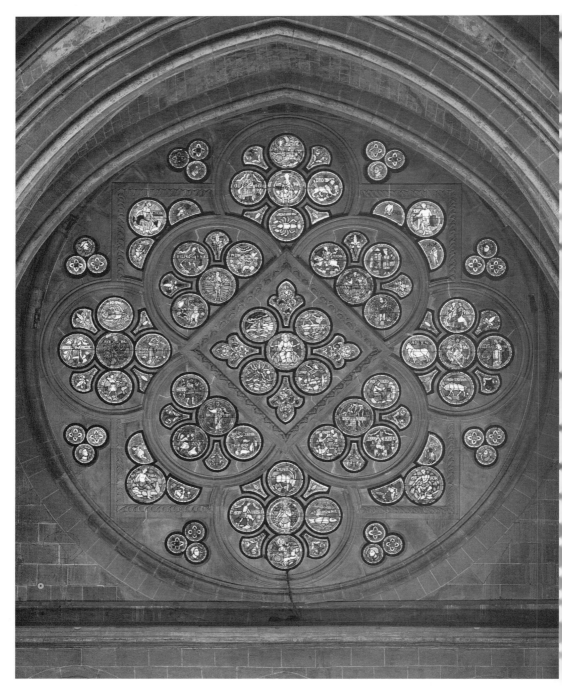

Fig. 1.19a Rose Window. Cathedral of Lausanne, south transept, 1232–5
Photograph © Claude Bornand, Lausanne

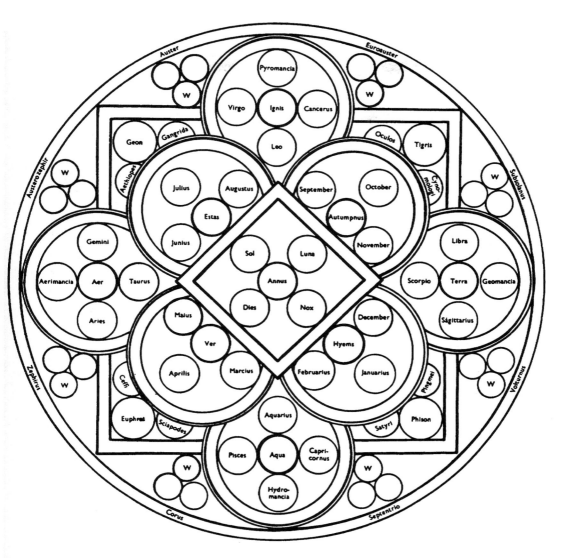

Fig. 1.19b Rose Window. Cathedral of Lausanne, south transept, 1232–5, schematic diagram of subjects (Ellen Beer, *Die Rose der Kathedrale von Lausanne*)

Photograph courtesy of the Fine Arts Library, Harvard College Library

Latin and Latin-derived vernacular literature that largely confirmed that the world was spherical, these other vernacular works, such as romances and chronicles, almost exclusively described the flat tripartite division of the known inhabited world or *oikoumene* as on a circular T-O map. Perhaps the stories that most fostered this image amongst the populace were tales of lands of myth. As would be expected, the average listener empirically imagined the world as flat.[42]

Church Decoration: *Rotae*

For the general populace, the diagrams of Latin or vernacular manuscripts were inaccessible. To them, it was church decoration that made texts visible. As such, the rose window was the supreme embodiment of the illuminated manuscript made available to the public. The rose window of Lausanne (Figs. 1.19a, b)[43] provides us with an example that is perhaps the closest analog between the scholastic diagrams and mappae mundi. Although the window underwent extensive restoration in the nineteenth century we can reconstruct much of its original program. The center circle of the window originally held the god of the year (Annus) surrounded by the sun, moon, day and night, an image frequently found in *rota* diagrams in which Annus is conflated with Christ the Cosmocrator. Here Annus is surrounded by radiating quatrefoils that provide a cosmological schema that radiates outward. In the first tier are four lobes concerned with earthly time including the seasons and their accompanying months; in the next tier are four lobes that contains the elements and the zodiac, as well as the sun, moon, and two foretellers of the future;[44] in the next tier, sections that create the frame of an inscribed square, are the four rivers of Paradise and the lands of myth;[45] beyond are eight winds of the cosmos as described by Isidore of Seville. The window is in essence a highly developed hybrid of the types of *rotae* we have been considering. We have already noted the commonality of diagrams that locate the Isidorian winds at the perimeter of diagrammatic earth. Here, a thirteenth-century stained-glass window, transcribed into its diagrammatic form (Fig. 1.19b), takes on the appearance of the

42 Tattersall considers Alexander romances and French prose translations of *Le Romaunce del ymage du monde*; see Tattersall, 'Sphere or Disk?', esp. 34–46; Russell, *Flat Earth*, 13–46.

43 The rose window of Lausanne is situated in the south transept of the cathedral and is dated between 1232 and 1235. The window was restored in the nineteenth century and the center circle was incorrectly filled with an image of God the Father surrounded by scenes of creation. The error is understandable for as Beer indicates, even in Roman times, central images of circular diagrams were devoted to deities such as Annus who became conflated with Christ as cosmocrator; see Beer, 'Nouvelles', 57–62.

44 The figures of Aeromancy are surrounded by seven doves by whom she foretells the future, and Pyromancy who foretells the future by the flames of fire.

45 The Geon (Nile) flanked by Ethiopians and Gangaridae; the Tigris flanked by Oculos (Acephali) and Cynocephali; the Phison flanked by Pygmies and Satyrs; the Euphrates flanked by Cephi ('Ceffi') and a nineteenth-century replacement panel depicting Sciopods; see Painton Cowen, *Rose Windows*, London, 1979, 131.

Byrhtferth diagram with the added subject of strange races. The dimension of the future has obvious typological Christian ramifications for all the races of peoples inscribed within the circle of *terra*, a theme to be considered later in Chapter 5.

The *Rota* of Fortune

Until now we have concerned ourselves with the image of the *rota* as a fixed circle that allowed theoreticians to conceptualize a systematized cosmology. The wheel in motion, or the rotating wheel, was, however, consistently used for visualizing human events as subject to chance. Let us consider the connections with medieval mappae mundi of the two wheels most commonly applied to human activity, the Wheel of Fortune and its offshoot, the Wheel of Life.[46] As was the case of the cosmological diagrams, these images had wide currency and recognition and were also related, in their artistic conceptions, to the medieval maps under consideration. Let us begin with the Wheel of Fortune.

The Goddess Fortuna, the embodiment of Fortune, was a familiar topic of medieval and Renaissance literature. Images of the goddess Fortuna standing on a ball or sphere, or turning her wheel, had ancient roots. Whereas in Roman visual art the wheel was more likely a symbol of instability rather than an ideogram of Fortune's ability to control human events, literature provided a closer connection between Fortune's wheel and Fortune's deeds.[47]

It was, as Kitzinger notes, Boethius, sixth-century scholar and statesman, who in his *Consolation of Philosophy* most graphically 'visualized her with a wheel as an instrument which she turns capriciously and on which man ascends and descends'.[48] That was the image adopted by medieval authors and artists.[49] In medieval times, Fortune's image as

[46] I am indebted to Annie Robinson who researched parts of this section. Her findings were presented in a paper delivered at the Medieval Forum, Plymouth State College, April 1995.

[47] For background, see Howard R. Patch, *The Goddess Fortuna in Medieval Literature*, Cambridge, MA, 1927, 147–77. Patch cites Ammianus Marcellinus and Seneca, among others, as making the connection between the wheel and the fortunes of men (150). Also see Michael Schilling 'Rota Fortunae, Beziehungen zwischen Bild und Text in mittelalterlichen Handschriften', in *Deutsche Literatur des späten Mittelalters* (Hamburger Colloquium, 1973), ed. Wolfgang Harms and L. Peter Johnson, Berlin, 1975, 293–313.

[48] The image is based upon the text: *Haec nostra uis est, hunc continuum ludum ludimus; rotam uolubili orbe uersamus, infima summis summa infimis mutare gaudemus. Ascende si placet, sed ea lege ne utique cum ludicri ei ratio poscet, descendere, iniuriam putes* ('This is my force, this is the sport which I continually use. I turn about my wheel with speed, and take a pleasure to turn things upside down. Ascend, if thou wilt but with this condition, that thou thinkest it not an injury to descend when the course of my sport so requireth'). Latin text and English translation from Boethius, *The Consolation of Philosophy*, trans. H. F. Stewart, London, 1918, 180–1. For a description of Fortune, see *ibid.* 173–85. For discussion of the relationship of Fortune to Providence, Fate being controlled by Providence, according to Boethius, *ibid.* 339–51, esp. 341 in which is the following quotation from Boethius: 'For Providence is the very Divine reason itself, seated in the highest Prince, which disposeth all things. But Fate is a disposition inherent in changeable things, by which Providence connecteth all things in their due order.' Boethius also relates Fate to Providence, using a metaphor of orbs that rotate around a stable center; *ibid.* 343.

[49] Key studies on relevant medieval imagery are: Birgit Hahn-Woernle, 'Die Ebstorfer Weltkarte und Fortuna Rotis-Vorstellungen', in *Ein Weltbild vor Columbus*, ed. Hartmut Kugler and Eckhard Michael,

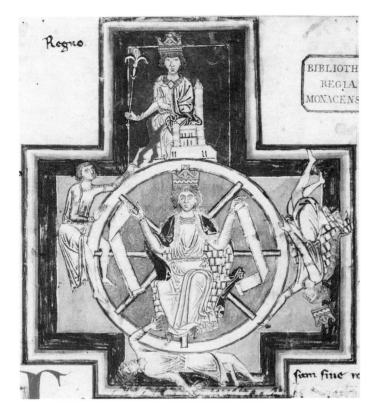

Fig. 1.20 The Wheel of Fortune. *Carmina Burana*, Munich,
Bayerische Staatsbibliothek, MS lat. 4660, f. 1. *ca.* 1230

it related to the wheel became conflated with other cosmological circles. In instances where she is depicted, seated and crowned, within the hub of a wheel she is described in conjunction with the earthly signifiers of *annus, homo, mundus*. In such images the telluric aspect of Fortuna is made abundantly clear as the rim shows the slippery aspects of earthly fortune as rising and falling personifications who slide up or down toward and away from the prized position of wealth and power at the top (Fig. 1.20).[50]

Weinheim, 1991, 185–99; Ernst Kitzinger, 'World Map and Fortune's Wheel: A Medieval Mosaic Floor in Turin', *Proceedings of the American Philosophical Society*, 117, 1973, 344–73; Sears, *Ages of Man*, esp. 144–51. Also see F. P. Pickering, *Literature and Art in the Middle Ages*, London, 1970, 168–222; Schilling, 'Rota Fortunae', 293–313; Marcia Kupfer, 'The Lost Wheel Map of Ambrogio Lorenzetti', *The Art Bulletin*, 78, 1996, 286–310. For a good selection of photos, see Pierre Courcelle, *La Consolation de Philosophie dans la tradition littéraire*, Paris, 1967, figs. 65–86.

50 *Carmina Burana*, Munich, Bayer. Staatsbibl., MS lat. 4660, f. 1r. For facsimile, see *Carmina Burana*, ed. Bernhard Bischoff, Munich, 1967. In *Carmina Burana*, Fortuna is specifically described (lxxvii) as dealing in royal favors and taking them back at will. Note that the texts surrounding Fortuna frequently are: *regnabo, regno, regnavi, sum sine regno* ('I shall rule, I rule, I have ruled, I am without rule'), see Kitzinger, 'World Map', 364, in n. 134 Kitzinger provides a list and bibliography for other thirteenth-century representations of Fortuna in the center of the wheel.

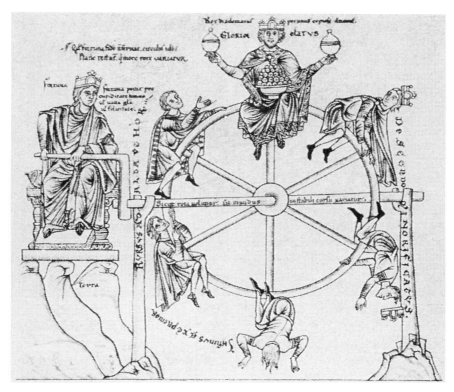

Fig. 1.21 The Wheel of Fortune. (A. Straub and G. Keller, *Hortus deliciarum* by
Herrad of Landsberg, 1879–99, f. 215)
Photograph courtesy of the Fine Arts Library, Harvard College Library

In another type, Fortuna is depicted as outside the wheel whence she directs the
course of action by turning a crank.[51] In the example in Fig. 1.21 her earthly position is
especially pronounced, as she is clearly seated upon a mountain, which according to
Straub and Keller was labeled *terra*.[52] In each case, true to type, she is depicted as
having a powerful influence over the course of earthly events.

The conflation of Fortuna with the earthly realm is perhaps best exemplified
artistically by a mappa mundi in the form of a medieval mosaic pavement from the

[51] Kitzinger also provides a list and bibliography for twelfth-century representations of Fortuna outside the
wheel. According to Kitzinger, this version predominated in the twelfth century whereas the image of
Fortuna within the wheel was most popular in the thirteenth; see Kitzinger, 'World Map', 364, n. 135.

[52] The *Hortus deliciarum* was written by Abbess Herrad of Hohenbourg (*ca.* 1176 to *ca.* 1196). It was
destroyed in 1870 and is known only through reconstructions. Comte Auguste de Bastard's notes and
sketches were made from the original before its destruction. After the destruction of the manuscript,
Canon Straub of the Cathedral of Strasbourg edited the traces without referring to Bastard's work. For
background, see A. Straub and G. Keller's edition of Herrade de Landsberg's *Hortus deliciarum*,
Strasbourg, 1901, 42 ff. and pl. 55 bis (Supplement). Straub and Keller's work has been superseded by
Herrad of Hohenbourg, *Hortus deliciarum*, ed. Rosalie Green, Michael Evans, Christine Bischoff, Michael

excavated church of San Salvatore in Turin. According to Kitzinger, the mosaic once consisted of a square field with inscribed circle; the circle bounded by a broad black band was filled with wavy lines denoting the world's ocean; personifications of the four primary winds and their accompanying secondary winds were depicted in the spandrels of the four corners. The world encircled by the ocean, around which the winds are placed, is the stock perimetrical enframement of a medieval circular T-O map. However, within the mosaic pavement's circular format there is substituted a Wheel of Fortune for the earthly geography of a mappa mundi.[53] Here we have graphic evidence of the relationship between the fixed world whose outer rim is composed of the winds and the earthly realm seen as a function of history and change as well.

Similarly the earth-bound characteristics of the Wheel of Fortune were grafted onto its descendant, the Wheel of Life. Medieval moralists' preoccupation with vainglory in the face of eternity may account for the transformation of the image of the Wheel of Fortune into its Christianized counterpart, the Wheel of Life, where the wheel is perceived as a metaphor for the ephemeral and temporal characteristics of earthly life. The practical and religious implication of the Wheel of Life, unlike that of the Wheel of Fortune, is that each person is allotted only one revolution on the wheel. Thus the viewer is encouraged to look beyond the worldly life, transitory and unpredictable, to a spiritual existence not limited by time and change.

As Sears points out, by the thirteenth century 'the full-fledged Wheel of Life developed out of the Wheel of Fortune, never to be completely divorced from it'.[54] Some of its most sophisticated treatments are found in the Psalter illuminated by the English artist William de Brailes *ca.* 1240.[55] The later Arundel Psalter (also known as the de Lisle Psalter, after the wealthy English baron, Robert de Lisle, who commissioned the

Curschmann, *et al.*, 2 vols., London, 1979. Also see Kitzinger, 'World Map', 368–9. The inscription based on Straub and Keller is given in *Hortus deliciarum* (ed. Green *et al.*), I: 200:
> Fortuna; terra.
> Fortuna ponit pro cupiditate humane vel vana gloria vel felicitate.
> Rex diadematus pecuniis copiose ditatus.
> Glorior elatus; descendo minorificatus; infimus axe premor; rursus ad alta vehor.
> Sicut rota volutatur sic mundus instabili cursu variatur.
> That Fortuna does not keep faith the very circle, which changes like a wheel, clearly testifies.
> Fortuna; Earth.
> Fortuna appoints, instead of human desire or vainglory or happiness.
> A crowned king abundantly enriched with wealth.
> I vaunt myself when lifted high; I descend humbled; at the bottom I am crushed by the axle; again I am borne aloft.
> Just as the wheel rolls about so the world varies in its unstable course.

[53] The detailed study by Kitzinger of the late Romanesque mosaic proves that it is closely related to medieval maps. Apart from the framing devices of circle, ocean, and winds, many of the texts support his argument. The conflation of a world map with a representation of Fortuna in her wheel in one representation is unique. However, Kitzinger notes that Henry III's decoration of the hall at Winchester Palace contained a Wheel of Fortune and a world map, a subject to be dealt with later. For other tangential examples, see Kitzinger, 'World Map', 365, n. 140.

[54] Sears, *Ages of Man*, 145.

[55] For general introduction, see Nigel Morgan, *Early Gothic Manuscripts 1190–1250* (Survey of Manuscripts Illuminated in the British Isles, 4), London, 1982, I: 118–19 (cat. no. 72a).

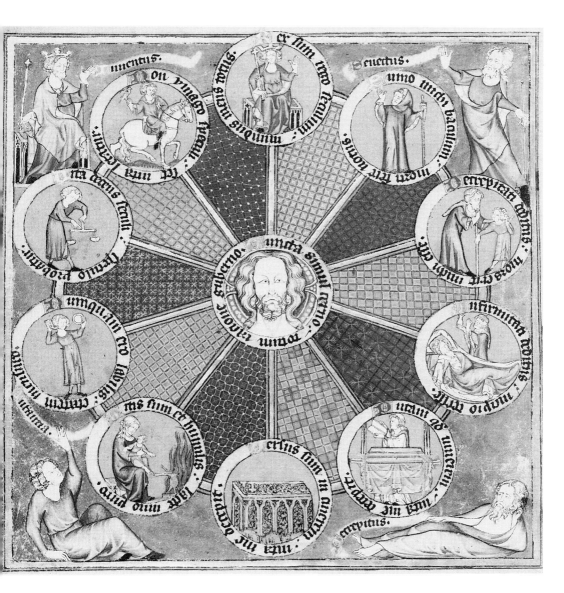

Fig. 1.22 The Wheel of Life or the Ten Ages of Man. De Lisle Psalter, British Library, London, MS Arundel 83 II, f. 126v. *ca.* 1310, England
By kind permission of the British Library

manuscript) provides another example. De Lisle was devoted to the Franciscan Order: and in keeping with Franciscan methods of teaching there are four large illuminated wheels, two of which (Figs. 1.22, 1.23), call for particular mention in light of our discussion of the medieval interchangeability and conflation of didactic *rotae*.[56]

Thus, in the Wheel of Life or the Ten Ages of Man (Fig. 1.22) the central figure of Fortuna is replaced by a Christ-like divinity. The Latin text refers to the orderly turn of the wheel as it goes through the stages of life from infancy to death, a clear departure from the erratic nature of Fortuna's cranking. For Christian didactic purposes the unpredictable role of Fortune was subsumed under God's control.[57] The phases of the ten stages of life are described by five rhyming couplets. Although the couplets are in Latin, the simple rhymes suggest an oral folkloric tradition that evidently found its way into richly decorated manuscript illumination.[58] The example serves as another illustration of the porous nature of the motif.

The other *rota* from the Arundel Psalter worth mention here is the Shape and Strata of the Universe, based upon a commentary by the thirteenth-century Franciscan scholar John Peckham on the *De sphaera* of John of Sacrobosco (Fig. 1.23).[59] The treatise, written for use in Franciscan schools, was in the ongoing tradition of showing the fixed earth surrounded by concentric spheres of elements, planets and stars in orbital

[56] The De Lisle Psalter, also known as the Arundel Psalter, London, BL, Arundel, MS 83 II, executed before 1339, England. For background, see Lucy Freeman Sandler, *The Psalter of Robert de Lisle*, Oxford, 1983. The psalter consists of only nineteen folios (fs. 117–135v) on which there are thirteen diagrams that Sandler believes were used as teaching devices. Similar groupings of many of the charts contained are known as the *Speculum theologie*, believed to derive from the work of the Franciscan, Johannes Metensis (John of Metz), active in Paris during the last quarter of the thirteenth century. The four *rotae* included in the Arundel Psalter are: fs. 123v (Sphere of John Peckham); 126r (Wheel of the Twelve Attributes of Human Existence); 126v (Wheel of the Ten Ages of Man); 129v (Wheel of Sevens). The Sphere of John Peckham and the Wheel of the Ten Ages of Man are not commonly found in most other examples of the *Speculum theologie*; for discussion and list of other examples, see *ibid.* 23–7. For discussion and reproductions of four *rotae*, see *ibid.* 36–7, 38–9, 40–1, 52–3.

[57] Dow points out that Boethius explained God as a fixed point or center of the circle, not necessarily connected with Fortune's wheel. However, medieval commentators such as Honorius of Autun supplied more specific texts to show the development of the replacement of Fortune with God as the center of the Wheel of Life, e.g. 'Per rotam hic mundus figuratur qui celeri circutione ut rota jugiter voluntatur [*sic*]' ('By means of a wheel this world is represented, which perpetually turns with swift circling like a wheel'). See Helen J. Dow, 'The Rose Window', *Journal of the Warburg and Courtauld Institutes*, 20, 1957, 272.

[58] For texts and English translations of couplets, see Sears, *Ages of Man*, 147; Sandler, *Psalter of Robert de Lisle*, 125.

[59] London, BL, MS Arundel 83 II, f. 123v. John Peckham, Archbishop of Canterbury (d. 1292) wrote his treatise during his years at the University of Paris (1250–70). This illumination is described by Murdoch, *Album of Science*, illustr. 276 (pp. 335–7); Sandler, *Psalter of Robert de Lisle*, 36, 124 (texts). From the innermost to outermost ring are the following texts relating to the concentric circles: *Infernus; Spera terre; Spera aque; Spera aeris; Spera ignis; Celum lune; Celum mercurii; Celum veneris; Celum solis; Celum martis; Celum jovis; Celum saturni; Celum sidereum sive stelle; Celum cristallinum sive applanes; Celum medium inter empireum et cristallinum motum motu simplicissimo; Celum empireum fixum et inmotum, in quo est tronos salominis, et locus dei et spirituum.* For transcription of texts and in-depth background, see *The Sphere of Sacrobosco and Its Commentators*, ed. and trans. Lynn Thorndike, Chicago, 1949, 445–50. It is worth noting that an illuminated example of *De sphaera* belongs to the Lincoln Cathedral Library: Lincoln Cathedral Library, MS 148 (B.1.8), fs. 19r–45v, English, twelfth century; see Rodney M. Thomson, *Catalogue of the Manuscripts of Lincoln Cathedral Chapter Library*, Woodbridge, 1989, 114–15, p. 55.

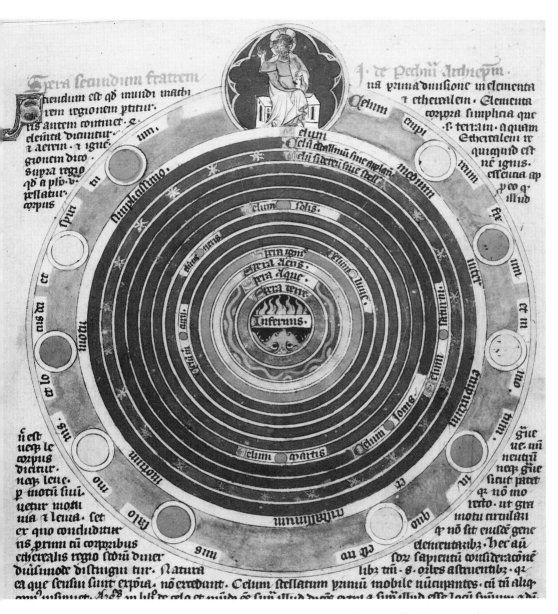

Fig. 1.23 The Shape and Strata of the Universe. De Lisle Psalter, British Library, London, MS Arundel 83 II, f. 123v. *ca.* 1310, England
By kind permission of the British Library

movement before the ultimate realm of the fixed empyrean. In this image we find a visual map of Christian cosmology. Fifteen concentric rings that mark the distance between itself and the empyrean surround the earth, which contains hell. The circles of earth/hell are on a radial axis with the larger circle that contains the seated Christ above. The circular format here has resonance with other circular learning devices and the larger realm of circles stamped with Christocentric meaning that were accessible to the general public.

The last manuscript image of wheel symbolism that brings many of these strands together and is conceptually reminiscent of the Hereford map is a thirteenth-century manuscript from Venice (Fig. 1.24).[60] In this image, worldly life is depicted as a Wheel of Fortune. Christ is placed above, not as a symbol of earthly and fleeting kingship but rather as Christ the eternal king above human flux. Above this wheel, with a sword in his mouth, Christ is shown as Judge; the Wheel of Fortune is thus transmuted into a Wheel of Judgment. Christ is the fixed point on the Wheel. The transient rise and fall of the figures, and thus the spin of the wheel and mortal death, are starkly contrasted with the fixed points of heaven above and hell below.[61] The concept of earthly time with its mortal end is made clear in a way that is similar to that of the Hereford map. On the Hereford map the letters M-O-R-S ('death') that surround the circular world may be seen as a counterpart to figures on the Wheel of Fortune. And on the Hereford map Christ is similarly fixed above the world as the final Judge.

As we already noted, the examples of the mosaic floor and the rose window at the cathedrals of Turin and Lausanne respectively attest to the ubiquity of cosmological imagery beyond the relatively inaccessible form of the manuscript page.[62] In fact, the images of the Wheel of Fortune and its variant, the Wheel of Life, were accessible and visible to all in church decoration, in painted, sculptural, and glazed parallels to manuscript images that were, by comparison, limited to the few. Most obviously, painted

[60] Berlin, Deutsche Staatsbibliothek, MS Hamilton 390, f. 2v, second half of the thirteenth century, Venice (according to Hahn-Woernle), see Hahn-Woernle, 'Ebstorfer Weltkarte und Fortuna', 197, fig. 10.

[61] Along the edge of the outer wheel, three men fall to the right: one, pierced with a sword, has the inscription *Sententia maledictionis*; the lower one is labeled *Demon*; at the bottom a fourth man in flames, labeled *In Inferno*, is flanked by two devils. To the left three figures are shown rising: the lower figure is labeled *Benedictus qui venit in Nomine Dei*; the upper, *Vade in Paradiso*. An inner wheel forms the hub of a circular arcade, and is itself surmounted by an enthroned figure that appears as a worldly ruler, with globe in his left hand. This wheel has three figures along its edge: to the right, a falling man *Ista [sic] cadit*, at bottom, a prostrate man *Iacet hic*, to the left, a climbing man raises his hands. An innermost circle encloses Christ as the Lamb of God holding a cross staff above the Virgin and John the Evangelist. The inscription reads *Agnus Dei*. The overall theme is the superimposition of rule of God over rule of men. Above, St Peter guards the heavenly Jerusalem. Below stand the Virgin and St John on either side of the crucified Christ through whom the way to heavenly Jerusalem is opened. Words encircle: *Crux bona, crux digna, lignu(m) sa(lutis) diab(?) . . . s [libe]ra nos a mor(te) [male?] dic(tionis?)*; see Dow, 'Rose Window', esp. 282–3.

[62] For instance, the remaining text for the visitor about to step on the San Salvatore pavement is: 'Whoever you are . . . stepping over . . .' (translation from Latin by Kitzinger, 'World Map', 332). The term 'whoever' suggests that the map / Wheel of Fortune has meaning for all visitors.

Fig. 1.24 The Wheel of Fortune and the Wheel of the Last Judgment. Staatsbibliothek zu Berlin – Preussischer Kulturbesitz, MS Hamilton 390, f. 2v. 13th–14th century, Venice

wheels occurred in churches as wheel windows and rose windows.[63] Consider, for instance, the sculpted figures surrounding the thirteenth-century rose window of the south transept of the Cathedral of Amiens where the advancing and declining Ages of Man surmounted by a regal figure symbolic of wealth and fortune are represented, a fitting comparison to the manuscript illumination just considered.[64]

In England, however, there was a particularly strong tradition of wallpaintings in churches and secular buildings that made available to a diverse viewing public the Wheel of Fortune and its transformation as the Wheel of Life. In considering these images within the context of their culture and architectural settings, one may come to a better understanding of the abilities of medieval viewers to receive and integrate visual images into their model of the structure of knowledge.[65] In Chapter 2, that subject will be specifically explored in considering the ways of 'reading' the Hereford map as a didactic object within the artistic realm of images.

The Hereford Map in the Context of Medieval *Rotae*

Wherein does the intersection between the world of medieval cosmological *rotae* and mappae mundi ultimately lie? Mappae mundi were circular diagrams that fulfilled numerous purposes. The breadth of information incorporated within their perimeters was meant to impress viewers with the immensity of factual information available about the world they lived in. And to some degree, unlike diagrams in medieval schoolbooks that were organized geometrically to indicate a systematic universe, mappae mundi were pictorial atlases filled with bits and pieces of information seemingly without an underlying symmetry. Only the barest references to the organizing spokes and rings of scholastic cosmological *rotae* are detectable. Nevertheless the links are considerable.

For instance, in the Hereford map, which will serve as the paradigm for this study and will be formally introduced in Part II, the two outer rings indicate familiarity with cosmological diagrams. The outermost ring presents the cardinal directions, the inner-

63 For rose windows, see Cowen, *Rose Windows*; Dow, 'Rose Window', 248–97. For the twelfth-century rose window (*ca.* 1135) in the north transept of Saint-Étienne, see Courcelle, *La Consolation de Philosophie*, fig. 69; Elaine Beretz, 'Fortune Denied: The Theology against Chance at Saint-Etienne, Beauvais (France)', unpublished Ph.D. thesis, Yale University, 1989. Other examples of surviving rose windows that specifically relate to cosmological wheels are found at Basel and Lausanne; see Ellen Beer, *Die Glasmalereien der Schweiz vom 12. bis zum Beginn des 14. Jahrhunderts* (Corpus Vitrearum Medii Aevi, Schweiz, 1), Basel, 1956, 34–71; see Sears, *Ages of Man*, 145, nn. 33, 34; Dow, *Rose Window*, 271. See also Jourdain and Duvall, 'Roues symboliques de N.-D. d'Amiens et de St Etienne de Beauvais', *Bulletin Monumental*, 2, 1845, 59–64.

64 The window is located in the south transept of the cathedral of Amiens. Seventeen figures surround the windows: eight beardless ascending men, eight bearded descending men, a regal figure above; see Sears, *Ages of Man*, 145. Maurice Eschapasse dates the window to the end of the thirteenth century. According to Eschapasse, the uppermost figure has a dog at his feet; see Maurice Eschapasse, *Notre-Dame d'Amiens*, Paris, 1960, 110, fig. 68. Also see Jourdain and Duval, 'Roues symboliques'.

65 For a discussion of scientific paradigms and the medieval approach to natural history, see Thomas S. Kuhn, *The Structure of Scientific Revolutions*, Chicago, 1970 (2nd edition), 16–17.

Fig. 1.25 The Sphere of Pythagoras. Vienna, Österreichische Nationalbibliothek, MS Cod. 67, f. 174r. 12th century

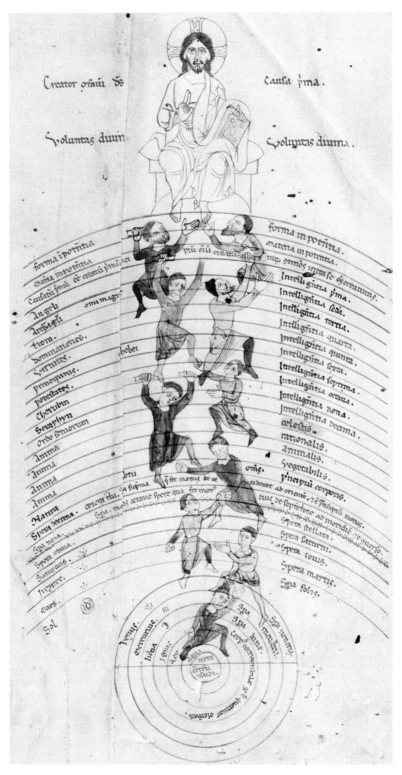

Fig. 1.26 The Scale of Being. Paris, Bibliothèque Nationale, MS lat. 3236A, f. 90r. 12th century

most constitutes a wind *rota* with inscriptions based on Isidore of Seville.[66] The margins of the terrestrial world are thus delimited.

In the Hereford map, and other maps to be considered later, it is the painted framing device (the pictorial frame) that surrounds and contains the circular world that impose the Christian cosmological and structural hierarchy on the images and texts within. The maps with surrounding pictorial frames became inversions of the vast array of cosmological images previously considered. In these maps, Christ looms above the world as creator, ruler and, in the case of the Hereford map, as judge. It is the pictorial frame that links the outer perimeter of the world to cosmic order, leaving the inner circle free for more worldly information.

Vestigial links to the *rotae* are evident. In the case of the Hereford map, as already noted, four 'handles' that extend out from the perimeter underscore the temporal aspect of what is to be found within the map. They enclose from east to west, in a clockwise fashion, the letters M-O-R-S. This conceit appears to be derived from didactic diagrammatic sources (Fig. 1.25).[67] The handles of the map anchor the temporal terrestrial world as fixed.[68] At the same time they visually suggest the cranks belonging to the Wheel of Fortune and thus introduce the element of time.

In the Hereford map the outer ring that contains the orienting winds (cf., as already noted, the cosmological *rotae*) reminds us of the dichotomy between the orderliness of Platonic visual schemes and the confusing arrays of information detached from their encyclopedic sources. The variety of information within the map is closer to a *florilegium*, an anthology of collected quotations, particularly from classical authors, than a *summa* which represents a logical and orderly collection of information collated from sources.[69] The frame must be relied upon for reminding the viewer that the map is a microscopic view of what is contained in the undifferentiated inner hubs of cosmological constructs.

Within the circular perimeter, space is centrifugal, and despite efforts to organize the material world within discrete geographic spaces, the overall effect is confusing and discontinuous. The world is thus presented as eluding comprehension because of what Stephen Nichols refers to as 'discontinuous narrative'. Each text, each image, must be dealt with as a separate entity. The interstices between images and information suggest vast unknowns, the spaces between are condensed, and emptiness was to be avoided. Each text, each image informs and dispels a fear of the unknown and replaces it with

[66] The inscriptions on the Hereford map are closer to texts of Isidore of Seville than the *rotae* used as examples here. Because of emendations and editorial changes, they suggest an intermediary source. The four cardinal winds are marked by squatting naked grotesque figures. The others are indicated by animal heads breathing red fire-like wind.

[67] The inscription MORS relating to a *rota* may be connected to diagrams of the sphere of Pythagoras (Miscellany, Vienna, Osterreichische Nationalbibliothek, MS 67, f. 174r). Caviness notes that this example is taken from a typical twelfth-century schoolbook where Life is associated with the heavens and Death with the earth; see Caviness, 'Images of Divine Order', 103, fig. 9.

[68] The term 'fixed' refers to its 'creational' aspect rather than the Aristotelian concept of stasis. The concept of the earth's rotation on its axis is not considered here. For discussion, see *A Source Book in Medieval Science*, ed. Edward Grant, Cambridge, MA, 1974, 494–516.

[69] Clanchy, *Memory to Written Record*, 84–5.

authoritative evidence, and the limited number of spatial interstices dispel the horror of the vacuum ('horror vacui'). The idea of the map was to fill the spaces, to prove that the world was contained within the framework of Creation, Judgment, and Redemption.

An illumination of The Scale of Being (Fig. 1.26),[70] in which humans are delightfully shown attempting to ascend the undifferentiated temporal earthly realm to the eternal realm of the Creator, provides a visual summary of what has been suggested in this chapter. The Scale of Being is the visualization of the medieval desire to rise above the temporal world, to move from the earthly to the heavenly realm. It provides a diagrammatic bridge to understanding the hierarchical organization of the Hereford map. The circular realm had a tradition of meanings to which the circle of the world map could be included and deconstructed. The fact, however, that the Hereford map's circular world is surmounted by the vision of the Last Judgment takes us from the temporal realm into the eternal one. The map becomes not merely a picture of the world but rather a portrait of God above the universe as he looks down upon the earthly. The circle's meaning has thus been transformed from a didactic *rota* that describes what the world contains to an image that sets the circular world in relation to God, a subject to be further explored in Chapter 2.

[70] Paris, BN, MS lat. 3236A, f. 90r, twelfth century (Hugh of St Victor, *Allegoriae in Vetus Testamentum*). For in-depth discussion of this image and its companion, see Marie-Thérèse d'Alverny, 'Les Pérégrinations de l'âme dans l'autre monde', *Archives d'histoire doctrinale et littéraire du Moyen Age*, 13, 1940–2, 239–99, esp. 267–9.

Part II

The Hereford Map as a Conceptual Device

2

THE FRAME AS TIME

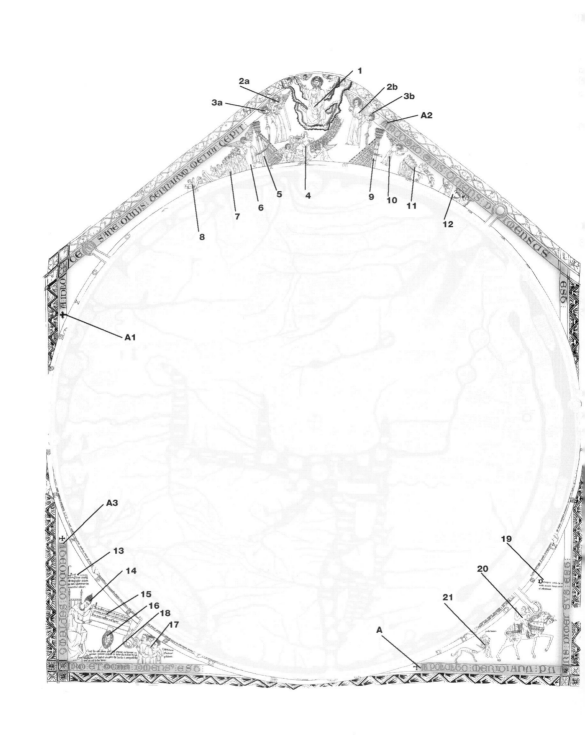

UPPER SECTION (within border)

Christ in Majesty, adoring angels above: Inscription (left and right) *Ecce testimonium meum ·* (Behold my testimony.)

1a **Angel with Instruments of the Passion** (left)
1b **Angel with Instruments of the Passion** (right)
2a **Angel with Trumpet** (left): Inscription: *Leuez · si uendrez a ioie pardurable ·* (Rise, you will come to perpetual bliss.)
2b **Angel with Trumpet** (left): Inscription: *Leuez · si alez au fu de enfer estable ·* (Rise, you are going to the fire prepared in hell.)

The Virgin Baring her Breast Group: Inscription: *Veici beu fiz mon piz · de deinz la quele chare preistes · E les mamelectes · Dont leit de uirgin queistes · Eyez merci de touz · si com uos memes deistes ·*

Ke moy ont serui · kant sauueresse me feistes · (See, dear son, my bosom within which you became flesh, and the breasts from which you sought the Virgin's milk. Have mercy, as you yourself have promised, on all those who have served me, who have made me their way to salvation.)

5 **Heaven's Gates** (open)
6 **Angel Leading**
7 **The Elect**
8 **The Resurrected**
9 **Heaven's Gates** (closed)
10 **Angel with Sword**
11 **A Demon Leading the Damned**
12 **Door to Hell in front of Hellmouth**

LOWER LEFT CORNER (within border)

13 **Above Emperor**: Inscription: *Lucas in euuangelio · Exiit edictum ab augusto cesare · ut describeretur huniuersus orbis ·* (In the Gospel of of Luke: A decree came forth from Caesar Augustus that the whole world was to be enrolled.)
14 **Emperor**
15 **Emperor's Document**: Inscription: *Ite in orbem vniuersum · et de omni eius continencia referte ad senatum · et ad istam confirmandam Huic scripto sigillum meum apposui ·* (Go forth into the whole world and report to the Senate on all its parts, and in confirmation of this I have set my seal to this ordinance.)

16 **Emperor's Seal**: Inscription: *S[IGILLVM] · AUGUSTI ·*

CESARIS · IMPARATORIS · (Seal of Augustus Caesar, emperor.)

17 **Three Surveyors**: Inscription: *Nichodoxus · Theodocus · Policlitus* (Nichodoxus, Theodocus, Policlitus)
18 **Below Seal**: Inscription: *Tuz ki cest estorie ont · Ou oyront ou lirront ou ueront · Prient a ihesu en deyte · De Richard de haldingham o de Lafford eyt pite · Ki lat fet e compasse · Ki ioie en cel li seit done ·* (All who have this history, or shall hear or read or see it, pray to Jesus in godhead that he may have mercy on Richard of Haldingham or of Lafford, who has made and contrived it, that joy may be given to him in heaven.)

LOWER RIGHT CORNER (within border)

19 **Above Horseman and Horse**: Inscription: *Descripcio orosii de ornesta mundi · sicut interius ostenditur* (Orosius's account of the *Ornesta* of the world, as shown within.)

20 **Horseman on Horse**
21 **Huntsman Leading Hunting Hound**: Inscription: *passe auant ·* (Go ahead.)

OUTER EDGE INSCRIPTIONS

Top Left: *+ A · IULIO · CESARE · ORBIS TERRARVM · METIRI · CEPIT* (Measuring the lands of the earth was undertaken by Julius Caesar.)
Top Right: *+ A · NICODOXO · OMNIS · ORIENS · DIMENSUS · EST* (All the east was measured by Nicodoxus.)

Bottom Left: *+ A · TEODOCO · SEPTEMTRION · ET · OCCIDENS · DIMENSUS · EST* (The north and west was measured by Theodocus.)
Bottom Right: *+ A · POLICLITO · MERIDIANA · PARS · DIMENSVS · EST* (The southern part was measured by Policlitus.)

THE HEREFORD MAP, the only extant thirteenth-century large-scale mappa mundi, is preserved at Hereford Cathedral.[1] Including over a thousand images and texts, it is a veritable compendium of medieval knowledge and lore. Using the pictorial frame as our reference, some of the following questions will be considered with specific reference to the Hereford map: For whom was it made? By whom was it meant to be seen? How might it have been experienced by viewers in the Middle Ages given that time and space are telescoped within the confines of the circular schema? These questions and their suggested answers may help us to better understand the Hereford map within the larger context of the visual language of medieval art.

The pictorial frame's configuration takes us on a circular journey from the lower left corner where there is a statement from the donor and an *apologia* for the map's historical legitimacy as grounded in the biblical and antique, to the lower right corner where the allusion is to the contemporary aristocratic realm of the hunt, and finally to the top of the pictorial frame where the cosmological event of the Last Judgment surmounts the orb of the earth. To pursue our line of inquiry, we begin at the lower left section.

The Donor

The first question is: For whom was the map made and for what purpose? The first clue to its possible origin is given in the lower left-hand corner's short inscription in Anglo-Norman.

> Tuz ki cest estorie ont
> Ou oyront ou lirront ou ueront
> Prient a ihesu en deyte
> De Richard de haldingham o de Lafford eyt pite
> Ki lat fet e compasse
> Ki ioie en cel li seit done
>
> (All who have this history
> Or shall hear or read or see it
> Pray to Jesus in godhead
> (that) he may have mercy on Richard of Haldingham or of Lafford
> Who has made and contrived it
> That joy may be given to him in heaven)

1 The first record of its existence in Hereford Cathedral is *ca.* 1680, according to Thomas Dingley, *History from Marble, Compiled in the Reign of Charles II* (Camden Society, old series, vols. 94, 97), ed. J. G. Nichols, 1867–8, I: 35–6, clx. Harvey discovered the signature of 'John Nicolles' in the lower right corner. Harvey suggests that the signature may have been that of the son or other relative of William Nichols, vicar-choral of Hereford Cathedral, who died in 1635; see P. D. A. Harvey, *Mappa Mundi: The Hereford World Map*, Toronto, 1996, 14.

Before a look at the text itself, what would the inscription's position in the lower corner suggest to the medieval viewer? As in other medieval works of art that include the name or image of the donor, the inscription is frequently discreetly placed at the base of the image. Aside from illuminated manuscripts in which that area is often devoted to the author/donor,[2] one need only to look at the famous example of the tympanum of St Denis to find a more general example, one accessible to a wide audience. In medieval art the donor is often shown presenting the donated object itself or kneeling in obeisance, most frequently to Christ. At St Denis, the donor Abbot Suger kneels in perpetuity at Christ's feet. If we recognize that in the Hereford map, the circular world may be considered a metaphor for Christ's body, an idea graphically depicted in the related thirteenth-century Ebstorf map,[3] the circle as Christ with donor text below may be visually likened to the example of Abbot Suger (Fig. 2.1).[4] In the Hereford map, the donor, Richard of Haldingham or Lafford, is also permanently memorialized in the frequently reserved donor space of the lower left corner, so that according to the inscription, joy in heaven might be awarded to him. Richard of Haldingham or Lafford thus leaves a permanent reminder to all those who in the future may own or read or see this history – implying that the map may be read or seen, experienced through words or pictures or a combination thereof.[5]

As is the case with several of the texts of the pictorial frames to be considered later, the donor's comment is written not in Latin but in Anglo-Norman. Anglo-Norman was the vernacular language spoken by the English aristocracy, which in 1300 would have been widely used among this social group in England. That these relatively accessible Anglo-Norman texts are located in the pictorial frame underscores the introductory nature of the pictorial frame acting as a preface to the interior of the map which contains only Latin inscriptions. The shared role of vernacular and Latin inscriptions within the framing spaces suggests the complexity of the moment in terms of the evolution of textual literacy. In England, French and Latin both functioned as established written languages and to a varying degree churchmen, schoolmen, the gentry, and even the masses developed some level of literacy which was not limited to Latin. The pictorial frame thus serves as an introduction to the Latin texts that were less accessible to most readers.[6]

2 For general contemporary examples, see Morgan, *Early Gothic Manuscripts*, 4/2, fig. 26: Christ in Majesty, Oxford, All Souls College, MS 6, f. 6 (cat. no. 101); fig. 67: Crucifixion, London, BL, MS Add. 44874, f. 6 (cat. no. 111). The position of the donor may alternatively represent the donor as symbolic testament to the event depicted.

3 The body of Christ with Jerusalem as the *omphalos* or navel may be considered the eucharistic vessel which contains all of time, space, and creation. This theme has been examined in cosmological theories relating microcosm to macrocosm. For discussion, see Chapter 8.

4 For basic bibliography on the twelfth-century Abbey Church of St Denis, see Sumner McK. Crosby, *The Royal Abbey of Saint-Denis*, ed. and completed by Pamela Z. Blum, New Haven, 1987; Whitney Stoddard, *The West Portals of Saint-Denis and Chartres*, Cambridge, MA, 1952.

5 The inscription is written in rhyming couplets. The term *estorie* may denote 'history', 'story', or in this case, a pictorial representation. Similarly the term *fet* derived from *faire* may indicate 'make' or 'design'.

6 Jeffrey and Levy consider Anglo-Norman lyric verse of a religious character as homiletical, liturgical, or devotional. Most of it dates between the first quarter of the thirteenth century and the first quarter of the

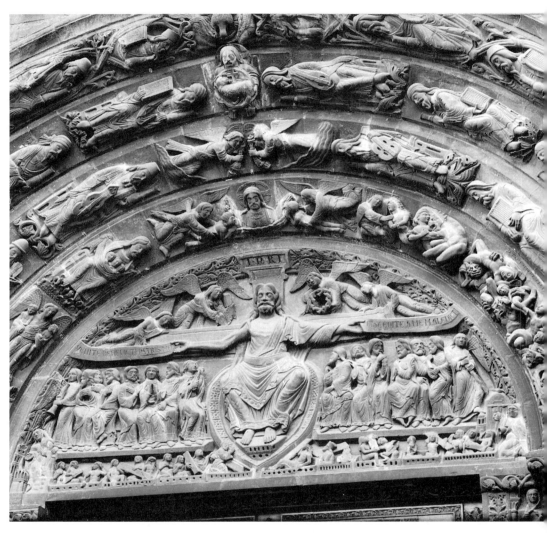

Fig. 2.1 The Last Judgment. Tympanum, St Denis, France. 12th century
Photo Zodiaque

A brief consideration of our 'donor' is in order here. Richard of Haldingham or Lafford (referring to the prebendary of the parish of Lafford, later known as Sleaford, which contained the hamlet of Haldingham, later known as Holdingham) most likely refers to Richard de Bello, of aristocratic Norman descent. Well educated and of good family, Richard de Bello become a canon of Lincoln Cathedral in 1264 and held the important rank of Treasurer from 1267 to 1278. Recently it has come to light that Master Richard de Bello/Richard of Haldingham and Lafford died in 1278. It is now believed that a relative, a second Richard de Bello (d. 1326), is the Richard de Bello mentioned in the account roll of Richard Swinfield, Bishop of Hereford from 1283 to 1317.[7] It has also been suggested that the map was composed at Hereford after an exemplar from Lincoln and completed some time around 1300, after the second Richard de Bello came to Hereford and brought the exemplar (in the form of a roll or a *schedulae*) with him.[8] The fact that Lincoln is more prominently displayed on the map than Hereford, which appears to be added as an afterthought, reinforces the notion of the Lincoln exemplar.[9]

fourteenth century. According to Jeffrey and Levy, by the second half of the thirteenth century the status of French as a vernacular language in England was losing ground and by the turn of the fourteenth century it became a second language. They suggest that Anglo-Norman of this period was an expression of 'biculturalism', self-consciously preserved in Anglo-French verse; see Jeffrey and Levy, *Anglo-Norman Lyric*, 2. This subject is further explored in Chapter 3.

7 The argument for two Richards de Bello was first put forth by Denholm-Young, 'The *Mappa Mundi* of Richard of Haldingham at Hereford', *Speculum*, 32, 1957, 307–14. Most recently Flint has presented evidence that also argues for two Richards de Bello; see V. I. J. Flint, 'The Hereford Map: Its Author(s), Two Scenes and a Border', *Transactions of the Royal Historical Society*, 8, 1998, esp. 24 ff. Before Flint's discovery of an obituary for the first Richard de Bello (d. 1278) Yates offered an alternate theory that suggested that there was only one Richard de Bello. It followed these lines: Richard de Bello (Richard of Haldingham and Lafford) did not die until 1326. Records show that Canon Richard at Lincoln had begun his career in 1260 as Rector of Kingsworth and Dymchurch, then went on to Lincoln 1264–83. Yates believed that Richard followed Canon Swinfield to Hereford in 1283. However, there is no clear documentary evidence of his presence in Hereford until 1289 when he is cited as receiving a gift from Bishop Swinfield. By 1298 he went on to become a canon in Salisbury, and died in 1326. If Yates's theory is correct, it is likely that Richard de Bello was less than twenty years old in 1260. If he actually died in 1326, he would have lived into his early eighties, an extraordinarily long lifetime, but not impossible according to Yates; see Wilfred Nigel Yates, 'The Dean and Chapter of Hereford 1240–1320', Ph.D. thesis, University of Hull, September 1969, 88–9. If one assumes Denholm-Young and Flint's thesis of two related canons then the documentary evidence after 1278 refers to the second Richard de Bello. The inscription on the map that refers to Richard of Haldingham and Lafford would be in memory of the first Richard.

8 Based on substantial paleographic and visual evidence recently presented at the Hereford Mappa Mundi conference, Hereford, 27 June – 1 July, 1999, the possibility of the map being largely composed in Hereford appears extremely likely; see Malcolm Parkes, 'The Mappa Mundi at Hereford: Report on the Handwriting and Copying of the Text' (Paper presented at the Hereford Mappa Mundi Conference, Hereford, 27 June – 1 July, 1999). Also see Nigel Morgan, 'The Hereford Mappa Mundi – Art Historical Aspects' (paper presented at the same conference). Both papers will be published in a forthcoming volume.

9 However, it now appears that the map is to be dated *ca.* 1300 based on style and paleography (see above, n. 8). Thus a Lincoln provenance for the completed map appears less likely. However an argument may still be made for the map having been related to Lincoln workshop practices. Lincoln was a cosmopolitan center with an important cathedral library and artistic workshops – Jewish as well as Christian. According to A. D. Baynes-Cope, the lasting blackness of the ink used on the map may indicate it is the same as that used for Torah scrolls written by Jewish scribes in Lincoln. This possibility has been suggested to me by Baynes-Cope in a letter dated 27 August, 1994. In the same correspondence, Mr Baynes-Cope pointed to the extraordinarily large size and excellent condition of the parchment used for the Hereford map. He

Records show that Richard de Bello (the second Richard) was a particular favorite of Swinfield, who as chancellor at Lincoln Cathedral was the overseer of the cathedral's library and previously worked closely with the Canon Richard of Haldingham or Lafford. Recorded within the inventory of the Lincoln library was a mappa mundi as part of the collection as early as 1148 (although by approximately 1200 the map was no longer extant).[10] The fact that the Hereford map is not specifically mentioned in the same inventory suggests that the map, in the debatable form of exemplar, was probably owned by Richard of Haldingham or Lafford himself and could be taken with him from place to place or given to a family member.

That the map was made of a single piece of parchment more than five feet in diameter is also of interest here. The map is believed to be made of traditional calfskin.

also suggests that the Jewish scribes of Lincoln required large skins. Given the documentary evidence and the fact that the Jews were expelled from Lincoln by 1290, the *terminus ante quem* would be 1283, suggesting that the map was commissioned by the canon de Bello before he died. That being the case, it was brought to Hereford in exemplar form by the second Richard de Bello whose name first appears in Hereford Cathedral records in 1289. Others have suggested a Lincoln provenance. See Gerald R. Crone, *The World Map by Richard of Haldingham in Hereford Cathedral, circa A. D. 1285*, London, 1954; John Glenn has made a similar proposal. Glenn elaborated on the fact that the topography and waterways of Lincolnshire are carefully shown on the map (the Trent, Don, Yorkshire Ouse flow together to form the Humber) as compared to much less detail relating to Hereford, where the Wye appears to have been added after the coastline of the Severn estuary was drawn; see John Glenn, 'Notes on the *Mappa Mundi* in Hereford Cathedral', in *England in the Thirteenth Century* (Proceedings of the 1984 Harlaxton Symposium), ed. W. M. Ormrod, Woodbridge, 1986, 60–3. Moir notes the fact that the name Richard de Bello may be traced to Belleau, near Alford in Lincolnshire. He also notes that Richard refers to his Lincoln prebendaries which reinforces a connection to Lincoln at the time the map was made; see A. L. Moir, *The World Map in Hereford Cathedral*, Hereford, 1975 (7th edition), 7. As Muratova points out repeatedly in her studies of bestiaries, Lincoln was a center of book production; see Chapter 4. Because Lincoln and Hereford were secular cathedrals they probably did not have cathedral scriptoria. Thomson specifically notes that Hereford probably did not have a cathedral scriptorium. But twelfth- and thirteenth-century records show there were a number of scribes, painters (not necessarily of books), and parchmenters working in Hereford; see R. A. B. Mynors and Rodney M. Thomson, *Catalogue of the Manuscripts of Hereford Cathedral Library*, Cambridge, 1993, xix. Lincoln, on the other hand, although similarly a secular cathedral, appears to have had a number of books in its library collection that were produced in the twelfth and thirteenth centuries at Lincoln; see Reginald Maxwell Woolley, *Catalogue of the Manuscripts of Lincoln Cathedral Library*, Oxford, 1927, v–vi; Thomson, *Catalogue*. Thomson does not subscribe to Muratova's definitive version of a monastic scriptorium at Lincoln, rather he leaves the question open as to whether the scriptorium was attached to the cathedral or if the cathedral hired freelance scribes and illuminators or a combination thereof, see Thomson, *Catalogue*, esp. xiii–xiv. By the first half of the thirteenth century Matthew Paris of the abbey of St Albans is known to have employed at least one lay assistant. Egbert suggests that by the early fourteenth century there were loosely organized groups of illuminators who traveled from place to place and were responsible for the illuminations of the Tickhill Psalter and related manuscripts; see Donald Drew Egbert, *The Tickhill Psalter and Related Manuscripts*, New York, 1940, 80–1. The subject of professional lay artists beginning to supplant monastic craftsmen in the thirteenth century is taken up again in Chapter 4.

10 In statutes of the earliest date, the charge of theological books is listed amongst the responsibilities of the Chancellor of Lincoln Cathedral. A twelfth-century catalogue (*ca.* 1160) recorded in the Great Bible (Hereford Cathedral, MS 1) lists 136 books of which, according to Thomson, thirty-nine survive. The list is a double inventory that indicates that when Hamo was made Chancellor at Lincoln (*ca.* 1150), forty-four books were kept in the Cathedral's *armarium* for study; see Thomson, *Catalogue*, xiii–xiv; Woolley, *Catalogue*, v–vi. From the original list, number 33 is a 'mappa mundi'. The map, now lost, is not the Hereford map; see Woolley, *Catalogue*, v–vi.

However it has also been suggested that the map is made of deerskin.[11] If the latter is true one should note that deer were protected animals of the royal domain. Swinfield apparently had access to the royal domain; records show that he gave valued gifts of venison in 1289 to Richard de Bello.[12] This reinforces the theory that the two Richards were indeed related and were canons successively during Swinfield's respective tenures at Lincoln and Hereford Cathedrals.

Much larger than any manuscript page, the map was apparently meant to be displayed. Its Latin texts, given their simple nature and textual inaccuracies suggest an undiscerning viewer who would rely more on pictures and schemata than on text; but we know Richard de Bello ('Haldingham and Lafford') as an Oxford-educated canon, well versed in Latin. Rather than only a personal object of study, it appears that the map was meant by our donor to be seen by a spectrum of people with differing levels of literacy, both visual and textual, as the donor text implies: 'All who have this history, or shall *hear* or *read* or *see* it . . .'

In the inscription, Richard de Bello does not take credit for actually making the map; and it is entirely possible that the Hereford map represents a standard format with specific additions requested by the purchaser. Additions such as the donor inscription and the other Anglo-French inscriptions are unique to this map and limited to the pictorial frame. Canons, unlike monks,[13] did not take oaths of poverty. Therefore it would be perfectly appropriate for an ambitious canon such as de Bello (II) to have inherited the exemplar, and to have carried it with him from place to place until such time as he wished to commission and finally to donate the map in its final form as an 'object d'art' – in this case to Hereford Cathedral.

11 Calfskin was suggested to me by Joan Williams, Hereford Cathedral Librarian, during the Hereford Mappa Mundi Conference, Hereford, 27 June – 1 July, 1999. However in a clarifying e-mail of July 2000 Ms Williams indicated to me that it was Hereford Cathedral's conservation consultant, Chris Clarkson, who described the map's parchment as '?calfskin' in an unpublished report to the Dean and Chapter. But the skin being so large, the other alternative is deerskin; and according to Mr Clarkson it is practically impossible to tell them apart.

12 Although debatable, it is likely that as chancellor, Swinfield knew de Bello as a relative of the canon de Bello of Lincoln, and thus provided the opportunity for Richard's advancement at Hereford. Swinfield, given to extravagances and overt favoritism, especially in providing posts for members of the Swinfield family, appears to have also favored Richard. According to Yates, in 1289 Bishop Swinfield presented a gift of venison to Richard as a token of particular favor. A gift of this type was known as 'de familia'. For reference, see Yates, 'Dean and Chapter of Hereford', 88–9. Yates does not give a reference for this statement. I am most grateful to Ms Williams once again for her informative e-mail of August 2000 in which she provides a source and additional comment on this: 'We know it comes from *A Roll of the Household Expenses of Richard de Swinfield, Bishop of Hereford, During Part of the Years 1289 and 1290* (Camden Society, vols. 59 and 62, for 1853 and 1855), ed. John Webb, London, 1854, 1855. In I: 19–20, there is an entry for 17 November, 1289, in which Magister Richard de la Batayle is given 'a side and a haunch' of meat from 'three fattened fallow dear does' (translation by Ms Williams). The original manuscript is now in the Bodleian Library (MS lat. hist. d. 1 [R]). Note also that in 1313, Richard represented Bishop Swinfield at St Paul's Cathedral in London as another indication of Swinfield's repect for Richard de Bello; see A. T. Bannister, *Registrum Ade de Orleton, Episcopi Herefordensis, A.D. 1317–1327*, Hereford, 1907, vi.

13 Both Lincoln and Hereford Cathedrals are 'secular' cathedrals, meaning they were served, since their establishment, by secular canons, not monks.

The Historical Legitimacy of the Map

In the lower left-hand corner, the authority of the map confusedly links the geographical survey originally commissioned by Julius Caesar but carried out during the reign of Caesar Augustus to the biblical census described in Luke 2:1. The results of the survey were incorporated into what is known as 'Agrippa's map' which is believed to have been a model for the Hereford map.[14] On the Hereford map the seated figure of Caesar Augustus, who is mistakenly confused with Julius Caesar, is elevated to papal status, as evidenced by the tiara,[15] and is shown as he appoints his commissioners Nicodoxus, Theodocus, and Polyclitus to make a geographical survey of the world. Surrounding the entire pictorial frame, enclosing all the introductory material of the five corners of the frame and tying it all together are the large capital red letters that delineate the limits of their territories: *A IULIO CESARE ORBIS TERRARUM METIRI CEPIT. A NICODOXO OMNIS ORIENS DIMENSUS EST. A TEODOCO SEPTEMTRION ET OCCIDENS DIMENSUS EST. A POLICLITO MERIDIANA PARS DIMENSUS EST* ('Measuring the lands of the earth was undertaken by Julius Caesar. All the east was measured by Nicodoxus. The north and west were measured by Theodocus. The southern part was measured by Polyclitus').[16]

14 Two accounts are generally cited for Julius Caesar's initiative to have four geographers measure the world. They are the *Cosmographia*, said to have been written by Julius Honorius (fourth or fifth century AD), and the *Cosmographia* by an anonymous author sometimes referred to as Pseudo-Aethicus (earliest manuscript dates from the eighth century AD). Pseudo-Aethicus' work is close to that of Julius Honorius with significant additions from Paulus Orosius' *Historiae adversus paganos*. The *Cosmographia* attributed to Julius Honorius suggests that the author makes reference to a map of the world (*sphaera*) which was likely based on the prototypical map of 'Agrippa'. Although Julius Caesar initiated the undertaking, the map and accompanying lists of measures of provinces and regions (*Commentarii*, of which fragments are conserved) was finally completed under his nephew Gaius Julius Caesar Octavianus (63 BC – AD 14), who took the title of honor Augustus in 27 BC. Based on Julius Honorius' accounts, the length of time it took the four geographers to complete the survey dates the conclusion of their work as late as 19 BC. By that time Caesar Augustus had visions of expansion, a new map was planned, and Augustus' friend, senior general, and son-in-law, Marcus Agrippa, was entrusted with the project. Following Agrippa's death in 12 BC, his sister Vipsania Polla saw to its conclusion. 'Agrippa's map is assumed to refer to the map of Vipsanius Agrippa, displayed in the portico constructed at the edge of the Campus Martius, completed *ca.* 7–2 BC during the reign of Augustus. The map and its *Commentarii* must have also been accessible in written form.; see Claude Nicolet and Patrick Gautier Dalché, 'Les *Quatre sages* de Jules César et la *Mesure du monde* selon Julius Honorius: Réalité Antique et Tradition Médiévale', *Journal des savants*, October–November 1986, 157–218; Peter Wiseman, 'Julius Caesar and the Hereford World Map', *History Today*, November 1987, 53–7.

15 Note that his seal reads *S. Augusti Cesaris Imperatoris*. The papal status is based on a miracle described in the Golden Legend. It may also refer to the theme of the Sibyl's prediction of the coming of Jesus to Augustus, the basis for the church of S. Maria d'Aracoeli in Rome; see *The Golden Legend of Jacobus de Voragine*, trans. Granger Ryan and Helmut Ripperger, New York, 1969 (repr.), 49. I am indebted to Jill Adels for this suggestion.

16 Trans. Harvey, *Mappa Mundi*, 54. Also see text and translation, Gerald R. Crone, 'New Light on the Hereford Map', *The Geographical Journal*, 131/4, 1965, 448. The subject of four geographers and their respective roles is described in both versions of *Cosmographia*. In the Hereford map, however, there are only three geographers, Theodocus measuring both the north and the west. Wiseman suggests the inclusion of only three geographers on the Hereford map may relate to the fact that the world of the *Cosmographia* of Julius

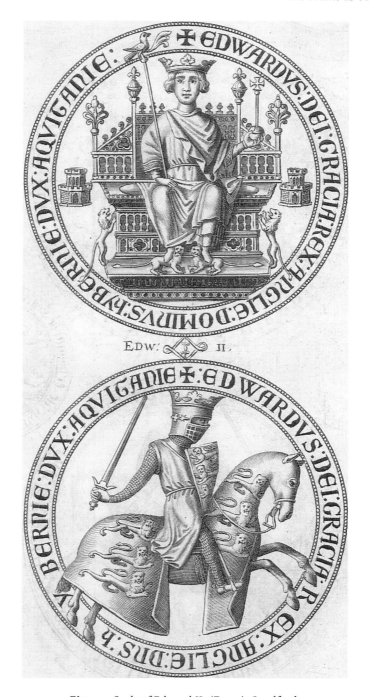

Fig. 2.2 Seals of Edward II. (Francis Sandford,
*A Genealogical History of the Kings of England and Monarchs
of Great Britain*, 1677)
Courtesy of John Adams Thierry

The Latin inscription located above the figure of Caesar opens with a gold letter and is followed by the first words painted in red, similar to letters in a Gospel book: *Lucas in euuangelio. Exiit edictum ab augusto cesare ut describeretur huniuersus orbis* ('In the Gospel of Luke. A decree came forth from Caesar Augustus that the entire world was to be enrolled').[17] In this sentence we have the event of the Gospel census conflated with the event of the geographical mapping of the world, an idea already familiar to the Middle Ages.[18]

Lastly, the rotulus held in Caesar Augustus' hands reads: *Ite in orbem vniuersum et de omni eius continencia referte ad senatum, et ad istam confirmandam huic scripto sigillum meum apposui* ('Go forth into the whole world and report to the Senate on all its parts and in confirmation of this I have set my seal to this ordinance').[19] The text on the rotulus uses decorative conventions that are unique to this document. The authenticating seal (*S. AUGUSTI CESARIS IMPARATORIS*) is the final visual element that all viewers would recognize as authoritative. Seals were commonly used in England; the device of a seated figure on one side of a seal and an equestrian image on the other side (counterseal) was frequently used on English royal and baronial seals (Fig. 2.2).[20] This might have a bearing on the next image, the worldly hunt which prominently displays a rider on horseback.

Honorius was based on a quadripartite world as opposed to the tripartite world of the T-O map with Jerusalem in the center; see Wiseman, 'Julius Caesar', 55.

17 The text refers to the census called for in Luke 2: 1–2. The Latin term *describeretur* derives from *scribere*, and according to Wiseman may be construed as 'to write' or 'to draw'; see Wiseman, 'Julius Caesar', 53–4.

18 The association is made in the encyclopedia of Lambert of Omer in which Pseudo-Aethicus is given prominence. For instance, the measurement of the world and its asssociation with the census described in the Gospel of Luke has been noted as occuring for the first time in a manuscript of Lambert of St Omer (Gand, Universitätsbibl., 92, f. 138). Gautier Dalché cites an illumination from *Liber floridus* by Lambert of St Omer (Paris, BN, lat. 8865, f. 45r) in which Augustus is depicted sword in right hand, in his left a globe divided into three parts (T-O) with names of continents. The figure is surrounded by a circle with the inscription: *Exiit edictum a Cesare Augusto ut describeretur uniuersus orbis* (Luke 2: 1). The miniature is inscribed in a chronology of the six ages of the world. The geographical survey attributed to Caesar, as described in Pseudo-Aethicus, is also included; see Gautier Dalché, in Nicolet and Gautier Dalché, 'Quatre sages', 203–4, fig. 6; Anna-Dorothee von den Brincken, 'Zur Universalkartographie des Mittelalters', in *Miscellanea medievalia*, 7 (Methoden in Wissenschaft und Kunst des Mittelalters), Berlin, 1970, 249–78, esp. 249–51.

19 See Crone, 'New Light', 448.

20 By the time of the Hereford map, seals were commonly used. According to Clanchy, seals functioned as a 'notarial form of authentication'; see Clanchy, *Memory to Written Record*, 308. For the seals of English kings, see W. de G. Birch, *Catalogue of Seals in the Department of Manuscripts in the British Museum*, London, 1887–98; Alfred Benjamin Wyon, *The Great Seals of England*, London, 1887 (I am grateful to P. D. A. Harvey for this reference); P. D. A. Harvey and Andrew McGuinness, *A Guide to British Medieval Seals*, London, 1996. Note also the equestrian seal of Humphrey de Bohun, Earl of Hereford; see *Royal Commission on Historical Monuments, Herefordshire*, 1931, I: 108 and pl. 150; George Henderson, 'Romance and Politics on some Medieval English Seals', *Art History*, 1, no. 1, 1978, 26–42, esp. 27, pl. 13. Note the sculptured mandorla-like seal of Bishop Hugh de Foliot (?) located in the Lady Chapel of Hereford Cathedral begun in 1222.

The Worldly Hunt

Whereas the image of Caesar is a reference to the past, the scene of a young man on a horse followed by a small huntsman or fewterer with greyhounds refers to the worldly pursuit of the hunt – in short, the present.[21] The text *passe auant* is most likely a reference to the hunting cry *Hors de couple, au aunt, cy auaunt* recorded by William Twiti in his treatise *The Art of Hunting*.[22] William Herbert, a Franciscan teacher, writer and compiler of Anglo-Norman poetry, and who also had strong connections to Hereford, made the earliest known copy of the treatise.[23] The imagery on the map is close to contemporary images of the hunt especially as exemplified in the margins of the Queen Mary Psalter, a manuscript of recurring interest to this study (Fig. 2.3).

In the medieval imagination the hunt was fraught with symbolism. Apart from its association with courtliness, it was also associated with the mutability of life and the illusory quality of earthly pleasures.[24] For instance one finds numerous images of the horseman as hunter in imagery of the horsemen of apocalyptic manuscripts meant to remind the viewer of the transitory nature of the earthly world as compared to the eternal world beyond the Last Judgment (Fig. 2.4).[25] The fact that the young man turns

21 The fewterer, in charge of the greyhounds, was responsible for unleashing the greyhounds at the sighting of the hunted animal; see John Cummins, *The Hound and the Hawk*, London, 1988, 13, 22. The combination of the greyhounds and the fewterer carrying a bow as well as a horn, hunting spear, and club suggests an adulteration of hunting *par force de chiens*, possibly suggesting a deer hunt (*ibid.* 45–6). Harvey (*Mappa Mundi*, 17) has suggested that the dappling is a later addition. However Prof. Harvey has lately indicated to me that Prof. Nigel Morgan, on close observation of the map, believes the dappling to be original.

22 The hunting cries were used by huntsmen to kennel. The terms were all originally French and were used in the hunt for the hare. The terms cited here occur in the section relating to the Hunting of the Hare in William Twiti's *The Art of Hunting*, *1327*; see William Twiti's *The Art of Hunting*, *1327* (Cynegetica Anglica, 1, Stockholm Studies in English, 37), ed. Bror Danielsson, 1977, 44, 72. The expression occurs in both known Anglo-French examples of Twiti's treatise: MS Phillipps 8336 (now London, BL, MS Add. 46919, fs. 15v–18v), England, *1327*; and Caius College, Cambridge, MS 424, pp. 91–5. William Twiti (d. 1328) was huntsman to King Edward II. He died as a pensioner at corrody in Reading Abbey in 1328.

23 William Herbert belonged to the Minorite Order at Hereford, was sent to Oxford and Paris, and traveled to other monasteries in order to collate texts. He died in 1333 and was buried in the Convent of the Minorite Order at Hereford. Danielsson suggests that he may have found the exemplar for his copy of Twiti's treatise in Reading Abbey where Twiti died; see Danielsson, *Twiti's Art of Hunting*, 36–8.

24 Anne Rooney, *Hunting in Middle English Literature*, Cambridge, 1993, 103–11. Rooney provides us with four Middle English alliterative poems that specifically relate the hunt to the theme of worldy vanities and earthly mutability. Of particular interest is the poem *De tribus regibus mortuis* ('The Three Dead Kings') which is portrayed in English wallpaintings. For the poem 'The Three Dead Kings', see *Alliterative Poetry of the Later Middle Ages: An Anthology*, Thorlac Turville-Petre, London, 1989, 148–57. For discussion of the wallpaintings, see E. Carleton Williams, 'Mural Paintings of the Three Living and the Three Dead in England', *Journal of the British Archaeological Association*, 3rd series, 7, 1942, 31–40; E. Clive Rouse and A. Baker, 'The Wall Paintings at Longthorpe Tower near Peterborough, Northants', *Archaeologia*, 96, 1955, 1–57, esp. 42. The other poem of interest is 'Somer Soneday' in which the narrator tells of wandering away from the hunt and encounters Fortune turning her wheel; see Turville-Petre, *Alliterative Poetry*, 140–7.

25 There are numerous English thirteenth-century illuminations of the horsemen of the Apocalypse which bear superficial relationship to the image on the Hereford map. In the Apocalypse illuminations, the rider is pictured in a variety of guises including hunter, king, knight, etc.; see Suzanne Lewis, *Reading Images*, Cambridge, 1995, e.g. figs. 41–9.

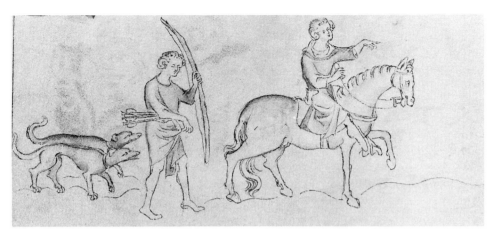

Fig. 2.3 Hunting Scene. Queen Mary Psalter, British Library, London, MS Royal 2.B. vii,
f. 151v. Early 14th century
By kind permission of the British Library

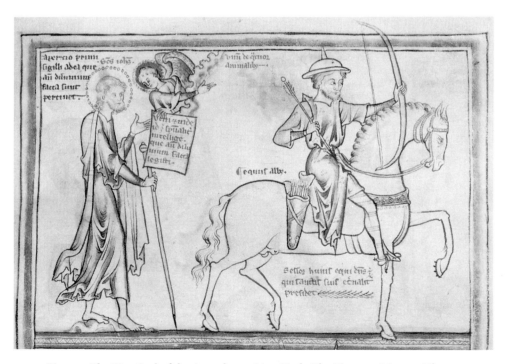

Fig. 2.4 The First Seal of the Apocalypse. New York, The Pierpont Morgan Library,
MS M.524, f. 2r. England

on his horse and points to the map as if to bid goodbye to the world suggests the correctness of this reading. Consider also that the same hunter is placed next to one of the four terminals that together spell the word MORS ('death').[26] The hunter thus becomes the personification of the viewer who lives in the world of the present and will literally 'passe avant' at the end of his or her time on earth.

In travelling around the corners of the circle of the Hereford map we are presented with the two images of seated figures: one enthroned, the other on horse, a combination reminiscent of the great seals of England. Because the horseman in this case is *not* shown armored as he would be on an actual seal, we are presented with an image of a lesser mortal involved in lesser activities. I have previously suggested that one might read the two images as exemplifying past and present. One might also consider the images as ruler and liege. Both figures, however, sit as mortal counterparts at the base of the pictorial frame. They are seen as mortals, bound to the earth, as opposed to the eternal ruler, also seated, but seated above the world and time in judgment.

To reinforce the suggestion that the seated figure in the lower left corner of the map represents the past and that the seated rider in the lower right corner makes reference to present, there is another text in that quadrant, located above and apart from the hunting scene. It reads: *Descripcio orosii de ornesta [Ormista] mundi sicut interius ostenditur* ('Orosius' description of the Ornesta of the world, as is displayed within').[27] The reference is to book III of Orosius' *Historiae adversus paganos* (fifth century) as a source for the information contained on the map.[28] In the thirteenth century copies of Orosius abounded.[29] Orosius' work was in many ways an attempt to link the pagan past and the Christian present insofar as his work was meant as a history of the Christian era as contrasted to the darkness of the pagan past. This is a subject that will be further elaborated upon in Chapter 6.

[26] Peter Barber has mentioned to me that he believes 'passe avant' refers to passage of time based on Spanish sarcophagi.

[27] *Ornesta* is a corruption of 'Ormista', i.e. 'Or[osii] m[undi h]ist[ori]a'. See Crone, 'New Light', 448.

[28] For translation, see Paulus Orosius, *The Seven Books against the Pagans*, trans. Roy J. Deferrari, Washington, 1964, hereafter referred to as Orosius.

[29] According to Ross, Orosius was considered a standard universal history and copies were widely available in monastic, school, and university libraries, mostly without illuminations; see D. J. A. Ross, 'Illustrated Manuscripts of Orosius', *Scriptorium*, 9, 1955, 35–56. Although a copy of Orosius is part of the library holdings at Lincoln Cathedral, it appears that the manuscript was not included in the cathedral library's inventory during Richard's tenure at Lincoln. The manuscript (Lincoln, Cathedral Chapter Library, MS A.4.10), is listed in Woolley, *Catalogue*, MS 102 (p. 66) and in Thomson, *Catalogue*, MS 102 (p. 77). Thomson suggests that the manuscript was made for York Minster, where it was in the fifteenth century and came to Lincoln by the seventeenth century; see Thomson, *Catalogue*, 77.

The Last Judgment

The map's Last Judgment[30] is clearly inspired by church arts, especially English artistic models such as manuscript painting and the more popularly seen and understood examples of wallpainting[31] that were closely tied to the oral tradition of vernacular hymns and teachings.[32] The Last Judgment, in its many depictions, forced the viewer to consider the earthly life as compared to the eternal one.

In effect the upper section of the pictorial frame, shaped as a tympanum, or even more tellingly as the framing arch of a parish church,[33] depicts a particularly popular English version of the Last Judgment – a version in which the Virgin figures prominently in a unique manner, as we shall see shortly. Let us look at the scene more closely: Christ in majesty with arms outspread showing his wounds is seated upon a throne of clouds with four adoring angels above. The Latin inscription reads: *Ecce testimonium meum.* Below Christ are four standing angels; the two closest to Christ hold the instruments of the Passion. To the right of Christ, an angel holds the cross and nails;

30 The Last Judgment is a subject of vast importance in the Middle Ages; for instance, see Karl Künstle, *Ikonographie der christlichen Kunst*, 2 vols., Freiburg, 1928, esp. I: 521–57; Engelbert Kirschbaum and Gunter Bandmann *et al.*, ed., *Lexikon der christlichen Ikonographie*, Rome, 1972, IV: 513–23. The Last Judgment was frequently referred to in sermons by preachers to capture the attention and imagination of their audience. The subject fulfilled a need for vivid material in the instruction of the people. It was frequently used not only to strike terror but because of its centrality to the medieval view of all human activities as a preparation for the day of Christ's return and all of present life as transient in relation to the world to be revealed. For a discussion of the subject of 'Doom' in later fourteenth century sermons and preaching, see G. T. Owst, *Literature and Pulpit in Medieval England*, Cambridge, 1933, esp. 294–302.

31 For English wallpaintings, see E. W. Tristram, *English Medieval Wall Painting, The Twelfth Century*, Oxford, 1944; *English Medieval Wall Painting, The Thirteenth Century*, 2 vols., Oxford, 1950; *English Medieval Wall Painting, The Fourteenth Century*, London, 1955; A. Caiger-Smith, *English Medieval Mural Painting*, Oxford, 1963; E. Clive Rouse, *Medieval Wall Paintings*, Buckinghamshire, 1991. Tristram and Caiger-Smith include helpful catalogs of wallpaintings listed by monument. Tristram includes subjects cross-referenced to monuments. Tied to the developments relating to literacy and preaching, Caiger-Smith suggests that wallpaintings of the Last Judgment not only had shock value in making the viewer consider doom, but could also provide a spiritual dimension through contemplation of everyday life. To that effect he cites a passage from the *Moralia* of Gregory the Great (sixth century) as an example of a relevant spiritual exercise; see Caiger-Smith, *English Mural Paintings*, 39–40.

32 The occurence of Last Judgment scenes in church wallpainting is extremely common in England; see Caiger-Smith, *English Mural Paintings*, esp. 31–43; also see Tristram's indices of subjects (see n. 31). Caiger-Smith notes that the details are frequently similar to those found in 'lurid' stories such as the Vision of Tundal, St Patrick's Purgatory, and the Vision of the Monk of Eynsham; Caiger-Smith, *English Mural Paintings*, 36.

33 Note the example of a sculptured twelfth-century Last Judgment tympanum which is presumed to have belonged to the round-naved twelfth-century chapel of St Giles' Hospital, Hereford, for the care of lepers. The chapel was probably a possession of one of the crusading orders, most probably the Templars or the Hospitallers. There is some confusion on this matter; see Eileen Robertson Hamer, 'Patronage and Iconography in Romanesque England: The Herefordshire School', Ph.D. thesis, The University of Chicago, 1992, esp. 294–7; George Zarnecki, 'Regional Schools of English Sculpture in the Twelfth Century', unpublished Ph.D. thesis, Courtauld Institute, London University, 1950, 342–4 (reference in Hamer); *Royal Commission on Historical Monuments, Herefordshire*, III: 130–1; Nikolaus Pevsner, *Herefordshire. The Buildings of England*, Harmondsworth, 1963, 185.

to the left of Christ, an angel holds the crown of thorns. Two other angels bend toward scenes depicted below, each of them shown blowing a trumpet from which issues an Anglo-Norman inscription: *Leuez-si uendrez a ioie pardurable* ('Arise, and come to ever-lasting joy') (to Christ's right); *Leuez-si alez au-fu de enfer estable* ('Rise and depart to hell-fire prepared') (to Christ's left).

To Christ's right, beyond the architectural form that represents a tower, city walls, and open gate, an angel leads the blessed saved. First in line is a bishop, wearing a mitre, followed by a crowned royal figure, who in turn leads four tonsured monks. Behind them are four additional figures (young children and bearded older figures one of whom may also be a tonsured monk) rising from their coffins with lids marked by crosses. To Christ's left on the opposite side, also marked by a tower and city walls, the gate is shown as closed. With drawn sword in his right hand, an angel admonishes the damned: six figures tied together are led by a devil and his helper. Beyond the damned another devil stands within the open entrance to hell's furnace beyond which looms the Jaws of Hell.[34]

Immediately below Christ is the Virgin, as only rarely shown, opening her robe to display her breasts. To the left is a woman offering a crown to the Virgin. Two angels complete the scene; one of whom points to a long inscription written in Anglo-Norman, to which we shall return later.

In keeping with ecclesiastical developments, the Last Judgment as here depicted emphasizes the humanity of Christ. In the thirteenth century we find numerous exam-ples of Christ in majesty showing the wounds of his crucifixion, as well as the instru-ments of the Passion, images that graphically underline his pain and suffering on this earth as a human being.[35] One can compare, for instance, the Hereford scene with the Huth and Queen Mary Psalters, both thirteenth-century English manuscripts.[36] In the Huth Psalter (Fig. 2.5) Christ's robe falls from his shoulder to reveal the wound in his side. An angel holds the cross, a symbol of the Passion, to the left of Christ. The cross is

34 The image of the Jaws of Hell depicted as the mouth of a whale is a popular motif in English iconography. The motif is based on the story of Jonah and the whale as the foreshadowing of Christ's descent into Hell (Matthew 12: 40).

35 Caiger-Smith discusses thirteenth-century pictorial developments of the Last Judgment that mirror the rise in contemplatives. He uses as an example the wallpainting of the Doom at Ashampstead in Berkshire where Christ's robe is shown to fall from his shoulder to reveal the wound in his side, blood appears to drip from his feet, and his uplifted hands show nail marks. The cross, as a reminder of the Passion, is painted green and held by an angel on the left of the Judge; on the right, an angel carries the lance; see Caiger-Smith, *English Mural Paintings*, 31–2.

36 The Huth Psalter: London, BL, MS Add. 38116, English, after 1280 (?). The provenance is possibly Lincoln or York. According to Morgan, the Huth Psalter contains one of the earliest examples of the motif of the Virgin showing her breast to remind Christ of how she suckled him. Morgan also notes that the motif appears in the late thirteenth-century wallpaintings in St John's, Winchester, and in four-teenth-century examples such as the the Queen Mary Psalter; see Lucy Freeman Sandler, *Gothic Manu-scripts 1285–1385* (A Survey of Manuscripts Illuminated in the British Isles, 5), London, 1986, vol. II, cat. no. 56. And for the wallpaintings of Chalgrove (Oxon), see Morgan, *Early Gothic Manuscripts*, 4/2, cat. no. 167, fig. 339. Note also similarities of the description of the wallpainting of the Doom at Ashampstead in Berkshire in previous note to the Huth Psalter. Note that f. 8 (Morgan, *Early Gothic Manuscripts*, 4/2, fig. 336) of the Huth Psalter contains a scene of the Creation with God and compass.

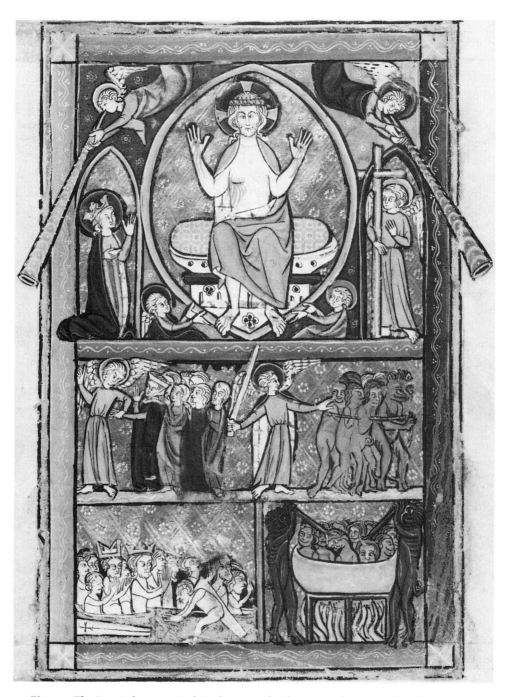

Fig. 2.5 The Last Judgment. Huth Psalter, British Library, London, MS Add. 38116, f. 13v.
(?) after 1280, England
By kind permission of the British Library

painted green to signify new life. To Christ's right is the Virgin depicted as showing her breast. Two angels with horns are on either side.

By approximately 1290–1300, as in the Queen Mary Psalter (Fig. 2.6),[37] the figure of Christ was not only depicted with wounds, which emphasized his humanity,[38] but often the Virgin and either John the Baptist or John the Evangelist were shown kneeling beside the ascended Christ, as here.

In the Hereford map we find below Christ the unusual (but similar to Huth Psalter) depiction of the Virgin kneeling without either of the accompanying Johns. Not only is the Virgin kneeling, she also bares her breasts, underscoring the late medieval emphasis on salvation through the Virgin's mercy.[39] The figure in the Hereford map is yet another examples of this motif. Although of interest as a comparison, richly decorated manuscripts[40] were largely inaccessible to the lay public. A more apt comparison would be to wallpainting, Given that wallpaintings could be enjoyed by many persons at the same time, often a general audience, wallpaintings were functionally more akin to a painted vellum wall map than a page from an illuminated manuscript. Furthermore wallpaintings, especially those in English parish churches, more closely parallel developments of popular forms of piety such as hymns and poems to the Virgin that emphasize her emotional response to the Crucifixion and, in some instances, describe her as baring her breasts. Note the original text from the map:

> Veici beu fiz mon piz de deinz la quele chare preistes
> E les mameleites dont leit de uirgin queistes
> Eyez merci de touz si com uos memes deistes
> Ke moy ont serui kant sauueresse[41] me feistes

> (See, dear son, my bosom within which you became flesh,
> and the breasts from which you sought the Virgin's milk.
> Have mercy, as you yourself have promised, on all those
> who have served me, who have made me their way to salvation.[42])

[37] London, BL, MS Royal 2B.vii, early fourteenth century; see Sandler, *Gothic Manuscripts*, 5/2, cat. nos. 56, 57; George Warner, *Queen Mary's Psalter*, London, 1912. For the most recent survey, see Anne Rudloff Stanton, 'The *Queen Mary Psalter*: Narrative and Devotion in Gothic England', Ph.D. thesis, University of Texas at Austin, 1992. I am indebted to Anne Stanton for these references.

[38] Morgan describes the devotional aspects of the image as representing actions such as the nailing of the hands and feet and spearing of the side as presented simultaneously; see Morgan, *Early Gothic Manuscripts*, 4/2, 168.

[39] For a survey of the topic with excellent bibliography, see Nigel Morgan, 'Texts and Images of Marian Devotion in Thirteenth-Century England', in *England in the Thirteenth Century* (Proceedings of the 1989 Harlaxton Symposium), Stamford, 1991, 69–103. The Hereford map is cited on p. 97; Caiger-Smith discusses the development as well (*English Mural Painting*, 34–5).

[40] This motif is noted as rare in Morgan's discussion of the Huth Psalter. He suggests that the motif originates *ca.* 1280 and the Huth Psalter may be one of the earliest examples along with the Hereford map. He also notes its appearance in the Queen Mary Psalter; see Morgan, *Early Gothic Manuscripts*, 4/2, 168.

[41] Thomas McCormick noted the unusual usage of the terms *sauveresse* ('savioress') and *uos* both of which strongly emphasize the role of the Virgin in prayer. I am intrigued by the woman who crowns the Virgin. The question of her identity was raised by Armin Wolf at the Hereford Mappa Mundi Conference, 27 June – 1 July, 1999. It is a subject worth further exploration.

[42] Translation from Harvey, *Mappa Mundi*, 54.

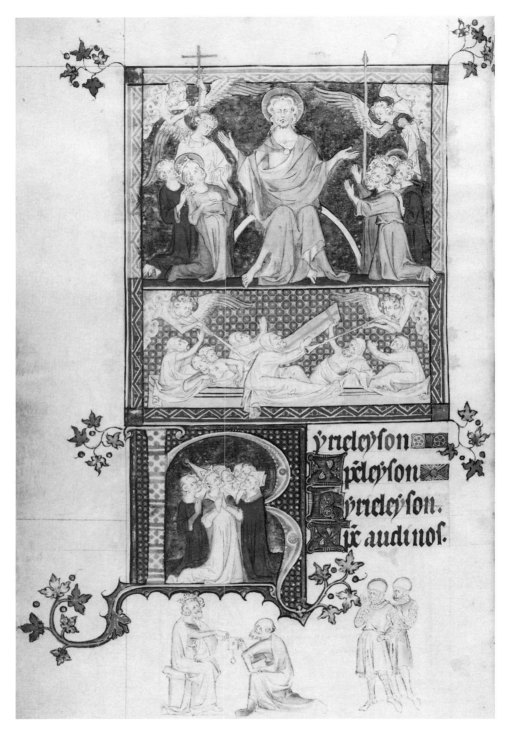

Fig. 2.6 The Last Judgment. Queen Mary Psalter, British Library, London, MS Royal 2.B. vii, f. 302v. Early 14th century

By kind permission of the British Library

Consider its parallel from one of the many such hymns describing the Virgin:

> Surge mea sponsa, swete in siȝt,
> And se þi sone þou ȝafe souke so scheene;
> Þou schalt abide with þi babe so birȝt,
> And in my glorie be callide a queene
> Thi mammillis, moder, ful weel y meene,
> Y had to my meete þat y miȝt not mys;
> Aboue alle creaturis, my moder clene
> Veni, coronaberis[43]

The rhymes given here suggest the developing and continuing emphasis on the inter-cessory abilities of the Virgin. They underscore the loving relationship between the Virgin and Christ and the pains of the Passion. These themes relate to the greater role of vernacular lyrics as a reflection of historical developments, including Franciscan preaching of developing importance in England at this time,[44] and the concurrent rise

[43] Lambeth MS 853, *ca.* 1430, cited in Frederick J. Furnivall, *Hymns to the Virgin & Christ, The Parliament of Devils and other Religious Poems*, London, 1867, 1. The manuscript includes a collection of poems that are religious and secular. For instance within the manuscript are poems about hunting, 'Revetere', 91–4, and the vanity of earthly desires, 'Earth', 88–90, and the 'Mirror of the Periods of Man's Life', 58–78. Although this manuscript is relatively late, there are numerous examples of thirteenth-century religious lyrics that suggest equivalents. A cursory look at the table of contents in Brown, *English Lyrics*, indicates a number of examples that underscore the intercessory role of the Virgin. For reference to her role as nursing mother, see two versions of no. 17 (pp. 24–6) 'Of One That Is So Fair and Bright' (Cambridge, Trinity College, MS 323; London, BL, MS Egerton 613). Also see three versions of no. 32 (pp. 56–61) 'A Prayer of Penitence to Our Lady' (Cambridge, Trinity College, MS 323; London, BL, Cotton MS Caligula A. ix; London, BL, Royal MS 2 F. viii). For references to the sorrow of the Virgin, see no. 47 (pp. 83–4) 'Our Lady Sorrows for Her Son' (London, BL, MS Arundel 248) and two versions of no. 49 (pp. 87–90) 'Dialogue between Our Lady and Jesus on the Cross' (Oxford, Bodl. Lib, MS Digby 86; London, BL, MS Royal 12 E.1). Morgan in 'Texts and Images', 97, cites no. 68, p. 127 in Brown, *English Lyrics*, 'Our Lady Help Us at Our Ending' (London, BL, MS Cotton Cleopatra B. vi).

[44] Morgan suggests that in the twelfth and thirteenth centuries private prayers for clerics and laity and additions to the public liturgy were influenced by Marian themes already incorporated into monastic devotions. By the mid-thirteenth century, they were established practices in the secular church. He suggests that the practices of canons regular, especially the Augustinians, may have been influential in this development; see Morgan, 'Texts and Images', 73–4. In regard to private prayer of the laity Brown notes the developing phenomenon of collections of English lyrics from *ca.* 1250 to 1300. He cites the earliest and most important of these collections in Cambridge, Trinity College, MS 323, a miscellany of material in English, French, and Latin, indicating numerous contributors. Brown suggests that it was compiled and designed for instruction of laymen and probably belonged to a house of Dominican friars. Because much of the material appears in other manuscripts, Brown suggests that there was a lively circulation of these lyrics and the English lyrics were probably circulated orally; see Brown, *English Lyric*, xx–xxvi. For discussion of specifically Anglo-Norman lyrics, and those specifically compiled or transmitted by mendicant preaching orders, see David L. Jeffrey, *The Early English Lyric and Franciscan Spirituality*, Lincoln, NE, 1975, 169–268. According to Frankis, the four so-called 'Friars' Miscellanies' of the thirteenth century are of unknown provenance: Cambridge, Trinity College, MS B.14.39; London, BL, Cotton Caligula A.ix; Oxford, Jesus College, MS 29; and Oxford, Bodl. Lib., MS Digby 86. Frankis questions the attribution to Franciscans and Dominicans. He suggests a date for all four of *ca.* 1260–80 and on linguistic grounds offers a provenance of south-west Midlands; more specifically, the diocese of Worcester or the dioceses of Worcester and Hereford. He argues that for Cambridge, Trinity College, MS 323 there is no reason to assume a mendicant provenance as opposed to a house of regular or secular canons and that Oxford, Bodl. Lib., MS Digby 86 provides insights into the upper middle class of thirteenth-century England. Frankis makes a strong claim for the argument that such thirteenth-century manuscripts were prepared

in literacy.[45] The themes found their visual counterpart in the most popular and folk-loric form of church decoration, wallpaintings,[46] especially those found in parish churches where the Virgin is depicted offering her breast to her adult son, as at Winchester (Fig. 2.7),[47] and Chalgrove (Fig. 2.8).[48]

for laymen by clerics although he admits that the intended audience is not certain; see John Frankis, 'The Social Context of Vernacular Writing in Thirteenth Century England', in *Thirteenth Century England*, 1, (Proceedings of the Newcastle upon Tyne Conference), ed. P. R. Coss and S. D. Lloyd, Woodbridge, 1985, 180–4. In terms of Hereford, the well-known lyrics of William Herebert (d. 1333), Franciscan friar from the convent at Hereford whose role as author of vernacular lyrics in preaching was important, serve as examples. For hymns by Friar Herebert from Phillipps, MS 8336, see Brown, *Religious Lyrics of the XIVth Century*, nos. 12–25 (pp. 15–28). For more on Herebert, see Jeffrey and Levy, *Anglo-Norman Lyric*, 4, 6, 8, 9, 14, 16, 81–2, 149, 271. They cite London, BL, MS Add. 46919 as a collection by Herebert which includes a variety of texts, similar to Selden Supra 74; see Chapter 1, n. 30. Although most of the lyrics postdate the year 1290 I assume that lyrics of this type were available throughout the second half of the thirteenth century in similar form and thus were relevant to the Hereford map.

45 Scholars agree that there was an increased emphasis on teaching the laity as promulgated in England at the Fourth Lateran Council (1215) followed by the *Statues of Salisbury* promulgated at the Council of Oxford (1222), with special emphasis given to the task by the Franciscans as illustrated by the work of the Franciscan Archbishop of Canterbury John Pecham; see Morgan, 'Texts and Images', 76; Jeffrey and Levy, *Anglo-Norman Lyric*, 3. The development toward fuller religious instruction for the laity, influenced by the Lateran Council of 1215, allowed for many passages to be translated from the Latin into the vernacular and appear in vernacular miscellanies, and in simplified forms, in sermons; see Caiger-Smith, *English Mural Painting*, 40.

46 The Last Judgment in wallpaintings was extremely popular. For an excellent discussion see Caiger-Smith who indicates that there are at least seventy-eight examples extant in England (although he does not list them all); they are most commonly found above the chancel arch (Caiger-Smith, *English Mural Painting*, 31–43). For a list of twelfth-century English wallpaintings of the Last Judgment, see Tristram, *Wall Painting: Twelfth Century*, 85 and plates; for a list of thirteenth-century English wallpaintings of the Last Judgment, see Tristram, *Wall Painting: Thirteenth Century*, I: 469–70 (text), for plates, see vol. II.

47 Formerly in St John's church, Winchester, *ca.* mid-thirteenth century, destroyed. The wallpainting is known from drawings by F. J. Baignet in 1853 and engravings made after the drawings. The Last Judgment was located on the north nave wall. Tristram suggests that it was executed by lay painters from Winchester and the monk depicted in the Crucifixion and Last Judgment is St Francis. Thus Caiger-Smith argues that the wallpaintings may be influenced by Franciscan teachings; see Tristram, *Wall Painting: Thirteenth Century*, I: 177–8 (text), 620; II, pls. 55, 56.

48 St Mary's Church, Chalgrove, Oxfordshire, fourteenth century. Caiger-Smith dates the wallpaintings to the mid-fourteenth century; see Caiger-Smith, *English Mural Painting*, 165. R. W. Heath-Whyte dates the decoration and rebuilding of the chancel to 1310–30; see R. W. Heath-Whyte, *A Guide to the Medieval Wall Paintings of St Mary-the-Virgin Church*, Chalgrove, 1985. For background to Chalgrove's wallpaintings, see Stephen T. J. Maynard, 'A Study of the Wall Paintings of St Mary's, Chalgrove', MA thesis, Centre for Medieval Studies, University of York, 1986. Also see catalog entries with bibliography in Caiger-Smith, *English Mural Painting*, 165; Tristram, *Wall Painting: Fourteenth Century*, 153–5. The program at Chalgrove is largely intact; a large proportion of the paintings is devoted to the Virgin, especially those beginning at the west end of the south wall following the Last Judgment where the Virgin is shown baring her breast; they are from west to east scenes from the the Assumption of the Virgin described in the thirteenth-century *Golden Legend* by Jacobus de Voragine: the Virgin receives the palm, the Apostles at the deathbed of the Virgin, the death of the Virgin, the funeral of the Virgin, the conversion of the High Priest, St Thomas receives the girdle of the Virgin, and the burial of the Virgin. Caiger-Smith considers the subject matter and its derivation in more detail in *English Mural Paintings*, 64–75. I am grateful to Maureen Pemberton, Jill Adels, R. W. Heath-Whyte, and the Rev. I. Cohen for photographs.

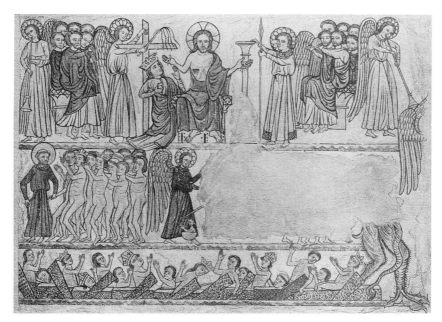

Fig. 2.7 The Last Judgment. St John's Church, Winchester (destroyed). *ca.* mid-13th
century. (Drawing by F. J. Baignet, 1853 from Ernest William Tristram,
English Medieval Wall Painting, The Thirteenth Century, vol. 2, London)
Photograph courtesy of the Fine Arts Library, Harvard College Library

Fig. 2.8 The Last Judgment (detail). St Mary's Church, Chalgrove, Oxfordshire. 14th century
Author's photograph

Fig. 2.9 The Last Judgment (?). Stanningfield, Suffolk. Mid-15th century. (*Burlington Magazine*)
Photograph courtesy of the Fine Arts Library, Harvard College Library

The Pictorial Frame in Artistic Context

The prominence of the Last Judgment immediately above the entire map mirrors the key position of this theme in medieval art and theology. The scene, which in effect marks the end of earthly time, placed above the terrestrial orb of earthly history is particularly appropriate. The arrangement may have been suggested by the frequent placement of the Last Judgment in medieval sculpture above the central entrance to a church, as for instance at Lincoln Cathedral.[49] Similarly, consider how frequently in England wallpaintings of the Last Judgment were placed above archways leading into the sacramental space of the apse, as exemplified at Stanningfield (Fig. 2.9).[50] In such

49 Caiger-Smith offers a quotation from *Magna vita Sancti Hugonis* (Rolls Series, London, 1864, 289) in which Hugh, Bishop of Lincoln, in conversation with King John, uses the sculptural Last Judgment as a moral lesson for the king to contemplate. The text suggests how the sculptural decoration of the church provided a touchstone for self-examination and self-definition; see text quoted and translated by Caiger-Smith, *English Mural Paintings*, 40–1.

50 Stanningfield, Suffolk, fifteenth century. Caiger-Smith refers to the painting at Stanningfield as a later development that emphasizes even further Christ's wounds and suffering, in *English Mural Paintings*, 33, 37, pl. XVI. According to Long, Stanningfield, now largely obliterated, showed Christ, almost life-size, seated on a rainbow, his right hand raised in blessing, the Virgin on his right, an angel with instruments of passion on his right, scenes of heaven and hell on either side. Heaven was represented by a building of several stories; for more details see E. T. Long, 'The Stanningfield Doom', *Burlington Magazine*, 70, 1937, 128.

instances, as we shall see shortly, the location of the Last Judgment provided a dramatic focus to the contemplation of the terrestrial world in relationship to the hereafter. The Last Judgment, placed above the worldly themes of the Hereford map's interior, reproduced the experiential memory of physically moving from the world outside a church through the doorway, into the nave; or from the nave toward the sacred space of the apse. I refer to this as a 'Visual Journey'.

The Visual Journey

The meaning of a scene of Last Judgment above a central door leading into the nave of a medieval church has been treated repeatedly.[51] However, consider the other depictions of the Last Judgment *within* a medieval church where it is depicted over the arch leading to the apse. For example, this configuration exists at St Mary's church at Kempley, a small parish church near Hereford.[52] In reconstructing the visual journey it imposes upon the viewer, we may gain a better sense of how the medieval visitor in this case telescoped space and time into experiential memory.

Under the doorway of St Mary's, inspired by a Norman Tree of Life (Fig. 2.10), one enters into the church, leaving the past behind. Directly opposite the entrance on the western end of the north nave's wall is a large wallpainting of a Wheel of Life (Fig. 2.11) upon which the parishioner could contemplate the 'presentness' of earthly existence. (There is no evidence that any texts accompanied the image, which is not surprising in a parish church.)[53] Moving from the nave toward the apse, the parishioner would encounter the painting over the arch leading into the apse, which shows the remnants of a wavy mandorla once enclosing Christ in majesty at the Last Judgment – a dramatic reminder of future and eternity. The configuration at once physically and emotionally experienced leads the worshipper from the earthly world, to the contemplation thereof, and finally to the future divine world. The arched space of the chancel entrance, surmounted by Christ in majesty, provided an archetypal memory

51 For instance, see M. F. Hearn, *Romanesque Sculpture: The Revival of Monumental Stone Sculpture in the Eleventh and Twelfth Centuries*, Ithaca, NY, 1981.

52 St Mary's Church, Kempley, Gloucestershire. This is a Norman church built between 1090 and 1100, the wallpaintings dating from the twelfth century. Kempley was included in William the Conqueror's royal gift to Walter de Lassy which included territories on the Welsh border around Ewyas Harold and Longton in Herefordshire. There are two wallpainting campaigns. In the chancel, among other images largely based upon Revelation 1, 4, the twelfth-century fresco program includes the towers of heavenly Jerusalem on the north and south windows of the chancel, and on the ceiling a figure of Christ in benediction upon a rainbow his feet resting on a round ball that represents the earth. On the north wall, the fourteenth-century decoration, presumably in tempera, includes the Wheel of Life showing ten stages of man. Near the wheel is a Norman window. On one splay is a depiction of St Anthony of Padua, on the other is St Michael weighing souls, with the Virgin shown pleading for their mercy. On the west wall of the chancel arch are remains of a Last Judgment. For background and bibliography, see Tristram, *Wall Painting: Fourteenth Century*, 187; Craiger-Smith, *English Mural Painting*, 142.

53 The only text to be found on the wallpaintings is the text relating to the donation located on the west wall, north side.

Fig. 2.10 The Tree of Life. Tympanum, south doorway of St Mary's Church, Kempley, Gloucestershire. 1090–1100
Author's photograph

for most Christians who learned their lessons in small parish churches throughout England.

Let us deconstruct the experiential memory just described, and conceptually superimpose it upon the flat surface of the Hereford map. We enter the map to find a 'Wheel of the World', a tool to aid us in contemplation of earthly existence. It too is surmounted by an arch that contains an image of the Last Judgment, which brings us to the contemplation of eternity. The arches of the Last Judgment in both cases separate the worldly from the eternal. Even the vine and dentil patterns of the outermost border of the map's pictorial frame are reminiscent of painted and sculptural ornament on contemporary church arches painted or sculpted with Last Judgments.[54]

I suggest a further parallel between the visual journey taken within a parish church and the visual journey embedded in the map's pictorial frame. The Wheel of Life or Fortune is placed in the nave, an area concerned with the here and now. Its meaning can only be understood in the context of the surmounting archway leading to the eastern apse whereupon the image of Christ as Judge is painted. The sacred surmounts

[54] The decorative borders of the map mirror decorative borders of Last Judgments, arch, and chancel arch decoration, e.g. Stowell Church (Gloucestershire), Last Judgment, second half of the twelfth century; see Caiger-Smith, *English Mural Painting*, 10, 32, 59; Tristram, *Wall Painting: Twelfth Century*, 147–8, pl. 67. Also note sculptural similarities to Leominster (see n. 64 below). For leaf pattern, note as two examples amongst many the decoration in Wareham Church, Dorset, and Lydiard Tregoze Church, Wiltshire; see Tristram, *Wall Painting: Thirteenth Century*, II (plates), supplementary pls. 24c and 28c respectively.

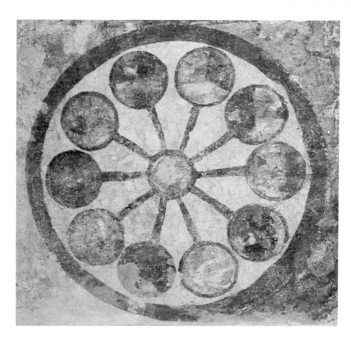

Fig. 2.11 The Wheel of Life. St Mary's Church, Kempley,
Gloucestershire. 14th century
Author's photograph

the profane as we move from past to present to the eternal future. So too, the circular world of the map in its physicality is surmounted by the Last Judgment. The lower sections of the pictorial frame provide the visual memory of the past and present by their respective allusions to classical antiquity and the secular world. They support the Wheel of the World, the geographic counterpart to the Wheel of Life. The arch above the map that contains Christ in eternal time and space completes the pictorial frame. We have in a single image a visual journey that mirrors the physical experience of moving from the external world into the nave, and then moving toward the chancel as through the archway of St Mary's church in Kempley.

Beyond this particularly apt comparison, I believe the map parallels the symbolic nature of church architecture irrespective of the particulars of its decorative scheme. The church provokes an experience in space in which the viewer conflates the meaning of the memory of its parts and moves toward the apse from the earthly to the eternal. Through prayer and contemplation of one's life, the church building functions as a memory house that prepares one for the spiritual realm. The map also leads one to consider the significance of the earthly realm in its encyclopedic fullness, and to reconcile the temporal realm with that of the eternal.

The Wooden Framework in Architectural Context

There is ample reason to believe that the map finally did find a permanent placement in Hereford Cathedral and was displayed there soon after it was completed. That the map could be placed in a prominent position within a cathedral appears to be a reasonable assumption. Its deliberate combining of images with texts in Anglo-Norman as well as Latin suggests an effort to reach the widest audience possible. Given the conceptual interchangeability of the map and Wheels of Life or Fortune, all having strong associations with the earthly realm, a logical place would have been within the nave of Hereford, as was the case at Kempley. However, the relatively recent discovery of the wooden framework that is believed to have once contained the map as the center of a triptych (Fig. 2.12) provides evidence for the exhibition of the map within an altar-piece-like format.[55] Scholars now argue that the map was brought from Lincoln in exemplar form and finished around 1300 in Hereford. It is my contention, however, that the map, once completed, was soon after put into the wooden framework. The map became the centerpiece of a triptych to be installed in the north transept where pilgrims from near and far were drawn to the tomb of Bishop Thomas Cantilupe. During Bishop Swinfield's tenure as bishop, Hereford Cathedral underwent architectural and decorative changes of significance that provided new possibilities for its exhibition.[56]

[55] In 1989 a wooden frame that once held the Hereford map was rediscovered. A sample of the carved decoration of the canopy, based on radio-carbon dating tests, was dated to 1040–1280 and two samples from the back of the main panel to 890–1020 and 1270–1400 respectively. Given the possibility of reused wood, replacements, etc., the possibility of a date *ca.* 1280 is within reason. Although only the central panel was discovered, recorded evidence from at least 1684 indicates that the frame was once part of a triptych with the frame and two doors gilded and painted with letters and figures (Dingley, *History from Marble*, 78, clx). An account of 1770 corroborated the existence of the frame with two panels (Richard Gough, notebook entry, Oxford, Bodl. Lib., MS Top. Gen. e 19, f. 88; one later in Richard Gough, *British Topography. Or, An Historical Account of What Has Been Done for Illustrating the Topographical Antiquities of Great Britain and Ireland*, London, 1780, I: 71–6). Lastly John Carter, in a preliminary design (London, BL, MS Add. 29926, f. 190), *ca.* 1770, for the title page of *Specimens of Ancient Sculpture and Painting*, London, 1780, indicates the side panels showing on the left panel the Angel of the Annunciation, on the right, the Virgin. The style appears Gothic. In 1855, the wooden frame was unfortunately stripped of almost all of its painted decoration. In an entry in an unpublished diary, Sir Frederick Madden, Keeper of Manuscripts at the British Museum, noted that the central frame, before 'restoration' included 'a scroll ornament or border in which was introduced on each side the dragon-shaped animal that so often appears in MSS executed about 1300'. Sir Frederick's displeasure regarding the poor judgment of the restorer was evident. The Annunciation wings as described were apparently dismantled sometime after their recorded descriptions, possibly as a result of the collapse of the West Tower in 1786, and perhaps used as doors to the chantry, and finally lost during the rebuilding and restorations by James Wyatt. In any case by *ca.* 1800 the side panels apparently were no longer on display; see Martin Bailey, 'The *Mappa Mundi* Triptych: The Full Story of the Hereford Cathedral Panels', *Apollo*, 137, no. 376 (n.s.), 1993, 377. The original side panels with the painting of the Annunciation were presumably lost but in the nineteenth century new wooden wings were added. For in-depth discussion regarding the history of the frame and the side panels, see *ibid.* 374–8. I am indebted to Dominic Harbour for bringing this article to my attention along with Martin Bailey's news story regarding the discovery in *The Observer*, 5 November, 1989.

[56] Bishop Swinfield was instrumental in the canonization of his predecessor, Bishop Cantilupe, for whom he served as confidential clerk and chaplain for eighteen years; see E. N. Dew, *Extracts from the Cathedral*

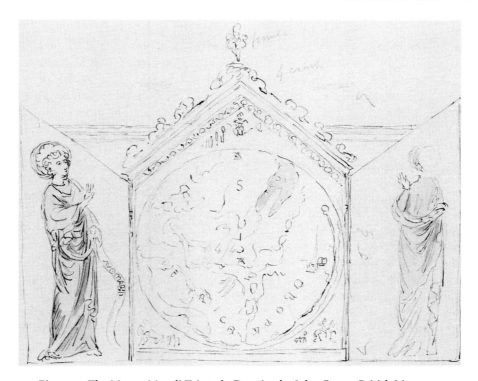

Fig. 2.12 The Mappa Mundi Triptych. Drawing by John Carter, British Museum, London, MS Add. 29942, f. 148. 1770s

By kind permission of the British Library

Because the map's wooden framework had painted side panels depicting the Annunciation (the angel Gabriel on the left, the Virgin to the right), it appears that at some point it was decided to emphasize the religious nature of the map. The Annunciation panels reinforce and prefigure the Virgin's role on the map itself where she is depicted and described as intercessor at the Last Judgment. Whether the map with its wooden framework was placed on an altar, in the north transept, or anywhere else is still being debated. If ensconced in some manner in the north transept, which served as a

Registers of Hereford: Hereford Cathedral Registers 1275–1535, Hereford, 1932: e.g. see entries for years 1285 (p. 25), 1289 (p. 31). During the three decades that followed Cantilupe's death, gifts were plentiful and provided immense funds toward improvements to the fabric of the church. The aisle of the north transept was completed *ca.* 1287, the body of Cantilupe was placed in a tomb therein, and the central tower and aisles of the nave were built. Following that campaign, the foundations were reinforced and the aisles of nave and choir rebuilt and the eastern transepts reconstructed. In 1320, five sepulchral monuments in each choir aisle and two in the north-east transept, including Bishop Swinfield's, were created or restored as several had been destroyed during the building campaigns; see Arthur Thomas Bannister, *The Cathedral Church of Hereford*, London, 1924, 72. Swinfield died on 15 March, 1316, and was buried in the transept of the cathedral 'maxima pompa' according to Leland; see Francis T. Havergal, *Fasti Herefordenses & Other Antiquarian Memorials of Hereford*, Edinburgh, 1869, 19–20. One of the stone coffin lids found during restoration of the foundations of the cathedral from 1857 to 1860 affixed to the wall of the north-east transept includes a shield that supposedly represents the family 'Hereford' and includes a cosmological diagram below; see Havergal, *Fasti*, pl. VII.

pilgrimage site for Bishop Cantilupe's tomb, it would have attracted a good deal of attention.[57] As a metaphor of God's Creation, it did in fact have the potential for religious instruction. However, as Kupfer argues, and I agree, given the secular nature of a map, it is unlikely to have been displayed on an altar. It may have simply been hung on a wall; I believe in the transept where it could be didactically explained or simply open to interpretation by each visitor and pilgrim.[58] The map, although embellished by images of church doctrine, was closely associated with temporal material of such fascination that it very likely became an attraction in itself.[59]

Stylistic evidence corroborates my argument for the map and its framework being of the same date. The date of *ca.* 1300 has already been established on stylistic grounds. The gabled wooden framework has been shown scientifically to date most likely to *ca.* 1300 as well. It should be added that the wooden foliate decoration on the center gable of the triptych is close in shape and concept to the stone gables on the sepulchral monuments of the Swinfield and Charlton families at Hereford Cathedral (Fig. 2.13). In fact, the lushly foliated gable is stylistically similar to numerous gables in a variety of media other than wood (e.g. stone sculpture, stained glass).[60] Panel painting was also ubiquitous,[61] and comparing the style of the painting of the side panels to other works

57 In considering the Hereford map, for instance, it should be noted that in the *Consuetudines* (Constitution) of Hereford Cathedral drawn up *ca.* 1245/6–64, the resident canons were allowed to be absent for sixteen weeks each year (not continuous). For pilgrimages in England a canon was allowed to be absent three weeks per year. Once in his life he could go on a pilgrimage beyond the seas. Seven weeks were allowed for the journey to St Denis in Paris, eight to St Edmund (Rich) at Pontigny, eighteen to Rome or St James of Compostela, and a full year to Jerusalem; see Bannister, *Cathedral Church*, 60.

58 Gautier Dalché has written extensively on the relationship between text and maps (envisioned and actual) as pedagogically interrelated; see Hugh of Saint-Victor, *La 'Descriptio mappa mundi' de Hugues de Saint-Victor*, ed. Patrick Gautier Dalché, Paris, 1988. Kupfer has made important contributions in this discussion as well; see Marcia Kupfer, 'Medieval World Maps: Embedded Images, Interpretive Frames', *Word and Image*, 10, no. 3, 1994, esp. 264–6, 269–70.

59 Other scholars have not specifically argued for the north transept as the location for the map. Bailey argues for the map being placed on an altar of the cathedral. His reasoning is based on the elaborateness of the object and frame. At the Hereford Mappa Mundi Conference, 27 June – 1 July, 1999, Martin Bailey reiterated his position. Anna-Dorothee van den Brincken took a similar position. Her argument was based on the religious aspect of the map as a religious triptych. Working independently, recently Flint has also recognized the possible connection between the map and Bishop Cantilupe; see Flint, 'The Hereford Map', esp. 34–7.

60 Lush floral gables were commonly used in the late thirteenth century. A brief look through the catalog of Alexander and Binski, *The Age of Chivalry*, shows contemporary stone monuments with similar gables, cat. nos. 5, 326. One finds similar gables in painted canopies on contemporary stained glass and manuscript illumination.

61 Although panel paintings were ubiquitous, the Westminster Retable (also known as the Westminster Painted Panel) (1269) is one of the earliest extant English painted wooden altarpieces to which we may compare the Hereford triptych. Tristram has argued that the panel, divided into five sections, was probably not a retable but rather a side of the cover of St Edward's Shrine or Reliquary (*cooperculum*). The central panel depicted Christ as creator holding the terrestrial globe surrounded by the Virgin and St John, and St Peter and St Paul. Tristram notes that fleurs-de-lis and dragons (more accurately, wyverns) on the gable of the central niche have precedents in England; see *Wall Painting: Thirteenth Century*, I: 127–49, esp. 132–3. In a more recent analysis of the panel paintings, Binski has argued that the paintings indeed functioned as a retable on the altar at Westminster; see Paul Binski, 'What was the Westminster Retable?', *Journal of the British Archaeological Association*, 40, 1987, 153–74; Alexander and Binski, *The Age of*

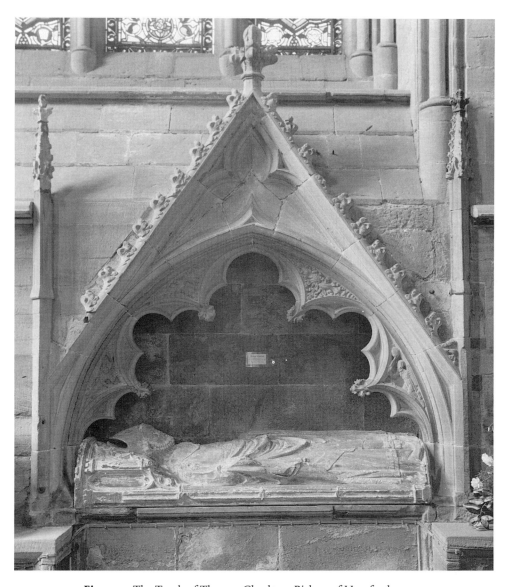

Fig. 2.13 The Tomb of Thomas Charlton, Bishop of Hereford. 1343
By kind permission of The Dean and Chapter of Hereford Cathedral
and the Hereford Mappa Mundi Trust

of art from approximately the same period further fixes the date of the painted panels as contemporary with the map.[62]

However, was it actually used as an altarpiece? I believe that is doubtful. It was clearly a rare object, its painted pictorial frame made its religious meaning clear, and the additional panels of the Annunciation provided it with a specifically altar-like feature. Yet in comparison with actual altarpieces, the map would have been an incongruous object to have been associated with the Mass. The painted side panels were not painted on the exterior to be meditated upon but rather it suggests, when closed, a portable case.[63] But it was not a portable altar; its secular material, its worldly emphasis was not in keeping with orthodox subject matter for altarpieces. In cases where maps were actually found in churches, they were never used as altarpieces. At Leominster, Hereford Cathedral's close neighbor and relative,[64] a wallpainting of a Wheel of

Chivalry, cat. no. 329 (pp. 340–1); Paul Binski, *Westminster Abbey and the Plantagenets*, New Haven, 1995, 152–67.

[62] Comparing the side panels of the Hereford triptych to the Westminster Retable of 1269, there are similarities in poses that suggest the French style 'Honoré' that is a noted feature of the painted figure of St Peter in the Westminster Retable; see Alexander and Binski, *The Age of Chivalry*, 340. A version of the style closer to that of the Hereford panels might be the Newport chest (late thirteenth century), *ibid.*, cat. no. 345 (p. 347). Note that the Newport chest features a depiction of the agonized Christ figure similar to that of Christ at Calvary on the Hereford Map. This characteristic is found in examples of art of *ca.* 1300 and was important to Nigel Morgan in dating the style of the Hereford map to *ca.* 1300 (see n. 8 above). Stylistically one could also argue for the close similarities of the Annunciation figures on the Hereford map to English sculpture of *ca.* 1300–30. In the following comparisons, note the use of lush foliate gables, the agonized Christ figure, the style of the Virgin's headdress and drapery in the Last Judgment (flat folds, and decorated rounded neckline), *ibid.*, cat. nos. 518, 519, 520 (pp. 424–6).

[63] Binski's discussion of the subject matter of retables and portable altars would argue against a map as an appropriate subject for the central image above or in front of an altar upon which the Mass was performed; see Binski, *Westminster Abbey*, 141–75.

[64] Leominster, Herefordshire, a Benedictine priory, cell of Reading Abbey. Leominster Priory was founded as a priory church in 1120. Its façade sculpture dates to *ca.* 1130; see Joe Hillaby and Reg Boulton, *The Sculpture Capitals of Leominster Priory*, Leominster, 1993; Joe Hillaby, 'Leominster and Hereford: The Origins of the Diocese', in *Medieval Art, Architecture and Archaeology at Hereford*, ed. David Whitehead, London, 1995, 1–14. It was originally conceived of as a monastic and parochial church. The presbytery, transepts, and crossing with tower were meant as the monk's church and they were consecrated in 1130. The nave, which was used by the parish, was completed shortly thereafter. A second nave to the south of the original one was built in the early thirteenth century and a large south aisle was added in the fourteenth century. In 1539 the priory was dissolved and the lead was stripped from the monastic church and the conventual buildings were used as a quarry; see Hillaby and Boulton, *Capitals*. Note the sculptured toothed pattern on the abaci of capitals at the west façade entrance of Leominster church. Several have three-lobed foliage within triangles divided by pellets, a pattern found on the border of the Hereford map. The same motif is found throughout the Romanesque fabric of Hereford Cathedral and into the early thirteenth century with the remodeling of the Lady Chapel. According to Thurlby the cathedral was completed and consecrated between 1142 and 1148. Remodeling of the east end was begun under Bishop William de Vere (1186–98) and continued on the Lady Chapel *ca.* 1222–40; see Malcolm Thurlby, 'Hereford Cathedral: The Romanesque Fabric', in *Medieval, Art, Architecture and Archaeology at Hereford*, ed. David Whitehead, London 1995, 15–28. Note the saw-tooth design in windows of the Lady Chapel, Hereford Cathedral; see F. C. Morgan, *Hereford Cathedral Church Glass*, Hereford, 1979, pl. II (begun in 1222). Also note saw-tooth design in the second-level triforium chamber built *ca.* 1245–68 under the direction of Peter de Aquablanca (*ibid.*). Apparently the design was widespread and commonly found in English sculptural decoration.

Fortune was a prominent feature of the original church.[65] As was the case with the painted Wheel of Life at Kempley, no words were required to provide the meaning of the wheel, suggesting its familiarity as a feature of medieval church decoration. Certainly there is enough evidence to indicate that numerous versions of such painted wheels did indeed once adorn churches far and wide.[66] Mappae mundi, although mostly familiar from examples painted on vellum, are also known to have existed as wallpaintings in churches, although only a scant number of such painted examples are recorded.[67] Unquestionably the maps had an equally wide circulation in the secular world, and to fulfill a role within a church the Christian pictorial frames were particularly apt. However, there is no indication of them ever being used as altarpieces. I believe that the ensemble was installed in the chapel of Bishop Cantilupe but it did not serve as an altar.

Apparently wall-hanging maps were comparable to wallpaintings and they hung or were painted on walls of the secular as well as the religious realm. As to the secular realm, it is of note that the map and the wheel were exceptionally popular in England, and were known to have been commissioned by a number of English kings,[68] especially Henry III (1216–72), most notably at Westminster Palace and at Winchester and Clarendon Castles.[69] We know that a mappa mundi (believed to have been copied by Matthew Paris in his ordinal)[70] existed in 1230 at Westminster Palace in the king's Chamber known as the Painted Chamber. However, it may have been painted earlier, before Henry III's accession to the throne.[71] In any case, in 1239 another painted

[65] The surviving north aisle and northern nave are Norman. The painting of the Wheel of Fortune is located in the western bay of the north aisle on the north wall. It is approximately seven feet in diameter, and encloses ten small circles connected by spokes to the center which holds a head of Christ. The remains of the inscriptions and of the images indicate the Ages of Man; Tristram dates them to *ca.* 1275. For further description and bibliography, see Tristram, *Wall Painting: Thirteenth Century*, I: 558. It has been suggested that the Wheel of Fortune is modeled after the Arundel Psalter (recall Chapter 1, fig. 22).

[66] Tristram lists the following English thirteenth-century wall paintings of the Wheel of Fortune: Clarendon Palace (destroyed); Kemsing, Kent (?); Rochester Cathedral; Winchester Castle (destroyed). Wheel of Life: ?St Albans Abbey; Kempley, Gloucestershire, Kemsing, Kent (?); Leominster; see Tristram, *Wall Painting: Thirteenth Century*, I: 477. For further discussion of the Wheel of Fortune at Rochester Cathedral, see Tancred Borenius and E. W. Tristram, *English Medieval Painting*, Paris, 1927, pls. 38, 39. Note the reference to the map at Waltham Abbey, see Tristram, *Wall Painting: Thirteenth Century*, I: 180.

[67] For a twelfth-century example in France, see Marcia Kupfer, 'The Lost *Mappamundi* at Chalivoy-Milon', *Speculum*, 66, 1991, 540–71.

[68] Accounts show that English kings were interested in maps; in 1299–1300 we know of 'a piece of cloth with the form of the Map of the World' in the possession of Edward I. Such maps existed in Waltham Abbey and in Westminster Palace in the fourteenth century; see Tristram, *Wall Painting: Thirteenth Century*, I, esp. 180, n. 3.

[69] Tancred Borenius, 'The Cycle of Images in the Palaces and Castles of Henry III', *Journal of the Warburg and Courtauld Institutes*, 6, 1943, 40–50; note esp. the list of all the wallpaintings by building and room, 47–50; Tristram, *Wall Painting: Thirteenth Century*, I: 178–87; W. R. Lethaby, 'English Primitives: The Painted Chamber and the Early Masters of the Westminster School', *Burlington Magazine*, 7, 1905, 257–69; W. R. Lethaby, 'English Primitives – VIII', *Burlington Magazine*, 33, 1918, 3–8.

[70] The reference occurs in London, BL, MS Cotton Nero D.V. f. 1v.

[71] According to Binski, a date in or before 1230 cannot be ruled out. A reference to the *magna historia* was made in 1237. The *magna historia* may have been a narrative cycle or it may simply have been a reference to the mappa mundi. No evidence indicates that it was commissioned by Henry in 1230, but rather it

mappa mundi was certainly delineated specifically for Henry III's Great Hall at Winchester Castle.[72] Interestingly in this instance where we are assured of Henry III's patronage, the image was placed not in the King's Chamber but in the Great Hall, a more public room than the Painted Chamber which was essentially the King's Chamber, its decorative scheme a personalized statement regarding kingship.[73] At Winchester a painting of a Wheel of Fortune had already been commissioned for the Great Hall in 1236.[74] It should be added that another theme of wallpainting that will prove relevant to our maps later is the story of Alexander.[75]

The maps may be considered world histories filled with lore in which chance and fortune are confined to God's plan of Creation. Their relationship to other *rotae* such as the Wheel of Life and the Wheel of Fortune are intertwined as memory wheels of human existence. Their relationship to *rotae* and computistical treatises is rather more associational insofar as the maps' circular forms are part of the way the medieval world envisioned Christian cosmology.

Clearly the Hereford map was one of many such examples. It deserves our closest attention because it is the most complete and best-preserved example of a large-sized medieval mappa mundi painted on parchment from the Gothic period. Beyond that, it

appears to have been part of the conservation of an earlier set of wallpaintings; see Paul Binski, *The Painted Chamber at Westminster*, London, 1986, 44. Pamela Tudor-Craig dates the repainting of chamber following a fire in 1262 to 1262–5 with emendations and additions 1265–72; see Pamela Tudor-Craig, 'The Painted Chamber at Westminster', *The Archaeological Journal*, 114, 1957, esp. 93, 100–3.

72 *Calendar of Liberate Rolls: Henry III*, Public Record Office, Texts and Calendars, 6 vols., London, 1916–63, (hereafter referred to as *CLR*); *CLR*, I, 1239, 405. In 1247 Henry III also commissioned a painted Tree of Jesse alongside a Wheel of Fortune for the mantel of the fireplace in the King's Chamber at Clarendon (*CLR*, III, 1247, 157); see Borenius, 'Cycle of Images', 42–4. Matthew Paris refers to the world map at Westminster Palace and the one at Winchester; see *Chronica Maiora*, Part I, no. 88, MS 26 f.vii verso (Morgan, *Early Gothic Manuscripts*, 4/2, 84).

73 Binski suggests that the iconographic scheme of the Painted Chamber as it was completed under Henry III's auspices provides a personalized statement regarding kingship. Binski suggests that the room underscores the wise and virtuous ruler using Edward the Confessor and Solomonic allusions to Henry III's reign; see Binski, *Painted Chamber*, 44–5.

74 Extensive architectural and masonry work was carried out on the Great Hall ca. 1233 and completed by 1236. Records of 1236 indicate gilding on capitals and a painting of a Wheel of Fortune in the eastern gable over the dais. The paintings in the Great Hall, including the later mappa mundi, were probably completed by 1240 because records show that later entries refer to renovations. At Winchester, in the queen's chamber an image of a city was also known to have been commissioned (*CLR*, III, 1246, 30); see Binski, *Painted Chamber*, 44. For the suggestion that the heightened interest in maps and cityscapes may have been triggered by Matthew Paris's itineraries, see Binski, *Painted Chamber*, 44, n. 80; *The Illustrated Chronicles of Matthew Paris*, ed. and trans. Richard Vaughan, Gloucestershire, 1993, 242 ff. Tristram suggests Henry III's choice of the Wheel of Fortune related to his belief in the importance of charity; see E. W. Tristram, *The Burlington Magazine*, 83, 1943, 161.

75 An Alexander cycle existed at Clarendon and is mentioned in records from 1237 onwards (*CLR*, I, 1237, 304); T. Hudson Turner, *Some Account of Domestic Architecture in England*, Oxford, 1851, 187. Also see Borenius, 'Cycle of Images', 44, n. 12. Another Alexander cycle is known to have been commissioned by Henry III in 1252 for the Queen's Chamber at Nottingham; see Turner, *Some Account*, 236; Borenius, 'Cycle of Images', 44, n. 13. Also note the existence of three 'Antioch Chambers' with relevance to the crusades; see Borenius, 'Cycle of Images', 45. For more on Antioch Chambers and references to the crusades and Matthew Paris, see Tristram, *Wall Painting: Thirteenth Century*, I: 184.

is particularly significant because it is a vessel of secular information yet it clearly also functioned as an object for religious contemplation. Its painted pictorial frame provided the medieval viewer with a gloss to the map's meaning and helped toward spiritual understanding.

3

THE MEDIEVAL AUDIENCE

The Reading Audience

OUR INTEREST IN the experiential dimension of the Hereford map also engages us in questions regarding readership such as: for whom were the texts intended, and how were texts that accompanied images read and understood? Because the map employs both Anglo-Norman and Latin, we know that it was not exclusively intended for a monastic audience.[1] More likely it was intended for a readership of clerics or educated lay persons, since both groups were, to some extent, conversant in French and Latin. Because schoolmen and secular clerics were responsible for introducing a number of vernacular texts, the Anglo-Norman texts on the pictorial frame reinforce the possibility of a clerical commission but do not limit the audience to clerics.[2]

Parkes suggests that in England around the year 1300 there were, broadly speaking, three types of readers: 1. professional readers, generally members of the holy orders; 2. cultivated readers, primarily concerned with what he refers to as 'literacy of recreation'; 3. pragmatic readers, who were required to read or write in the course of transacting business.[3] All of these groups were familiar with both Latin and French and could, to a varying degree, have read the texts on the Hereford map. However, the popular nature of the subject matter, use of the vernacular, and short simplified Latin texts suggest a work not specifically meant for professional readers but rather a work that might be read and understood by the entire range of educated persons. If the cleric Richard of Haldingham commissioned the map it would appear that it was with the intention of sharing it with a more general readership – perhaps a combination of educated clerics, 'litterati' (clergy with some Latin training), and educated lay persons.[4]

An educated layperson in 1300 was probably familiar with some writing in Latin and French.[5] Because French was the language of the king's court, and was in common use as a written language, ambitious men and women in England, like the cleric Richard of Haldingham, required an accurate knowledge of it both written and

1 Clanchy, *Memory to Written Record*, 167–8.
2 Clanchy, *Memory to Written Record*, 87.
3 Parkes, *Scribes, Scripts*, 275–84; Clanchy, *Memory to Written Record*, 170.
4 Those outside the 'clergie' were 'laymen'. For discussion of *clericus* versus *litteratus*, see Clanchy, *Memory to Written Record*, 177–81. *Clericus* was in common discourse a person of some scholarly attainments – not necessarily a 'cleric' or a 'clerk'. The term *litteratus* was somewhat interchangeable with *clericus*; see Clanchy, *Memory to Written Record*, 179.
5 Given the proliferation of these languages in England from 1066 onward, lay people became familiar with a variety of documents which led to a 'gradual extension of literate modes to more people and diverse activities'; see Clanchy, *Memory to Written Record*, 86–7. However, Latin was the language of manorial records (accounts, surveys, court rolls) on all estates at this period, a point for which I thank P. D. A. Harvey.

spoken.[6] As Clanchy points out, those who read or wrote had to master a variety of languages as required.[7] This suggests that there was a broad group of lay people who, to varying degrees, could have deciphered the texts on the Hereford map. On the other hand, all classes did not know French; French did not become the mother tongue to the general public after the Norman Conquest. French was the language of the rulers, and of the educated laity.[8] Latin was the language of clerics.

The Non-Reading Audience

Thus, even though the texts on the Hereford map are relatively simple, only a very small portion of the population would have been able to read them discerningly. If the map was meant to be exhibited in a prominent location for many to see, how could the general viewer with little or no education 'read' it? Recent scholarship emphasizes the importance of hearing the written word spoken out loud as a key to learning in the Middle Ages. For example, to be 'litteratus', the circumstance of many lay brothers, meant having some knowledge of Latin but not necessarily the ability to read and write Latin; they learned by the experience of having Latin texts read to them by their more educated brethren. Even the educated prefered listening to reading.[9] In the Middle Ages, to varying degrees, hearing was an important method of mediating the visual languages of texts and images to all people, from the highly educated to those without learning. For a broad spectrum of listeners – both literate and non-literate – living in an age steeped in orality, the texts of the Hereford map were undoubtedly read, or trans-

6 By the time of Edward I even though English was the spoken language, French appeared to be replacing Latin as most common written language; see Clanchy, *Memory to Written Record*, 153–4. According to Clanchy, it was not the Norman Conquest but the emergence in the mid-twelfth century of French as the international literary and cultural language that provided impetus for French to be used in England more commonly for documents, etc. By the 1170s French had the status of the literary language for jongleurs, whereas Latin continued to be used for documents meant for posterity; see Clanchy, *Memory to Written Record*, 168–9.
7 Clanchy, *Memory to Written Record*, 174.
8 Clanchy, *Memory to Written Record*, 157. For instance, in England, by *ca.* 1250 Walter of Bibbesworth took for granted that the gentry had some knowledge of 'clergie' (reading knowledge of Latin) and French. The existence of Anglo-Norman features in the language of Walter of Bibbesworth and other English writers of French did not imply that they thought their French different from the French of France. For Walter and his audience, English was assumed to be the mother tongue but there was need to know good French also because it was the language of the gentry and the king's court. Walter of Bibbesworth and Walter of Henley were typical of educated English gentlemen who acted as stewards and managers for royal and baronial enterprises. French was language of management and lordship and they were familiar with Latin because it was the language of schoolmen and of older branches of the royal administration; see Clanchy, *Memory to Written Record*, 113, 151–4.
9 Literacy needed to be preceded by a 'literate mentality' (literate habits and assumptions) 'to take root in diverse social groups and areas of activity before literacy could grow or spread beyond a small class of clerical writers'; see Clanchy, *Memory to Written Record*, 149–50. Stock has argued that in the Middle Ages, there was a lingering distrust of the written word as opposed to spoken word; see Brian Stock, *The Implications of Literacy: Written Language and Models of Interpretation in the Eleventh and Twelfth Centuries*, Princeton, 1983.

lated, aloud.[10] Finally, in circumstances when the written word was simply not made accessible, the sheer exuberance of the visual material on the map marked it as a remarkable object worthy of fascinated attention. The additional fact that there are numerous scribal errors on the Hereford map (including the outstanding error of misnaming the continents) reinforces a theory that the images were more accessible, and thus more important, than the texts to most viewers.

Literacy and Memory

Recalling Aristotle's words 'the soul never thinks without a mental picture',[11] the Hereford map would, depending upon the education and background of the viewer, have been digested and studied, and meanings abstracted in a variety of ways. In clerical circles amongst those who were capable of reading and understanding the Latin, references to Megasthenes, Pliny, Isidore, and others would have reinforced the authority of the production. Many of the texts on the Hereford map are based upon Isidore of Seville's *Etymologiae*, in which the name of the item represented is introduced by its etymological origin. One should keep in mind that the earliest form of memory device based on etymologies, wherein one superimposes what is heard upon what is already known in order to facilitate memorization, dates back as far as 400 BC.[12]

Dislocating Texts

Much has been written regarding the ways of experiencing texts during the Middle Ages. Ivan Illich describes the monastic experience in which the text is physically expe-

10 There exists evidence of texts that relate closely to medieval works of art. They are conjectured to have been used as teaching devices in relationship to the artworks. For instance on the relationship of a manuscript with the texts from twelfth-century windows at Canterbury, see Montague Rhodes James, 'The Verses Formerly Inscribed on Twelve Windows in the Choir of Canterbury Cathedral' (Cambridge Antiquarian Society, Octavo 38), Cambridge, 1901; also see Madeline Harrison Caviness, *The Early Stained Glass of Canterbury Cathedral, circa 1175–1220*, Princeton, 1977, 115–16; Madeline Harrison Caviness, *The Windows of Christ Church Cathedral, Canterbury* (Corpus Vitrearum Medii Aevi Great Britain, 2), London, 1981, 77, 79. Another example is *Pictor in carmine*; see Montague Rhodes James, 'Pictor in Carmine', *Archaeologia*, 94, 1951, 141–66. Smith suggests the possibility of written keys to maps without explanatory writing for use in oral explication; see Catherine Delano Smith, 'Cartographic Signs on European Maps and their Explanations before 1700', *Imago Mundi*, 37, 1985, 9–29, esp. 10–11. Recently scholars have cited a number of possible correspondences between mappa mundi and specific texts possibly used in conjunction with the maps, e.g. Gervase of Tilbury's *Otia imperialia* and the Ebstorf map, Peter Comestor's *Historia scholastica* and the Duchy of Cornwall map, Orosius' *Historia adversus paganos* and the Hereford map; for summary see Peter Barber, 'The Evesham World Map: A Late Medieval English View of God and the World', *Imago Mundi*, 47, 1995, 13–33, esp. n. 73 (p. 32).

11 Cf. the citation in the Introduction.

12 Yates refers to the fragment known as the *Dialexeis* which contains a section on memory that suggests relating words to images, thus combining memory for things and memory for words by placing the word or notion to be remembered onto the image; see Yates, *Art of Memory*, 29.

rienced through the mouth and body in the process of reading toward wisdom.[13] At the beginning of the thirteenth century, however, nourishing pious reading or *lectio spiritualis*, largely the province of the monastery, was superseded by the requirements of the university which aimed at increasing factual knowledge. The sacred book, to be physically and spiritually 'digested', was replaced by texts that were tabulated, organized, and experienced as texts apart from their connection to the sacred objecthood of the book so that prayer and study were separated.[14] In that context, the presentation of the massive number of factual texts on the Hereford map was consistent with the 'epoch of the university' (although in this instance not connected to a particular university) wherein the desire to increase factual knowledge represented a 'determinant of a new world view'.[15] This being the case, the heavily pictorialized and textualized mappa mundi may be considered a graphic exemplar of their time, wherein texts and images were plucked and detached from the original intent of their many sources and reconfigured as didactic elements in a new cosmological system. But how could such a visual encyclopedia of images and disparate facts be experienced and synthesized by the viewer?

Whereas language is linear and discursive, a picture is based on a non-discursive structure; it is an artificial representation of reality, which requires a consistent vocabulary for conceptualizing. The texts and images within the pictorial frame were part of the larger cosmological construct – frame, circle, map. Because many of the non-geographical images and texts (e.g. strange races, animals, etc.) are taken out of their narrative contexts, the synapse between their original context and their new role within the geography is strained. This taxes the viewer's ability to make connections between what is seen and what is known. The viewer is forced to provide a narrative structure in order to link diverse pictures, to make connections where no connections are apparent, to create dramatic incident where few emotive clues are provided: in short, to use the map as a vehicle for imaginative comprehension.

There is a clash between the expectancy of structure of the *rota* and the incoherence of the information presented. The circular perimeter acts as a window into a representation of the world in which space is apportioned by geography and time has no chronological separators. The maps obviously elicited visions of distant travel, but they also provided a field for imaginative rumination about creation and history whose narrative depended upon the viewer's personal invention that occurs between the boundaries of images and words.

[13] Exemplified in the writings of Hugh of St Victor; see Ivan Illich, *In the Vineyard of the Text: A Commentary To Hugh's 'Didascalicon'*, Chicago, 1993, 51–7.

[14] Illich describes this change as evidenced in comparing the theories on reading of Hugh of St Victor's to those of his contemporary William of St Thierry; see Illich, *Vineyard*, 64–5.

[15] According to Illich, the uprooting of texts coincident with the detachment of the letter from its historic dependence on Latin inaugurated this new era; see Illich, *Vineyard*, 115–19.

Ideology and Context

The role of the outer pictorial frame and the perimeter of winds were to provide a cosmological work that suggested levels of meaning and interpretation for the confusing array of images of the map's interior. From the viewer's Christian vantagepoint, literal, symbolic, and contextual interpretations helped bring order to his or her understanding of the map as a blueprint of earthly time and space. As we move into the various areas of information that are transmitted on the map, it is important to keep in mind the concept of 'memory theater', wherein the structure of the work of art provides a particular stage from which the images are presented and interpretation suits personal experience. As we move to the next sections in which individual themes will be considered – animals, strange races, legends and history – we will note how the viewer's familiarity with sources, both textual and artistic, may color meanings and how memory arouses expectations and influences responses.[16] Aristotle's statement that 'the thinking faculty thinks of its forms in mental pictures' is of relevance here. Aristotle recognized that thinking required the deliberate process of conjuring mental images similar to that required by individuals inventing mnemonics or constructing images.[17] The factual information regarding the physical world here contained and integrated within the Christian framework of Creation, Judgment, and Redemption was respected accordingly. In the Middle Ages meaningful material was often committed to memory. In fact, in memory treatises, the subject of heaven and hell were given special prominence, themes most prominent on the Hereford map.

A significant question remains. How did the viewer, who may have been more dependent upon images than words, bring meaning to this admixture of material featured? In her discussion of the growing reliance upon devotional manuals for the laity, Rubin provides the following quotation that to my mind is relevant to our reading of the Hereford mappa mundi.

> The aim of manuals for the laity, as of all instruction, was to build a horizon of images, a vocabulary of associations, which would conjure each other, a train of symbols which followed from recurrent visual stimuli created by ritual or by private reading. Most people did not use manuals and prayer books, and even had they done, a large area of *Rezeption* was bound to be undetermined, open to fantasy, imagination, extrapolation, creating new and reproducing old interpretations. Teaching, none the less, attempted to antici-

[16] I am indebted to Susan Ward for introducing me to this line of inquiry. Consider for instance the difference between looking at a bestiary manuscript and a map upon which animals taken from a bestiary are scattered throughout. In such a case, the composition may signify a change in meaning so that the animal on the map may be primarily associated with geographical place but continues to carry its bestiary message as part of 'memory theater'. Similarly, certain shapes, based upon stored memory, may arouse certain expectations of the viewer, e.g. as shown in Chapter 2, the shape of the top of the Hereford map's pictorial frame is reminiscent of a chancel arch or tympanum and thus triggers related associations.

[17] Yates, *Art of Memory*, 32–3.

pate and to create *clusters* of images which would come to mind through habit and repetition, and supported by an internal logic.[18]

The Hereford map had 'wall power'. It was an elaborate object that would have held the attention of viewers from all walks of life who came with varying levels of knowledge and reading skill. The map's significance was dependent upon how the viewer was able to deconstruct its meaning. In the context of an object of veneration possibly installed in an area that was meant specifically for pilgrims, the map's geographical and secular material would not have been considered out of character in a cathedral setting. If indeed it was installed in the chapel that contained the tomb of Bishop Cantilupe, as is argued in Chapter 7, it is also likely that there would have been a cleric on hand to help visitors decipher the map in keeping with its significance within the Cathedral.

Part III: The Hereford Map and Its Worlds, follows. The chapters are devoted to a close study of the material within the circle of the world. In its prodigious detail, the Hereford map provides a massive source of information regarding the medieval world and the medieval viewer.

[18] Miri Rubin, *Corpus Christi: The Eucharist in Late Medieval Culture*, Cambridge, 1991, 105.

Part III

The Hereford Map and Its Worlds

4

THE WORLD OF ANIMALS

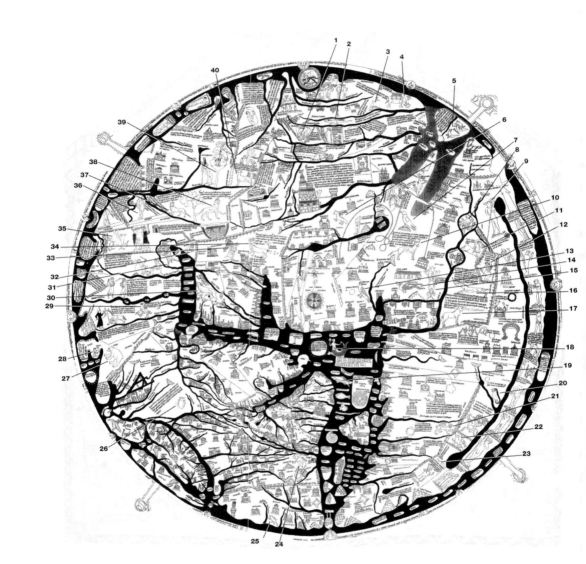

'ANIMALS' (clockwise)

* Bestiary 'Animals'
† Mythical 'Animals' (non-bestiary)
‡ Other

1* **Aualerion** (Alerion): Inscription: *Au[is]alerion · par in mundo ·* (Alerion. There is one pair in the world.)

2* **Lacertus** (Lizard): Inscription: *Lacertus ·* (Lizard.)

3* **Spitacum** (Parrot): Inscription: *Solinus · yndia mittit auem spitacum [=psittacum] · colore uiridi · torque puniceo ·* (Solinus. India produces the parrot, a green bird with a purple collar.)

4* **Elephantes** (Elephants): Inscription: *Yndia mittit eciam elephantes maximos · quorum dentes ebur esse creditur · quibus yndei turribus in positis in bellis utuntur ·* (India also sends out the biggest elephants, whose teeth are believed to be ivory and which the Indians make use of in war by putting turrets on them.)

5* **Dracones** (Dragons): Inscription: *Dracones ·* (Dragons.)

6‡ **Marsok** (Marsok): Inscription: *· Marsok bestia · transmutata ·* (The Marsok, a transforming beast.)

7* **Phenix** (Phoenix): Inscription: *Phenix auis · Hec quingetis [quingentis] uiuit annis · est autem unica auis in orbe ·* (The phoenix bird lives for 500 years and is the only one of its kind in the world.)

8* **Cocadrillus** (Crocodile): Inscription: *Cocadrillus* (Crocodile.)

9* **Satirii** (Satyrs): Inscription (partially unreadable): *Satirii ·* (Satyrs.)

10* **Eale** (Yale): Inscription: *Solinus · Eale nascitur in yndia · equino corpore · cauda elephanti · nigro colore · maxillis caprinis · preferens cornua ultra cubitalem longa · neque enim rigent · sed mouentur · ut usus exigit preliandi · quorum cum uno pungnat · alter replicat ·* (Solinus. The eale is born in India, with a horses body, an elephant's tail, black in color, with a goat's jaws, bearing horns more than a cubit in length; they are not stiff, but move as use in fighting demands; it fights with one, and folds the other back.)

11† **Fauni** (Centaurs): Inscription: *Fauni · semi caballi homines ·* (Centaurs are half horse, half human.)

12† **Sphinx** (Sphinx): Inscription: *spinx auis est penna · serpens pede · fronte puella ·* (The Sphinx, feathers like a bird, legs like snakes, the face of a girl.)

13‡ **Cirenus** (Cirenus): Inscription: *Auis cirenus ·* (Cirenus Bird.)

14* **Salamandra** (Salamander): Inscription: *Salamandra · dracona uenenosa ·* (Salamander, a poisonous snake.)

15* **Mandragora** (Mandrake): Inscription: *Mandragora erba mirabiliter uirtuosa* (Mandrake, a wonderfully powerful plant.) The mandrake, although a plant, is described in the bestiary.

16* **Rinosceros** (Rhinoceros): Inscription: *Solinus · In yndia nascitur Rinosceros cui color buxeus · in naribus cornu unum mucronem excitat · que aduersus elephantes preliatur · par ipsis in longitudine · sed breuior cruribus · naturaliter aluum petens · quam solam intelligit ictibus peruia ·* (Solinus. The Rhinoceros is born in India. Its color is that of the boxwood tree. On its nose is a single horn which it thrusts upward like a sword point when fighting against elephants. Because it is the same length but has shorter legs it naturally attacks the whites of the eyes which it knows are the only things vulnerable to its blows.)

17* **Monoceroti** (Unicorn): Inscription: *Ysidorus in libro · XII · ethimologiarum capitulo · ii · Sicut asserunt qui naturas animalium scripserunt · Huic monoceroti virgo puella proponitur: que uenienti: sinum aperit · in quo ille omni ferocitate deposita · capud [=caput] ponit · sic que soporatus · uelud [=uelut] inermis capitur ·* (Isidore in book XII of the Etymologiae, chapter ii. Just as they have affirmed who have recorded the characters of animals: before this unicorn is set a virgin girl, who opens her lap to it as it approaches, on which, with all ferocity laid aside, he puts his head, and thus made sleepy is taken as if harmless.)

18† **Mermaid** (Mermaid): No inscription

19* **Miles Maris** (Sea Soldier): Inscription: *miles · maris ·* (Sea Soldier.) The image appears as a 'sword' fish. The swordfish appears in the bestiary.

20* **Basiliscus** (Basilisk): Inscription: *Basiliscus · semipedalis · est albis lineis maculatus ·* (The Basilisk is half-footed and marked with white stripes.)

21* **Leopard** (Leopard): Inscription: *Leopard ·* (Leopard.)

22* **Leo** (Lion): Inscription: *Leo ·* (Lion.)

23* **Formice** (Ants): Inscription: *Hic grandes formice[s] · auream sericam [=seruant] arenas ·* (Here giant ants guard sands of gold.)

24* **Buglossa** (Buffalo): Inscription: *Buglossa ·* (Buglossa (Ox-tongue).)

25‡ **Geneis** (Genet): Inscription: *Geneis ·* (Genet.)

26* **Scorpio** (Scorpion): Inscription: *Scorpio ·* (Scorpion.)

27* **Ursus** (Bear): Inscription: *Vrsus ·* (Bear.)

28* **Simia** (Ape): Inscription: *Simea ·* (Ape.)

29* **Ostricius** (Ostrich): Inscription: *Ostricius · capud auce corpus gruis · pedes uituli · ferrum comedit ·* (The Ostrich has a head like a goose, a body like a crane, and feet like a calf. It eats iron.)

30* **Linx** (Lynx): Inscription: *Linx uidet per muros · et mingit lapidem nigrum ·* (The Lynx sees through walls and pisses black stone.)

31† **Velus aureum** (Golden Fleece): Inscription: *velus aureum · propter quod iason · a pelo [=Pelia] rege · missus est ·* (The Golden Fleece for which Jason was sent by king Pelias.)

32* **Pines** (Pines): Inscription: *Pines ·* (Pines (Pica?).)

33‡ **Tigolopes** (Tigolopes): Inscription: *Tigolopes ·* (Tigolopes.)

34* **Bonnacon** (Bonnacon): Inscription: *In frigia nascitur animal qui dicitur bonnacon · capud taurinum · iuba equina, · cornua multiplici flexu · profluuio citi uentris fimum egerit · per longitudinem trium iugerum · cuius ardor quicquit [=quidquid] attigerit: adurit ·* (In Phrygia there is born an animal called bonnacon; it has a bull's head, horse's mane and curling horns; with a discharge from its swift gut it emits dung over an extent of three acres which burns whatever it touches.)

35* **Griphes** (Griffins): Inscription: *Griphes capitibus et alis aquileas · corpore leones imitantur uolando · bouem portabunt ·* (Griffins, their heads and wings are like those of eagles, their bodies like lions', they can carry an ox as they fly.)

36† **Minotauri** (Minotaurs): Inscription: *Hic inueni[untur] bestie minotauri similes · ad bella utiles ·* (Here are found beasts similar to Minotaurs useful for war.)

37* **Tigris** (Tiger): Inscription: *Tigris bestia · cum catulum suum captum percipit · concito cursu persequitur cum catulo fugientem · at ille velocis equi cursu in fugam properans speculum ei proicit · et sic liber euadit ·* (A tiger, when it sees its cub stolen chases the one fleeing with its cub at a swift pace. But he, hastening into flight with the speed of a fast horse, throws down a mirror at it and thus escapes unhampered.)

38* **Manticora** (Manticore): Inscription: *Solinus · manticora nascitur in yndia · triplici dencium ordine facie hominis · glaucis oculis · sanguineo colore · corpore leonino · cauda scorpionis voce sibilla ·* (Solinus. The manticore is born in India, with a threefold series of teeth, the face of a man, gray eyes, bloody in color, with a lion's body, the tail of a scorpion, and a whistling voice.)

39* **Pelicanus** (Pelican): Inscription: *Pellicanus · dicor pro pullis scindo michi · cor ·* (I am called Pelican; for my young I rend my heart.)

40* **Camelos** (Camel): Inscription: *Bactria camelos habet fortissimos · nunquam pedes atterentes ·* (Bactria has the strongest camels whose hooves never wear out.)

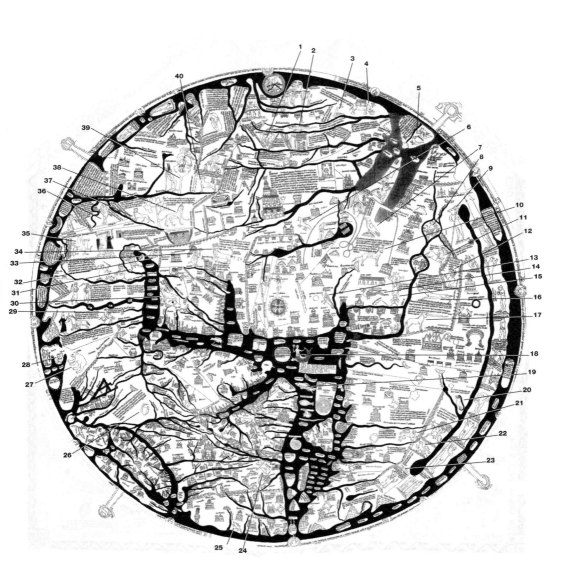

EXPERIENTIAL MEMORY IN its many manifestations is our subject. Because animal imagery was such an inextricable component of medieval art, testimony to God's wealth of creation, it held particular fascination and evocative power. For the medieval viewer, the Hereford map, upon which animals were sprinkled like confetti throughout the world, provided a veritable zoological park for the eyes. In an earlier chapter I suggested that the medieval viewer experienced the map's component parts in a way parallel to the experience of moving through a church where one registers images in a telescopic way. In this chapter and those following, we shall see that the various images within the map do not follow an organized pattern. Although most of the images have counterparts in other visual arts, especially manuscripts, on the map they are scattered like buckshot. There is no single model to point to that can account for the style or choice of imagery on the map itself. It is a creative conflation of information and imagery from a myriad of sources, textual and visual; in the case of animals scattered chaotically over distant lands, it was associative memory that enabled the viewer to make interpretative connections that gave the disjointed elements cohesiveness. The framing device of the Hereford map imposed cohesion and meaning to the images within. The circular perimeter of the map was the link to cosmological diagrams, and by extension, it reminded the viewer of God as 'architect' and the circle of creation.[1] Once within the circular world, it was up to the viewer to find meaning based on personal knowledge and associations.

In the Middle Ages, animals in art were everywhere. Romanesque sculpture abounded with composite beasts staring down from capitals and corbels, contorted and fabulous, often restrained only by artistic imagination (Fig. 4.1).[2] On the Hereford map, the animals, as distant relatives to bestiaries and model books, were akin in spirit to Romanesque art insofar as here also the strange, unique, and fabulous were given prominence. The difference was that on the map the animals were contained within a framework that provided a visual metaphor of the artistry of God's creation; and the circle imposed order upon the boundless creativity and centrifugal imaginative energy that the animals unleashed.

Let us begin by considering the sources of animal lore available to the medieval mapmaker and how sources were consolidated in order to fit the conceptual model of a map. A close look at the animals and accompanying texts on the Hereford map suggests a confluence and overlay of two traditions: (1) the classical, underscored by the many texts based on Pliny and Solinus; and (2) the Christian, popularized by the

[1] For a list of images that include God with compass, see Friedman, 'Architect's Compass', esp. 420, n. 2.

[2] Close to Hereford Cathedral, one notes Romanesque sculptural capitals from Leominster, dating from *ca.* 1130; see Hillaby and Boulton, *Sculpture Capitals*; also see Chapter 2, n. 64.

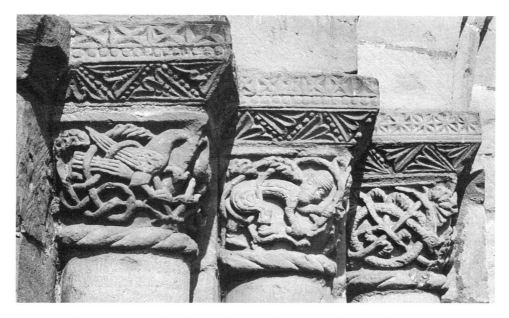

Fig. 4.1 Exterior West Façade Sculpture. Leominster Priory. 12th century.
Author's photograph

Bestiary, a collection of antique animal lore that was transformed into a Christian moralizing handbook.

The classical context, as we have seen, was introduced in the pictorial frame, where references to Orosius, Caesar Augustus, and by extension 'Agrippa's map', gave ancient authority and credibility to the map. And although for the animals Solinus is the most quoted source, it is likely that viewers infused their interpretations of what they saw, both real and fantastic, with what they knew from bestiary lore. It is important to realize that by the Middle Ages much of animal lore had been popularized in bestiaries that amplified classical descriptions of animals with moralizing Christian interpretations. Many of the animals represented on the map were included in the bestiaries, which by the late thirteenth century were transmitted in a great variety of ways to a broad audience. Whether stated or not, bestiary lore overlaid the textual, or more likely, the visual readings of the map.

For mapmaking, this reconciliation of natural histories from antiquity with Christian theology and bestiary lore was an awkward process. For the classical authors, the animals primarily belonged to the realm of 'place'. On the Hereford map, however, the selected animals, although generally situated in their supposed indigenous locations, were especially concentrated in 'places' exotic and distant from England and the European world. Although animal descriptions were precisely based on authoritative Latin texts that implied factuality and lent credence to their existence, their oddities were underscored making them particularly difficult to reconcile with biblical accounts of the Creation. In effect, the fascination of the distant, strange, and unknown vied with the need to reconcile such foreign beasts with Christian theology. To some extent, the

Bestiary, which combined the folkloric with the theological, provided the bridge. Thus, although the map did not substantially depend upon the Bestiary's texts, its imagery and choice of subject matter was understood as closely allied to the medieval Bestiary. For the Hereford map, the theme of Creation, a subtext of the Bestiary, provided the metaphorical circular container for this conflation of pagan and Christian sources and underscored the sanctity of items included in the map.

Because of the availability of numerous artistic and textual sources, combined with the rise of workshop practices that allowed for appropriations and exchanges through the use of models and the making of copies, the map became an artistic surface for experimentation. Texts of the ancients were retained but the imagery and popular lore of Christian bestiaries was the contemporary intellectual filter.

If we consider the image and accompanying text for the map's elephant as a prototypical comparison to its Bestiary parallel, divergent intentions are clear.[3] Although bestiaries may have provided the model for the image, the text accompanying the map is grounded in the classical rather than the Christian world.[4] I believe that for the medieval viewer however, the medieval associations of image took precedence over the classical texts. Bestiary accounts of the elephant are closely associated with the Genesis account of the Fall. According to the Bestiary, the elephant is introduced as chaste, reluctant to mate; when offspring are desired, the elephant goes to the east near Paradise, where first the female then the male eat from the mandrake tree found only in Paradise. Immediately afterward, the female conceives, whereupon at the time of birth she enters a pool in order to avoid being devoured by the dragon. In the Bestiary's convoluted allegorical readings, the elephants are interpreted as symbols for Adam and Eve, their tasting of forbidden fruit, and their expulsion from Paradise.[5]

On the map, these aspects of the elephant are overlooked entirely, giving only a description of the elephant's teeth and wooden tower.[6] Although the elephant is placed in India in proximity to Paradise, it faces the opposite direction. And although a mandrake plant is included in the map, it is distantly situated from the elephant and the Garden of Eden. On the map the mandrake is simply described as a potent plant, most recognized for its medicinal properties.[7] No linkage to the allegorical underpinnings of relationships between these images can be detected; rather it is their paradox-

3 Hereford text: *Yndia mittit etiam elephantes maximos. quorum dentes ebur esse creditur. quibus yndei turribus impositis in bellis utuntur* ('India produces also the largest elephants, whose teeth, it is believed, are ivory; the Indians place towers on them and use them in war').

4 As George notes and research corroborates, accounts are largely taken from Herodotus to Pliny, Aelian and Isidore of Seville with special attention, often explicit, to Solinus; see Wilma George, *Animals and Maps*, Berkeley, 1969, 35.

5 Florence McCulloch, *Medieval Latin and French Bestiaries*, Chapel Hill, 1962, 115–19; Malcolm Letts, *The Pictures in the Hereford Mappa Mundi*, Hereford, 1975 (7th edition), 35. Also see Xenia Muratova, *Le Bestiaire*, Paris, 1988.

6 According to McCulloch the text for elephants is often one of longest of the Bestiary. In the Bestiary, mention is made of his teeth of ivory in B-Is (see n. 44 below on the classification of bestiaries into types); see McCulloch, *Latin and French Bestiaries*, 116. For elephant with tower, see Debra Hassig, *Medieval Bestiaries: Text, Image, Ideology*, Cambridge, 1995, 129–44.

7 See n. 6 above.

ical interest and oddities that are stressed. In the case of the elephant, generally having one of the longest accompanying texts in the Bestiary, there may be incidental mention of his teeth made of ivory and the wooden tower used to hold warriors, the two characteristics selectively shown on the map.[8] It appears therefore that the material appropriated onto the map is not the Christian content but bits and pieces of data as if recalled by a traveler returning with tall tales of strange places and unique things seen like the Bactrian camel that never wears out its hooves.[9] In this case, it is the depiction of the elephant that closely relates to the Bestiary elephant – but the connection that is made is that elephants are found in India.

Nevertheless, the Bestiary, as the medieval lens through which this information was filtered provided the memory system that empowered viewers to read the images on multiple levels. On the map, the overall impression of the elephant standing alone and apart, like its iconic counterpart on a bestiary page, was presented as a symbol. In spite of the secular textual material, most people, whether they could read or not, knew the Bestiary and its Christian symbolism either through sermons or explications of animal imagery on church surfaces. Those who were so well educated as to be able to read Anglo-Norman and Latin may have possibly even held a bestiary in their hands at some point in their life. To the average viewer, the picture of the elephant on the map, seen devoid of narrative props, was visually and intellectually conflated with its Christianized counterparts of the Bestiary. Thus the image may have recalled the strange and exotic as part of creation and it also may have provided the viewer with a further moralized 'reading' rooted in the Bestiary. The map belonged to the realm of the Neo-Platonic in which the construct, conceptualized by the circle of creation, was the essence; the Aristotelian realm of naturalism was not yet particularly evident here.[10] If that is the case, what is the relevance of the classical allusions?

[8] For in-depth discussion of the elephant and mandrake in relation to the Bestiary see McCulloch, *Latin and French Bestiaries*, 115–19.

[9] Although some of the characteristics credited to various animals appear fanciful, they were grounded in the 'scientific' legitimacy of their ancient descriptions. And according to George, they are based on reports of actual animals whose descriptions and identifications were distorted through time and distance, as for instance that of the Bactrian camel. For discussion of thirteenth-century maps, see George, *Animals and Maps*, 29–39. As an interesting aside, according to Strabo, Alexander made military decisions on the basis of crocodiles found in the Nile. When he saw crocodiles in the Hydaspes and Egyptian beans in the Acesines, both rivers in India, he thought he had found the source of the Nile. Herodotus knew that crocodiles lived in the Indus, as well as the Nile; however, it appears that Alexander had no knowledge of this; see George, *Animals and Maps*, 27.

[10] That the map is not based on 'scientific' naturalism is evident from its foremost reliance upon ancient sources of animals. For later attempts to bring a greater scientific understanding to the natural world based on Aristotle, see Michael Camille, 'Illustrations in Harley MS 3487 and the Perception of Aristotle's *Libri naturales*', in *England in the Thirteenth Century* (Proceedings of the 1984 Harlaxton Symposium), ed. W. M. Ormrod, Woodbridge, 1986, 31–43.

The Classical Tradition

The intention of the texts: giving credibility to the strange

On the Hereford map, there are forty-three identifications and textual references to animals; eleven images are accompanied by identifying names only,[11] the others, with longer texts, are either closely associated with place, or are briefly described with emphasis on unusual characteristics such as composite parts. As to place, legends may be as short and generic as 'hic serene habundant' to indicate the location of the sirens or more specific, as the texts for the yale (*eale*),[12] manticore (*manticora*)[13] and parrot (*psitticus* [*spitticus*]),[14] which are explicitly credited to Solinus and his description of India. According to these texts, the yale, manticore, and parrot are indigenous to India. A separate text, not specifically credited to Solinus, notes an export of Indian elephants – an allusion to the continuing lure of the east and its commerce in rarities.[15]

In spite of their exotic habitats, the animals in general are described as being characteristic of types, not as monstrous distortions. Though often described as composites (e.g. the bonnacon has a bull's head and a horse's mane) their composite nature is not necessarily meant to describe a freakish oddity but rather a method of allowing the viewer to visualize the animal.[16] The uniqueness and rarity of the animals is what is often stressed, as the case of the alerion as the only pair in the world,[17] or the phoenix

11 *Cocadillus* (crocodile), *cirenus* (? cinnamologus), *leo* (lion), *leopard* (leopard), *simea* (ape), *miles maris* (? swordfish), *lacertus* (lizard), *dracones* (dragons), *ursus* (bear), *scorpio* (scorpion), *buglossa* (? buffalo).

12 See below for the texts.

13 Hereford map: *Solinus. manticora nascitur in yndia. triplici dencium ordine. facie hominis. glaucis oculis. sanguineo colore. corpore leonino. cauda scorpionis. voce sibilla.* ('Solinus. The manticora is born in India, with a threefold series of teeth, the face of a man, gray eyes, bloody in color, with a lion's body, the tail of a scorpion, and a whistling voice'). Solinus: *Mantichora quoque nomine inter haec nascitur, triplici dentium ordine . . . facie hominis, glaucis oculis, sanguineo colore, corpore leonino, cauda velut scorpionis . . . voce tam sibila* ('The mantichora is also born among these, with a threefold series of teeth . . . the face of a man, gray eyes, bloody in color, with a lion's body, a tail like a scorpion's . . . and a whistling voice') (Solinus, 52: 37).

14 Hereford map: *Solinus. yndia mittit auem spitacum. colore viridi. torque puniceo.* ('Solinus. India produces the parrot bird, green in color, with rosy collar'). Solinus: *Sola India mittit avem psittacum colore viridem torque puniceo* ('India alone produces the parrot bird, green in color, with rosy collar') (Solinus, 52: 43).

15 Although having a long history of inclusion in bestiaries, reports of the elephant, which Henry III kept in the Tower of London from 1255 to 1259, abounded and may have added to their fascination. The elephant is recorded to have been a gift from King Louis. Matthew Paris in *Chronica maiora*, V: 489, mentions that many people flocked to see it; see Suzanne Lewis, *The Art of Matthew Paris in the 'Chronica Majora'*, Berkeley, 1987, 212–15; also H. Sands, 'Extracts from the Documentary History of the Tower of London', *Archaeological Journal*, 69, 166; A. T. Hatto, 'The Elephants in the Strassburg *Alexander*', in *The Medieval Alexander Legend and Romance Epic, Essays in Honour of David J. A. Ross*, ed. Peter Noble, Lucie Polak, and Claire Isoz, New York, 1982, 85–105; Frederick Madden, 'On Knowledge Possessed by Europeans of the Elephant in the Thirteenth Century', *The Graphic and Historical Illustrator*, ed. E. W. Brayley, London, 1834, 335–6, 352; George C. Druce, 'The Elephant in Medieval Legend and Art', *Archeological Journal*, 76, 1919, 1–73.

16 This point is stressed by George, *Animals and Maps*, 21–5.

17 *Au*[*is*] *alerion. par in mundo.* ('The bird alerion. The [only] pair in the world'). Pliny speaks of a black eagle, pre-eminent in strength, therefore called 'Valeria'. He also describes a pair of eagles, 'par

who lives for five hundred years and is the only one in the world.[18] In the same vein, supreme powers such as the salamander being the most venomous dragon or the mandragora plant's ability to provide miraculous cures are specifically noted.

Apparently the animals are not described as frightening but rather as having notable, thus memorable, characteristics. For instance, the camel never wears out his hooves; the lynx can see through walls, the rhinoceros because of his height can fight elephants, the yale has moveable horns, the manticore has the voice of a siren, and the bonnacon emits fiery dung. The bonnacon, associated with Phrygia, 'when chased discharges dung over an extent of three acres which burns whatever it touches'[19] is an example of bodily functions as salaciously humorous, which is also the case with the lynx which urinates stones.

In addition to several other composite animals such as the griffin, basilisk, and ostrich, there are more developed texts that include the substance of the Bestiary narratives but omit their moral and exegetical interpretations. For instance, the ants and the golden sand,[20]

aquilarum' that require a large tract of country (Pliny, *Natural History*, X: 4.14; see Pliny the Elder, *Natural History*, ed. H. Rackham, Cambridge, MA, 1940). According to McCulloch the alerion does not appear in Latin bestiaries and is unique to Pierre de Beauvais's French bestiary. She also notes that the alerion is mentioned in Prester John's letter on the Marvels of the East. In Pierre de Beauvais's bestiary the alerion is described as a bird, larger than an eagle and only one pair exists in the entire world. They live sixty years and then lay two eggs on which they sit sixty days; see McCulloch, *Latin and French Bestiaries*, 197–8. For Christian symbolism, see Charles Cahier and Arthur Martin, *Mélanges d'archéologie, d'histoire et de littérature*, Paris, 1847–9, I : 162–4. For discussion of many other animals of the Bestiary, see *ibid.* I: 85–232.

18 *Phenix auis. hec quinge[n]tis uiuit annis. est autem unica auis in orbe.* ('The phoenix bird lives for five hundred years; there is only one bird of its kind in the world'); see Letts, *Pictures*, 36. According to Herodotus, the phoenix is a red and golden bird the size of an eagle. Every five hundred years the phoenix visited Heliopolis, the city of the sun, with the embalmed body of its father in a roll of myrrh and buried it in the temple of the sun. Then it plunged to its own death in fire, to be reborn from the ashes. The story is considered a Christian symbol of the Resurrection; see McCulloch, *Latin and French Bestiaries*, 158–60. On the Hereford map the phoenix originally may have been painted in gold and is shown as sitting on a burning nest, as frequently depicted in bestiaries. For in-depth discussion of sources and iconography, see Guy R. Mermier, 'The Phoenix: Its Nature and Its Place in the Tradition of the *Physiologus*', in *Beasts and Birds of the Middle Ages*, ed. Willene B. Clark and Meradith T. McMunn, Philadelphia, 1989, 69–87.

19 *Infrigia nascitur animal qui dicitur bonnacon. capud taurinum. iuba equina. cornua multiplici flexu. profluuio citi uentris fimum egerit. per longitudinem trium iugerum. cuius ardor quiccit attigerit adurit* ('In Phrygia there is born an animal called bonnacon; it has a bull's head, horse's mane and curling horns; with a discharge from its swift gut it emits dung over an extent of three acres which burns whatever it touches'). The bonnacon is not mentioned by Isidore but it is described by Solinus (40: 10), and Pliny (VIII: 15.40); see McCulloch, *Latin and French Bestiaries*, 98.

20 *Hic grandes formice. auream sericam [seruant] arenas* ('Here huge ants guard [corrected from 'silk'] golden sand'). The ants that guard the golden sand fall into the category of the miraculous and legendary. Large ants, the size of dogs (also known as ant-lions), that dig up gold dust with their feet, and jealously guard it against all comers, later foiled, then place the gold dust in the pack of a mare, are described in the B-Is version of the Bestiary and the H version (book II of Pseudo-Hugo of St Victor which is closely related to the B-Is version, both belonging to the First Family of Bestiaries); see McCulloch, *Latin and French Bestiaries* , 28–33, 81–4. The same description occurs in the Bestiary by Guillaume le Clerc which has a moralizing, contemporary preaching cast. Morgan cites Paris, BN, MS Fr.14969, f. 17; see Morgan, *Early Gothic Manuscripts*, 4/2, cat. no. 129. Another example of this rare ant motif occurs in the Anglo-Saxon manuscripts of the *Marvels of the East* (London, BL, MS Cotton Vitellius A. XV); see Elzbieta Temple, *Anglo-Saxon Manuscripts 900–1066* (A Survey of Manuscripts Illuminated in the British Isles, 2), New York, 1976, cat. no. 52, fig. 185. Gold-digging ants are described by Herodotus (iii: 102–5) as existing in

the tiger and its cub,[21] the pelican and its young,[22] and most telling, the text attributed specifically to Isidore, *Etymologiae*, book XII, where the unicorn is linked to a virgin but no further text is given to make its deeper meaning explicit.[23]

The explicit references to Solinus or Isidore on several of the texts strengthened the legitimacy of the factual, and by so doing these disassociated, intriguing tidbits of information were also given due weight and validity.

Solinus

As noted, Solinus is the Hereford map's most quoted author.[24] Copies of Solinus' *Collectanea rerum memorabilium* ('Collection of Remarkable Facts') were widely avail-

India. Solinus (30: 23) indicates the ants are from Ethiopia. They are described as from Ethiopia in the B-Is family of bestiaries and are located in Ethiopia on the Hereford map. A bean-like image of the ants, similar to that on the Hereford map, is found in the Morgan Bestiary (New York, Pierpont Morgan Library, MS 832, f. 7v); see Kauffmann, *Romanesque Manuscripts*, cat. no. 106.

21 *Tigris bestia. cum catulum suum captum percipit. concito cursu prosequitur cum catulo fugientem. at ille uelocis equi cursu in fugam propera[n]s speculum ei proicit et sic liber euadit* ('A tiger, when it sees its cub stolen, chases the one fleeing with his cub at a swift pace. But he, hastening into flight with the speed of a fast horse, throws down a mirror at it and thus escapes unhampered'). According to the Bestiary account, the thief escaping with a tiger cub throws down a mirror to delude the pursuing tiger which sees its own reflection in the mirror and mistakes it for the cub. It stops to fondle it, loses valuable time and thus allows the thief to escape; see McCulloch, *Latin and French Bestiaries*, 176–7. An unusual change takes place in two Third Family bestiaries: In London, Westminster Abbey, MS 22, f. 25 and Oxford, Bodl. Lib., MS e. Mus. 136, f. 18v the tiger looks at a circle representing the mirror, hanging from a tree. Note that the tree on the Hereford map next to the tiger possibly contains a circular object. Due to the poor condition of the paint, it is difficult to be certain.

22 *Pellicanus. dicor. pro pullis scindo michi. cor.* ('I am called Pelican; for my young I rend my heart'). The legend of the pelican feeding its young by wounding its own breast is a type for Christ's love and a symbol of the Resurrection. The pelican according to St Augustine and Isidore of Seville is reputed to kill its young by kisses or blows, and after three days, it wounds itself in the breast to revive the brood with its own life-blood; see McCulloch, *Latin and French Bestiaries*, 155–6. In the case of the pelican on the Hereford map, the reference to feeding its young is clear. The B-Is group of bestiaries refers to the pelican as an Egyptian bird living in the Nile but on the Hereford map the pelican is not located in Egypt. Note that a roof boss in the bishop's cloister in Hereford Cathedral has a depiction of the theme.

23 *Ysidorus in libro XII ethimologiarum. capitulo ii. Sicut asserunt qui naturas animalium scripserunt. Huic monoceroti virgo puella proponitur. que uenienti sinum aperit. in quo ille omni ferocitate deposita. capud ponit. sicque soporatus. velud inermis capitur* ('Isidore in book XII of the *Etymologiae*, chapter ii. Just as they have affirmed who have recorded the characters of animals: before this unicorn is set a virgin girl, who opens her lap to it as it approaches, on which, with all ferocity laid aside, he puts his head, and thus made sleepy is taken as if harmless'). Much attention has been given to the subject of the unicorn (monoceros). It is a frequent subject for bestiaries; the unicorn's strength and gentleness is symbolic of Christ; see McCulloch, *Latin and French Bestiaries*, 179–83; for in-depth discussion of the unicorn in relation to the Bestiary, see Jürgen W. Einhorn, *Spiritualis unicornis* (Munstersche Mittelalter-Schriften, 13), Munich, 1936, 50–80, 136–44. The unicorn is often referred to in the Greek form of the word as 'monoceros', and as 'rinoceros vel unicornis'. The two names are based on two descriptions given by Pliny: unicorns as oxen with solid hoofs and one horn (VIII: 31.76) and the rhinoceros with one horn who fights elephants (VIII: 29.71) and in Solinus, the monoceros (52: 39, 40) and the rhinoceros (30: 21). On the Hereford map the monoceros is presented as a unicorn and the rhinoceros is described separately. The image of the monoceros is based on Solinus. Note the exact text as found on the Hereford map is also used in *Marvels of the East* (Oxford, Bodl. Lib., MS Bodl. 614). For further discussion regarding the *Marvels of the East* (also known as the *Wonders of the East*), see Chapter 5.

24 There are twelve explicit references to Solinus on the Hereford map. Animals: *eale* (Yale), *manticora*,

able.[25] Although Solinus' *Collectanea* was largely an abbreviated version of Pliny's *Naturalis historia*, it was keyed to inclusive geographical areas whereas Pliny's work separated natural history out from other factual information.[26] Solinus presents the world as a wondrous place authoritatively described by others who have supposedly experienced distant travel first-hand. Ctesias, Megasthenes, Posidonius and others are mentioned as authorities who give weight to the derivative nature of Solinus' comments. The book, also known as the *Polyhistor*, is divided into chapters, the first several of which include, amongst other things, diverse factual information about Rome, its foundation, how the annual calendar is conceived, rites of reverence for the dead, and the valiance of Caesar and other notable Romans. As the chapters unfold, the subjects progressively move away from Rome and the descriptions include more exotica. Because many of the descriptions of animals and strange races on the Hereford map were inspired by the writings of Solinus, it is worth a detour to consider Solinus' discussion of India and Ethiopia, two places described with particular emphasis on animals and strange races.

In his relatively short description of India, he begins by indicating its borders, crediting sources for added authenticity:

> Posidonius placed it opposite Gaul. Indeed there is no uncertainty about it: for, after being discovered through the wars of Alexander the Great and thereafter traversed through the diligence of other kings, it has now been added thoroughly to our knowledge. Megasthenes stayed for some time with the Indian kings and wrote of Indian matters in order to put on record a confirmation of what his eyes had been exposed to. Dionysius too, who was himself sent by King Philadelphus as an observer to put the truth to the test, published comparable accounts.[27]

rinosceros, spitacum (Parrot). Peoples: *Antropophagi, Gangis* (Astomi), *Yperborei, Eones.* Geography: *Gangis* (Ganges), *Ganges, Getulea, Initium orientis estivi* (Scythia).

[25] Muratova suggests the possibility that an unillustrated copy of his *Collectanea rerum memorabilium* ('Collection of Remarkable Facts') presently in Lincoln Cathedral Library may have provided texts for the map; see Xenia Muratova, 'Bestiaries: An Aspect of Medieval Patronage', in *Art and Patronage in the English Romanesque*, ed. Sarah Macready and F. H. Thompson, London, 1986, 118–44, esp. n. 105 (p. 143). However, it appears to be unlikely that the version she refers to was used. Although the unillustrated copy of Solinus cited belonged to the Lincoln Cathedral library, according to Thomson, who has studied the manuscript carefully, it exists as fifteenth-century annotations added to a fourteenth-century manuscript of Bartholomaeus Anglicus, *De proprietatibus rerum*; see Thomson, *Catalogue*, MS 154 (B.1.14), 122. However, because of the popularity of Solinus' text, it is likely that an earlier example did exist but is unrecorded.

[26] For a discussion of Solinus in relation to Pliny, see William H. Stahl, *Roman Science*, Madison, 1962, 136–42. Stahl suggests that Solinus recognized the attractiveness of Pliny's work and gleaned from his geographical books the most interesting names of places adding 'livelier bits' taken from Pliny's non-geographical books. Solinus also interpolated excerpts taken from Mela's *Chorography*, especially those relating to 'peculiar manners and customs'. Stahl credits Mommsen for his scholarly derivation of Pliny's sources.

[27] Solinus, 52: 2, 3: *hanc Posidonius adversam Galliae statuit. sane nec quicquam ex ea dubium: nam Alexandri Magni armis comperta et aliorum postmodum regum diligentia peragrata penitus cognitioni nostrae addicta est. Megasthenes sane apud Indicos reges aliquantisper moratus res Indicas scripsit, ut fidem, quam oculis subiecerat, memoriae daret. Dionysius quoque, qui et ipse a Philadelpho rege spectator missus est, gratia periclitandae veritatis paria prodidit.*

He follows with a rather positive description of India, which is reported as being endowed with three thousand towns, and a long history of one hundred and fifty-three kings during the period between the entry into India of Liber Pater and the time of Alexander the Great. Solinus then lists and describes the great rivers of the Ganges and Indus, followed by the 'noble' river of the Hypanis (Pliny's Hypasis) and its connection to Alexander's journey, 'as the altars standing on the banks thereof testify'. He then goes on to describe animals and then discusses trees followed by the jewels of India. The text is simple and descriptive, easy to lift onto the map in order to fill spaces between the rivers, cities, and mountains that were, no doubt, drawn first.

In the case of animals on the Hereford map, however, it is puzzling that although many of the inscriptions were clearly taken from Solinus,[28] they were not always placed in their appropriate geographical area. For instance, the illustrator conflated the animals of India and Ethiopia and placed them on the map in a relatively haphazard manner. It was common for classical authors to link India and Ethiopia.[29] Using the text for the yale as an example, one can readily see on the one hand how indebted the scribe was to Solinus, but on the other hand how the artist took license with placement. For instance, although the yale was supposedly born in India, on the map the animal was located in Egypt.

A sample comparison of the Hereford's text for the yale with relative texts from Pliny and Solinus may be instructive in seeing how radically the map's texts are edited from the original. Clearly there were intermediary textual sources as well.

> Hereford map
>
> Solinus. Eale. nascitur in yndia. equino corpore. cauda elephanti. nigro colore. maxillis caprinis. preferens cornua ultra cubitalem longa. neque enim rigent. sed mouentur. ut usus exigit preliandi. quorum cum uno pugnat. alter[um] replicat.
>
> (Solinus. The eale is born in India, with a horse's body, an elephant's tail, black in color, with a goat's jaws, bearing horns more than a cubit in length; they are not stiff, but move as use in fighting demands; it fights with one, and folds the other back.)
>
> Pliny, VIII: 73
>
> apud eosdem et quae vocatur eale, magnitudine equi fluviatilis, *cauda elephanti*, colore nigra vel fulva, *maxillis apri*, maiora cubitalibus cornua habens mobilia quae alterna in pugna se sistunt variantque infesta aut obliqua, utcumque ratio monstravit.[30]
>
> (Among the same people is also found the animal called the yale, the size of a hippopotamus, with an elephant's tail, of a black or tawny color, with the

[28] Thirty-three animals are related to bestiaries (see n. 39 below). At least seventeen of those animals are described by Solinus. Although the inscriptions are closely based on Solinus they leave out details as if taken not from the text itself but from an intermediary abbreviated form.

[29] Pliny's description of the yale (VIII: 30.73) locates it in Ethiopia, whereas Solinus locates the yale in India (Solinus, 52: 8). Another telling example is the rhinoceros which Solinus describes in his chapter on Ethiopia (Solinus, 30: 21), but the text of the map credits Solinus with its placement in India.

[30] Translation by Rackham, *Natural History*.

jaws of a boar and movable horns more than a cubit in length which in a fight are erected alternately, and presented to the attack or sloped backward in turn as policy directs.)

Solinus, 52: 35

Est et eale, alias ut equus, *cauda elephanti, nigro colore, maxillis* aprugnis, *praeferens cornua ultra cubitalem* modum *longa* ad obsequium cuius velit motus accommodata: *neque enim rigent sed moventur, ut usus exigit proeliandi: quorum* alterum *cum pugnat* protendit, *alterum replicat*, ut si ictu aliquo alterius acumen offenderit, acies succedat alterius. hippopotamis comparatur: et ipsa sane aquis fluminum gaudet.

(There is also the yale, otherwise like a horse, with an elephant's tail, black in color, its jawbone like a boar's, sporting horns over a cubit long, suitable for whatever service it wishes: for they are not stiff, but move according to the demands of fighting; it stretches out one of these when it fights, and folds back the other, so that if by some blow the point of one comes to harm, the point of the other may take its place. It is compared to the hippopotamus, and indeed, it delights in river waters.)

Although only a handful of medieval illustrated examples of the *Collectanea rerum memorabilium* still exist,[31] it would seem that they were perhaps more available than extant evidence shows. Of the rare examples, the primitively decorated pages of one such manuscript, already noted, may be of relevance, namely the thirteenth-century Italian work now in Milan. On one of the folios that illustrate Solinus' chapter on India, general relationships to the Hereford map are recognizable (Fig. 4.2).[32] Basically the images follow the text from left to right and from top to bottom. The most visually descriptive passages are explained with pithy, highly abbreviated accompanying texts as on the Hereford map.

The Christian Tradition

The Bestiary's influence: introduction
As already noted, a map is primarily about 'place'. However, in the Hereford map 'place' functions as backdrop for items of fantasy and curiosity and often the placement of the animals is unrelated to their original descriptions. The emphasis is rather on the

31 For a list of manuscripts and locations, see Solinus (ed. Mommsen), xxix–lii. Mommsen's list does not include the Lincoln manuscript. For England, Ker adds another twelfth-century English example from Exeter, Oxford, Bodl. Lib., MS Auct. F.3.7; see N. R. Ker, *Medieval Libraries of Great Britain. A List of Surviving Books*, London, 1964, 83.

32 Milan, Ambrosiana, cod. C. 246 inf. According to Wittkower, this thirteenth-century manuscript relates to an archetype of the sixth to seventh century AD; see Rudolf Wittkower, 'Marvels of the East', *Journal of the Warburg and Courtauld Institutes*, 5, 1942, 171; Cogliati summarizes the literature on the manuscript and suggests connections to a variety of sources; see Luisa Cogliati Arano, 'Il manoscritto C. 246 inf. della Biblioteca Ambrosiana, Solino', in *La miniatura italiana in età romanica e gotica* (Storia della Miniatura, Studi e Documenti, 5), Florence, 1979, 239–58. She reproduces a number of images; especially note the map reproduced from f. 30 (p. 257).

Fig. 4.2 Miscellaneous Subjects from Solinus, *Collectanea*. Milan, Ambrosian Library, MS cod. C. 246 inf., f. 57. 13th century

distant and strange, the animals chosen belonged to distant realms rather than places with which Europeans were familiar. On the map, in all of France, England, Italy, and Spain, only the buffalo and genet are depicted. The rest of the world overflows with animal life originally described by ancient sources but more familiarly known in the Middle Ages through the Bestiary, and some in lesser degree, through classical mythology.

For a consideration of the Hereford map as an object reliant upon antique sources but nevertheless an object created in the Middle Ages, the Bestiary must be vital to the discussion. Given its widespread popularity and familiarity as a depository of deeply rooted themes, the Bestiary was the focal point of memory and folklore and belonged to the realm of written as well as oral tradition. As such it could serve as the mental filter for understanding the animals on the map.

Bestiaries, basically pseudo-scientific compendia of information and lore relating to real and imaginary animals, birds, and other wonders of nature, were meant to illustrate Christian theology and lessons and to reinforce the symbolic and meaningful nature of all creation. All medieval bestiaries descended from the *Physiologus*, probably written in Alexandria in the third century AD.[33] By the eighth century the *Physiologus* had been translated from Greek into Latin[34] and in the following centuries further interpolations, many taken from writings of Solinus and Isidore of Seville,[35] amongst others, were added. With successive interpolations and expansions, which James has divided into three 'families', the medieval Bestiary, as a collection of moralized descriptions, became popularly known.[36] Each chapter of the medieval Bestiary is devoted to an example of natural history. For animals it generally begins with a biblical citation that relates to the subject, followed by an etymological discussion, an allegorical description of the behavior of the animal, and lastly, a moral and exegetical interpretation. Not all entries include the moralized interpretation. For instance, the following is the text for the yale taken from a typical example of a Third Family Bestiary:

> There is a beast called an eale, as large as a horse, with an elephant's tail; it is black in color and has the tusks of a wild boar as well as exceptionally long horns which are adapted to every kind of movement. For they are not rigid

[33] For scholarly debate relating to the date and author of the *Physiologus*, see McCulloch, *Latin and French Bestiaries*, 15–20; *Physiologus*, trans. Michael J. Curley, Austin, 1979, xvi–xxi. There is reason to believe that the *Physiologus* originally consisted of two distinct parts written independently: the legends and the allegories. The legends were based on well-known literary sources of ancient history from Herodotus and Aristotle down through Pliny's *Natural History* and Aelian's *History of the Animals*. To these legends, a Christian writer, steeped in the Alexandrian school of allegorical exegesis, added the allegorical interpretations; see *Physiologus*, xxii.

[34] There is scholarly debate regarding the earliest Latin translation which may have appeared as early as the fourth century. Curley indicates that the Latin translation was known in the early sixth century and may have been circulating as early as mid-fourth century; see *Physiologus*, xx.

[35] Much material was taken from Isidore of Seville's *Etymologiae*. Isidore's sources were largely ancient authors and Church Fathers. For an introduction to Isidore of Seville's work, see Ernest Brehaut, *An Encyclopedist of the Dark Ages, Isidore of Seville*, New York, 1964 (reprint).

[36] For discussion of 'Families', see n. 44 below.

but can be moved at need when it fights. It puts one out in front in a combat, so that if it loses its tip from a blow, it can bring the other one forward.[37]

As an example of a moralizing text from the same bestiary:

> The pelican is an Egyptian bird which lives in the solitary places of the River Nile. . . . It shows exceeding love towards its young. If it has brought offspring into the world, when these grow up they strike their parents in the face. The parents strike back and kill them. After three days, their mother opens her own breast and side, and lies on her young, pouring all her blood over the dead bodies, and thus her love brings them back to life. So our Lord Jesus Christ, who is the author and originator of all creatures, begot us, and when we did not exist, He made us. But we struck Him in the face; as Isaiah said: 'I have begotten sons and raised them up, but they have despised me.' Christ ascended the Cross and was struck in the side: blood and water came forth for our salvation, to give us eternal life.[38]

On the Hereford map, of the forty-three identifications and textual references to animals (plus the mandrake plant that looks like a composite plant–human) thirty-three can be related to subjects of the Bestiary.[39] Seven additional texts refer to animals that are included in the Bestiary (dragons and serpents are mentioned in five other texts, the elephant and tiger in two more).[40] Thus only four items are unaccounted for outside of the bestiary world, one of which – the genet (*geneis*), an animal

[37] The translation is based on the description of the yale in Oxford, Bodl. Lib., MS Bodley 764; see Richard Barber, *Bestiary: Being an English Version of the Bodleian Library, Oxford 764 with All the Original Miniatures Reproduced in Facsimile*, Woodbridge, 1993, 68.

[38] Barber, *Bestiary*, 146–7.

[39] Animals: *alerion* (alerion), *basiliscus* (basiliscus), *bonnacon* (bonnacon), **buglossa* (buffalo), *cameli* (camels), *cirenus* (cirenus), *cocadillus* (crocodile), **dracones* (dragons), *eale* (yale), *elephantes* (elephants), *formice* (ants), *griphis* (griffins), *leopard* (leopard), *leo* (lion), *lacertus* (lizard), *linx* (lynx), **mandragora* (mandrake), *manticora* (manticore), **marsok* (marsok), *monoceros* (unicorn), *ostricius* (ostrich), *spitacum* (parrot), *pellicanus* (pelican), *phenix* (phoenix), *rinosceros* (rhinoceros), *salamandra* (salamander), **miles maris* (sea soldier), *scorpio* (scorpion), *simea* (ape), *tigris* (tiger), *vrsus* (bear). other: *sirene* (siren), *fauni* (centaurs). The asterisks note the following discrepancies between the Hereford text and bestiary material. The discrepancy between buffalo and its text 'buglossa' (which refers to a plant) is an error in transcription. The Mandrake plant, although most often found in herbals, is included in a limited number of bestiaries as well. The confusion between the buffalo and the 'Buglossa' text reinforces the possibility of herbals and bestiaries being related by shared models. I have placed the marsok in the list of animals of the Bestiary on the premise that the Marsok is another term for the Cameleon or Parandrus, animals described in the Bestiary that change their appearance to conceal themselves. However, any strong resemblance is lacking between the Marsok on the Hereford map and images of the Cameleon or Paradrus in bestiaries. Margriet Hoogvliet notes a thirteenth-century sculpture of the Virgin atop an animal like a marsok on the south portal of Worms Cathedral (Germany). This was noted at the Hereford Mappa Mundi Conference, 27 June – 1 July, 1999. For further discussion of the Marsok, see below, n. 44. I believe that the image that accompanies the inscription 'Miles maris' is that of a *serra* (swordfish), a fish that is frequently included in bestiaries. The Siren and Centaur are composite animal–humans that occur in the Bestiary and are difficult to categorize.

[40] Dragons are indicated in at least three other places as part of the description; see *Aureos* (Golden Mountains), *Naddaber* (Napata), *Taphana* (Sri Lanka); serpents are indicated in at least two other places: see *Ardens* (Ardens), *Ebos* (Ebos). For another reference to the elephant, see *Taphana* (Sri Lanka). For another reference to the tiger, see *Hircani* (Hyrcani).

whose fur was prized in Europe[41] – is very likely discussed in the Bestiary as a large weasel. That actually leaves only the three commonly known mythical subjects of the Minotaur, Sphinx, and Golden Fleece.[42]

On the map, with few exceptions (the pelican, the tiger, the phoenix) the animals are shown singly without narrative details. The animals also exist independently of their environment, the only exceptions here being the unicorn and yale who stand upon rocky pedestals which are significantly not identified as specific geographic formations. In this respect the map's images subtly depart from contemporary bestiary illustration in which landscape was coming to be more prominently featured. In the Bestiary, the inclusion of specifics of landscape, according to Friedman, paralleled the contemporary development of the omission of moralization. As such, it was symptomatic of developments in the thirteenth century toward secularization.[43] If that is so, then on the Hereford map the retention of the iconic aspect of animal imagery and the conscious omission of scenic props reinforced the *retardataire* (an art historical term that suggests an antiquated style) nature of the map's illustrations. The *retardataire* style was in keeping with the equally *retardataire* respect for the integrity of the accompanying texts, which by the time of the map's making were no longer regarded as completely reliable. Conceptually then the map was a work of art that paid homage to the past. The beasts on the map retained their classical roots but were transformed in meaning in the viewer's eyes, in varying ways, by the Christian cultural paradigm, in which the Bestiary was central. New models and new ideas entered into its making.

The Bestiary's influence: conflations

The Hereford map contains animals closely associated with those found in the Transitional and Second Family of bestiaries,[44] terms used by James in 1928, and exemplified

41 Although Hassig does not mention the genet, her discussion of the stone marten, commonly known as the weasel, as a popular source of fur-lined and trimmed garments, is of relevance here; see Hassig, *Medieval Bestiaries*, 36–9.

42 There are also several examples of animals and composite monsters that are incorporated on the map that I have not included in my count such as four unidentified fish in the Mediterranean Sea located near islands with inscriptions – *Mena* (Mena), *Didimee* (Salina, one of the Aeolian islands), *Mare Leonum* (Lion Sea, located between Crete and Italy), and *miles maris* (sea soldier), indicated by a sawfish or swordfish (note the sword-like fin). It closely resembles a sawfish as represented in bestiaries; see McCulloch, *Latin and French Bestiaries*, 163–5: note close resemblance to long fish with dorsal fins (MS Bern 318, f. 18v). The sawfish (serra) is often described as a fish that attacks ships. A fifth fish is a long-nosed fish under the island of Choos (Chios), located in part of the sea which represents the Hellespont (Dardanelles). Whether Cos or Chios is intended, it is difficult to discern, either being equally remote from the Hellespont. As to composite monsters on the Hereford map, note the rock *Svilla* (Scilla) and whirlpool, *Caribdis* (Carybdis) located in the Mediterranean. Carybdis is shown as a coiled figure with a grotesque head protruding from the open end, and Scilla as a head, with open jaws, displaying rocks instead of teeth. These two examples fall more into the monster category than the animal; the island Lemnos (Lemnos) shows a cow-like animal above; and finally, a dragon-like beast is seen emerging out of Babel Turris (Tower of Babel).

43 See John Block Friedman, *The Monstrous Races in Art and Thought*, Cambridge, MA, 1981, 141.

44 The selection of animals on the Hereford map compared to twelfth and thirteenth-century bestiaries displays affinities to the Transitional (B-Is) and Second Family of bestiaries that developed from earlier

by a group of manuscripts, several possibly produced at Lincoln.[45] However, in its eclecticism and secularization, as we shall see, the map is more akin to the most expanded manuscripts of the Third Family as defined by James,[46] that begin to appear *ca.* 1220–30. The map reflects conceptual developments of these Third Family extended bestiaries that were often bound with other texts concerned with what was known about the world.

It is important to note that characteristic of the Third Family of bestiaries was the inclusion of images that accompanied Isidore's treatise on the Fabulous Nations of the World; thus in addition to the familiar bestiary images, these manuscripts were expanded to contain the strange and curious races as well.[47] Characteristically, Third Family bestiaries were also frequently bound with a wide assortment of other texts and images which extended the range of the Bestiary even further. For instance, in Cambridge University Library, MS Kk. 4.25 the Bestiary is part of a volume that opens with the Letter of Alexander the Great to Aristotle concerning the wonders of India

Isidorian additions to the *Physiologus*. M. R. James divided the various medieval bestiary manuscripts into four 'families', see Montague Rhodes James, *The Bestiary*, Oxford, 1928; McCulloch has further subdivided the groups: B-Is refers to the group between the oldest Latin versions or manuscripts of the *Physiologus* and those which contain substantial additions from Isidore of Seville; see McCulloch, *Latin and French Bestiaries*, 25–30. The 'transitional group', is described by McCulloch, *Latin and French Bestiaries*, 33–4. Note that as early as B-Is version the centaur and/or scorpion are included. See Morgan, *Early Gothic Manuscripts*, 4/1, cat. no. 54; Kaufmann, *Romanesque Manuscripts*, cat. nos. 36, 104). In the transitional group the unicorn and/or monoceros are included (Morgan, *Early Gothic Manuscripts*, 4/1, cat. nos. 11, 13, 115; Kaufmann, *Romanesque Manuscripts*, cat. no.106); and additions such as cameleon (marsok?) appear in Morgan, *Early Gothic Manuscripts*, 4/2, cat. no. 98 (Second Family) as well. The mandrake appears in the Second family manuscript cat. no. 20 but is more commonly found in medical and herbal texts (cat. nos. 9, 10) and in *Le Bestiaire*, the thirteenth-century vernacular Bestiary of Guillaume le Clerc (Morgan, *Early Gothic Manuscripts*, 4/2, cat. nos. 129, 187).

45 An argument has been made for Lincoln as the center for the production of several luxury Bestiaries; see Xenia Muratova, 'Adam donne leurs noms aux animaux', *Studi Medievali*, 18/2, 1977, 367–94, esp. 391–4. The manuscripts belonging to this group are described in Morgan, *Early Gothic Manuscripts*, 4/1, nos. 11, 17, 19, 21. Morgan is more circumspect in his attributions and mentions the possibility of Lincoln but attributes the four examples to the larger area of 'North Midlands'. Morgan also suggests that cat. no. 42 is part of this group due to its iconographic links to the Cambridge Bestiary (*Early Gothic Manuscripts*, 4/1, cat. no. 21). Although there may be evidence to point to Lincoln as the center of production, the bestiaries cited are more detailed stylistically than the Hereford map and include narrative detail lacking in the Hereford map suggesting parallel developments rather than an interchange of images and iconographic details.

46 See n. 44 above.

47 The bestiaries of this group are augmented by the addition of Isidore of Seville's accounts of Monstrous Races of the World (*Etymologiae*, XI: 3.12–27), extracts from the *Megacosmus* of Bernardus Silvestris and material from the *Pantheologos* of Peter of Cornwall; for a list of Third Family manuscripts based on families described by James, see McCulloch, *Latin and French Bestiaries*, 39; the list is repeated by Morgan: Cambridge, University Library, MS Kk.4.25 (Morgan, *Early Gothic Manuscripts*, 4/1, cat. no. 53); Cambridge, Fitzwilliam Museum, MS 254 (Morgan, *Early Gothic Manuscripts*, 4/1, cat. no. 55); London, Westminster Abbey Library, MS 22 (Morgan, *Early Gothic Manuscripts*, 4/2, cat. no. 172); Oxford, Bodl. Lib., MS Douce 88E, fs. 68–116v and Oxford, Bodl. Lib., MS e. Mus. 136. Morgan notes that such marvels as Cyclops, Giants, Pygmies, and the Sciapod appear in several other bestiaries. At the end of Westminster Abbey Library, MS 22, is the other Isidore text on 'The Imaginary Monsters of Pagan Mythology' (*Etymologiae*, XI: 3.28–39), with illustrations of the mythical creatures such as Cerberus, Chimera, and the Centaur; see Morgan, *Early Gothic Manuscripts*, 4/2, 174–5.

followed by a treatise on the nature of angels, the Bestiary, and a lapidary.[48] Other examples from the Third Family belong within similar compendia of diverse material whose composite scopes parallel the entire Hereford map's range of subject matter. They exemplify how Third Family bestiaries, already vastly inclusive, were bound together with a variety of other collections of information to form manuscript books about the world. In effect, the Hereford map was a conflation of selections from a wide variety of such pages onto a single surface; it simply provided another visual container for the contemporary pursuit of collecting, organizing, and reconciling information. To demonstrate the point, imagine superimposing or conflating the types of information onto a single surface using the related Third Family Bestiary (Cambridge, Fitzwilliam Museum, MS 254) as example. In this manuscript the introductory material deals with the strange races followed by a map of the world, in turn followed by the Bestiary that closely matches that of the previously described Cambridge manuscript (Cambridge University Library, MS Kk. 4.25).[49] Additionally, the inclusion of a map within the bestiary complex not only suggests its legitimate place within the broadened informational system but also provides the viewer with the suggestion of its infinite capacity as an expandable 'table of contents'.

Our final example, the most comprehensive member of the Third Family, the Westminster Bestiary (London, Westminster Abbey Library, MS 22) provides us with a book that, if conceptually compressed onto a single two-dimensional surface, could almost be thought of as an exemplar for the Hereford map. The manuscript pages of bestiary images are sandwiched between the monstrous races of the earth (fs. 1v, 3) and a full-page illumination of Adam naming the animals (f. 4), and end with a Wheel of Fortune (f. 54v) (Figs. 4.3–4.7).[50] The Wheel of Fortune resembles a number of examples that have previously been identified as conceptually akin to the Hereford map.[51] As already noted, as a paradigm of earthly existence, the Wheel of Fortune was symbolically interchangeable with a mappa mundi. They apparently were interchange-

48 Cambridge, University Library, MS Kk.4.25, *ca.* 1230, London. For description and bibliography, see Morgan, *Early Gothic Manuscripts*, 4/1, cat. no. 53. The pictures are similar to the simplicity of the map's images and several legends (e.g. yale) are close in nature as well.

49 Cambridge, Fitzwilliam Museum, MS 254, *ca.* 1220–30, (?) London region. For description and bibliography, see Morgan, *Early Gothic Manuscripts*, 4/1, cat. no. 55. Morgan notes that the map presents the world as 'divided into two semicircular zones separated and surrounded by sea. It is a relatively rare form of world map probably because it implied the existence of the Antipodes which was disputed by the Church' (Morgan, *Early Gothic Manuscripts*, 4/1, 103).

50 London, Westminster Abbey Library, MS 22, *ca.* 1270–90, (?) York. For description and bibliography, see Morgan, *Early Gothic Manuscripts*, 4./2, cat. no. 172. The manuscript begins with two full-page miniatures of the Monstrous Races of the Earth (fs. 1v, 3), followed by an illumination of Adam naming the animals (f. 4) and then an extremely large illustrated bestiary (fs. 6v–54). The last illumination is a Wheel of Fortune (f. 54v).

51 Morgan notes the resemblance of the Wheel of Fortune, where the Goddess of Fortune is shown within the wheel, to the thirteenth-century wallpainting in Rochester Cathedral. He also makes reference to the fourteenth-century pictures in the *Somme le roi* (Cambridge, St John's College, MS S.30, p. 139); the Holkham Picture Book (see respectively Sandler, *Gothic Manuscripts* 5/2, cat. nos. 60, 97) and the wallpaintings of Henry III at Winchester Castle and Clarendon Palace; see Morgan, *Early Gothic Manuscripts* 4/2, 175.

Fig. 4.3 Adam Naming the Animals. Bestiary, London, Westminster Abbey Library,
MS 22, f. 4r. *ca.* 1270–90, (?) York
© Dean and Chapter of Westminster

able in church decoration as well as in manuscript illumination. In considering the
ways in which medieval viewers memorized, collected, and conflated images, as we
proceed to telescope the imagery of the Westminster manuscript we are reminded of
the two previous examples from Cambridge. If in our memory and imagination we
telescope and compress sequentially experienced images onto a single large two-
dimensional surface, the Wheel page becomes the vessel for images that unfold in
order as one turns the pages of the manuscript. Whether the circular form, be it map or
fortune's wheel, precedes or succeeds the Bestiary makes little difference. In either case
it can be imagined as the conceptual circular containment for information relating to
God's creation. Interestingly, as also typical of the extended nature of the Third Family,
the Westminster Bestiary was once bound with a geographic description of Ireland.[52]

The Westminster Bestiary not only provides a deconstruction of key elements of the
Hereford map, but in its further inclusion of the scene of Adam naming the animals it
introduces the canonical animal world of the Bible. That material precedes and is juxta-
posed to the Bestiary's many real, but also strange and fabulous beasts. The scene of
Adam naming the animals becomes the link that finally connects an authoritative theo-
logical dimension to the folkloric aspect of the Bestiary. If strange animals were

[52] Giraldus Cambrensis, *Topographia Hibernica* (now London, Westminster Abbey Library, MS 23).

Fig. 4.4 Monstrous Races of the Earth. Bestiary, London, Westminster Abbey
Library, MS 22, f. 1v. *ca.* 1270–90, (?) York
© Dean and Chapter of Westminster

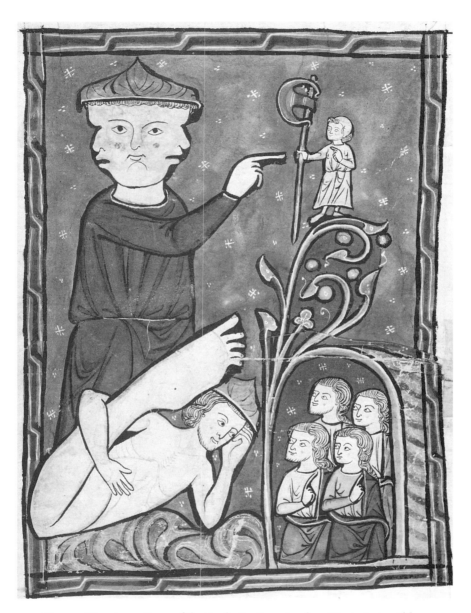

Fig. 4.5 Monstrous Races of the Earth. Bestiary, London, Westminster Abbey
Library, MS 22, f. 3. *ca.* 1270–90, (?) York
© Dean and Chapter of Westminster

Fig. 4.6 Elephant. Bestiary, London, Westminster, MS 22, f. 20v. *ca.* 1270–90, (?) York
© Dean and Chapter of Westminster

Fig. 4.7 The Wheel of Fortune. Bestiary, London, Westminster Abbey Library, MS 22, f. 54v. *ca.* 1270–90 (?) York

believed to exist in the world, if they were ultimately to be considered within God's plan, Isidore's etymological derivations of their names were continuous with the naming of the animals by Adam. In this manner bestiary subjects were included within the earthly realm, and the entire world of beasts, real and fabulous, was reconciled within the more specific framework of creation as understood in the medieval world.

The Bestiary appropriated

The texts on the map resonate with the Judeo-Christian belief in 'the power of naming', a theme closely tied to that of Creation: 'In the beginning was the word.'[53] And as the Bestiary expanded and individual sections were appropriated to other types of books, bestiary prefatory pages were invented and appropriated in ways that gave them a life of their own. That disassociation ultimately has significance in terms of understanding the Hereford map as a Circle of Creation.

As a brief survey, let us consider three English manuscripts whose prefatory pages show the development of the disassociation of the prefatory images from the Bestiary and their appropriation onto new types of visual collections that further parallel the map's conceptual organization. We will consider in order the Alnwick Bestiary, the Queen Mary Psalter, and the Holkham Picture Book. These three representatives of manuscript types are prefaced by a scene of Creation in which God the Creator, compass in hand, provides for the circular ring of the earth.

The Alnwick Bestiary, a member of the 'Transitional group',[54] presents a striking example of prefatory pages of Creation imagery placed before the Bestiary. The pages suggest themselves as models for later developments, not only for other bestiaries, but also for books meant for private use outside the monastic setting, such as the two chosen examples of paradigms of that development – the Queen Mary Psalter,[55] and the Holkham Picture Book.[56] We will follow the progressive detachment of the Creation pages from the Bestiary and their dissemination into the more popular realm.

In the Alnwick Bestiary the 'power of naming' assumes its rightful place as central to

53 John 1: 1.

54 Creation pages preceding the Bestiary, previously noted as characteristic of Third Family Bestiaries, are unique to the development of bestiaries, beginning with the Transitional group, e.g. Cambridge, Fitzwilliam Museum, MS 254, f. 2; London, Westminster Abbey Library, MS 22, f. 4.

55 Queen Mary Psalter. The Creation illuminations are as follows: God with Compass and Fall of Lucifer, f. 1v; creation of heaven, earth, sun, moon, and the stars, birds in heaven and beasts on earth, f. 2; creation of the waters and fish, f. 2v; creation of Adam and Eve (above), God forbids eating the fruit of the tree (below), f. 3; God reposes on his throne holding a T-O orb (above), Temptation and Fall, f. 3v. For texts and translations, see Warner, *Queen Mary's Psalter*, 55.

56 Holkham Bible Picture Book. The Creation images follow three prefatory pages: a Friar and artist-scribe commissioning and promising 'this book', f. 1; Wheel of Fortune, f. 1v. The Creation images are part of the first section of the book that begins with God the creator (f. 2) and ends with the story of Noah's drunkenness (f. 9r). The Creation scenes are as follows: God with compass within a circle, Heaven above and Hell below, f. 2; creation of animals, f. 2v; creation of Adam and Eve, f. 3r; The Forbidden Fruit, f. 3v; The Temptation and Fall, f. 4r; for these and others, see *The Anglo-Norman Text of the 'Holkham Bible Picture Book'*, ed. F. P. Pickering, Oxford, 1971.

Fig. 4.8 The Creation of Heaven and Earth. Alnwick Bestiary,
formerly Alnwick Castle, Collection of the Duke of
Northumberland, MS 447, f. 2. (?) 1250–60, northern England
The Conway Library, Courtauld Institute of Art

the Judeo-Christian understanding of creation itself.[57] As the illuminations unfold, page by page, the earthly realm of the Bestiary is explored where images are accompanied by texts largely based on Isidore's *Etymologiae* with added moralization. As Millar points out, the first eight illuminations (beginning with scenes from the Creation and ending with the naming of the animals by Adam) plus two unusual pages of sea animals are unique to the Alnwick Bestiary when compared to its 'sister books'[58] (Figs. 4.8, 4.9, 4.10). The fact that the Creation pages are unique to this relatively early bestiary and that the added pages so closely resemble pages from a model book argue

[57] For instance, the etymological derivation of Adam's name based upon the Greek names of the cardinal points was familiar to Greek and Jewish tradition; see Marie-Thérèse d'Alverny, 'L'Homme comme symbole. Le microcosme', in *Simboli e Simbologia nell'alto Medioevo* (Settimane di Studio del Centro Italiano di Studi sull'alto Medioevo, 23), Spoleto, 1976, esp. 165–6. For further discussion, see Chapter 8.

[58] Alnwick Bestiary, *ca.* 1250. It is considered 'sister' to the Worksop Bestiary, now New York, Pierpont Morgan Library, MS 81, and London, BL, MS Royal 12 C. XIX, executed at the same time and place. The tinted outline style is generally associated with St Albans. The first eight pictures representing the Creation and ending with Adam naming the animals are not found in MS Morgan 81 or in 12 C. XIX, nor are two composites of fish (fs. 48, 48v). Otherwise from f. 8 on the compositions agree very closely. The fish pictures have parallels in the Cambridge Bestiary but Millar does not believe they derive from the same archetype; see Eric George Millar, *A Thirteenth Century Bestiary in the Library of Alnwick Castle*, Oxford, 1958, 14–15.

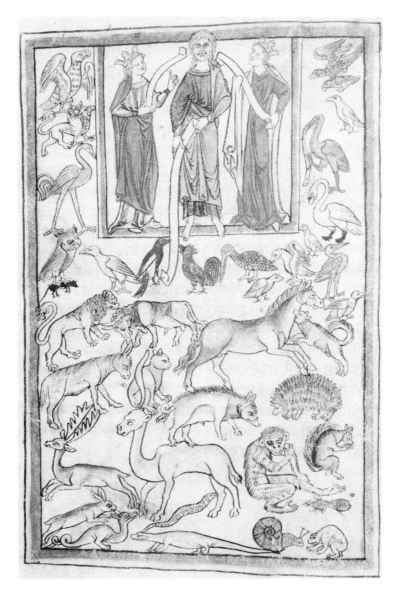

Fig. 4.9 Adam between Two Crowned Standing Women as he
Names the Animals. Alnwick Bestiary, formerly Alnwick Castle,
Collection of the Duke of Northumberland, MS 447, f. 5v. (?)
1250–60, northern England

The Conway Library, Courtauld Institute of Art

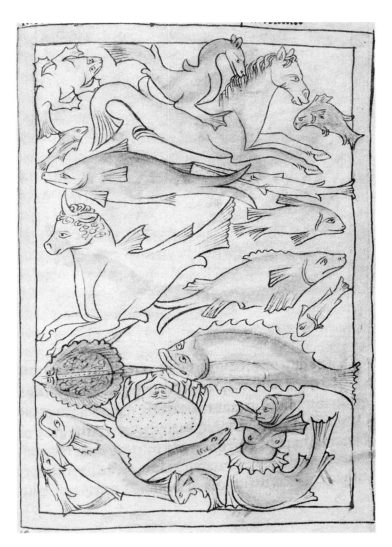

Fig. 4.10 Species of Fish. Alnwick Bestiary, formerly Alnwick
Castle, Collection of the Duke of Northumberland, MS 447,
f. 48. (?) 1250–60, northern England
The Conway Library, Courtauld Institute of Art

that the Alnwick Bestiary may have been used as a model for the later prefatory pages of a number of English Third Family bestiaries. We have already noted a sampling of Third Family Bestiary prefatory pages; some include the monstrous races, and also, significantly, images relating to the creation of the world and the naming of animals by Adam; one includes a map of the world.[59]

Ultimately the Genesis prefatory pages were appropriated onto other types of books. For example, in several highly decorated psalters commissioned for lay-patrons, the prefatory pages of Creation were incorporated as introductions, while the animals of the Bestiary were marginalized.[60] For instance in the Queen Mary Psalter one finds bestiary imagery relegated to the margins.[61] (This is particularly interesting insofar as

[59] In the Aberdeen 'Quartet' of bestiaries the following Creation scenes are depicted at the beginning of the manuscript (missing pages are omitted in description). For Aberdeen, University Library, MS 24 (Morgan, *Early Gothic Manuscripts*, 4/1, cat. no. 17): creation of heaven and earth, f. 1; creation of the waters and the firmament, f. 1v; creation of the birds and fishes, f. 2; creation of the animals, f. 2v; creation of Eve, f. 3; Christ in majesty f. 4v. The Bestiary begins with Adam naming the animals, f. 5. For Oxford, Bodl. Lib., MS Ashmole 1511 (Morgan, *Early Gothic Manuscripts*, 4/1, cat. no. 19): creation of heaven and earth, f. 4; creation of the waters and the firmament, f. 4v; creation of the plants and trees, f. 5; creation of the sun and moon, f. 5v; creation of the birds and fishes, f. 6; creation of the animals, f. 6v; creation of Eve, f. 7; Christ in majesty, f. 8v; Adam naming the animals, f. 9. For Oxford, Bodl. Lib., MS Douce 151 (poor copy of previous) and Oxford, University College, MS 120, fourteenth century (for brief bibliography see Alexander and Temple, *Illuminated Manuscripts*, cat. nos. 267, 27–8): in this series the creation of birds and fish is depicted on one page, the beasts on the next. An abbreviated version of the Aberdeen group is found in the Leningrad Bestiary, St Petersburg, State Public Library, Saltykov-Shchedrin MS lat. Q.v.V.I (Morgan, *Early Gothic Manuscripts*, 4/1, cat. no. 11); for the Leningrad Bestiary: God creating heaven and earth, f. 1, God creating the firmament, f. 1v, creation of the birds and fishes, f. 2, creation of Eve, f. 2v, Adam naming the animals, f. 5. For the Alnwick Bestiary, formerly Alnwick Castle, Collection of the Duke of Northumberland, MS 447 (Morgan, *Early Gothic Manuscripts*, 4/2, cat. no. 115; for facsimile, see Millar, *Thirteenth Century Bestiary*) the illuminations relating to Creation are: creation of the Angels and the Fall of the Rebel Angels, f. 1v; creation of heaven and earth, creation of trees, f. 2; creation of sun, moon, and stars, f. 2v; creation of birds and fishes, f. 3; creation of animals and of Adam and Eve, f. 3v; God seated on the seventh day, f. 4; Adam between two crowned standing women as he names the animals, f. 5v. Another bestiary with more modest Creation scenes is Cambridge, Gonv. and Caius Coll., MS 109; see McCulloch *Latin and French Bestiaries*, 36, n. 34. (In the Aberdeen Group of bestiaries the Creation is divided into two folios whereas in the Alnwick and Leningrad full pages are devoted to the Creation.)

[60] For a discussion of marginal decoration including bestiary imagery used as *exempla* and painted in the margins of the Queen Mary Psalter; see Lillian M. C. Randall, *Images in the Margins of Gothic Manuscripts*, Berkeley, 1966, esp. 7–8; Lillian M. C. Randall, 'Exempla and Their Influence on Gothic Marginal Art', *The Art Bulletin*, 39, 1957, 97–107. Hassall noted relationships between the bestiaries in the margins of the Holkham Picture Book, Queen Mary Psalter, Peterborough Psalter and Bestiary (Cambridge, Corpus Christi College, MS 53); see William Owen Hassall, *The Holkham Bible Picture Book*, London, 1954, 26. For updated description and bibliography of the Bestiary, Cambridge, Corpus Christi College, MS 53, see *Gothic Manuscripts*, 5, cat. no. 23. The theme of the developing importance of marginal imagery is discussed in depth in Michael Camille, *Images on the Edge: The Margins of Medieval Art*, Cambridge, MA, 1992. More recently Hassig develops the discussion of marginal bestiaries in relation to the Isabella Psalter and the Queen Mary Psalter; see Hassig, *Medieval Bestiaries*, 178.

[61] Queen Mary Psalter. London, BL, MS Royal 2.B. vii, early fourteenth century. For description and bibliography, see Sandler, *Gothic Manuscripts* 5/2, cat. no. 56. See additional references in Chapter 2, fig. 8, n. 5. The Queen Mary Psalter is a good example of an extravagantly illuminated psalter that includes a cycle of tinted drawings in the lower margins, fs. 85v–318. Included amongst the subjects depicted are: real and imaginary creatures from bestiaries, tilting, hunting and hawking scenes, other field sports, various secular pastimes and sports, drolleries, and grotesque monsters. Apart from the series of the miracles of

connections between the Hereford map and the Psalter have already been noted in Chapter 2.)[62] Whereas previously animals were the central imagery of the Bestiary, in these psalters the animals were relegated to the margins with no accompanying explanatory texts, another step toward the disassociation of the subject from the message. By removing the animals to the margins and dislocating them from the format of the traditional bestiary, the viewer was expected to assume more responsibility for making associative connections between the Creation and the scattered bestiary imagery. However, it was the Creation prefatory images, appropriated from the Bestiary to the psalter, that anchored the marginal bestiary images to a meaningful theological system rather than seen as fragmented bits of information. In their new placement, the prefatory pages continued to provide the context for understanding bestiary images now relegated to the *bas-de-page* without explanatory texts. It is of particular interest that on the Queen Mary Psalter, French is specifically employed on the pages of the prefatory Creation scenes and on those that contain the *bas-de-page* bestiary. This suggests that bestiary imagery was particularly chosen to accompany the pages most likely to have been understood by the laity and probably also most frequently looked upon and enjoyed. We clearly have a book that was meant for a lay patron, probably illuminated by a professional artist working outside the monastic realm.[63]

In the example of the Queen Mary Psalter, the prefatory pages of Creation provide the conceptual structure for explaining the bestiary material scattered within (Figs. 4.11, 4.12). For instance, images of animals, although relegated to the margins, still resonate with the inherited lessons of the bestiary tradition because they are associated with the prefatory page of Creation. Similarly, on the Hereford map, the many animals

the Virgin and the lives of the saints, the rest of the *bas-de-page* images are unrelated to the text. Warner indicates that most of the bestiary illustrations are based on *Le Bestiaire* of Guillaume le Clerc with additions influenced by a more comprehensive Latin prose model; see Warner, *Queen Mary's Psalter*, 32–8, pls. 149–72.

62 Queen Isabella Psalter. Munich, Staatsbibl., MS gall. 16, 1303–(?)8. For description and bibliography, see Sandler, *Gothic Manuscripts*, 5/2, cat. no. 27. The psalter is in Latin (in black on versos) and French (in red on rectos); however, the Bestiary is limited to the lower margins of the French pages from f. 9 to f. 64.

63 Scholars have considered developments in workshop practices that were a function of monastic illuminators supplanted by professional lay artists working independently or in conjunction with religious houses. For instance, according to Egbert, the Tickhill Psalter was written by a monastic scribe, John Tickhill, at the Augustinian Priory of Worksop, near Nottingham, but illuminated by a group of traveling professional artists. Some of the professional artists seem to have worked on other manuscripts such as the Psalter of Queen Isabella (1303–8), the Book of Hours executed for members of the Grey and Fitzpayn families, now MS 242 in the Fitzwilliam Museum at Cambridge (before 1308), and others. Egbert suggests that at least four manuscripts, including the Tickhill, were produced in central England in the diocese of York during the first quarter of fourteenth century. He believes that they were decorated by a group of illuminators who worked largely for Augustinian monasteries and for a number of interrelated families with ties to the Augustinian houses. Egbert notes that Matthew Paris employed at least one professional illuminator; and based on a fragment of the Royal Household Account Rolls of Edward II (1302–7) a professional painter was in the king's employ; see Egbert, *Tickhill Psalter*, 3, 80–1. Muratova suggests a variety of workshops in Lincolnshire including a monastic scriptorium at Crowland (which she suggests may have connections to the Leningrad and Morgan Bestiaries), a cathedral scriptorium and lay workshops, although no conclusive study has been done; see Muratova, 'Adam', 392–3.

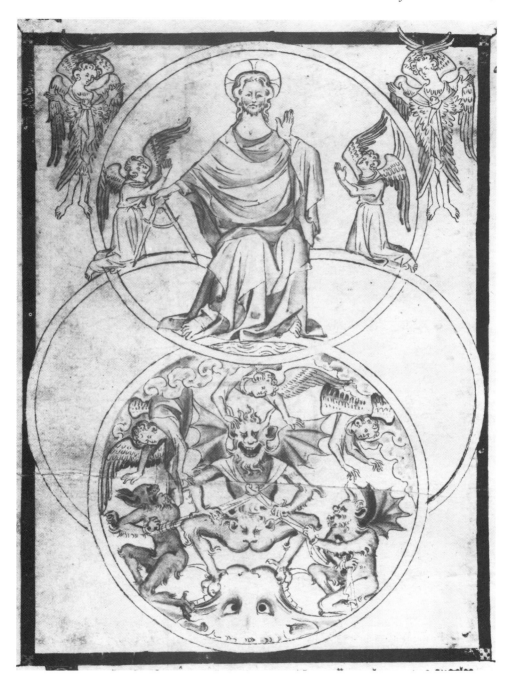

Fig. 4.11 God with Compass and the Fall of the Rebel Angels. Queen Mary Psalter,
London, British Library, MS Royal 2.B. vii, f. 1v. Early 14th century
By kind permission of the British Library

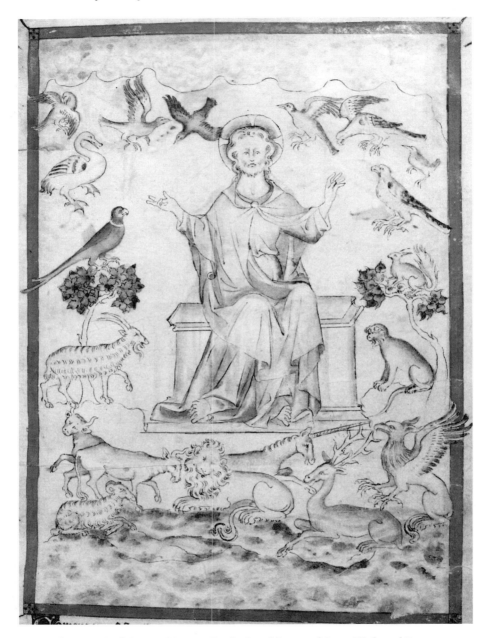

Fig. 4.12 God Creates Heaven, Earth, Sun, Moon and Stars, Birds and Beasts.
Queen Mary Psalter, London, British Library, MS Royal 2.B. vii, f. 2.
Early 14th century
By kind permission of the British Library

are also marginalized insofar as they are largely devoid of their full descriptions, and are scattered geographically (which appears at first sight as random). Nevertheless, they recall the viewer to the Bestiary as part of the memory system of medieval devotion.

In the Holkham Bible Picture Book,[64] (Figs. 4.13, 4.14) the preliminary images of the Wheel of Fortune, God with Compass, and the Creation of the Animals, although uniquely tied to prefatory bestiary pages, are disassociated from a bestiary altogether. The Holkham Bible Picture Book, although possibly also related to the Queen Mary Psalter,[65] is the hybrid of the group – not a bestiary or psalter, rather it is an odd collection of images and texts.[66] Written entirely in Anglo-Norman, Hassell suggests it was directed to a comfortable and educated, but not high-brow, audience of laymen or ladies.[67] Its intention for a rich lay owner is made clear by the Dominican Friar's words of instruction to the artist-author of the book on the opening page where he indicates that the volume should be particularly fine because it will be seen by a wealthy gentleman, presumably a benefactor:

> So you will make it well and splendidly,
> For it will be shown to a powerful nobleman.[68]

[64] Holkham Picture Book. London, BL, MS Add. 47682, *ca.* 1320–30. For description and bibliography, see Sandler, *Gothic Manuscripts*, 5/2, cat. no. 97; for facsimile, see Hassall, *Holkham Bible*; for Anglo-Norman text, see Pickering, *Anglo-Norman Text*. Sandler believes that in concept and style the manuscript belongs to the 'movement toward the pictorial vernacular', a feature of English illumination of the second quarter of the fourteenth century. The date is in agreement with Hassall; see Sandler, *Gothic Manuscripts*, 5/2, 106.

[65] Pickering notes the resemblance between the prefatory pages of God with compass and the Creation images in both manuscripts. Pickering also cites approximately forty lines of texts in the Queen Mary Psalter which are close to those of Part I (Creation section of approximately 260 lines of text) of the Holkham Bible Picture Book; see Pickering *Anglo-Norman Text*, 70.

[66] The book has no contemporary title: it is not meant as an illustrated Bible. The book has been described by Hassall as concerned with the events of the Creation, Incarnation, and Doom; see Hassall, *Holkham Bible*, 4. Pickering notes its lack of typological or moralizing texts which set it apart from the *Biblia pauperum* or the *Speculum humanae salvationis*; see Pickering, *Anglo-Norman Text*, xiv.

[67] Hassall, *Holkham Bible*, 31, nn. 1, 2. The lack of heraldry suggests a wealthy but probably not noble patron.

[68] *Ore feres been e nettement, / Kar mustré serra a riche gent.* Pickering, *Anglo-Norman Texts*, 3. For another version, see Hassall, *Holkham Bible*, 54. The other inscriptions on this f. 1 are as follows: (angel):

In ceo livere est purtret	(In this book is portrayed
Meyn dé miracle que Deux a fet,	A great many miracles God has performed
E dedenz est escryt	And in it is written
Coment Jhesu de Marie naquyt,	How Jesus was born of Mary
E tretute sa passioun	And set out is his passion
E sa resurexioun,	And his resurrection,
E coment yl suffryt la mort	And how he suffered death
E meyn des hountes a grant tort,	And many an insult and great harm,
E yl tuz jurs lé malade garyt:	And all the time he rejected evil:
Por ceo l'en out de luy despyt.	For this they had contempt for him.
Grant amor yl nous a fet,	Great love he has shown us;
Joye avera en luy cret.	Who believes in him shall have joy.)

The artist's reply to the friar:

Si frai voyre, e Deux me doynt vivere,	(If I see true, and God grants me to live,
Unkes ne veyses un autretel livere.	Such another book you will not see.)

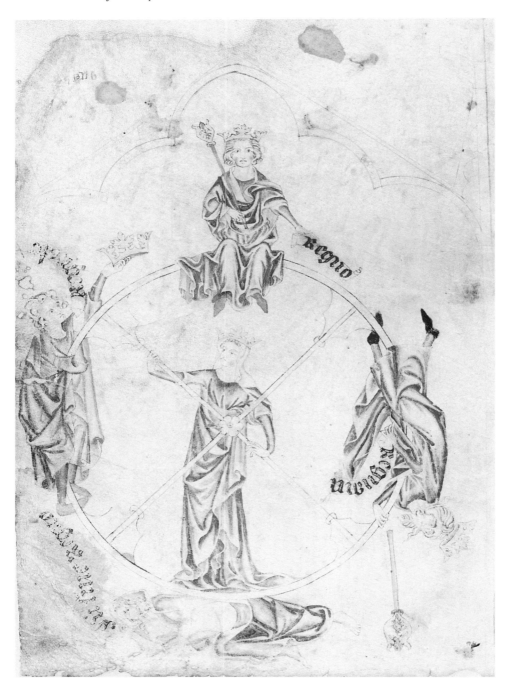

Fig. 4.13 Fortune's Wheel. Holkham Picture Book, London, British Library,
MS Add. 47682, f. 1v. 14th century
By kind permission of the British Library

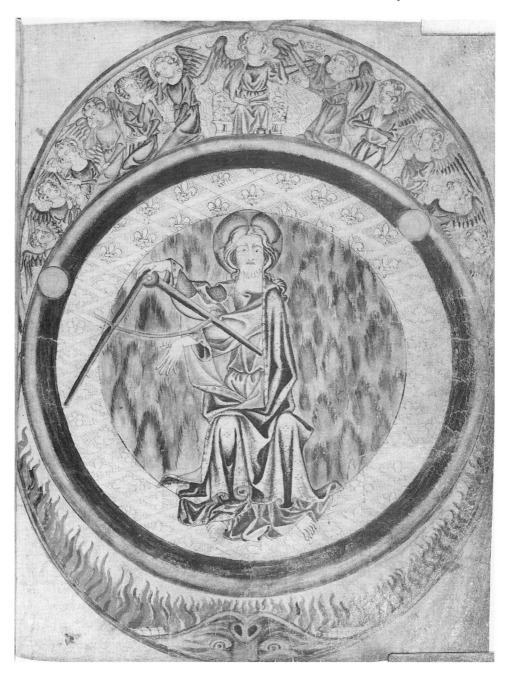

Fig. 4.14 God Creating with Compass, with Heaven and Hell. Holkham Picture Book,
London, British Library, MS Add. 47682, f. 2. 14th century
By kind permission of the British Library

There follow three prefatory pages that serve as introductions to the book: The Wheel of Fortune (Fig. 4.13); God with Compass or 'Divine Providence' (Fig. 4.14); The Creator of Living Things. These three images are separate from the rest of the book and appear to be related to those pages of the Queen Mary Psalter that are in turn based on the types of bestiary prefatory pages suggested earlier. In this arrangement the Wheel of Fortune faces the image of God with Compass. As Pickering aptly notes, the juxtaposition of the two circular images reminds the viewer of the relationship between earthly success or failure and Divine Providence.[69] Both scenes are apt introductions to the following page of God the Creator of *all* Living Things, a new and unique variant of the Bestiary.[70]

As we have seen, the prefatory pages of Creation, ending with Adam naming the animals, were progressively detached from the Bestiary proper and appropriated onto other types of documents. The images, however, detached from the Bestiary, nevertheless still resonated with associations with the Bestiary. At this time, the Bestiary was familiar to most people in one form or another. Memory and visual experience preserved relationships so that the original significance was rarely entirely severed from its source.

Ultimately below the surface, the Bestiary was key. By the year 1300 the parts may have detached themselves from the Bestiary – the image, the text, the moralized message became separate entities to be selected out or not. Prefatory pages that acted as the Bestiary's frame were appropriated onto other types of books. Nevertheless the overriding understanding of the telescopic image of the Bestiary, in which beasts and other aspects of the natural world belonged within the realm of God's creation became part of the collective consciousness. That consciousness is mirrored in the conceptual framework of the Hereford map.

The Bestiary's influence: beyond manuscripts

By the time of the Hereford map, bestiary stories were made widely available through a variety of means to an audience expanded beyond those select individuals fortunate enough to own a Latin bestiary. The material was used in sermons,[71] contained in

69 Pickering, *Anglo-Norman Text*, 70. Alse see Pickering, '*Augustinus oder Boethius? Geschichtsschreibung und epische Dicthung im Mittelalter*, Part I (Philologische Studien und Quellen, 39), Berlin, 1967.

70 From this point, the manuscript, according to Pickering, is divided into three parts: the Old Testament story from the creation to Noah, the New Testament story beginning with the lineage of Mary and Joseph and ending with the ministry and passion of Christ, and the last things, consisting of the fifteen portents of the day of judgment. For notes to texts see Pickering *Anglo-Norman Text*, 69–124.

71 For discussion of animal imagery in sermon 'exempla', see Owst, *Literature and Pulpit*, 195–209. According to Morgan, an example of a variant of the Second Family of bestiaries that functioned as a source for sermons was the Bestiary section of London, BL, MS Harley 3244, after 1235. For description and bibliography, see Morgan, *Early Gothic Manuscripts*, 4/1, cat. no. 80; In comparing bestiary texts, especially those of Cambridge, University Library, MS Ii.4.26 (possibly from the Cistercian abbey of Revesby in Lincolnshire) to Cistercian sermons, Morson argues cogently for the Bestiary being a sourcebook for monastic teachings; see John Morson, 'The English Cistercians and the Bestiary', *Bulletin of the John Rylands Library*, 39, 1956, 146–70. Muratova reiterates the point regarding the use of bestiary material for sermons, emphasizing the Lincoln connection to Gilbert of Holland, Abbot of the Cistercian monastery at Swinehead in Lincolnshire, who according to Morson based many of his sermons on bestiary material;

Fig. 4.15 Dove Diagram, Aviary. Paris, Bibliothèque Nationale, MS lat. 2495, f. 2. Late 12th century, northern France

schoolbooks (Fig. 4.15)[72] and romances,[73] incorporated into encyclopedias,[74] and significantly, into the four major French vernacular bestiaries.[75] The fact that by the thirteenth century even many of the Latin bestiaries omitted allegorical discussion,[76] and bestiary images were often unaccompanied by texts, suggests the significance of the themes was well known. From the rarefied borders of expensively illuminated psalters used for private devotion to the more accessible church decoration in stone and paint,[77] images taken from the Bestiary abounded. In the progressively widening secularization and dissemination of the bestiary images, it is not surprising to find that bestiary images were painted on the walls of the painted chamber of the Palace of Westminster as well.[78] In most cases, the images were familiar and fascinating enough to

see Muratova, 'Bestiaries', 118–44, esp. 121, n. 27. Similarly Muratova emphasises how the preface from the Morgan Bestiary was donated, along with other books and a map, to the Augustinian house, Worsop Priory 'ad edificationem fratrum' by Philip Apostolorum, canon of church of Lincoln. This is another example, pointing to Lincoln as a center of bestiary production and the use of the Bestiary in sermons; see Muratova, 'Bestiaries', 118.

72 For example, the Theobaldus Physiologus (containing chapters in metrical verse on thirteen animals), based on the version of the Bestiary known as the *Dicta Chrysostomi*, was used as a schoolbook; see Curley, *Physiologus*, xxviii and McCulloch, *Latin and French Bestiaries*, 40–1; for the aviary as a teaching text, especially for lay brothers; see Willene B. Clarke, 'The Illustrated Medieval Aviary and the Lay Brotherhood', *Gesta*, 21/1, 1982, 70–1. The subject is also considered in Beryl Rowland, 'The Art of Memory and the Bestiary', in *Beasts and Birds of the Middle Ages*, ed. Willene Clark and Meradith T. McMunn, Philadelphia, 1989, 12–25.

73 As an introduction, see Meradith McMunn, 'Bestiary Influences in Two Thirteenth-Century Romances', in *Beasts and Birds in the Middle Ages*, 134–50.

74 Many of the animal legends originally introduced in the *Physiologus* were popularized in encyclopedic works of Thomas of Cantimpré, Albertus Magnus, Vincent of Beauvais, Pseudo-Hugh of St Victor, Alexander Neckam, Jacques de Vitry, Bartholomaeus Anglicus, and Honorius of Autun.

75 The French vernacular bestiary tradition of *ca.* 1225–1325 includes the four major bestiaries as listed by McCulloch: those of Philippe de Thaon, Gervase, Guillaume le Clerc, and two versions probably written by Pierre de Beauvais. Apart from the work of Gervase, the others are largely based upon the B-Is version of the Bestiary; see McCulloch, *Latin and French Bestiaries*, 45–69. Bestiaries written in Anglo-Norman and French provide additional testimony to their enduring fascination and dissemination. In all of these versions, however, to a varying degree, the texts presented Christian interpretations.

76 For instance, The Glossary of Andileubus is a collection of twenty-two short *Physiologus* descriptions, arranged alphabetically and lacking the allegorical discussion; see McCulloch, *Latin and French Bestiaries*, 24.

77 For numerous examples of bestiary images in manuscripts, stone and wood sculpture (misericords), largely confined to English examples with a few French examples (e.g. the painted bestiary of St Savin-le-Mont), see George C. Druce, 'The Medieval Bestiaries, and Their Influence on Ecclesiastical Decorative Art', *The Journal of the British Archaeological Association*, n.s. 25, 1919, 40–82 (part I) and n.s. 26, 1920, 34–79 (part II); Francis Donald Klingender, *Animals in Art and Thought to the End of Middle Ages*, Cambridge, MA, 1971; Muratova argues for Lincoln, York, and Peterborough as key locations for the provenance of bestiaries; see Xenia Muratova, 'Les Cycles des bestiaires dans le décor sculpté des églises du XIIe siècle dans le Yorkshire, et leur relation avec les manuscrits des bestiaires enluminés', in *Atti del V Colloquio della Società Internazionale per lo studio dell' epica animale, della favola e del fabliau*, Turin and Saint-Vincent, 1983, 337–54.

78 Of significance also is the fact that bestiary images were supposed to have decorated the Painted Chamber of Henry III's palace at Westminster. According to Borenius, not only was a 'city' painted over the door of the Queen's Chamber in 1246, and a map of the world painted in the hall of the same castle in 1239, but Borenius also notes two large painted lions for the Painted Chamber in 1233/4 and panels 'containing the species and figures of lions, birds and other beasts' under the 'great history' of same chamber. These

obviate the need for textual accompaniments. In short, the expanded sources and audiences for bestiaries, previously the exclusive realm of religious houses, mirrored developments in literacy, expanded readerships, and workshop practices.

With the relative expansion of literacy and the proliferation of many types of manuscripts and their influences upon one another, the Bestiary underwent further transformations that were reflected in the map. The Hereford map appears to be a product of a workshop environment in which Latin bestiaries of the expanded Third Family, as well as herbals, medical manuscripts, and new vernacular bestiaries were familiar and accessible. Anomalies on the Hereford map, for instance, suggest cross-influences between these types of illustrated texts.[79] The relationship of these different conceptual modes and images to the Hereford map recalls methods of appropriation. This brings us to the larger question of models, model books, and workshop practices.

Models and Model Books

The intent here is to consider the amalgamation of subjects and images on the map operating in the medieval world of ideas. The Hereford map, as considered here, is above all a decorative object that belongs within the domain of art. As primarily a large painting on vellum, the map is related to manuscript illumination; its size and use suggest relationships to wallpainting as well. In considering its animal imagery, I have underscored its relationships to subjects depicted in contemporary manuscripts by referring to bestiaries and other illuminated texts that testify to the expansion, integration and popularization of the subject matter.

The Hereford map was most likely created in a workshop that was not limited to the production of maps. It may possibly have a Lincoln provenance; however, any center of manuscript production would suggest a variety of available models interchangeably

panels were ordered to be displaced in 1237; see Borenius, 'Cycle of Images', 40–50, esp. 46. For discussion of the unusual scene of the rescue of the king of the Garamantes at Westminster, included in a limited number of insular Second Family bestiaries based on Solinus, see David John Athole Ross, 'A Lost Painting in Henry III's Palace at Westminster', *Journal of the Warburg and Courtauld Institutes*, 16, 1953, 160. Binski notes the Garamantes image at Westminster but omits discussion of the Bestiary; see Binski, *Painted Chamber*, 44, 138, n. 97. The exact nature of the bestiary images at Westminster is open to question.

79 For instance, although the alerion is a type of eagle, the description of the alerion as the only pair is not part of the Latin bestiary tradition but is found in the vernacular tradition of Pierre de Beauvais's *Bestiaire*; see McCulloch, *Latin and French Bestiaries*, 197. As already noted regarding buffalo/'buglossa' there is confusion with medical and herbal texts. Similarly, the marsok on the Hereford map is probably inspired by the parandrus described by Solinus as from Ethiopia, the size of an ox, color of a bear, with cloven hooves, branching horns, stag's head, and long hair. When in hiding, it is able to change its appearance to match its surroundings (Solinus, 30: 25). Another possibility is the 'cameleon'. The cameleon rarely occurs in bestiaries; see the chart which lists Oxford, Bodl. Lib., MS Bodley 764 as including both the parandrus (f. 25v) and the cameleon (f. 27); see Morgan, *Early Gothic Manuscripts*, 4/2, cat. no. 98; Richard Barber, *Bestiary*. The animal on the Hereford map appears to be in the process of change; note four different forms of hooves: this is not depicted in either the paradrus or cameleon in MS Bodley 764.

used for manuscripts and maps. It is known that within workshops, ideas and images from existing manuscripts and model books were appropriated and combined in a variety of ways.[80]

The problem of using existing models and model books for mapmaking is compounded by the fact that maps, illuminated or not, are conceived according to different conceptual models. The mapmaker, inventing, or even if creatively 'copying' another map, must select and conflate diverse material from an array of sources. Ultimately the haphazard arrangement of animals, their lack of moralized accompanying texts, the sketchiness of the images, and the lack of narrative detail characterize the non-linear presentation of material on maps as compared to manuscripts, wherein the continuous text ties the narrative together. With a manuscript, by turning pages the reader is forced to remember what came before and to make connections to what follows; maps are experienced piecemeal, requiring the viewer to make disparate connections. On the Hereford map, for instance, the discrete images do not necessarily relate to one another.

If the Bestiary was the most accessible and prevalent source of animal imagery and lore, there were additional, though less accessible, sources perhaps available to the mapmaker as well. Picture books of nature with images of animals obviously had a long tradition and were intermittently available in the Middle Ages. In bestiary studies, scholars have noted in passing such examples as an illuminated manuscript of Hrabanus Maurus' *De universo* (Fig. 4.16).[81] I have already noted the illuminated manuscript of Solinus' *Collectanea rerum memorabilium*. The Montecassino Hrabanus and the Milan Solinus examples were most likely unknown to the Hereford mapmaker, but no doubt there were similar models at hand. According to Edson, Isidore's *Etymologiae* has a great deal of information on animals, some of it scattered through the geographical sections, and may be a likely source as well.[82] However, to my knowledge there were no illuminated or drawn images of animals accompanying any of Isidore's books.

Let us begin by briefly considering some of the ways that models were used. We know that in some instances, based on the close relationships between a number of illuminated bestiaries, illuminated books were copied, one from the other.[83] We know

[80] For general background on model books see Robert Walter Hans Peter Scheller, *A Survey of Medieval Model Books*, Haarlem, 1963; *The Göttingen Model Book: A Facsimile Edition and Translations of a Fifteenth-Century Illuminators' Manual*, ed. Helmut Lehmann-Haupt, Columbia, 1972. For emphasis on model books for animal imagery; see Xenia Muratova, 'Workshop Methods in English Late Twelfth-Century Illumination and the Production of Luxury Bestiaries', in *Beasts and Birds of the Middle Ages*, 53–68; Muratova, 'Bestiaries', 119–44; Samuel A. Ives and Helmut Lehmann-Haupt, *An English 13th Century Bestiary*, New York, 1942.

[81] Hrabanus Maurus, *De universo*, Montecassino, Konv.-Bibl. cod. 132; see Diane O. Le Berrurier, *The Pictorial Sources of Mythological and Scientific Illustrations in Hrabanus Maurus' 'De rerum naturis'*, New York, 1978.

[82] This along with numerous other important facts was communicated to me by Evelyn Edson.

[83] A number of 'paired bestiaries' have been noted to be so similar as to suggest that one was used as a model or else in each group there was a lost prototype. Yapp lists the 'paired group' as London, BL, MS Harley 4751, and Oxford, Bodl. Lib., MS Bodley 764; and the 'Aberdeen Quartet' as Aberdeen, University Library, MS 24, Oxford, Bodl. Lib., MS Ashmole 1511, and Douce 151, and Oxford, University

Fig. 4.16 Animals. Hrabanus Maurus, *De universo*, Montecassino, Abbey Library, MS cod. 132, f. 189

that in some instances only a selection of pages was appropriated from one manuscript to another. Similarly if a map was copied from another map, one assumes there were requirements and also means to individualize the new version. My earlier discussion on the appropriation of prefatory pages of the Bestiary adds further substantiation to the theory. Recall the two pages that were briefly mentioned earlier as anomalously belonging to the Alnwick Bestiary (e.g. Fig. 4.10) – two pages filled with animal images that are indistinguishable from what we actually know as a model book (Fig. 4.17). We also know that alongside actual manuscripts, medieval artisans relied on model books to a substantial degree. The more generalized model books were used in more individualized ways.

In our final discussion concerning sources for the animals on the Hereford map, let us consider generic model books. The Reun Muensterbook (Vienna, Nationalbibliothek, MS Cod. 507), a rare example of a medieval model book, could have been used as a model for objects as conceptually diverse as a map or an illustrated bestiary. Several pages of images and texts were meant to be used as models for bestiaries, others for more generic purposes. The simple outlines of model books closely approximate the linear drawings typical of large illustrated maps such as the Hereford. One could well imagine how these simple models might be copied or transmuted toward descriptive ends. Employing techniques of the miniaturist, the map's artist works with brief sketches applied directly onto the vellum. For the most part, the artist uses simple pen and ink outlines, characteristic of model books, with highlights generally of red, the color of the rubricator. There are also the additional washes and areas of color.[84]

For instance, in one type of image in the Reun Muensterbook, each frame within the page contains a narrative unit consisting of figures, animals, and backgrounds that situate the animal in the moralized narrative. The Latin text on the left of the frame describes the animal; the text above is the moralized message. This is akin to the organization of a bestiary, as opposed to the stark single figures of the Hereford map.

On the other hand, within the same model book are pictures of animals without accompanying texts and without narrative props (Fig. 4.17). Here animals and figures rarely overlap and the subjects do not necessarily follow a systematic order dictated by text. Clearly this type of model is more conceptually suited to the use of a mapmaker.[85]

College, MS 120; see William Brunsdon Yapp, *Birds in Medieval Manuscripts*, London, 1981, 2. For background and discussion of workshop practices relating to the 'Aberdeen–Ashmole' group, see Muratova, 'Workshop Methods', 53–63. An example of an illuminated manuscript, the Hofer-Kraus Bestiary (Cambridge, MA, Philip Hofer Collection, Harvard College Library, MS Typ 101H), has extant prick marks around the outlines of drawings which suggest that it was used as a model although no copy is known; see Scheller, *Model Books*, 101–3; Clarke, 'Illustrated Medieval Aviary', 26–43; Ives and Lehmann-Haupt, *13th Century Bestiary*.

84 Scheller, *Model Books*, 11–18; images are from Austrian model book of around the beginning of the thirteenth century (Vienna, Nationalbibliothek, Cod. 507).

85 Vienna, Nationalbibliothek, MS Cod. 507. The manuscript is attributed to Reun abbey and dated to the early thirteenth century. Folios 1–13 are considered a model book which contain a variety of images including images from the *Physiologus* (fs. 3–3v) and drawings of a variety of animals (fs. 7–10v). Folios 14–16 contain a *mappa mundi*. Folios 16–39 contain the text of Honorius Augustodunensis' *Christianus ad solitarium quendam de imagine mundi*. Also included are works by Hugh of St Victor and

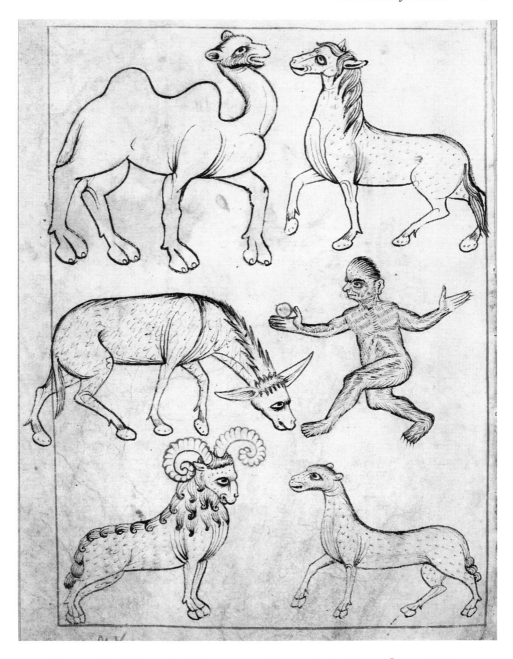

Fig. 4.17 Model for Animal Pictures. Reun Muensterbuch, Vienna, Österreichische Nationalbibliothek, MS Cod. 507, f. 7v

For instance, on f. 9v, in addition to an array of dragon, snake, and scorpion-like forms, there is a monstrous human figure.[86]

It is of particular interest that within the model book a poem entitled *De monstris Indie* has been interpolated between chapters xiii and xiv of Honorius' *De imagine mundi* which is close to Honorius' description of monsters and beasts (f. 43v, *De monstris et bestiis*). This material coupled with the inclusion of a mappa mundi and astronomical drawings accompanying further works by Honorius[87] suggests that books of this type may have provided useful source material for the creation of the splendid types of large maps we are considering here. The model book here mirrors the trend of amalgamating sources into a single compendium, as was the case, for example, in the Third Family of bestiaries.

Using an array of sources both visual and textual as represented by a model book that is at least one step removed from the original source, especially textual, may explain the numerous errors found in the Hereford texts such as 'spitacum' replacing 'psittacum', an error easily made in transcribing,[88] or the confusion of buffalo and 'buglossa'.[89] Similarly it may explain how the image and text in some instances do not always mirror one another. For instance, the manticora is described by Solinus (52: 37) is an animal with a scorpion's tail with stinger; the map's text, credited to Solinus, only mentions the scorpion-like tail; the image makes no reference to either the scorpion-like tail or its stinger.

Conclusion

The book as a model medium through which images and texts were transformed and interchanged in this climate of growing cultural accessibility takes us back to the point about how the circle and the confetti of animals present a powerful image of God's creation. Whereas it is clear that the animals, like most of the material on the map, were based upon antique sources, their meaning was transformed in the medieval context. The fabulous realms and beasts of distant places continued to exert power over the imagination. But in the Christian world, living creatures were to conform within the circle of God's creation. This circle was able to encompass a burgeoning list of strange and diverse creatures, reflected in the conceptual construct of prefatory pages

several anonymous tracts. For discussion of manuscript, see Scheller, *Model Books*, 84–7; Julius Hermann Hermann, *Die deutschen romanischen Handschriften*, 2, Leipzig, 1926, 352–62; P. J. H. Vermeerhen, *Über den Kodex 507 der Österreichen Nationalbibliothek*, The Hague, 1956. The figure from f. 3 includes from top to bottom, left to right: unicorn, panther, lion, phoenix, crocodile, salamander. Folio 3v shows elephant (above), eagle (below).

86 *Lyrche = lurche*, written to accompany the frog.

87 Folios 45–80: Honorius Augustodunensis, *Philosophia mundi*, books 3–5; fs. 81–8: Honorius Augustodunensis, *Chronicon*.

88 Yapp notes that on f. 33v of Oxford, Bodl. Lib., MS e. Mus. 136 (previously noted as a member of the Third Family) *sitacus* is mistakenly written for *psittacus*. She suggests that this error is due to the scribe working from dictation; see Yapp, *Birds*, 2.

89 See above, n. 44.

relating to the Creation and specifically to the creation of animals (Genesis 1: 20–5) found in numerous bestiaries. The scenes of the Creation originally introduced the unifying concept for the moral and ethical teachings to follow. The circular outline of the Hereford map as the symbolic manifestation of God's creative act of encompassing the world within a circle introduces us in a parallel way to the realm of the natural world. Although the images of animals and their accompanying texts do not emphasize moral and ethical lessons, nevertheless the fact that the images are surmounted by the Last Judgment argues for the intentionality of latent meaning to reconcile the images with a deeper context beyond place. In this case the circle as a memory device encompasses the animals of Creation. 'Place' in this instance supplies the *locus* or visual container for recalling from memory information sorted and stored in visual constructs like those suggested in the previously described memory treatise, the *Rhetorica ad Herennium*.

The Bestiary probably originated in monastic centers where illuminated manuscripts were employed as memory devices for lay brothers for whom the images triggered memory of lessons that were read aloud to them.[90] However, by the twelfth and thirteenth centuries the subject matter was widely understood with or without texts. In spite of the fact that the Hereford map was dependent upon the Bestiary in terms of imagery and conceptualization, its lack of moralizing indicates a degree of secularization that belies its contemporary developments. This may be a reflection of at least two factors: (1) the Third Family of bestiaries played a role in the dissemination of ideas and greater detachment of the subject from the message; and (2) in the thirteenth century, the animals of the Bestiary, as exemplars of Christian moralization, entered the secular realm largely through sermons. These popularizations of the ethical and moralizing messages of the Bestiary ultimately opened possibilities for the exemplars to detach themselves from the Bestiary; images were appropriated without explanatory texts onto pages of other types of manuscripts and incorporated into other artistic forms. Bestiary material infiltrated so many avenues of experience, oral and visual, that it was able to touch the imagination and spirituality of a vast audience, both literate and non-literate. Thus the lessons of the pictorial frame, the circle and deeper meanings of animal symbolism, were not lost on viewers. The Bestiary, albeit filtered through the mapmaker's eyes and mind as well as the viewer's eyes and mind, was clearly relevant to the making and the understanding of the Hereford map both in texts and image. In a church setting, the animals could be 'read' as exemplars as well as geographical entities.

[90] Rowland, 'Memory and the Bestiary', 18; Clark, 'Illustrated Medieval Aviary', 71.

5

THE WORLD OF STRANGE AND MONSTROUS RACES

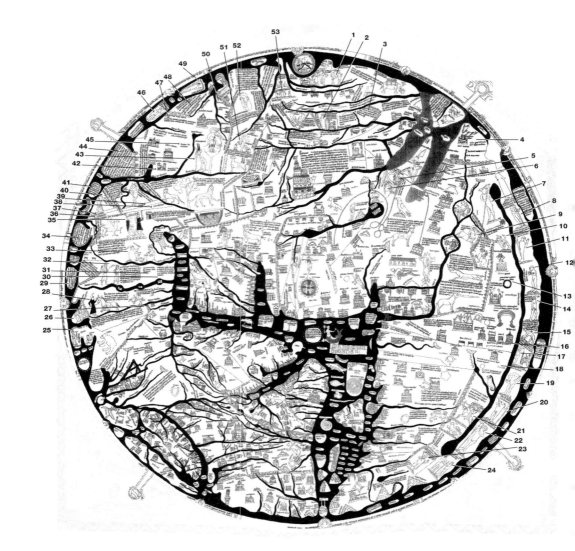

Gigantes (Giants): Inscription: *Gigantes* · (Giants.)

Pandea (Pandea): Inscription: *Pandea gens yndie a feminis regitur* · (The Pandean people of India are ruled by women.)

Corcina (Corcina): Inscription (no image): *Gens corcina circa malleum montem habitant · cuius umbre ab [=ad] aquilonem cadunt hyeme ad austrum estate* · (The Corcina people live around Mount Malleum, whose shadows fall north in winter, south in summer.)

Nibei (Nibei): Inscription (no image): *Nibei · gens nibie · ethiopes · christianissimi* · (The Nubians. The Nubians of Ethiopia are very Christian.)

Mahum (Mohammed): Inscription: *Mahum* (Mohammed.)

Judei (Jews): Inscription: *Iudei* · (Jews.)

Satirii (Satyrs): Inscription (partially unreadable): *Satirii* · (Satyrs.)

Ambari (Abarimon): Inscription: *Gens sine auribus · ambari dicti · quibus adversis plantis* · (A people without ears called the Abarimon because the soles of their feet face backwards.)

Fauni (Centaurs): Inscription: *Fauni · semi caballi homines* · (Centaurs are half-horse, half-human.)

0 Gens labro (Amyctyrae): Inscription: *Gens labro prominenti · unde sibi faciem obumbrans · ad solem* · (People with a very large lip with which they shade their faces from the sun.)

1 Scinopodes (Scinopodes): Inscription: *Scinopodes · qui uni cruri mire sceleres [celeres] · plantis obumbrantur · idem sont [sunt] monoculi* · (The Scinopodes, a strange and wicked (swift) one-legged race who are shaded by the sole of the foot; they are of the same [race] as the One-eyes.)

2 Gens ore (Straw-drinkers): Inscription: *Gens ore concreto calamo cibatur* (A people with rigid faces who are nourished through straws.)

3 Sienee gentes (Syene): Inscription (no image): *Sienee gentes* · (Syene people.)

4 Gens uterque sexus (Hermaphrodites): Inscription: *Gens uterque sexus innaturales · multimodis modis* · (A bisexual people, unnatural in many of their customs.)

5 Himantopodes (Himantopodes): Inscription: *Himantopodes · fluxis nisibus · crurium repunt potius quod [=quam] incedunt · et pergendi usum lapsu pocius destinant [quam] a gressu* · (Himantopodes. They crawl along with effort on shaky legs rather than walk and they try to travel by sliding rather than by steps.)

6 Gaetuli, Natabres, Garamantes (Gaetuli, Natabres, Garamantes): Inscription (no image): *Hic · barbari · getuli · natabres · et garamantes · habitant* · (Here dwell the barbarians Gaetuli, Natabres and Garamantes.)

7 Philli (Phylli): Inscription: *Philli pudiciciam uxorum probant · obiectu nouiter natorum serpentibus* · (The Phylli test the modesty of their wives by exposing their newborn children to snakes.)

8 Trocoditee (Troglodytes): Inscription (no image): *Trocoditee* · (Troglodytes.)

9 Blemee (Blemyae): Inscription: *Blemee · os · et oculos habent in pectore* · (The Blemyae have their mouth and eyes in their chests.)

0 [Epiphagi] (unnamed): Inscription: *Isti os et oculos habent in humeris* · (These people have eyes and mouths on their shoulders.)

21 Trocodite (Troglodytes): Inscription: *Trocodite · mire sceleres · specu accolunt · serpentes edunt · feras saltibus apprehendunt* · (The Troglodytes, marvelously wicked, they dwell in caves; they eat snakes, they capture wild animals by jumping.)

22 Marmini Ethiopes (Marmini): Inscription: *Marmini · ethiopes · quaternos oculos habent* · (The Ethiopian Marmini have four eyes.)

23 Agriophagi (Agriophagi): Inscription: *Agriophagi · Ethiopes solas panterarum et leonum carnes edunt · habentes regem · cuius in fronte [oculus] unus est* · (The Ethiopian Agriophagi eat only the flesh of panthers and lions, they have a king with only one eye in his brow.)

24 Gangines Ethiopes (Gangines): Inscription: *Gangines ethiopes · amic[it]ia cum eis non est* · (The Gangines of Ethiopia, there is no friendship with them.)

25 Gansmir (Gansmir): Inscription: *Gansmir* · (represented by man with ski).

26 Cinocephales (Cynocephali): Inscription: *In hoc tractu sunt cinocephales* · (The Cynocephali are in this tract of land.)

27 Alani (Alans): Inscription (no image): *Alani sithe* · (Scythian Alans.)

28 Griste (Gryphae): Inscription: *Hic habitant griste homines nequissimi · nam inter cetera facinora · eciam de cutibus hostium suorum · tegumenta sibi · et equis suis faciunt* · (Here the Gryphae live; most wicked men for among their other crimes they even make coverings for themselves and their horses from the skin of their enemies.)

29 Terraconta (Terraconta): Inscription: *Terraconta insula · quam inhabitant Turchi de stirpe Gog · et Magog · gens barbara et inmunda · iunuenum [=iuuenum] carnes · et abortiua manducantes* · (The island of Terraconta where the Turks dwell, descendants of Gog and Magog; a barbarous and unclean race, devouring the flesh of youths and abortions.)

30 Catharum (Satarchae): Inscription (no image): *Catharum [=Satarchae] · sithe · vsu auri argentique dampnato · in eternum a puplica [publica] se auaricia dampnauerunt [=uindicauerunt]* · (The Satarchae Scythians. Having condemned the use of gold and silver, they have forever saved themselves from public avarice.)

31 Scitotauri (Scithotauri): Inscription (no image): *Scitotauri · sithe · pro hostiis cedunt aduenas* · (The Scithotauri Scythians kill strangers for religious sacrifices.)

32 Scitharum gens (Scythari): Inscription (no image): *Scitharum gens interius habitancium · asperior ritus · specus incolunt · pocula non ut essedones de amicis · sed de inimicorum capitibus sumentes · amant prelia · occisorum cruorem ex uulneribus ipsius bibunt · numero cedium honor crescit · quarum expertum esse · apud eos prophanum est* · (The Scythari people inhabit the interior. They have rather harsh rituals. They are cave-dwellers making cups, not like the Essedones from the skulls of friends, but of their enemies. They love war; they drink the blood of enemies from their wounds; their reputation

increases with the number of foes slaughtered, and to be devoid of experience of slaughtering is a disgrace.)

33 **Essedones** (Essedones): Inscription: *essedones sithe · hic habitant · quorum mos est parentum funera cantibus prosequi · et congregatis amicorum cetibus: corpora ipsa · dentibus laniare ac pecudum mixtis carnibus dapes facere · pulcrius a se · quam a tineis · hec [haec] absumi credentes ·* (The Scythian Essedones live here, among whom it is the custom to accompany the funeral of parents with song and having gathered a group of friends to shred the corpses with their teeth and make a funeral banquet mixing it with the flesh of cattle, believing these things better consumed by themselves than by worms.)

34 **Yperborei** (Hyperboreans): Inscription: *yperborei ut dicit Solinus · gens est beatissima · nam sine discordia et egritudine uiuunt · quam diu uolunt: quos tedunt vivere · de rupe · nota se in mare precipitant · illud optimum genus · sepulture arbitrantes ·* (The Hyperboreans are, as Solinus says, the happiest people for they live without strife or illness for as long as they wish. Then, when they are tired of living, they throw themselves from a well-known cliff into the sea, thinking that to be the best form of burial.)

35 **Carimaspi** (Arimaspi): Inscription: *Carimaspi · cum griphis pro smaragdis dimicant ·* (The Carimaspi (Arimaspi) battle Griffins for emeralds.)

36 **Robasci** (Rhobosci): Inscription (no image): *Robasci sithe ·* (Rhobosci Scythians.)

37 **Sauromate** (Sauromatae): Inscription (no image): *Sauromate sithe ·* (Sauromatae Scythians.)

38 **Hunochi** (Hunochi): Inscription (no image): *Hunochi sithe ·* (Hunochi Scythians.)

39 **Massagete** (Massagetae): Inscription (no image): *Massagete ·* (Massagetae.)

40 **Albani** (Albani): Inscription: *Albani pupillam · glaucam habent · et plus nocte uident ·* (The Albani have gray-green eyes and see better at night.)

41 **Capharica** (Carparica): Inscription: *Capharica · insula · silvarum habet copiam · ars habitancium in ea in subu[er]tendis] urbigus est · armorum habent copiam ·* (Capharica (Carparica) has many forests. The skill of the inhabitants is in battering down cities. They have plentiful weapons.)

42 **Sogdiani Dache gentes** (Sogdiani and Dahoe): Inscription (no image): *Sogdiani · et dache gentes ·* (Sagodiani and Dahoe people.)

43 **Cicone** (Cicone): Inscription: *Cicone gentes ·* (The Cicone people.)

44 **Antropophagi** (Essedones): Inscription (no image): *Omnia horribilia plus quam credi potest · frigus intollerabile · omni tempore uentus acerimus a montibus quem incole bizo vocant · Hic sont [sunt] homines truculenti nimis · humanis carnibus vescentes · cruorem potantes · fili caim maledicti · Hos inclusit dominus per magnum alexandrum · nam terre motu facto in conspectu principis montes super montes in circuitu eorum ceciderunt · ubi montes deerant · ipse eos muro insolubili cinxit ·*
Isti inclusi idem esse creduntur · qui a solino antropophag[i] dicuntur inter quos et essedones numerantur · nam tempore antichristi erupturi · et omni mundo persecucionem illaturi · (Everything is horrible, more than can be believed; their is intolerable cold; the whole time there if the fiercest wind from the mountains, which the inhabitants call Bizo (the north-east wind). Here there are very savage men feeding on human flesh, drinking blood, the sons of accursed Cain. The Lord closed these in by means of Alexander the Great: for an earthquake took place in the sight of the leader, and mountains fell upon mountains in a circuit around them; where the mountains were absent he himself confined them with a wall that cannot be demolished. And closed in also are believed to be the ones who are called Anthropophagi by Solinus, among whom are numbered the Essedones; for at the time of the Antichrist they will break out and will carry persecution to the whole world.)

45 **Hircani** (Hyrcani): Inscription (no image): *Hircani hic habitant ·* (The Hyrcani live here.)

46 **Phanesii** (Phanesii): Inscription: *Phanesii membranis aurium suarum teguntur ·* (The Phanesii are covered by the skin of their ears.)

47 **Seres** (Chinese): Inscription (no image): *Seres primi homines post deserta occurrunt · a quibus serica uestimenta mittuntur ·* (The Chinese, the first men who come after the desert, export silk garments.)

48 **Eones** (Oeones): Inscription: *Solinus dicit · eones insulas qui inhabitant · omnis [ouis] marinarum auium vivunt ·* (Solinus says all the inhabitants of the Oeones islands live on the eggs of seabirds.)

49 **Ipopodes** (Hippopodes): Inscription: *Ipopodes equinos pedes habent ·* (The Hippopodes have horse's feet.)

50 **Hunni** (Huns): Inscription (no image): *Huni sithe ·* (The Scythian Huns.)

51 **Gangis** (Astomi): Inscription: *Solinus · gangis fontem qu[i] acolunt · solo uiuunt odore pomorum siluestrium · qui si fetorem senserint: statim moriuntur ·* (Solinus. They occupy the source of the Ganges and live only on the scent of the fruits of the forest. If they perceive any bad smell they die instantly.)

52 **Monoculi** (Sciopodes): Inscription: *Monoculi · sunt in yndia singulis cruribus · pernici sceleritate [=celeritate] · qui ubi defendi se uelint a calore solis · plantarum suarum magnitudine · obumbrantur ·* (The Sciopodes are in India swift and nimble with one leg who, when they wish to defend themselves from the heat of the sun, are shaded by the size of their one large foot.)

53 **Pigmei** (Pigmies): Inscription: *Pigmei · cubitales homine[s]* (Pigmies, cubit-high men.)

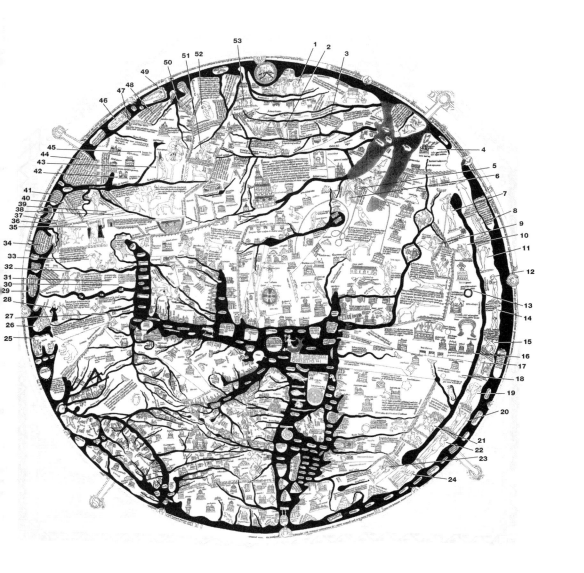

SCYTHIA, INDIA, AND ETHIOPIA were some of the distant lands long ago described by Solinus as exotic, alien, and populated by strange peoples. In the Middle Ages, the same descriptions of far-away places and strange peoples again captured the imagination, for many Europeans heard reports of distant lands from returning crusaders and pilgrims that whetted their appetites for more.[1] Known only through hearsay, the stories of the strange and monstrous races inhabiting countries beyond the reach of the crusades unleashed a fascination with imagined deformities of these folk. Their bodies, attire, habits of eating and locomotion, sexual behavior, treatment of elders, and methods of rulership, as described by the ancients, rekindled interest in that rich source of the fantastic as something to match the European Christian standard against. In the previous chapter we briefly noted how the monstrous races, described by Isidore of Seville, were integrated into the Christian construct of the Bestiary, providing a conceptual parallel between the bestiaries of the Third Family and the Hereford map. In this chapter, we shall see that the strange and monstrous peoples, like the animals, were also originally described by texts largely based on antique authors like Solinus. And they too were incorporated into the medieval collective lore of the distant through odd assortments of information such as 'The Wonders of the East', and other tales about freakish folks. We may glimpse something of the complex process whereby the existence of uncouth races was tenuously reconciled with the Christian belief system of the Middle Ages.

The debate regarding the question of redemption for human monstrosities had a long history. In the Middle Ages, scholars referred to St Augustine's *Civitas Dei* for guidance in dealing with the predicament that monsters posed for the Church. Expanding upon such treatises as Isidore's discussion of monstrous races, Augustine grappled with the question of how the Church could explain the presence of monstrous races in a world created by God. To begin with, Augustine described monsters as prodigies, placed on this earth as an indication of God's power to create all things. By arguing that they were related to the sons of Noah, and therefore redeemable, he provided the

[1] Wittkower provides a good introduction to this material with background to Greek sources, especially links between the earliest surviving report of India by Ctesias from Cnidus (fifth century BC), and Megasthenes' *Indica* (ca. 303 BC) based on Alexander the Great's invasion of India. According to Wittkower many of the Greek descriptions of monsters and strange races had literary origins in Indian epics. Several enlightened figures of the Hellenistic world like Strabo (b. 63 BC) questioned the validity of these stories of marvels, prodigies, and fabulous races, but in spite of developments in geographical knowledge from Aristotle to Ptolemy, the work of Ctesias and Megasthenes was preserved and incorporated into the natural histories of Pliny and Solinus. Their works were given preference by Christian writers of the Middle Ages. Thus according to Wittkower, 'Megasthenes' report on India remained unchallenged for almost 1500 years'. (Actually this is a bit of an overstatement; for instance, Isidore of Seville also questioned some of the 'stories' in *Etymologiae*, XI.) For a detailed discussion of these developments, see Wittkower, 'Marvels of the East', 159–66.

means by which these peoples could be incorporated into the biblical structure with purpose and meaning. According to Augustine, God placed monsters on this earth to participate in the Last Judgment, at which time God's power to refashion the bodies of the dead would be manifest.[2]

Although there is no specific citation of Augustine's words on the map (though he does appear in Hippo within an aedicule), medieval art, in all its manifestations of strange humanoids and composite beings, ultimately carries his message of Christian redemption for all peoples from the furthest corners of the world. On the other hand, much had been written regarding how monsters at the edge of the world represented the 'other', a world of portents unknown.[3] Deep down many Christians still believed that deformed characteristics were signs of God's displeasure, corroborated by crusading literature replete with projections of monstrous traits upon the enemy.[4]

According to St Augustine, the monstrous races provided, in their many guises, material proof of God's plan and final judgment. And yet, as we shall see, given the events of the crusades, the question of the Christian redemption of the 'monstrous' developed as an urgent problem. On the Hereford map, the Judgment and Resurrection are the crowning themes of the pictorial frame that encompasses much of the material from the *Wonders* and Bestiary. Again we find the centrifugal forces of fantastic details tenuously contained within the framework of the Christian belief system.

The Strange Races on the Map: Classical Sources

The encyclopedic tradition was an attempt to embody all knowledge, including that which was known of the monstrous races, and ultimately to contain them within the cosmological construct of the Church. The following is a chronological list of key works regarding the monstrous individuals and races.[5]

2 St Augustine in *City of God*, XVI ('The City of God from the Flood to King David') describes human monsters such as Hermaphrodites, people with no mouths, people who breathe only through their ears and live on air, Pygmies, people whose women conceive when they are five years old and die before they are eight, Sciapodes of one leg with two feet who nevertheless run with speed without bending a knee and shield themselves from the sun with their feet, neckless folk (Blemyae), dog-headed people, etc., all deriving from Adam. In *City of God*, XXI.8 Augustine describes 'monsters as divine omen'. For discussion, see Gibb, 'Wonders', 41–52. For translation of St Augustine, esp. discussion relating to *monstra, ostenta, portenta, prodigia*, see Saint Augustine, *The City of God against the Pagans*, trans. William M. Green, Cambridge, MA, 1972, VII: 57–8. The text is cited by Mary Campbell, *The Witness and the Other World*, Ithaca, 1988, 77.

3 This subject has attracted a great deal of renewed interest. John Block Friedman, following Wittkower's ground-breaking article, has provided a starting point for much new scholarship on this topic; see Friedman, *Monstrous Races*. Later scholars have concentrated on the contextual meaning of the 'other', e.g. Campbell, *The Witness*; Jeffrey Jerome Cohen, 'The Limits of Knowing: Monsters and the Regulation of Medieval Popular Culture', *Medieval Folklore*, 3, 1994, 1–37.

4 See Chapter 7.

5 The list and brief bibliography is based on Paul Allen Gibb, 'Wonders of the East: A Critical Edition and Commentary', unpublished Ph.D. thesis, Duke University, 1977, 36–7, n. 15; Bruno Roy, 'En marge du monde connu: les races de monstres', in *Aspects de la marginalité au Moyen Age*, ed. Guy-H. Allard, Montreal, 1975, 70–80, esp. 79–80; Wittkower, 'Marvels of the East', 168–71.

Table 1

5th c. BC	Ctesias of Cnidus
4th c.	Megasthenes, *Indica*
1st c. AD	Pliny, *Natural History*, VII, VIII.
3rd c.	Solinus, *Collectanea rerum memorabilium*
5th c.	Martianus Capella, *De nuptiis Philologiae et Mercurii*, VI (ed. Adolfus Dick, Stuttgart, 1969, 344 ff.)
6th c.	*Liber monstrorum de diversis generibus* (ed. Moriz Haupt, in *Opuscula* II, Leipzig, 1876)
	Cosmas Indicopleustes, *Topographie chrétienne* (ed. Wanda Wolska-Conus, Paris, I, 1968)
7th c.	Isidore of Seville, *Etymologiae*, XI: 3 (2 vols., ed. W. M. Lindsay, Oxford, 1911)
	Aethicus Ister, *Cosmographia*
9th c.	Hrabanus Maurus, *De universo* VII (*Patrologia latina*, CXI: 195–9)
	Letter of Alexander to Aristotle (cf. Edmond Faral, in *Romania*, 43, 1914)
	Letter of Prester John (V. Slassarev, *Prester John. The Letter and the Legend*, Minneapolis, 1959)
11th c.	Pseudo-Hugh of St Victor, *De bestiis* (*Patrologia latina*, CLXXVII)
12th c.	Honorius Augustodunensis, *Imago mundi*, I: 11–12 (*Patrologia latina*, CLXXII: 123–4)
13th c.	*Roman d'Alexandre* (cf. A. Hilka, *Romanische Forschungen*, 29, 1911)
	Gervase of Tilbury, *Otia imperiala* (cf. Montague Rhodes James, *Marvels of the East*, Oxford, 1929)
	Thomas of Cantimpré, *Liber de naturis rerum*, III (ed. J. B. Friedman, in *Cahiers d'études médiévales*, 2, 1974)
	Jacques de Vitry, *Historia Hierosolymitana*, XCII (ed. W. A. Hinnebusch)
	Vincent of Beauvais, *Speculum naturale*, 31, ch. 118–27; *Speculum historiale*, I: 64; IV: 53–60
	Roger Bacon, *Opus maius*, (ed. John Henry Bridges, Oxford, 1897, I: 291–368)
	Brunetti Latini, *Le Trésor*, I : 4–5 (ed. Francis J. Carmody, Los Angeles, 1948)
	Gauthier of Metz, *Le Romaunce del ymage du monde* (cf. C. V. Langlois, *La Connaissance de la nature et du monde*, Paris, 1927, 166–80)
	Rudolf of Ems, *Weltchronik*, ch. 20 (ed. Gustav Ehrismann, Berlin, 1915, repr. Dublin, 1967)
	Albertus Magnus, *De animalibus* XXII–XXVI (2 vols., ed. Hermann Stadler, Münster, 1916)
14th c.	*Gesta Romanorum* (ed. Hermann Oesterley, Berlin, 1872, 574–6)
	John of Mandeville, *Voyages* (*Mandeville's Travels: Texts and Translations*, 2 vols., ed. Malcolm Letts, London, 1953)

Once again, let us return to the classical sources as the foundation.

Solinus

Although much of the information on the map regarding these peoples is excerpted from the geographical thumbnail sketches in Solinus' *Collectanea*, the selective detachments from the original substantially changed the tenor of intentions from model to copy. Whereas the map's texts are taken out of context so as to emphasize the strange and odd, Solinus' work in its original entirety was more inclusive. For instance, in his account of India, there is awe and respect for the people and their customs. When describing the Indians he speaks of how

some farm the fields, many engage in warfare and others in trade: the best and wealthiest take charge of public affairs, minister justice and assist the kings. There is an untroubled kind of most outstanding wisdom there in that those who have completed their life summon death with burning pyres.[6]

Similarly, in describing the Prasians of Palibotra he pictures an orderly society.[7] For the Pygmies he suggests they are dark skinned simply because they are scorched by the sun.[8] The Pandeans are governed by women: again no derogatory message here.[9] He speaks positively of the difference in attire, customs, and conditions, including the fact that some peoples wear no clothes.[10]

In describing the behavior and aspect of the Indians, Solinus describes a range of attire, sizes, and habits:

> Some are nourished only by fish and live by the sea. There are those that slay their parents and relations like sacrificial offerings, before they wither with sickness or age, and then make a feast of the flesh of the victims, which they count there not as a crime but a sign of piety.[11]

The description takes pains *not* to belittle these people and their customs; he points out that wickedness is not fixed but is relative to the cultural context. Only when Solinus continues with Megasthenes' description of the mountainous areas are the people described as deformed and monstrous. Interestingly, scholars have noted that in the Middle Ages, and obviously well before, mountains were associated with fear and loathing and 'were taken as examples of God's anger'.[12] In this region, according to Solinus, are those with heads like dogs (Cynocephali),[13] those born with only one leg, some who move swiftly and shield themselves from the sun with their large feet (monoculi),[14] and others who display unusual ways of parturition. There are women described by Ctesias who bear children only once, who turn gray-haired as youths but who live extremely long.[15] Near the Ganges are giants and people who do not eat but live on the scent of apples and die of corrupt air (Astomi).[16] There are others whose women bear children at five years of age and whose life expectancy is only eight

6 Solinus, 52: 9: *Indorum quidam agros exercent, militiam plurimi, merces alii: optimi ditissimique res publicas curant, reddunt iudicia, adsident regibus. quietum ibi eminentissimae sapientiae genus est vita repletos incensis rogis mortem accersere.*

7 Solinus, 52: 12–14.

8 Solinus, 52: 14–15.

9 Solinus, 52: 15–17.

10 Solinus, 52: 19–21.

11 Solinus, 52: 21–2: *plerique tantum piscibus aluntur et mari vivunt. sunt qui proximos parentesque priusquam annis aut aegritudine in maciem eant, velut hostias caedunt, deinde peremptorum viscera epulas habent: quod ibi non sceleris, sed pietatis loco numerant.*

12 John Block Friedman, 'The Marvels-of-the-East Tradition in Anglo-Saxon Art', in *Sources of Anglo-Saxon Culture*, ed. P. E. Szaarmach and V. D. Oggins (Studies in Medieval Culture, 20), Kalamazoo, 1986, 334–6.

13 Solinus, 52: 27–8.

14 Solinus, 52: 29–30; The fact that the Hereford map's inscription indicates *monoculi* ('one-eyes') but illustrates the one-footed figure suggests that the Hereford inscription is a misreading of Solinus' *monocoli*.

15 Solinus, 52: 28

16 Solinus, 52: 30–1.

years.[17] There are people without heads (Blemyae), with eyes on their shoulders (Ephiphagi),[18] and a race of wild men with teeth like dogs who gnarl like dogs, amongst whom are bigamists and whose wives offer themselves as sacrifice upon their husband's funeral pyre.[19] The descriptions are largely non-judgmentally anthropological.

The Map

On the map those peoples of India selected for depiction are all, except the Blemyae, who will be discussed shortly, closely grouped around the easternmost section surrounding the medallion that encloses the Garden of Eden: the Gangines (Astomi), Monoculi (*recte* Monocoli, i.e. Sciopods), Pygmies, Giants,[20] and Pandean queen. Not depicted but described in terms of place are the Corcina people who live near Mount Malleus. The peoples selected for India are relatively close to the norm in appearance. The Pandeans and Gangines (Astomi) differ from westerners in customs and diet respectively. The Pandeans are ruled by women and the Astomi live entirely on the scent of apples. Pygmies and Giants are different from westerners only in size. The Corcina are mentioned but not described as odd in any way. Only the Monocoli are seriously deformed. The humanness of the Gangines (Astomi), Pygmies, and Pandean queen is underscored by the fact that their bodies are covered, the civilian clothing of the Gangines (Astomi) opposed to the shields of the Pygmies and Pandean queen. Descriptions are largely taken from Solinus.

When we move to the southern perimeter and consider the foreign races depicted there, their deformities become more outlandish and their customs more deviant. These peoples form a J-shaped chain surrounding the Nile extension, an area that represents Ethiopia, where many ideas about it were based on traditional lore. Lined up, one above the other, individually mounted on pedestals of rocks representing frightening mountainous places, the viewer is shown a parade of deformities. Piles of rocks located these people in mountainous places, which set them apart from those who inhabited cities symbolized by castles, churches, and towers. In other words, on the map, these peoples' 'otherness' was underscored by the rocky pedestals in comparison to the buildings symbolic of 'civitas'. The figures set on the rocks were the relatives of the wildmen who were believed to live as savages in the undeveloped wilderness. In the Middle Ages, nature was feared; the uncontrollable wilderness loomed frighteningly against the security of the enclosed. For these strange peoples, the flatness of their images is starkly contrasted with the attempt to describe in three dimensions cities, churches, and other enclosures. For instance, the Garden of Eden is visualized on the map as encircled by a protective wall, whereas the strange peoples'

[17] Solinus, 52: 31–2.
[18] Solinus, 52: 32.
[19] Solinus, 52: 32–3.
[20] Solinus, 52: 20. The giants as illustrated are conflations of dog-headed Cynocephales and Gigants.

confrontations with the viewer are unmediated. The imagery of the map provides rhetorical emphasis to the understated non-judgmental fragments of texts.

Looking from bottom to top we are met by these beings, many of whom look directly at the viewer. Along the north-western side of the Nile from bottom to top is an assortment of peoples and animals: The one-eyed king of the Agriophagi, wondrous large ants that guard golden sand, and the 'exceptionally villainous' Troglodytes (Trocodytes) or 'hole dwellers' who eat serpents and capture wild animals by leaping on them. This provides an introduction to the chain of deformed and/or culturally alien peoples on the southern side of the Nile extension: the Gangines of Ethiopia of whom it is said 'there is no friendship with them' (i.e. they cannot be befriended: two of them are shown embracing each other, so the enmity is evidently toward outsiders), followed by single prototypes of the Marmini with four eyes, Epiphagi (just called 'these' on the map) with mouth and eyes on their shoulders, Blemyae with faces on their chests, Philli (i.e. Psilli) women whose chastity is tested by having their children exposed to serpents (the serpents of Mons Ardens are shown to the right), Himantopodes who walk on all fours, Hermaphrodites ('people of both sexes'), Straw-Drinkers (not actually named), and Scinopods who are conflations of Monoculi (one-eyed people) and Monocoli (one-footed people). On the opposite side of the Nile extension from the Scinopod is an Amyctyra (not named) whose lower lip protrudes so far as to provide shade from the sun. The chain of figures concludes with the Ambari who have no ears. Mention is also made of other peoples though they are not depicted (Barbari, Patabres, Getuli, Garamantei, Sienee gentes).[21]

Here, as opposed to the peoples of India, the overriding theme is the deformity of the races: Himantopodes, Blemyae, Marmini, the king of the Agriophagi, Straw-Drinkers, Hermaphrodites, Amyctyrae, Ambari, Scinopods, Epiphagi exhibit distortions of birth. Those few who are not born deformed (the Philli, Agriophagi people, Ethiopian Gangines, and Troglodytes) are earmarked by their peculiar cultural ways. These are described respectively as their exposure of infants to serpents, their exclusive diet of panthers and lions, their unfriendliness to outsiders, and their diet of serpents (along with their criminality). Their diets, cultural mores, and involvement with serpents and wild animals separate them from the European norm. These people are described as beyond the bounds of civilization: all except the king of the Agriophagi are shown naked. Most have prominent sexual organs, and in some cases traces of red accents can still be detected on these parts. Their weapons do not include shields as was the case with the Indian peoples, but rather (when shown) wooden poles and mallets of varying shapes and sizes.[22] Only the one-eyed king is clad; he wears a crown and carries the regalia. Yet his clothes do not offset the eeriness of his cyclopean gaze.

The last group of races is located largely in Scythia, along the northern edge of the map. It is in this section that the mapmaker has provided the longest and most damning description of the inhabitants. Again, most of the inscriptions are taken from

[21] The inclusion of the centaur and sphinx testifies to the complex byways of the overall conflation of sources. For instance, the centaur and sphinx were also included in the Bestiary; see Appendix.

[22] Timothy Husband, *The Wild Man, Medieval Myth and Symbolism*, New York, 1980, 10.

Solinus. Several folks are listed but not described: Robasci, Sauromate,[23] and Huniochi (?) Scythians,[24] the Massagete.[25] The Albani (Albanians) are simply described as having gray eyes and seeing well at night[26] and the Arimaspi are depicted and described as fighting with griffins for emeralds.[27] All other peoples are shown as horrific and cannibalistic. The Scythotauri (Scitotauri) are described as murdering strangers for sacrifices[28] and the Essedones are described as devouring the corpses of their parents.[29] The customs of Scythian gens (those Scythians who dwell in the interior) are described as 'unduly' harsh. The people are described as 'cave dwellers making cups, not like the Essedones out of the skull of friends, but of their enemies. They love war; they drink the blood of enemies from their wounds; their reputation increases with the number of foes slaughtered, and to be devoid of experience of slaughtering is a disgrace.' The text relating to the skulls used by Essedones is part of the longer description by Solinus that speaks of the Essedones and their custom of setting skulls in gold to use as drinking cups for blood.[30] The material here, largely taken from Solinus, is gory and frightening, unlike those descriptions of peoples in the region of India and Ethiopia. These are peoples to be feared; they are evil-doers.

Scythia is shown to be particularly fraught with dangers, especially the 'enclosure' of the Antichrist that occupies a substantial portion of the geography of Scythia. The place is enclosed on three sides by mountains. The fourth side is surmounted by four tower-like structures or castellations. The accompanying texts suggest a Christian conflation of material taken from the Alexander legend and Solinus:

> Everything is horrible, more than can be believed; there is intolerable cold; the whole time there is the fiercest wind from the mountains, which the inhabitants call Bizo (the north-east wind). Here there are very savage men feeding on human flesh, drinking blood, the sons of accursed Cain. The Lord closed these in by means of Alexander the Great: for an earthquake took place in the sight of the leader, and mountains fell upon mountains in a circuit around them; where the mountains were absent he himself confined them with a wall that cannot be demolished.
>
> And closed in also are believed to be the ones who are called Anthropophagi by Solinus, among whom are numbered the Essedones; for at the time of the Antichrist they will break out and will carry persecution to the whole world.[31]

23 Solinus, 15: 18.
24 Solinus, 15: 17.
25 Solinus, 49: 7–8
26 Solinus, 15: 5
27 Solinus, 15: 23.
28 Solinus, 15: 14.
29 Solinus, 15: 13.
30 Solinus, 15: 13.
31 *Omnia horribilia plus quam credi potest. frigus intollerabile. omni tempore uentus acerrimus a montibus quam incole bizo uocant. Hic sont homines truculenti nimis. humanis carnibus uescentes. cruorem potantes. fili Caini maledicti. Hos inclusit dominus per magnum alexandrum. nam terre motu facto in conspectu principis montes super montes in circuitu eorum ceciderunt. ubi montes deerant ipse eos muro insolubili cinxit. / Isti inclusi idem esse creduntur qui a*

The northern realms are thus associated with darkness and evil. Here the term 'truculentus' (savage) is uniquely employed. Whereas several races of India and Ethiopia were shown to be naked and to follow unacceptable practices, none were described as savage or ferocious. And finally they are described with the sobriquet of 'sons of cursed Cain'.

In this case the enclosing wall is not a safe haven but rather a tenuous container of the forces of evil. It is the monstrous counterpart to the Garden of Eden and Jerusalem. In the next chapter we will examine this Scythian fortress of evil in the context of Alexander the Great.

The Integration of the Strange and Monstrous Races into Medieval Cosmology: More Visual Conflations

Whereas Solinus appears to be the most cited textual source for the Hereford map the 'Plinian races', were, as noted previously, a standard part of the medieval encyclopedic tradition.[32] Two visual sources are also particularly apt for this study: *The Wonders of the East*[33] and the *Liber monstrorum*[34] both of which enjoyed particular favor in England, and were closely tied to Anglo-Saxon tradition. Until relatively recently the texts were considered unworthy of scholarly attention due to their apparent disorder and lack of polished authority; the fantastic texts, distorted progeny of their sources, have nonetheless proven to be deserving of renewed scholarly interest. Because *The Wonders* enjoyed a richly illustrated tradition, they are particularly relevant as they provide a visual parallel to the compressed information on the Hereford map.

Given their concern with locating subjects in geography, albeit quite fictional, the three well-known English versions of *The Wonders of the East*[35] (The Vitellius, the

solino antropophagi dicuntur. inter quos et essedones numerantur. nam tempore antichristi erupturi et omni mundo persecucionem illaturi. See Chapter 6 for further discussion of this topic.

32 See above, n. 6.

33 Also referred to as the 'Marvels of the East' or 'Mirabilia group'. According to Gibb, the 'Wonders' ultimately derive from a purported letter to the emperor Hadrian or Trajan from an obscure king generally referred to as Farasmanes of *ca.* AD 100. For extensive treatment of the subject of the 'Wonders' and extended bibliography, see Gibb, 'Wonders'; Wittkower, 'Marvels of the East', 159–97; James, *Marvels of the East*, 1929.

34 John Block Friedman, 'Marvels', 319–41. Friedman suggests that the texts of the *Liber monstrorum* presented a more savage description of monsters than *Wonders* texts, and therefore a more ethnocentric viewpoint of the 'other'. In his discussion of the imagery of the Tiberius manuscript he argues the more aggressive stylistic presentation may be influenced by knowledge of the *Liber monstrorum*. The *Liber monstrorum* was compiled in England in the 740s and migrated to the Continent. The five known manuscripts are of Continental origin (for a list, see 'Marvels', 321, n. 13). Much of the information is from the *Letter of Farasmanes* tradition and the *Epistola Alexandri* plus Virgil and other Roman authors. For discussion of the *Liber monstrorum*, see Friedman, 'Marvels'; Gibb, 'Wonders', 27 with texts, Appendix; Douglas R. Butturff, 'The Monsters and the Scholar: An Edition and Critical Study of the *Liber monstrorum*', Ph.D. thesis, University of Illinois at Urbana, 1968 (not consulted but cited by Gibb, 'Wonders', 39).

35 London, BL, MS Cotton Vitellius A xv, fs. 98v–106v; London, BL, MS Cotton Tiberius B.v., vol. I, fs. 78v–87v; Oxford, Bodl. Lib., MS Bodley 614, fs. 36r–51v. The *Wonders* sections of these manuscripts are

Tiberius, and the Bodleian 614) may be considered as relevant to mapmaking. By the twelfth century *The Wonders* were included within codices of 'scientific' texts, suggesting that they were by then believed to be more factual than fictitious. Similarly, in the progression, Christian content becomes more pronounced. A brief digression outlines these developments leading to the twelfth-century manuscript, Bodleian 614, which is the closest conceptual analog of the group to the Hereford map.

The Vitellius manuscript (*ca.* 1000), written in Old English,[36] besides including the famous copy of *Beowulf*, also contains, amongst other things, the prose *Letter of Alexander the Great to Aristotle* and the *Life of St Christopher* which involves a story of a saint with a dog's head.[37] Story-telling within the larger province of history and lore, secular and religious, is the framework for the Vitellius *Wonders*. On the other hand, the placement of *The Wonders* text in the Tiberius manuscript, roughly contemporary with the Vitellius,[38] is relatively unconcerned with story-telling but is devoted to texts and images that explain the physical universe and the phenomenal world as it is experienced on earth. Amongst other things, it includes a metrical calendar, computational tables for lunar and solar cycles, a zodiac tract, the *Aratea*, the *Periegesis* and two mappae mundi. There are several images (including the 'Tiberius map') that indicate the import of the work. The page shown here (Fig. 5.1) belongs to what must be considered a cosmological treatise.[39] In this case, *The Wonders* is presented in both Old English and Latin; the addition of the Latin translations further underscores the authority of the material within the pseudo-scientific realm of medieval encyclopedias, catalogs, and cosmological treatises.[40] Thus the historical development of *The Wonders*

available in facsimile in James, *Marvels of the East*. Gibb lists eight known Continental manuscripts with texts similar to *Wonders* but sufficiently different to warrant a different title. Gibb suggests that they are based on a common ancestral text; see Gibb, 'Wonders', Appendix II. Gibb discusses the 'fictive' aspect of the geography of *Wonders*; see Gibb, 'Wonders', 55–9.

[36] Wittkower offers the suggestion that the *Wonders* were translated into the vernacular and thus attracted a lay public possibly following interest in geography fostered by Alfred the Great's Anglo-Saxon version of Orosius; see Wittkower, 'Marvels of the East', 172.

[37] Bibliography for Tiberius manuscript: for a facsimile of Tiberius B.v., vol. I, see *An Eleventh-Century Anglo-Saxon Illustrated Miscellany: British Library Cotton Tiberius B.V. part I*, ed. Patrick McGurk, et al., Copenhagen 1983. The codex, in Old English, contains: *Life of St Christopher*, fs. 94r–98r; *Wonders of the East*, fs. 98v–106v; *Letter of Alexander to Aristotle*, fs. 107r–131v; *Beowulf*, fs. 135r–201v.

[38] Bibliography for Vitellius manuscript: Alexander and Temple, *Illuminated Manuscripts*, 72, cat. no. 52. The contents of the Tiberius manuscript are as follows: an illustrated Latin metrical calendar, fs. 2–7v; computational tables for lunar and solar cycles, fs. 8–19; various lists and genealogies, fs. 19v–23; a note regarding Archbishop Sigeric of Canterbury's pilgrimage to Rome, fs. 23v–24; the Bede extracts, fs. 24–28v; a mappa mundi, f. 29; a prayer to the Trinity, f. 30; the Zodiac tract, fs. 30r–32r; the *Aratea*, fs. 32v–49v; the sun and moon extracts, fs. 49v–54v; a second mappa mundi, f. 56v; the *Periegesis*, fs. 57–73; and *Wonders of the East*, fs. 78v–87v, as described by Gibb, 'Wonders', 6, n. 13.

[39] The Tiberius map is not connected to *Wonders* but it includes several subjects mentioned in *Wonders*; see Gibb, 'Wonders', 57–9.

[40] I am indebted to Andrew P. Scheil for a copy of his paper presented at Kalamazoo, May 1994, 'The Old English *Wonders of the East*: Oriental Discourses in Late Anglo-Saxon England' wherein he discusses the importance of the change from epistolary form to 'open-ended' catalog.

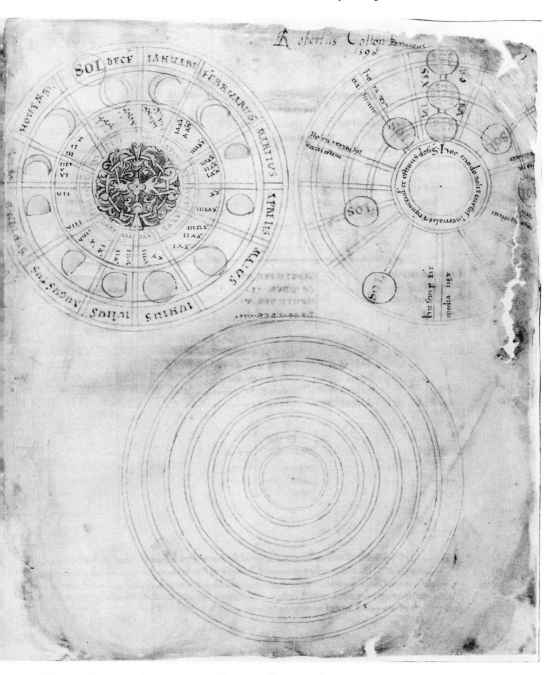

Fig. 5.1 Rotae. Anglo-Saxon Miscellany, London, British Library, MS Cotton Tib. B.V., f. 2
By kind permission of the British Library

Sunt etiã hoĩes ermafrodite nuncupati. eo q̃d
eis utꝗ sexus appareat. Erna q̃ppe apd grecos
masculus dr̃. afrodi femina. Hii dextam mamillã
uirilẽ. sinistrã muliebrẽ habentes. uicissim co
eundo & gignunt & pariunt.

Monstruose q̃ gentiũ scribuntt facies. labro subtu
ou adeo pminentt. ut in sol ardoub; totã exeo
faciẽ ctegant dormientes.

Satiri homuntioẽs s̃t. aduncis naribz frontte
cornibz aspata. cui extrema pars corpouis
in caprũ pedes desinit. q̃lẽ ĩsolitudinẽ s̃c̃s anteo
ǁnius uidit.

Fig. 5.2 Strange Races. *The Wonders of the East,* Oxford, Bodleian Library,
MS Bodl. 614, hermaphrodite, monstrous man, f. 50v (above);
satyr, parrot, f. 51r (right)

Psitacī intti die litoub; gignūt. colore uiridi. torq; puniceo gūdi lūg. & cētīs aiub; latiore. tinde & articlata ūba exprimit. & salutat dicēs. aue. & kare. cētā noīa īstitutioē discit.

Cernunt & in galli carū finib; vii. mulieres chozū ducentes. humo in girū subplantis earū decrescente que huīmodi airsicantes pata lingua edunt uoces. Ise ta misere quā male vii. dū scīn ykri comoui. quando uenet finis secli? Ise q̄ ōs sorozes ferunt cū matre die qdā festo choru duxisse. bisq; pnoiato prbo ad missam parato eas corripiente. trio ut nunq̄. cessarent īprecante? sic pmansisse. Yacuiū autē paret spacū q̄ mat se submonito in trninatiois ab ri putt. duarū separati brachiis ptensis. Haseta te media aliq̄is dieb; ab ōi motu ꝫ uoce coptū ſ. ē. qescere.

from its earliest epistolary form[41] to its Anglo-Saxon transformation into a confusing and choppy catalog suggests the urge to categorize and organize the material in a manner consistent with the scholarly endeavor to embrace knowledge within a larger Christian framework.[42]

In the Tiberius version, *The Wonders* were extended and the book ends with the story of the magicians Jamnis and Mambres – an addition suggestive of the drive toward inclusiveness. The wizards' portents and magic were meant to counteract the miracles of Moses and Aaron. Mambres opens the magical books of his brother Jamnis thereupon learning of his brother's practice of magic and idolatry. Jamnis' soul answers:

> Hail, brother; I am not unjustly dead, but truly and justly I am dead and God's judgment will go against me because I alone was wiser than all the other sorcerers and I withstood the two brothers called Moses and Aaron, who wrought those great tokens and portents.[43]

The message is clearly meant as a moralizing one, taking *The Wonders* out of the secular and into the religious realm. The description of judgment and hell add an obvious Christian dimension.[44]

The last of these versions, MS Bodleian 614, is a twelfth-century recension modeled after the Tiberius *Wonders*. In this recension, the texts are exclusively Latin and *The Wonders* treatise (Fig. 5.2) is incorporated within a codex that includes computational tables followed by tracts on celestial bodies and signs of the zodiac as well as short sections on comets, winds, rainbows (Fig. 5.3), and falling stars.[45] In short, *The Wonders* is fully integrated within a cosmological context.

Subtle changes, however, accompanied this transformation, wherein the Christian cosmological tendencies were further clarified. The texts of the Bodleian *Wonders* were faithful to the Vitellius version, except in one instance – the description of the phoenix. In the Bodleian version, the phoenix was described as a symbol of the redemptive

41 The English examples of *Wonders* descend from a largely Continental text of *The Letter of Farasmanes to Hadrian*. Gibb suggests a date no later than the sixth century for the model; however, if the letter is entirely pseudepigraphical the *terminus ad quem* could be as late as eighth century. For discussion, see Gibb, 'Wonders', 15–18. For discussion of earlier classical sources and history and provenance of text, see Gibb, 'Wonders', 16–30. Gibb suggests that the greatest single source for the text was the legends of Alexander the Great; see Gibb, 'Wonders', p. 21, n. 11. Bibliography for Letter, see Friedman, 'Marvels', 320, n. 5.

42 Scheil suggests that the development from epistolary form to open-ended catalog form provides the proper framework for encyclopedic projects (Scheil, paper, Kalamazoo, 1994); see above, n. 40.

43 Gibb, 'Wonders', 111.

44 Gibb, 'Wonders', 180–4.

45 Bibliography for Bodley 614: Otto Pacht and J. J. G. Alexander, *Illuminated Manuscripts in the Bodleian Library*, Oxford, 3 vols., Oxford, 1966–73, III: no. 156; Kauffmann, *Romanesque Manuscripts*, 77, cat. no. 38. The contents of the manuscript are as follows: (1) an illustrated calendar, incomplete, fs. 1–14; (2) computational tables, fs. 14v–16; (3) illustrated tracts on celestial bodies and signs of the Zodiac, fs. 17–33v; (4) short sections on comets, winds, rainbows and falling stars, fs. 34–35v; (5) *Wonders of the East*, fs. 36–51, as described by Gibb, 'Wonders', 8, n. 16.

nature of Christ, taken verbatim from Ambrose's *Hexameron*.[46] Twelve new subjects
were also added, many of which were well known through bestiaries accompanied by
texts from Isidore of Seville's *Etymologiae*.[47] These internal additions and changes to *The
Wonders* gave a Christian tone to what may have been misconstrued by some as pure
fantasy. The 'scientific' nature of the text was demonstrated by its inclusion amongst
other authoritative texts. There was an overt attempt here to include the world of
strange peoples and animals within a Christian cosmological scheme.

Mary Campbell has wrestled with the idea that the texts of *The Wonders* were 'sub-
versively literal'. She suggests that structurally the disorganized presentation of beings
of a grotesque nature underlied an ethnocentric bias against the impurities and taboos
embodied within the description of these subjects.[48] That may be true, but I would also
argue that because moralized bestiaries were their close analogs, even as early as the
Tiberius version of *Wonders*, a moralized message was implied. Certainly the develop-
ment of the Latinization of *The Wonders* reinforces the possibility.

In any case, in the Bodleian *Wonders* and more obviously in the contemporary besti-
aries with *The Wonders*, the strange and fearful are manifestly brought within the
bounds of Christian salvation. In the Bodleian version the story of Jamnis and
Mambres concludes *The Wonders* as in the Tiberius manuscript, but it is followed by
twelve figures, ten of which are taken from Isidore of Seville and common to bestiaries;
these suggest a moralizing reading. In this twelfth-century version, the addition of the
phoenix as a symbol of the resurrection of Christ, the inclusion of the wizard brothers'
story as a reference to Christian Judgment, and the addition of twelve new 'wonders'
that are largely recognizable through familiar bestiary lore, almost invariably told with
a Christian message, suggest a highly Christianized amalgamation of numerous strands
of story-telling and lore.[49]

Visually the twelfth-century codex, in its themes, messages, and imagery begins to
approximate to the Hereford map – ultimately the many texts that come to be associ-
ated with *The Wonders*, astrological and cosmological, find their place within the inclu-
sive nature of the mappa mundi.

[46] Gibb, 'Wonders', 9. Although the description of the phoenix gains allegorical characteristics, the image
does not indicate its newly moralized function.

[47] James lists the ten apocryphal wonders based on Isidore of Seville as: the unicorn; the mountains of gold;
the chameleon, confused with the camelopard; Sciapodes; Antipodes; Hippopodes; Hermaphrodites;
men with large lower lips; Satyrs; parrot. The two unidentified subjects are: two perpetually fighting
brothers; the accursed dancers. For texts and accompanying notes, see James, *Marvels of the East*, 22–4,
30–2. To compare the list to those included in Hrabanus Maurus and Solinus manuscripts, see Le
Berrurier, *Pictorial Sources*, Table 1, 2 (pp. 50–1).

[48] Campbell, *The Witness*, 60–3. She also cites the work of Mary Douglas. Scheil has also added discussion to
the sexual nature of several of the subjects, providing interesting new material relating to women (Scheil,
paper, Kalamazoo, 1994).

[49] James suggests that the twelve subjects may have been included in Vitellius but lost. No evidence sup-
ports this theory; see James, *Marvels of the East*, 8.

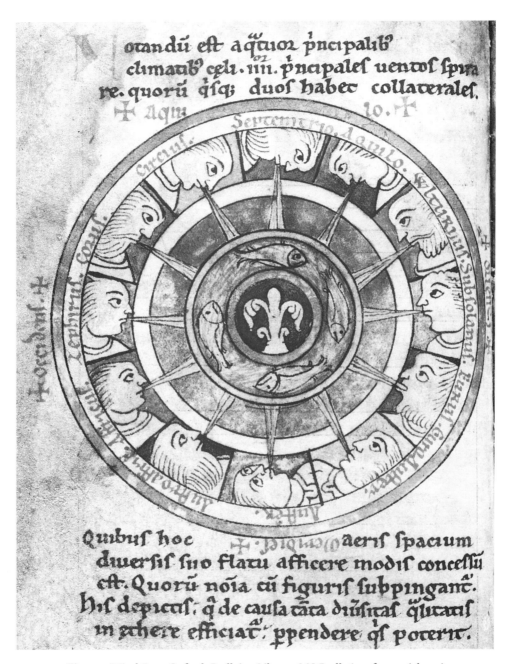

Fig. 5.3 Wind *Rota*. Oxford, Bodleian Library, MS Bodl. 614, fs. 34v (above)
and Rainbow, 35r (right)

© The Bodleian Library, University of Oxford

um calor solis humore eleuat. ut fumus
humidus euaporat? aqua in nube ut in
uitreo uase exspendore sol' relucet. et ubi ē.
tenuior ɣ calidior. rubeū ostendit colorem.
ubi spissior: purpureū uel nigrū. Inde est
ɋ arcus ille numǩm n in obstra parte solis
relucet. Aer enī uicin soli. ex eī spendore ita
irradiatur. quod diuersi colores ī eo apparent.

The Christian Context

As we have noted generally, in the transmitted sources, the 'strange races' were not overtly and overbearingly described as frightening but rather matter-of-factly listed one after another. Their appearances and, in some cases, outrageous habits and behaviors were listed as anthropological notations. This is how they were presented on the map. In fact, the questions of whether or not these strange heathen peoples had souls, were part of God's creation, were able to go to heaven, were not considered in the map's texts. The map was not a carefully composed doctrinal instrument so much as a rather crude attempt to impose a Christian system upon relatively unmediated information; and thus it depended on the viewer's imagination to bridge the gap. In fact, juxtapositions of content as well as style appear to be almost intentionally presented as such. Not only is the powerfully evocative Christian theme of the Last Judgment set above a hodgepodge of material inside the circle but textually and artistically the two are presented differently as well. Whereas the texts describing the peoples are all in the generally denatured Latin found throughout the map's interior, the pictorial frame's Judgment scene is accompanied by carefully composed vernacular texts. Similarly the squat, less refined forms of the peoples on the map appear exceptionally ungainly when measured against the Gothic elegance of the elongated figures of Christ and surrounding angels. Because the inhabitants of Europe are not described or illustrated, the figure of Christ and those surrounding him serve as their exemplars by default; their long bodies and graceful drapery are linked to the beauty of the Christian message.

These visual dichotomies and distinctions were understood to have meaning; the medieval viewer looked to visual clues as well as textual ones. The two different styles of images and texts called attention to the hierarchical order of Christ above other peoples of the world. Artistic devices bestowed a scale of importance and meaning – as for instance up–down, east–west, interior–borders of the map. Tellingly most of the strange and monstrous peoples are relegated to the southernmost and northernmost reaches of the world far from the navel of Jerusalem.

Ironically, whereas the classical texts emphasized the distant locations of these folks, by the twelfth and thirteenth centuries, many far places, while still considered exotic, no longer suggested the same degree of 'strangeness'. And although there were contemporary reports and descriptions of the 'other' peoples with discussion of their disgusting ways and appearances, the map's texts and images did not engage the viewer overtly in that contemporary discourse, although it was likely implied. The world of the monstrous was largely pushed beyond the Islamic world to the furthest edges of the map.

In spite of intentions to situate the strange races within a geographical construct or to compress them into a Christian system, for the viewer the attraction was atavistic. Physically the monstrous peoples were viscerally disturbing, not because they were so strange but rather because they *could* be reconciled into the existing Christian framework and as such presented themselves as mirrors. Lacking or having extraordinary

Fig. 5.4 Strange Races, Model Book. London, British Library, MS Harley 2799, f. 243.
12th century, German
By kind permission of the British Library

body parts, they threatened the medieval conception of the completeness and integrity of the body. The 'strange' races were reminders of fears of deformities that in varying degrees were seen in every village on a less exaggerated scale. And their murderous instincts, lustful ways, listed so matter-of-factly, only provided further reminders of their suitability to the earthly realm.

As we shall see, once the discourse regarding monsters was reopened within the context of the crusades, the categorization became a step toward the conscious assimilation of these individuals and peoples.[50] The seams were bursting though; and the scientific pressures of curiosity were soon to overcome the perimeter of Church dogma, and the circle of containment would be broken.[51] In effect, the Hereford map paid homage to authority – to the authority of the ancients and to the authority of a Church that attempted to incorporate what remained of ancient knowledge in the west. However, by *ca.* 1300, the pictorial frame could only tenuously contain this material (Fig. 5.4).[52]

[50] Roy, 'En marge', 70–80.

[51] Christian K. Zacher, *Curiosity and Pilgrimage: The Literature of Discovery in Fourteenth-Century England*, Baltimore, 1976.

[52] London, BL, MS Harley 2799, f. 243, twelfth-century German model book. Top register: Cynocephali, Cyclops, two Blemmyae, noseless man; middle register: Amyctyae (lip), Panotae, straw-drinkers, speechless one, Artibatirae (walk on all fours); horned humans with hooked noses and goat's feet; Antipodes (opposite footed); bottom register: Sciopod (shadow foot); Hippopod (horse footed), twelve-foot giant with horse's hooves; two pygmies with shields. The selection included here is very close in subject matter to that of the chapter *De portentis* in Hrabanus Maurus' *De rerum naturis* (also known as *De universo*). According to Le Berrurier, the following are subjects of illustrations and are generally displayed in this order: Hermaphrodites, Cynocephales, Cyclopes, Blemmyae, Epiphagi (eyes on shoulders), Prominent Lip, Small Mouth, Panotii, Artabatirae, Satyres, Sciopods, Antipodes, Hippopodes, Pygmies, Hydra, Chimaera, Minocentaur, Onocentaur, Hippocentaur. The representations appear close in organization to the Psalter map, e.g. see Le Berrurier, *Pictorial Sources*, fig. 1 (*De portentis*, Montecassino, Codex casinensis 132, f. 84v). Note general similarities of Hrabanus Maurus texts to Hereford map: e.g. Scinopodes and Cyclopes (*ibid.* 33), Small Mouth (*ibid.* 27), Hermaphrodites (*ibid.* 17), Hippopodes (*ibid.* 33), Blemmyae (*ibid.* 24), Satyrs (*ibid.* 29). Also see discussion of relationship between illustrations for Hrabanus Maurus and Solinus manuscripts, *ibid.* ch. 4. For additional comparisons, see Murdoch, *Album of Science*, fig. 207. For general comparison to other model books, see Scheller, *Model Books*.

6

THE WORLD OF ALEXANDER

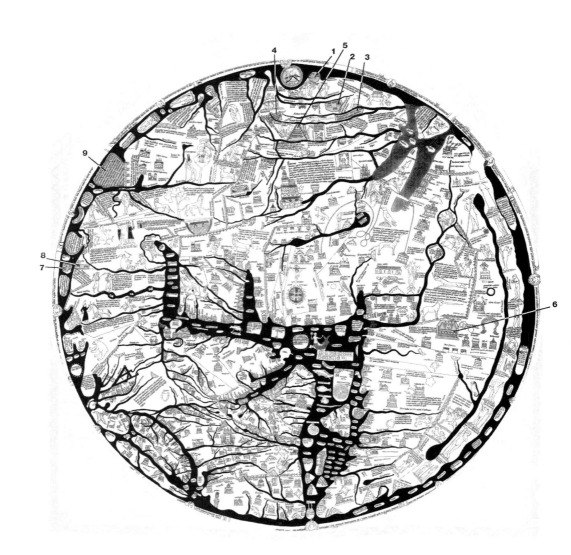

ALEXANDER CITATIONS (clockwise)

1 **Arbor Sicca** (Dry Tree, Balsam): Inscription: *arbor balsami · id est · arbor sicca ·* (The Balsam, that is, the Dry Tree.)

2 **Aree Alexandri** (Altars of Alexander): Inscription: *Aree alexandri ·* (Altars of Alexander.)

3 **Phori Regnum** (Porus): Inscription (no image): *Rengnum [Regnum] phori · et abisaris · qui decertauerunt cum magno alexandro ·* (The kingdom of Porus and Abisaris who fought to the finish with Alexander the Great.)

4 **Rengnum** [sic] **Craphis** (Kingdom of Cleopatra): Inscription (no image): *Rengnum [sic] craphis [Cleophidis] regine · qui alexandrum suscepit ·* (The kingdom of Cleophis (Cleopatra) who supported Alexander.)

5 **Dedalios** (Dedalios): Inscription: *Inter dedalios montes rengnum [sic] cleopatre [Craphis] regine que alexandrum suscepit ·* (Between the Daedalian Mountains the realm of Queen Cleopatra who supported Alexander.)

6 **Castra Alexandri** (Alexander's Camp): Inscription: *Castra alexandri magni ·* (Camp of Alexander the Great.)

7 **Insula mirabilis** (Magic Island): Inscription: *Insula mirabilis quam alexander · non nisi per preces · et obsides intrauit ·* (The wondrous isle which Alexander entered only through entreaties and hostages.)

8 **Aree Alexandri** (Altars of Alexander): Inscription: *Aree alexandri ·* (Altars of Alexander.)

9 **Omnia horribilia** (Walled Enclosure): Inscription: *Omnia horribilia plus quam credi potest · frigus intollerabile · omni tempore uentus acerimus a montibus quem incole bizo vocant · Hic sont [=sunt] homines truculenti nimis · humanis carnibus vescentes · cruorem potantes · fili caim maledicti · Hos inclusit dominus per magnum alexandrum · nam terre motu facto in conspectu principis montes super montes in circuitu eorum ceciderunt · ubi montes deerant · ipse eos muro insolubili cinxit ·*

Isti inclusi idem esse creduntur · qui a solino antropophagi dicuntur · inter quos et essedones numerantur · nam tempore antichristi erupturi · et omni mundo persecucionem illaturi · (Everything is horrible, more than can be believed; their is intolerable cold; the whole time there if the fiercest wind from the mountains, which the inhabitants call Bizo (the north-east wind). Here there are very savage men feeding on human flesh, drinking blood, the sons of accursed Cain. The Lord closed these in by means of Alexander the Great: for an earthquake took place in the sight of the leader, and mountains fell upon mountains in a circuit around them; where the mountains were absent he himself confined them with a wall that cannot be demolished. And closed in also are believed to be the ones who are called Anthropophagi by Solinus, among whom are numbered the Essedones; for at the time of the Antichrist they will break out and will carry persecution to the whole world.)

> After Alexander, son of Philip, the Macedonian, who came from the land of
> Kittim, had defeated Darius, king of the Persians and the Medes, he
> succeeded him as king. . . . He advanced to the ends of the earth . . . and ruled
> over countries, nations, and princes. (1 Maccabees 1: 1–4)

THE HEREFORD and other large wall maps were clearly influenced by textual sources, but because they were not meant to accompany a specific text within a codex, they were not bound by the conventions of narrative. The lack of signifying textual or programmatic accompaniment allowed for the more disjunctive approach to story-telling as compared to the more orderly, chronological, and continuous narrative of written manuscript accounts. The disjunctures suggest a hybrid form of arrangement of pictures and texts. Similarly the type of architectural space in which they could be displayed – a wall-space – suggests an accessibility to viewers of varying abilities and backgrounds. Large wall maps like the Hereford one were intermediaries between the world of the book, largely unavailable to a secular public, and the world of oral tradition, based partly on the written word, but popularized through story-telling.

As Cary points out, history was told in the form of anecdote. To help people remember events, anecdotal stories were attached to place. Anecdotal stories could then be linked to allegorical meanings. The short textual references on the map could thus be considered as short devices that could trigger a number of further meanings, including the allegorical. There was a great variety of sources available, written and oral, textual and cartographic, upon which the texts and images of the Hereford map could be based. Therefore it is not surprising that the Hereford map's depiction of places and events that relate to Alexander does not present a seamless picture of sources but rather a confusing array of texts and images. Although we shall see that a good deal of material on the Hereford map relates to the medieval viewer's knowledge of Alexander, a pattern of specific textual or cartographic sources for Alexandrian material on the Hereford map is elusive.

Sources

In order to begin our discussion of the choice of images and texts that appear on the Hereford map, we need to return to sources, keeping in mind that the distinction between 'poetic fables or romances' and 'historical accounts' is not clearcut.[1] Medieval knowledge of Alexander derived largely from two traditions: the romance tradition of

[1] Indispensable references are: George Cary, *The Medieval Alexander*, Cambridge, MA, 1956; David John Athole Ross, *Alexander Historiatus: A Guide to Medieval Illustrated Alexander Literature*, London, 1963.

the Greco-Egyptian romanticized biography of Alexander by Pseudo-Callisthenes (third century AD);[2] and the Latin 'historical' tradition based on the historical romance *Res gesta Alexandri Magni* by Quintus Curtius Rufus (first century AD),[3] its later Latin prose version by Julius Valerius, *Res gestae Alexandri Magni* (ca. AD 300)[4] best known in its abridged form known as the *Zacher Epitome* (ca. ninth century AD),[5] and Paulus Orosius' *Historiae adversus paganos*, book III (fifth century AD).[6]

The Merging of Traditions

By *ca.* 950 Archpriest Leo of Naples, following a mission to Constantinople, returned with a transcription of a Greek manuscript of Pseudo-Callisthenes that he later translated into Latin. Although Leo's original version does not survive, its closest relation is believed to be the Bamberg *Historia de preliis*, from which a vast literary tradition derives.[7] Contained within three medieval recensions of the *Historia de preliis*, known as *Preliis* I(1), I(2), and I(3), is Pseudo-Callisthenes' account, enriched with numerous additions from Orosius, Solinus, and interpolations from the 'Indian Tractates',[8] especially the letter of Alexander to his teacher Aristotle in which he described wonders and strange peoples encountered in India. Here the romantic and the historical traditions were joined, and the various recensions of the *Historia de preliis* became particularly vital to the development of medieval Alexandrian tradition and lore.[9]

2 For background, see Cary, *Medieval Alexander*, 9–12; Ross, *Historiatus*, esp. 5–6, 41–7; *The Romance of Alexander the Great by Pseudo-Callisthenes*, trans. Albert Mugrich Wolohojian, New York, 1969.

3 For background of *Res gesta Alexandri Magni*, see Cary, *Medieval Alexander*, 16–17; Ross, *Historiatus*, 67–8; Quintus Curtius, *Res gesta Alexandri Magni*, 2 vols., trans. John C. Rolfe, Cambridge, MA, 1946.

4 For background, see Cary, *Medieval Alexander*, 24; Ross, *Historiatus*, 9.

5 For background of *Zacher Epitome* (hereafter referred to as *Epitome*), see Cary, *Medieval Alexander*, 24; Ross, *Historiatus*, 9.

6 For background, see Cary, *Medieval Alexander*, 17, 68–70; Ross, *Historiatus*, 75–6; Orosius, trans. Deferrari.

7 For background, see Cary, *Medieval Alexander*, 38–61; Ross, *Historiatus*, 47–65. For translations see *The Romances of Alexander*, trans. Dennis M. Kratz, New York, 1991, 135–88.

8 The 'Indian Tractates' are: the *Commonitorium Palladiani*, an essay about the Indians, especially the Brahmans; *Dindimus de Bragmanibus*, an unfavorable comparison of the Macedonians to the Indians; *Collatio Alexandri cum Dindimo per litteras facta* (hereafter known as *Collatio cum Dindimo* or *Collatio*), an imaginary correspondence between Alexander and Dindimus, King of the Brahmans; and the *Epistola Alexandri Macedonis ad Aristotelem magistrum suum de itinere suo et de situ Indiae* (hereafter known as *Epistola ad Aristotelem* or *Epistola*), an apocryphal letter written by Alexander to Aristotle explaining his campaign against King Porus with descriptions of marvels and monsters encountered in India. The letter did not originally form part of Pseudo-Callisthenes although it is included in the earliest extant version; see Ross, *Historiatus*, 28–32; Kratz, *Romances*, 107–25; Edmond Faral, 'Une Source latine de l'Histoire d'Alexandre La Lettre sur les merveilles de l'Inde', *Romania*, 43, 1914, 199–215.

9 Recension I(1), *terminus ante quem ca.* 1110; the most important interpolations are the Indian Tractates. Another interpolated source was the *Letter of Pharasmanes to Hadrian*. For translation of Recension I(1), see *The History of Alexander's Battles ('Historia de preliis' – the J¹ Version)*, trans. R. Telfryn Pritchard, Toronto, 1992. Various monsters and fabulous races contained in this text entered the Alexander tradition through the first interpolated redaction of the *Historia de preliis* and later I(2) and I(3); see Ross, *Historiatus*, 33; Recension I(2), *terminus ante quem* twelfth century; interpolations are largely excerpts from Orosius (this recension is often known as the 'Orosius recension') but also include excerpts from Valerius Maximus,

By the twelfth century, numerous Alexander romances and Latin chronicles, creative fusions of sources, were available to a European public. For example, the Latin epic *Alexandreis* by Gauthier de Châtillon (also known as de Lille),[10] and Thomas of Kent's Anglo-Norman verse romance *Le Roman de toute chevalerie*[11] appeared alongside the Latin chronicle accounts in scholastic works of Peter Comestor's *Historia scholastica*,[12] Vincent of Beauvais's *Speculum historiale* IV,[13] Lambert of St Omer's *Liber floridus*,[14] and Fulcher of Chartres's *Historia Hierosolymitana*.[15]

Pseudo-Methodius, Josephus, the letter of Pseudo-Pharasmanes to Hadrian, and the Indian Tractates; Recension I(3), before 1150, based largely on *Preliis* I(1) has many interpolations, largely of a moralizing nature; see Cary, *Medieval Alexander*, 43–61; Ross, *Historiatus*, 50–65. For translation of *Epistola Alexandri ad Aristotelem de mirabilibus Indiae*, see Kratz, *Romances*, 107–26. Ross provides a check-list of manuscripts that contain the frequently grouped *Epitome + Epistola + Collatio*; see David John Athole Ross, 'A Check-List of Three Alexander Texts: The Julius Valerius *Epitome*, the *Epistola ad Aristotelem* and the *Collatio cum Dindimo*', in D. J. A. Ross, *Studies in the Alexander Romance*, London, 1985, 83–8. For translation of recension I(1) and excerpts from I(2), I(3) see Kratz, *Romances*, 1–82, 83–8, 89–106.

10 For background, see Cary, *Medieval Alexander*, 63–7; Ross, *Historiatus*, 72–3. According to Cary, the *Alexandreis* was written between 1178 and 1182. It was dedicated to William, Archbishop of Rheims, grandson of William the Conqueror. The principal source is Quintus Curtius, with additions from Justin (Epitome of the *Historiae Philippicae* of Trogus Pompeius), Josephus, Julius Valerius, and others. It became a standard school text on a par with the *Aeneid*.

11 *Ca.* second half of twelfth century. For background, see Cary, *Medieval Alexander*, 35–6; Ross, *Historiatus*, 25–7. For translation based on Durham Cathedral, Chapter Library, MS C. IV 27b, mid-fourteenth century, and interpolations from the earlier examples cited below, see Thomas Kent, *The Anglo-Norman Alexander ('Le Roman de Toute Chevalerie')* (Anglo-Norman Text Society, 29–33), ed. Brian Foster, London, 1976–7. Relevant examples of illuminated manuscripts of Thomas Kent's *Roman de Toute Chevalerie* are: Cambridge, Trinity College, MS O.9.34, *ca.* 1240–50, England (St Albans): see Morgan, *Early Gothic Manuscripts*, 4/1, cat. no. 81; and Paris, BN, MS Fr. 24364, *ca.* 1300, England: see Ross, *Historiatus*, 25. Also cf. the later example, Durham Cathedral, Chapter Library, MS C.IV 27b, mid-fourteenth century; see Ross, *Historiatus*, 27.

12 Dated 1169–73; see Cary, *Medieval Alexander*, 72–3; Ross, *Historiatus*, 36–7.

13 Mid-thirteenth century. The Alexander material is largely based upon the Julius Valerius' *Epitome* and the *Epistola ad Aristotelem* with extracts from Justin's epitome of the *Historiae Philippicae* of Trogus Pompeius, Quintius Curtius, Valerius Maximus, Orosius, and the *Collatio cum Dindimo*. Illustrations are rare; see Cary, *Medieval Alexander*, 73–4; Ross, *Historiatus*, 21; According to Bunt, much of Vincent of Beauvais's material relating to Alexander is taken from the *Chronicon* of his lesser known predecessor, Helinand of Froidmont, who in turn based his work on Peter Comestor; see G. H. V. Bunt, 'Alexander and the Universal Chronicle; Scholars and Translators', in *The Medieval Alexander Legend and Romance Epic, Essays in Honour of David J. A. Ross*, ed. Peter Noble, Lucie Polak, and Claire Isoz, New York, 1982, 1–10.

14 In Lambert's twelfth-century work there is a long chapter devoted to Alexander based on extracts from, amongst others, Julius Valerius' *Res gestae Alexandri Macedonis* and Orosius, which includes a complete transcription of *Epistola Alexandri magni ad Aristotilem* [sic] *magistrum suum de preliis suis et mirabilibus Indie*, as well as *Alexandri regis Macedonum et Dyndimi regis Bragmanorum de phylosophia facta collatio per epistolas*. The picture that Lambert of St Omer gives of Alexander is essentially based on Orosius; see Danielle Lecoq, 'L'image d'Alexandre à travers les mappemondes médiévales (XIIe–XIIIe)', *Geografia Antiqua*, 2, 1993, 63–103, esp. 63. Ross shows the probable source of the account of Alexander as largely *Epitiome + Epistola + Collatio*, material from Orosius book III, and the account of Alexander's visit to Jerusalem from Josephus' *Antiquitates Judaicae*, book XI; see David John Athole Ross, 'Alexander in the *Liber floridus* of Lambert of St Omer', in D. J. A. Ross, *Studies in the Alexander Romance*, London, 1985, 152–5 (article reprinted from *Medium Ævum*, 31, 2, 1962). The *Epistola*, when included in the *Liber floridus*, is generally unillustrated except for an equestrian portrait of Alexander in most of the manuscripts; Ross, *Historiatus*, 29. There is, however, a tradition of the *Liber floridus* incorporating a mappa mundi; see n. 21 below.

15 See Max Manitius, *Geschichte der lateinischen Literatur des Mittelalters*, 1931, III: 429–30.

Medieval vernacular romances about Alexander were particularly well known throughout Europe and England.[16] In England, Thomas of Kent's *Roman de toute chevalerie* provides a particularly apt model for the disjunctive sources that appear to comprise the map's story of Alexander.[17] The romance itself is patched together from a series of sources. It was based upon Julius Valerius' *Epitome*, the *Epistola ad Aristotelem* and the Indian Tractates,[18] Solinus' *Collectanea rerum memorabilium*,[19] and the fabulous *Cosmographia* attributed to Aethicus Ister[20] – a list that closely mirrors the component sources of the Hereford map.

Clearly there was widespread circulation of Alexander stories in the twelfth and thirteenth centuries – Latin texts largely for clergy, vernacular texts for a wider audience that read or heard stories in their native tongue. There were also mappae mundi to accompany medieval histories and romances relating to Alexander[21] (Fig. 6.1) as well as the larger number of maps not related to Alexander texts but that nevertheless make reference to him.[22] All of these ways in which the stories were disseminated may help us understand the material as it appears on the map.

16 Paul Meyer, *Alexandre le Grand dans la littérature française du moyen age*, 2 vols., Geneva, 1886; George L. Hamilton, 'Quelques notes sur l'histoire de la légende d'Alexandre le Grand en Angleterre au Moyen Age' in *Mélanges de philologie et d'histoire offerts à M. Antoine Thomas*, Geneva, 1973, 195–202.

17 See n. 11 above.

18 Also included are the Jewish Alexander traditions which describe Alexander's visit to Jerusalem, the enclosing of Gog and Magog (sometimes conflated with the enclosing the Ten Lost Tribes of Israel), the stories of the Wonderstone, prophecy of Daniel, bones of Jeremiah, and crossing of the Pamphylian Sea; see Ross, *Historiatus*, 33–5.

19 See Chapter 5.

20 The *Cosmographia*, according to Ross, 'a curious geographical description of the world', and 'a bogus travel book of the Dark Ages', was believed to have been written around the fourth century, but was more likely written during the second half of the eighth century. It contains several Alexander incidents including Alexander's contacts with the Meopari who helped him enclose Gog and Magog; see Ross, *Historiatus*, 79; for Aethicus Ister, see Heinrich Wuttke, *Die Kosmographie des Istrier Aithicus*, Leipzig, 1853.

21 For instance, according to Destombes, approximately one in four manuscripts of Gauthier de Châtillon's *Alexandreis* manuscripts preserved at the Bibliothèque Nationale, Paris, include a diagrammatic T-O map. On maps, see M. Destombes, 'The Mappamundi of the poem *Alexandreidos* by Gauthier de Châtillon (*ca.* AD 1180)', *Imago Mundi* 19, 1965, 10–12. The poem frequently was accompanied by such depictions with brief geographic description of Asia beginning 'Tertia pars mundi . . .'. For background on *Alexandreis*, see Ross, *Historiatus*, 72. For mappae mundi accompanying the *Liber floridus* of Lambert of Saint Omer and other similar examples, see Lecoq, 'L'Image', 63–5; for *Liber floridus*, see n. 14 above. Also see Evelyn Edson, *Mapping Time and Space: How Medieval Mapmakers Viewed Their World* (Studies in Map History, 1), London, 1997, 102–11.

22 Lecoq suggests the diversity of the types of books in which mappae mundi, specifically with items that may relate to Alexander, occur in the twelfth and thirteenth centuries. She lists, for example, the map of Henry of Mainz (now called the Sawley Map), where the map precedes one of the oldest recensions of the *Imago mundi* by Honorius Augustodunensis, and an example of a map from Isidore of Seville's *Etymologiae* (illustrating the first chapter of book XIV), the Psalter map (thirteenth century), the St Jerome map, and the Henry of Huntington map; see Lecoq, 'L'Image', 63–5. The list could be expanded.

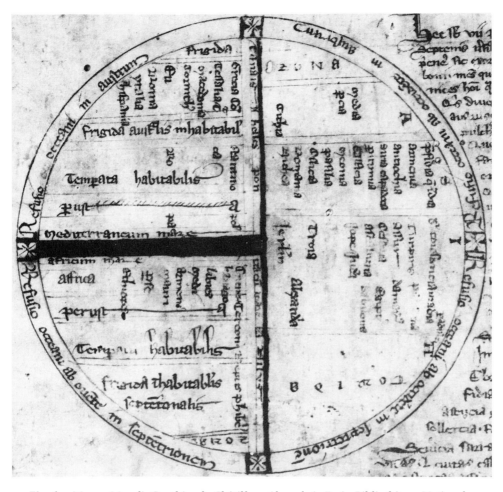

Fig. 6.1 Mappa Mundi. Gauthier de Châtillon, *Alexandreis*, Paris, Bibliothèque Nationale, Fonds Français 11334, f. 1. 13th century

The Geography of the Campaigns

A brief overview of Alexander's campaigns on the Hereford map indicates the obvious difficulty of following the path of the travels on the map itself and argues for a different way of reading this material. In the following section, I give a brief overview of historical accounts of Alexander's travel wherein the places actually found on the Hereford map are marked by bold type.

In the spring of 334 Alexander crossed the **Hellespont** and went straight to **Troy** ostensibly for two reasons: to complete the liberation of the Greek cities under Persian rule, a campaign begun by his father, Philip II of Macedon, and to avenge the death of his father who, in 338, according to Alexander, was assassinated at the instigation of Darius III, King of Persia. From there he marched through Asia Minor, defeating garrisons loyal to the Persians, to Issus. There Alexander finally encountered and defeated Darius in battle (Darius escaped leaving his family and treasury to the victor); Alexander did not pursue Darius but headed south along the Mediterranean coast to Tyre, where following seven months of fighting, the Tyrian fleet was defeated and the city fell. Continuing south, the fall of Gaza, coupled with the more legendary story of Alexander's visit to Jerusalem,[23] was prelude to his triumphal march into Egypt where he was enthroned as Pharaoh in **Memphis**. From Memphis he beached near Lake Mareotis, where he envisioned the building of the city of **Alexandria**, marked on the map by Alexander's large beacon or pharos.[24] He supposedly traveled to the **Nile's** source where he saw people who domesticated and rode the backs of **crocodiles**, shown on the map on the Nile's **Island of Meroe**,[25] then to **Cyrenaica**[26] where the **Castra of Alexander** is shown and where, according to Arrian, he was 'passionately

23 Josephus ascribes Alexander's visit to Jerusalem and his meeting with the High Priest of Jerusalem to the time of the siege of Gaza (*Antiquitates* XI: 325–39); see Yohanan Aharoni and Michael Avi-Yonah, *The Macmillan Bible Atlas*, New York, 1968, 111.

24 The beacon, shown on the map, was founded in 334 BC.

25 For discussion of the Nile see Orosius, I : 'This river seems to rise from the shore where the Red Sea begins at a place which is called Mossylon Emporium; then flowing some distance and forming an island in its midst called Meroe; finally, bending to the north, swollen by seasonal floods, it waters the plains of Egypt. Some authors say that this river has its source not far from Mount Atlas and straightway disappears in the sands, and, after a short interval, gushes forth into an enormous lake and then flows eastward through the Ethiopian Desert to the Ocean, and again turning to the left descends to Egypt. Indeed it is true that there is such a great river which has such a source and such a course, and which in truth begets all the monsters of the Nile. The barbarians near its source call it the Dara, but the other inhabitants call it the Nuhul; but here in the region of the peoples who are called Libyo-Egyptians, by no means far from that river which we have said rushes forth from the shore of the Red Sea, it is received and swallowed up in a huge lake; unless perchance by a hidden course, it erupts into the bed of that river which descends from the east' (quoted from Deferrari's translation, 10–11). Meroë was an ancient city on the east bank of the Nile (*Webster's New Geographical Dictionary*, Springfield, 1988, 752). Solinus describes the crocodile as a creature of the Nile (Solinus, 32: 22–4).

26 Ancient Cyrenaica or Cirenaica was the easternmost part of Libya founded by Greeks. After the death of Alexander the Great, it was ruled by Ptolemies who called it Pentapolis (*Webster's Geographical Dictionary*, 308).

eager to visit the **Shrine of Ammon** in Libya' (Cyrenaica), on the desert oasis of Siwah.[27]

Returning northward through Tyre and Damascus, Alexander met Darius in decisive battle at Gaugamela in 331, whereupon Darius fled to Media and later to the Caspian Sea. Alexander followed the course onward to **Mesopotamia** and the Royal Road south to **Babylon**,[28] **Susa**,[29] and through the Persian Gates to **Persepolis**[30] where he and his troops spent the winter before going over the Uxian Mountains[31] to Ecbatana[32] in **Media** in pursuit of Darius. Learning of Darius' escape from Ecbatana, Alexander followed north and through the **Caspian Gates** to **Hyrcania** where Darius had fallen to conspirators and where Alexander laid his own cloak over him and ordered a royal burial for Darius at Persepolis.

For complex reasons, in part the presence of a pretender in the field, Alexander assembled his forces, and convinced them of the mission to march into the unknown wilds of central Asia to the **Parthian** Desert and **Alexandropolis**, past Drangiana[33] and **Arachosia**[34] through the **Hindu Kush**[35] and into **Bactria**,[36] and **Sogdiana**.[37] Alexander marched north-east to the boundary of the **Jaxartes River** and the **Scythian Mountains** where 'civilization ended and the steppes began' and onto **Scythia**[38]

27 The inscription refers to ancient Ammonium, ancient seat of the oracle of Jupiter Ammon (*Webster's Geographical Dictionary*, 1122). Siwah was located approximatelly 400 miles west of Thebes. The visit was described by Diodorus, Arrian, Curtius, Plutarch, and Strabo (based on Callisthenes).

28 The inscription refers to the city of Babylon and provides a brief history of its founding. It does not directly refer to Alexander who captured the city from the Persians who ruled it from 538–331 BC.

29 The city of Susa was also known as Seleuceia, chief city of Seleucid empire, sacked by the Romans *ca.* AD 162.

30 According to Curtius, Darius abandoned the cities of the Royal Road to keep Alexander from following his trail. Persepolis was the ancient capital of Persia, partially destroyed by Alexander in 330 BC. Nearby at Naksh-i-Rustam are rock tombs of Darius and others (*Webster's Geographical Dictionary*, 943). In the Ebstorf map Alexander is shown near Asia, seated over the Euphrates, conquering Babylon and Persepolis. The text refers to Darius' tomb, built by Alexander. On the Ebstorf map, the bridge over the Euphrates is shown with text: 'The Bridge of Alexander. The Armenian river Araxis flows from the same mountain as the Euphrates and Tigris. It is said that when Alexander from greed wished to cross here he built the bridge, but the river flowed with such force that it destroyed the bridge.'

31 Zagros Mountains.

32 Ecbatana (Hamadan). Ancient capital of Media Magna and summer residence of Persian and Parthian kings; captured by Alexander in 330 BC.

33 Ancient region of Asia, a part of Ariana and a province of ancient Persian Empire and of the Grecian empire of Alexander, now included in west Afghanistan and east Iran (*Webster's Geographical Dictionary*, 343).

34 An ancient province, once the eastern part of the Persian Empire and of the empire of Alexander.

35 Known to historians of Alexander's time as Paropamisus or Cauvasus Indicus (*Webster's Geographical Dictionary*, 505).

36 Ancient country of south-west Asia, between Hindu Kush and Oxus River. Bactria was made part of the Persian Empire by Cyrus the Great (550–529 BC), and conquered by Alexander the Great in 328 BC (*Webster's Geographical Dictionary*, 104).

37 Sogdiana, north-eastern province of the Persian Empire, was invaded by Alexander the Great 329–327 BC (*Webster's Geographical Dictionary*, 1128).

38 Scythia is the ancient name of a country of undefined boundaries populated by a nomadic and savage people who dwelt chiefly in the steppes north and north-east of the Black Sea and in the region east of the Aral Sea (*Webster's Geographical Dictionary*, 1093).

where are found the **Massagetae**, the **Robasci**, **Anthropophagi**, and **Essedones**,[39] and where the strangeness of the landscape and the unknown is matched by accretions of tall tales.

In Scythia are found precious stones, gold, jewels and huge **griffins**. The griffin was believed to be born on the summit and sides of the mountain of the Hypergoraei. It was born with the body of a lion and wings and beak of an eagle; a four-footed beast with feathers that can swoop down and swiftly carry off an animal as large as an ox.

Off the coast of Scythia are islands of the **Hyperboreans**, **Miopar Island**, and **Mirabilis Island** and on the coast are the **altars of Alexander**.[40] Further west is **Terraconta**, the enclosure that relates to Gog and Magog.[41]

And on to India, close to the end of the earth as Alexander imagined, where his army mutinied. Alexander turned south to the mouth of the Indus and returned to **Babylon**. In June 323 Alexander died in Babylon aged 32.

Inscriptions on the Hereford Map

On the Hereford map, although there are at least sixty-nine inscriptions that have relevance to Alexander's histories and romances, only nine inscriptions directly mention Alexander; the inscriptions do not exaggerate or moralize about Alexander's feats but simply state the facts. Most are references to places and incidents described in early historical sources,[42] and more familiar sources such as Pliny, Solinus, and Orosius:[43]

[39] For discussion, see below, n. 43, no. 5.

[40] Note there are two locations on the Hereford map for altars of Alexander.

[41] The inscription describes the Turks as barbarous and as descendants of Gog and Magog, a subject treated later in this chapter.

[42] Ancient 'historical' accounts include amongst others Flavius Arrianus' *Anabasis of Alexander* (second century AD), Quintius Curtius, and Justin. For background and translations, see J. W. McCrindle, *The Invasion of India by Alexander the Great as Described by Arrian, Q. Curtius, Diodoros, Plutarch and Justin*, Westminster, 1896. According to Ross, Arrian's work was not well known in the west until it was translated into Latin in the fifteenth century; see Ross, *Historiatus*, 80–1. Because Arrian's work was relatively unavailable in the west, it was unlikely to have been a direct source for the map. For translation of Arrian, see Arrian, *The Campaigns of Alexander*, trans. Aubrey de Sélincourt, Harmondsworth, 1958.

[43] The nine inscriptions that expressly refer to Alexander and their sources most relevant to this study are:
(1) *Aree alexandri* ('Altars of Alexander') (the Orient, twelve altars on the Hyphasis). Arrian, V (McCrindle, *Invasion*, ch. 29, 129); Quintus Curtius Rufus, IX (McCrindle, *Invasion*, ch. 3, 230); Pliny, VI: 62; Solinus (52: 7); also see McCrindle *Invasion*, 348–9, n. N; Konrad Miller, *Mappaemundi: die ältesten Weltkarten*, 4: *Die Herefordkarte*, Stuttgart, 1895–8, 34; W. L. Bevan and H. W. Phillott, *Medieval Geography: An Essay in Illustration of the Hereford Mappa Mundi*, London, 1874, 28.
(2) *Inter dedalios montes rengnum cleopatre regine que alexandrum suscepit* ('Between the Daedalian Mountains the realm of Queen Cleopatra who supported Alexander') (the Orient). There is confusion of Cleopatra with Cleophis; see 4 below. Bevan and Phillott mistakenly confuse the two; see Bevan and Phillott, *Hereford Mappa Mundi*, 31; Miller, *Herefordkarte*, 33.
(3) *Rengnum graphis [Cleophidis] regine qui alexandrum suscepit* ('The realm of Queen Graphis [Cleophis] who supported Alexander') (the Orient). For Cleophis or Cleophidis, see Quintus Curtius Rufus, VIII (McCrindle, *Invasion*, ch. 10, 194); Justin, XII (McCrindle, *Invasion*, ch. 7, 322); Orosius, III (trans. Deferrari, 105); also McCrindle, *Invasion*, 383; see Miller, *Herefordkarte*, 33; Bevan and Phillott, *Hereford Mappa Mundi*, 31.
(4) *Rengnum phori et abisaris qui decertauerunt cum magno alexandro* ('The realm of Porus and Abisares who

Five texts are closely tied to Orosius: two mentions of the altars of Alexander, one of Alexander's camp, and two inscriptions that confuse Cleopatra and Cleophis. The description of the size of Africa is based on Pliny. The two inscriptions that refer respectively to the Mirabilis Islands and to Gog, Magog, and the Antichrist are more difficult to pinpoint and will be dealt with later. All the many other images and inscriptions that indirectly refer to Alexander suggest an intermingling of the larger network of sources and materials already noted.

Conflicting Images and Typologies of Alexander

In the Middle Ages, Alexander's travels and exploits were construed in numerous ways. Most simply, Alexander's travels lent credibility to a world of wonders that appealed to the broadest audience. It had always been partially recognized that many stories were 'tall tales' but to varying degrees there was a willingness to 'suspend disbelief'. Even in Alexander's purported letter to Aristotle, as apology, Alexander noted that in order to avoid lies or fabulous tales his description of India was based only on what he saw! The

contended with Alexander the Great') (the Orient). For Porus, see Orosius, III (trans. Deferrari, 105); Justin, XII (McCrindle, *Invasion*, ch. 7–8, 321–4), Porus and Abisares; see Arrian, V (McCrindle, *Invasion*, ch. 20–1, 111–15); Quintus Curtius Rufus, VIII (McCrindle, *Invasion*, ch. 12, esp. 202–3); also see McCrindle, *Invasion*, 375, 402, 345–6, n. K; Miller, *Herefordkarte*, 34; Bevan and Phillott, *Hereford Mappa Mundi*, 29.

(5) *Omnia horribilia plus quam credi potest. frigus intollerabile.[a] omni tempore uentus acerrimus a montibus quam incole bizo uocant.[b] Hic sont homines truculenti nimis. humanis carnibus uescentes.[c] cruorem potantes.[d] fili Caini maledicti. Hos inclusit dominus per magnum alexandrum. nam terre motu facto[e] in conspectu principis montes super montes in circuitu eorum ceciderunt.[f] ubi montes deerant ipse eos muro insolubili cinxit.[g] Isti inclusi idem esse creduntur qui a solino[h] antrophophagi dicuntur. inter quos et essedones numerantur.[i] nam tempore antichristi erupturi et omni mundo persecucionem illaturi.[j]* (Scythia). (For translation, see Chapter 5.) For detailed description of sources for individual sections, I refer to Miller who cites Aethicus Ister as chief source, to whose work the following references point, unless indicated otherwise. a. XXVII: 5; b. XXVII: 13; c. XXVII: 10; d. XXVIII: 24; e. XXVIII: 34; f. XXIX: 5; g. XXIX; h. XCII: 18; Pliny, VI: 53; i. Solinus, 15: 13; j. XIX: 16; XXIX: 28; see Miller, *Herefordkarte*, 25; Bevan and Phillott, *Hereford Mappa Mundi*, 50.

(6) *Insula mirabilis quam alexander non nisi per preces et obsides intrauit* ('The wondrous isle which Alexander entered only through entreaties and hostages') (Scythia). Aethicus Ister, XXIII: 23; see Miller, *Herefordkarte*, 27. Bevan and Phillott suggest the miraculous island as the Island Miopar. According to Aethicus Ister, Alexander gained possession of the bitumen of the island by giving the people gifts and altars in his name. The origin of this story may lie in Arrian's account of Alexander's siege of a fortress in Sogdiana where Alexander also gained possession by kind treatment; see Bevan and Phillott, *Hereford Mappa Mundi*, 57.

(7) *Aree alexandri* ('Altars of Alexander') (Scythia). Solinus, 49: 3–4; Pliny, VI: 49; Orosius, I (trans. Deferrari, 8); see Miller, *Herefordkarte*, 26; Bevan and Phillott, *Hereford Mappa Mundi*, 57, suggest a connection between these altars and the abovementioned (no. 6) account by Aethicus Ister.

(8) *Longitudo affrice ab ethiopico mari usque ad alexandriam magnam per meroen et sienem decies septies XXV passuum, longitudo tercies septies XC miliaria* ('The length of Africa from the Ethiopian Sea as far as Alexandria the Great through Meroe and Syena is ten times seven times 25 miles, its length thirty times seven times 90 miles') (Africa). (The map's text appears corrupt in several respects.) Pliny, V: 40; see Miller, *Herefordkarte*, 41.

(9) *Castra alexandri magni* ('Camp of Alexander the Great') (Africa, Libya). Orosius, I (trans. Deferrari, 8); see McCrindle, *Invasion*, 344–5, n. J; Miller, *Herefordkarte*, 41; Bevan and Phillott, *Hereford Mappa Mundi*, 90.

map, which cites authorities like Pliny and Solinus whose 'scientific' works concerned with geography and natural history also contained details relating to Alexander provided a vehicle for reinforcing the reality of these events and encounters.

Because the texts and images were often chosen to fill a space rather than to provide a clear path of Alexander's journeys, what is left are texts and images that have textual ancestry but their displacement and dislocation from the original sources leaves the map bereft of any intended meaning particular to a single author. For instance, the map specifically credits Orosius as a source, it is largely based on Orosius' geographical description, and a fair number of images and texts that specifically refer to Alexander can be traced to Orosius, and yet the map does not specifically underscore Orosius' negative view of Alexander, as an overridingly ambitious leader with an unbroken history of inhumanity:

> O wicked soul of man and heart always inhuman. Did I not fill my eyes with tears as I reviewed these events to prove the recurring in cycles of the misfortunes of all ages, in the relating of so much evil, because of which the whole world on learning of death itself or because of the fear of death trembled? . . .
>
> The Spaniards and the Morini came to Babylon to implore Alexander, and throughout Assyria and India voluntarily begged the bloody lord not to regard them as enemies, going around the ends of the earth and, unfortunately, becoming acquainted with both oceans, and yet the memory of so strong a necessity has failed in oblivion or become dim with age. Do we think that a fleeing thief will achieve everlasting remembrance because, while leaving most of the world safe, he despoiled a small corner of it? . . .
>
> But yet whether those times of Alexander are judged to be praiseworthy because of the bravery with which the whole world was seized rather than to be abhorred on account of the ruin by which the whole world was overturned, many, indeed, will be found who judge these times praiseworthy because they themselves have overcome many obstacles and regard the miseries of others their own good fortune.[44]

Rather the circular world with its admixture of facts and fiction, its blend of sources, provides a field for imaginative interpretations wherein a range of constructions of Alexander's life could be explored. Because the map was not beholden to a single rhetorical model, it could be a vessel for many interpretations, including conflicting ones.

Whereas Orosius may have been the basic source for Alexander in terms of geography, his clearly stated view of Alexander as a proud and destructive force was diametrically different from the prevailing twelfth century image of Alexander heralded as chivalric hero/crusader. Compare, for instance, Orosius' vituperative comments above to the following description of Alexander as given in the prologue of the *Historia de preliis* J3:

> Out of a desire to imitate the intention of those whom I have cited I decided to make the story of Alexander the Great, which is widely read in Greek,

[44] Book III (trans. Deferrari, 107–8).

accessible to Latin readers. It is my purpose that the Latins, who flourish in the glory of warfare, will receive both enjoyment and a pleasing argument for courtly behavior as they read the accomplishments of that man who was the master of warfare and who possessed every noble quality. I have not translated this story of Alexander only for people who live in the secular world. No, a cleric or even a monk can read it profitably. While he contemplates the splendid miracles that Alexander encountered in India, the mind of the reader who is weighed down by cares is refreshed. The evil thoughts that constantly invade the minds of men are repulsed. And even if a man's heart is controlled by excessive lust, when he forgets it in the midst of his reading, his lust is extinguished and not rekindled. In addition, this story warns that the sin of pride must be rejected. It shows this in the person of Darius who used to say that he was a god, by recounting his defeat at the hands of Alexander, who was his subject, because he responded with humility to Darius's arrogance. The same story teaches that earthly pomp must be utterly condemned, and it shows this through the example of Alexander, who mastered the entire world but was unable to protect himself from the power of death. Here begins the history of Alexander of Macedonia – his life, deeds, and birth, translated from Greek into Latin.[45]

Whereas ancient historians such as Orosius described Alexander as a tyrant of overriding ambition and pride, by the twelfth century there were instances, as shown above, where Alexander was shown as an untarnished chivalric model. Ironically the sin of pride is transferred onto Darius whose tomb in later manuscripts is shown decorated with a mappa mundi (Fig. 6.2).[46] Most interestingly, the author ends the prologue by saying that in spite of possessing every noble quality, Alexander, 'who mastered the entire world . . . was unable to protect himself from the power of death'. As the model of chivalry, he, as all mortals, was hostage to death – a theme central to understanding the Hereford map whose four handles spell MORS.

The Church's confusion over Alexander is witnessed in its viewing him as an instrument of God. He represented Virtue corrupted by Fortune, the pride of life riding fast toward judgment. Yet chivalrous knights found Alexander a kindred soul. In the *Alexandreis* and the *Roman d'Alexandre* (by Alexandre de Bernai, 1177) he was portrayed as the pattern of valor and courtesy – glorious in arms, protective to ladies, fair and generous to enemies, and liberal to vassals. Once again, on the Hereford map, the non-judgmental texts contained within the pictorial frame provided the viewer with choices. In an age of orthodoxy, he cast a spell.

45 Kratz, *Romances*, 89–90.

46 These illustrations are found in fifteenth-century examples of the Middle Dutch *Alexander in Historienbijbel*. Examples of the map on Darius' tomb appear on: (1) The Hague, Royal Library 128.C2., f. 84v, *ca.* 1450; (2) The Hague, Royal Library 78.D.38 f. 75v, *ca.* 1425; (3) The Hague, Royal Library 78.D.39 f. 370v, 1468; (4) Brussels, Royal Library, MS 9018–9023, f. 7r, 1430; (5) Vienna, Nationalbibliothek, MS 2771, f. 331, *ca.* 1465. For discussion of these manuscripts, see Ross, *Historiatus*, 22–3; David John Athole Ross, *Illustrated Medieval Alexander-Books in Germany and the Netherlands*, Cambridge, 1971.

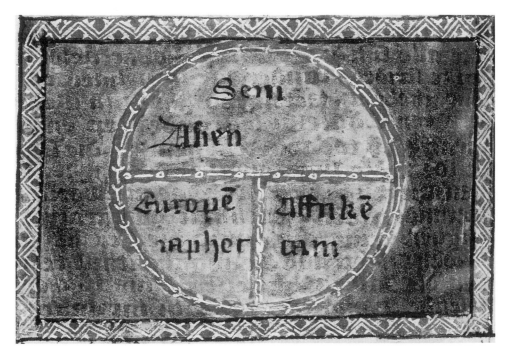

Fig. 6.2 Mappa Mundi on the Tomb of Darius. Alexander in Historienbijbel, The Hague, Koninklijke Bibliotheek, 128 C 2, f. 84v. *ca.* 1425–50, Middle Dutch

Visual Conflations: Alexander and the Wheel of Fortune

Recall that the medieval viewer had sophisticated ways of seeing and memorizing; the key to ordering information was the circle. The handles of the map that contain the letters 'MORS' remind the viewer that the scenes and texts within the map are of the worldly. As much as Alexander could be shown to be a chivalric model, indeed a liege of God, he nevertheless remained earthbound. Not surprisingly then, there is a literary tradition of Fortune as exemplar of Alexander's death.[47] The theme is also known to art, especially in manuscript illuminations that decorated Alexander books and chronicles in which Alexander was featured as the subject of his own wheel, the Wheel of Fortune (Fig. 6.3).[48] Interestingly this image also occurs in two crusading manuscripts

47 Cary lists literary references to Fortune and Alexander's death as an exemplar of Fortune; see Cary, *Medieval Alexander*, 313–15.

48 Carey lists several examples of illustrations in Alexander books and chronicles in which the Wheel of Fortune is depicted: Brussels, Bibliothèque Royale, MS 12012, f. 31v (marginal drawing in *Alexandreis* of Gauthier de Châtillon; as noted previously, the *Alexandreis* also often contained mappae mundi; see Destombes n. 21 above); Stockholm, MS V.u. 20, f. 78 (French Prose Alexander); frontispiece for book five of the fifteenth-century compilation of ancient history by Jean de Courcy known as *La Bouquechardière*; see Ross, *Historiatus*, 23–4; and for several manuscripts of the *Histoire ancienne jusqu'à César (Histoire universelle)*, see Cary, *Medieval Alexander*, 313. Ross lists examples from *Histoire universelle* as:

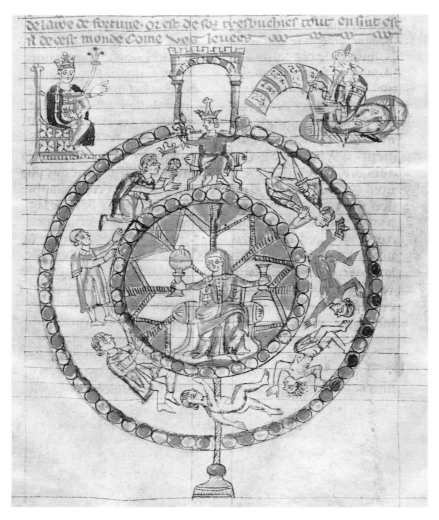

Fig. 6.3 Alexander on the Wheel of Fortune. French *Prose Alexander*, Kungl. Biblioteket, National Library of Sweden, MS V.u 20, f. 78r. Early 14th century, southern Spain or Portugal

created at Acre which included Alexander as part of the Universal History. Both manuscripts begin with full-page illuminations of the Creation and include the image of Alexander within the Wheel of Fortune (Figs. 6.4, 6.5).[49] These books, works clearly tied to the crusades, indicate the complexity of the fascination with Alexander and provide us with yet another case of conflation of ideas and images from manuscripts to map. The Wheel of Fortune provided a closed circle to mark the rise and fall of Alexander's overriding imperial ambition. On the map, the framing device of the Last Judgment echoes the message.

The Pictorial Frame Revisited

Once again consider the earthly world as it is described on the map in relation to its pictorial frame: the earthly realm is bounded by handles that spell MORS, and is surmounted by the pictorial frame's depiction of the eternal realm of the Redeemer. The earthly world is shown as prefiguration of the eternal. In the lower right corner of the pictorial frame, a knight is shown below the inscription *Descripcio orosii de ornesta* [*Ormista*] *mundi sicut interius ostenditur*.[50] which tells us that the map describes that earthly world according to Orosius, in book I of the *Historiae*, in which Orosius provides a geography of the world. Recall that Orosius, a disciple of St Augustine, was concerned with writing a history that reinforced St Augustine's view of the City of God as the ultimate conclusion to earthly history. Orosius says in the first paragraphs:

> You bade me speak out in opposition to the empty perversity of those who, aliens to the City of God, are called 'pagans' (*pagani*) from the crossroads and villages of country places or 'heathen' (*gentiles*) because of their knowledge of earthly things. Although they do not inquire into the future, and either forget or do not know the past, yet defame present times as most unusually beset, as it were, by evils because there is belief in Christ and workshop of God, and increasingly less worship of idols – accordingly you bade me set forth from all the records available of histories and annals whatever instances I have found recorded from the past of the burdens of war or ravages of disease or sorrow of famine or horrors of earthquakes or . . . even the miseries caused by parricides and shameful deeds and unfold them systematically and briefly in the

Paris, BN, MS Fr 20125 and 9682, and Dijon, Bibliothèque municipale, MS 562; see David John Athole Ross, 'The History of Macedon in the *Histoire ancienne jusqu'à César*', in D. J. A. Ross, *Studies in the Alexander Romance*, London, 1985, 215. For texts related to the mutability of Fortune, in *Histoire universelle*, see Ross, *ibid.* 215.

49 The *Histoire universelle*, written between 1206 and 1230, is based chiefly on the *Epitome* + *Epistola* texts with considerable additions from book III of Orosius. For background and list of manuscripts, see Ross, *Historiatus*, 18–20. For an example from *Histoire universelle*, see Dijon, Bibliothèque municipale, MS 562(323), f. 171v. For a description of the Dijon manuscript, see Hugo Buchthal, *Miniature Painting in the Latin Kingdom of Jerusalem*, Oxford, 1957, 148–9. The Dijon manuscript (third quarter of the thirteenth century), along with two other *Universal Histories* (Brussels, Bibliotheque Royale, MS 10175 (*ca.* 1270–80) and London, British Museum, MS Add. 15268 (*ca.* 1285)), was written and illuminated in Acre; they are described by Buchthal, *Miniature Painting*, 148–51.

50 See Chapter 2, n. 27.

Fig. 6.4 The Creation. *Histoire Universelle*,
Bibliothèque Municipale de Dijon, France, Cl. F.
Perrodin, MS 562, f. 1. Third quarter of
13th century, Acre

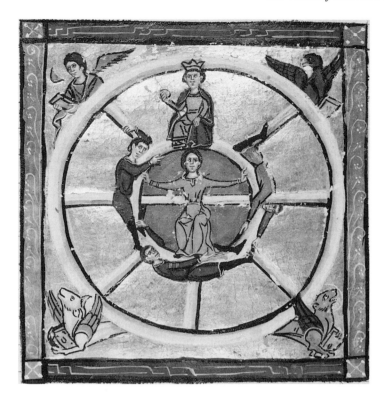

Fig. 6.5 Alexander on the Wheel of Fortune. *Histoire Universelle,* Bibliothèque Municipale de Dijon, France, Cl. F. Perrodin, MS 562, f. 171v. Third quarter of 13th century, Acre

context of this book. For I found the days of the past not only equally oppressive as these, but also the more wretched the more distant they are from the solace of true religion, so that it has properly become clear that an avaricious bloody death prevailed, as long as the religion which forbade bloodshed was unknown; that while the new dawned, the old grew faint; that the old comes to an end as the new already prevails; that the old will no longer be when the new shall reign alone. Of course, we make an exception of those remote and very last days at the end of the world and at the appearance of Antichrist, or even at the final judgment when Christ the Lord predicted in Holy Scriptures even by his own testimony that distresses would occur such as never were before, when according to that very standard which is both now and ever will be truly by a clearer and more authoritative discrimination approbation will come to the saints for the intolerable tribulations of those times and destruction to the wicked.[51]

Orosius was the source for much of the geography of the map and for a number of texts, direct and indirect, concerned with Alexander. Although the texts lack his rhetorical acerbity, the pictorial frame's Last Judgment indicated an underlying concern with

[51] Trans. Deferrari, 4–5.

the issue of unfolding history as a prelude to the City of God. It is therefore not Orosius' specific interpretation of Alexander as tyrant[52] that is incorporated into the map but rather Alexander as pagan who is subsumed into the apocalyptic foreshadowing of Christological history. Judgment and redemption colored the neutrality of the narrative. The pictorial frame reminded the viewer to consider the map in that light.

In the lower left hand corner is another allusion to the pagan classical world: Caesar Augustus, wearing papal tiara, sends three geographers to the corners of the earth. Earlier mention was made of the Christianization of Caesar as medieval revisionist invention. Similarly, in the Middle Ages, pagan Alexander was considered a *figura* of Christ. His journey to the far corners of the earth was seen as a prefiguration of the Pentecostal mission to the Apostles to convert all peoples to Christianity.[53] Alexander was also regarded as a link in the chain of historical geographers, completing the Herculean task of measuring the earth, the sea, and the heavens.[54]

Alexander and Gog and Magog

A conflation of two texts that allude to Gog and Magog especially support theophanic interpretations of Alexander's role in cosmic history. On the Hereford map Terraconta, one of the northernmost islands, encloses the descendants of Gog and Magog:

> The island of Terraconta where the Turks dwell, descendants of Gog and Magog; a barbarous and unclean race, devouring the flesh of youths and abortions.[55]

Further east, fortified by four towers, the long inscription cited in Chapter 5 alludes to an enclosure built by the Lord through Alexander the Great.[56] The two inscriptions

52 Orosius was a Spanish priest who wrote, at the request of his friend St Augustine, a brief universal history. Its purpose was to present the history of the ancient world with particular stress on the horrors and disasters of that history underscoring the perennial folly of men. This was to counter the argument that the ills of the Christian world were due to pagan gods angry with Christians. The book contained essential facts in brief, readable form. It became the standard universal history textbook of the Middle Ages. All monastic and university libraries had copies. According to Ross, these books are rarely illustrated in their original Latin or Greek but vernacular translations and adaptations are frequently illustrated (Ross, *Historiatus*, 67). For illustrated manuscripts, see D. J. A. Ross, 'Illustrated Manuscripts', 35–56, plus plates. A manuscript of Orosius' *Seven Books of Histories Directed against the Pagans* is in the Lincoln Cathedral Library and may have influenced the map's making if it is assumed that the Hereford map was originally created in Lincoln. (Lincoln Cathedral Library, MS A.4.10, twelfth century). It is described in Thomson, *Catalogue*, 66.

53 For a discussion of Pentecost as central to the mission of the Apostles, see Friedman, *Monstrous Races*, 59–84.

54 Lecoq, 'L'Image', 76. An interesting sermon that links Julius Caesar and Alexander the Great is cited by Owst. In the sermon Julius Caesar and Alexander the Great are presented as having prohibited 'the spoliation of temples and spared the church'; see Owst, *Literature and Pulpit*, 552–3, who cites London, BL, MS Harl. 4894, fs. 188v–189.

55 Translation Letts, *Pictures*, 39. *Terraconta insula quam inhabitant Turchi de stirpe Gog et Magog, gens barbara et inmunda iuuenum carnes et abortiva manducantes.*

56 See Chapter 5.

derive from the story of Gog and Magog, based on passages from Genesis (10: 1–5), Ezekiel (38), and Revelation (20: 7–10).[57] Genesis provides the genealogy for the brothers Gomer and Magog; Togarmah is the son of Magog. Ezekiel states that the hordes of Gomer and Beth-Togarmah (Terraconta?), located in the uttermost parts of the north, support Gog, who will apocalyptically appear to the accompaniment of shaking mountains and crashing walls. The passages in Revelation refer to Gog and Magog as Satan's accomplices in coming forth 'to deceive the nations which are in the four corners of the earth, Gog and Magog, to gather them together to the war'. In terms of *figura* wherein the relation between two real or historical events is revealed by an accord or similarity,[58] Gog and Magog may be interpreted as agents of the undoing of the Pentecostal mission of the Apostles. Whereas the Apostles were to bring all peoples under the aegis of Christianity, Gog and Magog were to help Satan deceive the nations of the four corners of the earth and help gather them together into an army of Antichrist. Legend adds that Alexander, by enclosing the races of Gog and Magog, was believed to have acted as God's agent.[59]

In the Hereford map, the texts that belong to that legendary narrative have been separated and embroidered upon. The first text describes Terraconta, the land of Gog and Magog, inhabited by their descendants, the Turchi. The second text describes the apocalyptic falling mountains of Revelation surrounding the sons of Cain, not specifically Gog and Magog. Also mentioned as within the enclosure are the Anthropophagi, specifically the Essedones, as attendants to the Antichrist. On the map, the Essedones are depicted and described elsewhere as cannibals.

That the original elements of the story have been drastically distorted and no longer exactly match literary tradition is not surprising given the long, convoluted history of this theme. For instance, the first text describes the people of Gog and Magog as Turchi. Although for centuries the term Gog and Magog in the west was 'synonymous with the type of barbarian that bursts through the northern frontier of civilization',[60] the partic-

57 For a thorough discussion of this theme, see Andrew Runni Anderson, *Alexander's Gate, Gog and Magog, and the Inclosed Nations*, Cambridge, MA, 1932, 3–14.

58 The term is taken from Eric Auerbach, *Scenes from the Drama of European Literature*, New York, 1959, 11–76. For further discussion, Michael argues that historical narrative of Alexander is more likely to lend itself to typological interpretations than literary examples; see Ian Michael, 'Typological Problems in Medieval Alexander Literature: The Enclosure of Gog and Magog', in *The Medieval Alexander Legend and Romance Epic, Essays in Honour of David J. A. Ross*, ed. Peter Noble, Lucie Polak, and Claire Isoz, New York, 1982, 131–47.

59 Anderson traces the history of the apocalyptic versions; see Anderson, *Gog and Magog*, 20–4. For the development from Alexander building the gate as a pagan king to Alexander as a worshipper and instrument of God and the identification of Gog and Magog with the hosts of the Antichrist, see Anderson, *Gog and Magog*, 24–7. According to Anderson, the episode of the building of the gate entered the west largely through the *Historia de preliis* I(1), I(2), and I(3), and the vernacular versions of the Alexander legend through interpolations of Revelations ascribed to St Methodius of Patara (hence known as Pseudo-Methodius) and written around the seventh century. Another influence was the *Cosmographia* by Aethicus Ister, particularly on medieval maps; see Anderson, *Gog and Magog*, 34, 87–90.

60 Anderson, *Gog and Magog*, 8. According to Anderson, some, amongst others, of the stories that relate Gog and Magog to the Turks are (1) Joinville noted that Louis IX was told by Tatar envoys that they came from the land beyond which Gog and Magog were enclosed; (2) Lambert li Tors describes Gog and Magog in *Li Romans d'Alixandre* as coming from the land of Turks to fight with Porus against Alexander

ular mention of the Turks (if the Turchi are to be so identified) in this context is tailored to the contemporary eastern threat to Christianity but probably derives from Aethicus Ister.[61] The second text, although clearly based on the story of Alexander, makes no mention of Gog and Magog; rather here the agents of the Antichrist are the more generic 'sons of Cain' and barbaric races epitomized by cannibalism.[62] 'And I found there also many peoples that ate the flesh of human beings and drank the blood of animals like water, for their dead they buried not, but ate'[63] – a description of the Essedones, reiterated, as we have already noted, by Solinus.

The map's two texts reflect the complex evolution of the legend into western vernacular versions of the Alexander legend as found for example in the Hereford map or in Thomas of Kent's *Le Roman de toute chevalerie* in which Alexander as the agent of the Lord is the hero in opposition to Gog and Magog, hosts of the Antichrist. More specifically, interpolations in Alexander's letters reinforce Alexander's position as the agent of the Lord. They show him as builder of a gate described as connecting two great mountains that extend like two walls on the right and left as far as the Great Sea and which enclosed peoples who are vilified because of their vile habits, as Alexander himself supposedly described. The location of the enclosed people returns us to another recurring contributing source to the Hereford map – Orosius. That the enclosure for the descendants of Gog and Magog, the sons of Cain, eaters of human flesh, was placed not in the northernmost space but rather along the Caspian Sea adds yet another level of reading that may have had particular resonance in the crusading era. The sons of Cain are connected to Gog and Magog as the Ten Tribes of Israel. As early as the fifth

before being enclosed; see Anderson, *Gog and Magog*, 13, 96. For discussion of the equation of Gog and Magog with the Tatars, Mongols, and Turks, see Anderson, *Gog and Magog*, 13, 96–104. See n. 61 below for discussion of Aethicus Ister, who is particularly relevant.

61 In the age of crusades, the east provided a more immediate threat to Christianity than the north (e.g. Scythians, Huns, Goths, Alans, Magyars described by other sources as the descendants of Gog and Magog); see Anderson, *Gog and Magog*, 12–15. Aethicus Ister's *Cosmographia* (ca. mid-seventh century) specifically classifies the Turks as the race of Gog and Magog; see Anderson, *Gog and Magog*, 13, 35, 51–3. Note that Aethicus Ister also makes reference to the Meopar Islands where Alexander made his submarine descent. On the Hereford map the Meopar Island is depicted next to the *insula mirabilis*; see above n. 43, no. 6. For discussion and relevant quotations from Aethicus Ister, see Anderson, *Gog and Magog*, 51–3. Anderson notes the importance and popularity of Aethicus Ister's work on the Hereford and Ebstorf maps and Thomas of Kent's *Le Roman de toute chevalerie*. Anderson also interprets the popularity of Pseudo-Methodius as important for the conflation of Gog and Magog with the sons of Ishmael, a theme of particular resonance in the age of crusades; see Anderson, *Gog and Magog*, 45, 87–90.

62 In the Greek Pseudo-Callisthenes example given by Anderson as well as its Armenian counterpart, the *Historia Alexandri* ascribed to Aristotle (specifically the *Letter of Alexander to Olympias*), reference is made to the fact that the people confined within the gates were incarcerated because of their uncleanness; see Anderson, *Gog and Magog*, 35–8. 'For they ate things polluted and base, dogs, mice, serpents, the flesh of corpses, yea unborn embryos as well as their own dead. Such were all of them practices which king Alexander beheld, and since he feared that these nations might come forth upon the civilized world, he confined them.' (Anderson, *Gog and Magog*, 36). The quotation was taken from Pseudo-Callisthenes, III: 26, in manuscript C, ed. Carolus Müller, Paris, 1846, 138.

63 Anderson, *Gog and Magog*, 38. The excerpt was taken from the *Letter of Alexander to Olympias*. For the entire text see Anderson, *Gog and Magog*, 38–41.

century, Orosius, shortly after introducing the birth of Alexander the Great, goes on to tell of the deportation of the Jews to Hyrcania on the shores of the Caspian.

Alexander's Campaigns Reread

Given the medieval fascination with Alexander, a generous amount of space and relatively large number of texts and images were allotted to Alexander. On the map, evidence of his campaigns extends to the four corners of the earth: to the western columns of Hercules, the southern Temple of Ammon, the northern altars, and the easternmost realm of Paradise. Known from an admixture of texts and stories, his travels and encounters are marked by cities, outposts, foreign lands, peoples, and animals.

Clearly the eastern segment of the T-O map is given prominence and coincidentally that is the area that describes Alexander's greatest number of exploits. And although the map is geographically close to Orosius' description of the world,[64] mappae mundi of medieval Christian bias gave even greater prominence to the east, placing Jerusalem firmly in the center, a late development in medieval mapping. The imaginary radius that extends from east to west and that connects the heavenly Paradise to Babylonia and then to Jerusalem is of interest here. The central gated form of Jerusalem with the figure of Christ to the east mirrors the circular gated form of the earthly paradise at the top of the map with Christ again immediately above – this time in heaven as judge. Babylonia, an inordinately large symbol of pride and unbelief, the cause of biblical punishment that brought a confusion of languages and alien races, to be redeemed by the unity of the Pentecostal mission, is located between Jerusalem and the heavenly Jerusalem. In medieval times, the fact that in some minds Alexander was considered a *figura* of Christ, a theme already discussed in terms of Gog and Magog and Alexander's role vis-à-vis the Antichrist, suggests that one might also consider this symbolic radius in terms of Alexander's role in universal history. The 'Jewish Alexander traditions' of the story of the enclosing of Gog and Magog[65] and the variant form of the enclosing of the Ten Lost Tribes of Israel[66] were known to medieval viewers. It was believed that

[64] In comparing the textual description of Asia to the Hereford map using the reconstruction of Miller as a guide, one finds the Hereford map is very closely based upon the Orosius description. Most of the places (provinces, cities, mountains, rivers, etc.) in Orosius are found on the Hereford map. Note, however, the reconstruction of Miller based on Orosius does not include Seres or the 'inclusi' (enclosure of Gog and Magog) in Asia. Some of the most obvious departures on the Hereford map are: Albania is shown absorbed into the larger area of Scythia. Jerusalem is located dead center. The names of the oceans and rivers surrounding the world are not specifically named. And prominence is given to the story of Gog and Magog and the enclosure. In the Hereford map, England is obviously more prominently shown and defined. For Miller's recreation of Orosius' cosmography and discussion; see Konrad Miller, *Mappaemundi: die ältesten Weltkarten, 6: Rekonstruierte Karten*, Stuttgart, 1895–8, figs. 28–30, pl. III, 61–8.

[65] Ross, *Historiatus*, 34–5. Ross indicates that the story of Gog and Magog has been shown to be of Christian Syrian origin, first emerging in Pseudo-Methodius, rather than Jewish.

[66] Ross, *Historiatus*, 35.

Alexander had been to Jerusalem,[67] and had made a journey to the earthly paradise during his lifetime.[68] Within that radius one could imagine his role as a proud counterpart to the Pentecostal mission; his death in Babylon begins the line that leads to Paradise and is surmounted by Christ who offers Pentecostal redemption to all.

Artistic Sources and Influences

In looking for artistic sources we need to consider the importance of the oral tradition of story-telling. I have described the map's narrative as disjointed, lacking cohesive links that a single source would supply; the same is true of attempts to visually link cities marking Alexander's campaigns. Stringing cities together on the basis of histories presented an incoherent maze. Rather, themes displayed on the map supply us with evidence of an array of sources blended together in the imagination: historical and romantic accounts of the life of Alexander as well as accounts of Alexander within books on natural history (e.g. Pliny, Solinus).

Although Alexander romances were relatively well known by 1300, one finds little to suggest that illuminated Alexander manuscripts influenced the map; in those manuscripts there was greater emphasis upon the miraculous events of Alexander's life as described by Pseudo-Callisthenes (e.g. Alexander's birth, the wonder stone, etc.). Manuscript illuminations, when relevant, are tied to sections that refer to Alexander's Indian campaign, based on the interpolated *Epistola* tradition. In those specific instances, images, when included, follow the text and are more graphic than our map in terms of Alexander's involvement and encounters with dangers. Recall that on our map, although several animals of Alexander's encounters are depicted, they are also known through Pliny and Solinus simply as indigenous to the geographic areas in which they are located. A digression relating to the *Epistola* tradition is nevertheless instructive.

Although no fully illustrated manuscripts of the *Epistola Alexandri* are known, Secomska has introduced a group of manuscript illuminations that suggest to me parallels though not necessarily models for the maps. The group consists of manuscripts that share a common model for the interpolated adventures of Alexander in India.[69] Of

67 Ross, *Historiatus*, 34.
68 Ross, *Historiatus*, 35–6. In the Middle Ages, the the story of Alexander in Paradise (*Iter ad Paradisium*) followed three literary forms: (1) Latin version, attributed to Salamon Didascalus Iudaeorum. The story's original source, now questioned as the 'original', was the Babyonian Talmud and was later included by Josephus in his *Jewish Antiquities*; (2) A version interpolated into eight manuscripts of the Old French *Roman d'Alexandre*; and (3) a brief digression in manuscripts of *Faits de Romains*. The story was also used as an exemplum for the lesson of humility and the futility of worldly ambition; see David Athole Ross, 'An Exemplum of Alexander the Great', in D. J. A. Ross, *Studies in the Alexander Romance*, London, 1985, 264–5. For knowledge of the Alexander and the earthly paradise in medieval English writings, see M. M. Lascelles, 'Alexander and the Earthly Paradise in Medieval English Writing', *Medium Aevum*, 5, nos. 1, 2, 1936, 31–47, 79–104.
69 Ross, *Historiatus*, 28–9; Krystyna Secomska, 'The Miniature Cycle in the Sandomierz *Pantheon* and the Medieval Iconography of Alexander's Indian Campaign', *The Journal of the Warburg and Courtauld Institute*,

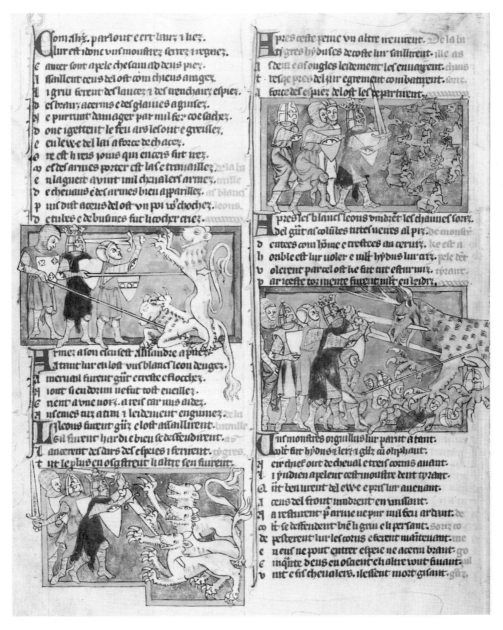

Fig. 6.6 Alexander's Battle with the Monsters, Combat with Lions, Tigers, Giant Bats, Odontotyrannus. Thomas of Kent, *Le Roman de toute chevalerie*, Paris, Bibliothèque Nationale, MS Fonds Français 24364, f. 54v. *ca.* 1300, England

particular interest here are three manuscripts of the *Pantheon* of Godfrey of Viterbo (*ca.* 1185–90), a writer at the court of Frederick Barbarossa;[70] and two English examples of *Le Roman de toute chevalerie* by Thomas of Kent (Fig. 6.6).[71] The fact that a similar series of illuminations based on the adventures of Alexander in India is found in such far-flung examples suggests an independent illustrated *Epistola* tradition existing as early as the thirteenth century in England.[72]

Ultimately, although the Alexander material may prove to be the most elusive, its suggestive impact upon the medieval viewer renders it a powerfully resonant feature of the map. Historically, Alexander as crusader and chivalric exemplar, whose vast campaigns served to define the ends of the earth, whose imperial goals provided a singularly well-suited subject for the Wheel of Fortune and its symbolic counterpart, the mappa mundi, provided a complex subject to be framed by the Last Judgment.

In conclusion, because the texts are taken out of context, the narrative is disrupted and the intentions of the original sources, whether Orosius, Pliny, Solinus, Aethicus Ister, or Pseudo-Methodius, are lost. It is the Last Judgment atop the pictorial frame that authorizes the viewer to create links between incidents and meanings. The sophistication of the reading was dependent upon the sophistication of the viewer. In the Middle Ages, Alexander came to represent many things to many peoples – because the map was probably read with a Christian bias, the inscriptions, which on first appearance were rhetorically neutral, were charged with new meaning. The history unfolded relatively unladen with meanings; the contextual interpretation once again depended on the viewer.

38, 1975, 53–71; Krystyna Secomska, *Legenda Aleksandra Wielkiego w 'Pantheonie' sandomierskim*, Wroclaw, Poland, 1977.

[70] Interpolations of the *Epistola* are found in the latest of five redactions of Godfrey's *Pantheon* inserted into the chapter on Alexander. Three manuscripts of particular interest are: (1) Paris, BN, MS lat. 5003 (Paris *Pantheon*), Italian, thirteenth century, which includes twenty-nine miniatures (f. 91 to f. 97); (2) Viterbo, Biblioteca Capitolare, Italian, fourteenth century (Viterbo *Pantheon*), based on the Paris *Pantheon*; (3) Sandomierz, Chapter Library, MS 114, Polish, 1335 (Sandomierz *Pantheon*).

[71] See n. 11 above.

[72] See Semoska, *Legenda* for other examples, especially: (1) *Historia de Preliis*, Leipzig, University Library, MS Rep.II 143, late thirteenth century, S. Italian; for description, see Robert Bruck, *Die Malereien in den Handschriften des Königreichs Sachsen*, Dresden, 1906, 176–200; (2) Oxford, Bodl. Lib., MS Bodl. 264, *Roman d'Alexandre*, Bruges, 1338–44. For description, see Montague Rhodes James, *The Romance of Alexander: A Collotype Facsimile of MS Bodley 264*, Oxford, 1933.

7

THE WORLD OF THE BIBLE AND THE CRUSADES

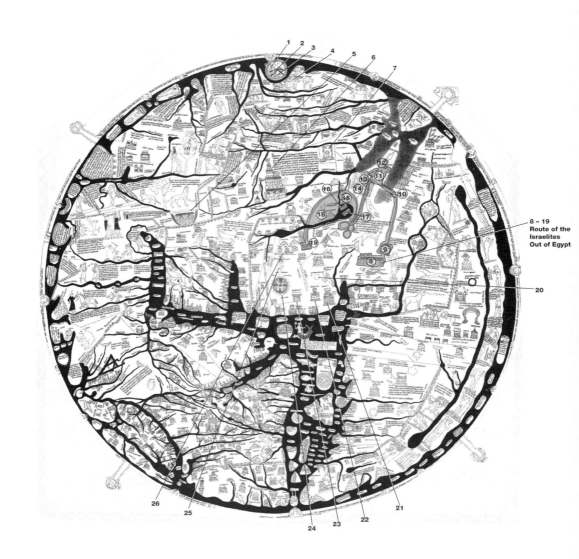

8 – 19
Route of the
Israelites
Out of Egypt

OLD TESTAMENT (selective list)

1 **Adam, Eva** (Adam, Eve): Inscription: *Adam, Eua* (Adam, Eve.)
2 **Four Rivers of Paradise**: Inscription: *Phison · Gion · Tigris · Eufrates ·* (Phison. Gion. Tigris. Euphrates.)
3 **Paradisi porte** (Gates of Paradise): Inscription: *Paradisi porte* (Gates of Paradise.)
4 **Ade et Eva** (Adam and Eve): Inscription: *Expulsio · ade et eua ·* (The Expulsion of Adam and Eve.)
5 **Arca Noe** (Noah's Ark): Inscription: *Archa noe sesesit in montibus armenie ·* (Noah's Ark rests in the mountains of Armenia.)
6 **Babel Turris** (Tower of Babel): Inscription: *Turris babel ·* (Tower of Babel.)
7 **Caldea** (Chaldea): Inscription: *Hur habet · et patria · et caldea.* (Ur holds him, and his homeland and Chaldea.) Confusing inscription, actually refers to Abraham at Ur.

ROUTE OF THE ISRAELITES OUT OF EGYPT

8 **Orrea Josephi** (Joseph's Barns): Inscription: *Orrea ioseph ·* (Joseph's Barns (pyramids).)
9 **Rameses** (Rameses): *Hic congregatus populus israel in ramesse · exiit de egipto altera die post pasca ·* (Here is gathered the people of Israel against Rameses. They left Egypt the day after Passover.)
10 **Mare Rubrum** (Red Sea): Inscription: *Transitus filiorum israel per mare rubrum ·* (The crossing of the Children of Israel through the Red Sea.)
11 **Moyses** (Moses): Inscription: *Moyses ·* (Moses.)
12 **Tabule Testamenti** (Ten Commandments): Inscription: *tabule testamenti ·* (The Tables of the Law.)
13 **Mahun** (Mohammed): Inscription: *Mahun* (Mohammed.)
14 **Judei** (Jews): Inscription: *Iudei ·* (Jews.)
15 **Mare Mortuum** (Dead Sea): Inscription: *mare mortuum ·* (Dead Sea.)
16 **Sodom** (Sodom): Inscription: *Sodom · c[iuitas] ·* (City of Sodom.)
17 **Gomor** (Gomorrah): Inscription: *Gomor · c[iuitas] ·* (City of Gomorrah.)
18 **Uxor Loth** (Lot's Wife): Inscription: *vxor loth · mutata in petra salis ·* (The wife of Lot, changed into a pillar of salt.)
19 **Jerico** (Jericho): Inscription: *vsque ad ciuitatem ierico ducebat moyses pupulus [=populum] israel* (Moses led the people of Israel as far as the City of Jericho.)
20 **Puteus juramenti** (Well of the Oath): Inscription: *Puteus iuramenti ·* (Well of the Oath.)

CITIES OF JUDAH AND PALESTINE (selective list)

21 **Gerara** (Gerara): Inscription: *Gerara ciuitas* (City of Gerara.)
22 **Gaza** (Gaza): Inscription: *Cuza ciuitas* (City of Gaza.)
23 **Bethleem** (Bethlehem) *Bethleem ciuitas* (City of Bethlehem.)

NEW TESTAMENT (selective list)

24 **Jerusalem** (Jerusalem): Inscription: *Ciuitas Ierusalem ·* (City of Jerusalem.)
25 **Calvarie** (Calvary): Inscription: *mons caluarie ·* (Mount Calvary.)
26 **Mons Oliveti**: Inscription: *mons · oliueti ·* (Mount of Olives.)

* Note that images of Crusader sites are not included.

THE HEREFORD MAP was an artifact of the age of the crusades, even though its date of *ca.* 1300 is two centuries later than the First Crusade.[1] Its descriptions of distant lands inspired a fascination with, and yearning for, distant and unknown places; the stuff of fantasies alluringly set, but held in check, by the pictorial frame's reminder of the equally compelling quest for grace and redemption. Thus the map presents two powerfully conflicting claims on the human spirit – *curiositas* and faith. In the Middle Ages, fueled by pilgrimages, the allure of the distant swelled. Travel, real and imaginary, implied paths of imaginative seeking and *curiositas*, which, according to Zacher's definition, 'referred to any morally excessive and suspect interest in observing the world, seeking novel experiences, or acquiring knowledge for its own sake'. The Church defined pilgrimage as an entirely spiritual journey during which the pilgrim was to concentrate on the real world only as a shadow of the invisible spiritual world. Extraneous fascination with novel experiences for its own sake constituted a vice similar to sloth and pride, a reminder of the original sin.[2] Whereas pilgrimages have been considered as a collective quest for miracles,[3] the more worldly aspects of the pilgrimage became threatening to the Church. In fact, a map could provide an alternative to pilgrimage for its viewers, especially for those bound by religious vows.[4]

For the crusader, the dilemma that *curiositas* presented was intensified, given the greater distances and stranger places encountered by those who served as armed pilgrims for the Church's ends. The delicate balance of piety and *curiositas* was compromised, although bound in 'unlawful marriage' by the promise of redemption. To the Church, the value of pilgrimage[5] and crusade countermanded the insidious threat of

1 Although Wright's study has been superseded by numerous works, it remains a classic; see John K. Wright, *Geographical Lore of the Time of the Crusades: A Study of the History of Medieval Science and Tradition in Western Europe*, New York, 1925. Although the Hereford map dates to *ca.* 1300 it is considered a crusader map. The First Crusade took place in 1095/6 and by 1291 with the fall of Acre the crusading movement had largely lost its momentum but crusades continued to be launched beyond that date.

2 Zacher, *Curiosity and Pilgrimage*.

3 H. Platelle, 'Le Miracle au Moyen-Age d'après un ouvrage nouveau', *Mélanges des sciences religieuses*, 42, 1985, 177–84.

4 The *Consuetudines* of Hereford Cathedral could not date to before 1245/6 nor after 1264. They specify that resident canons could be absent for sixteen weeks each year (not continuous). For pilgrimages in England, a canon was allowed to be absent for three weeks a year. Once in his life he could go on a pilgrimage beyond the seas. Seven weeks were allowed for the journey to St Denis in France, eight to St Edmund at Pontigny, eighteen to Rome or St James of Compostela, and a full year to Jerusalem; see Bannister, *Cathedral Church*, 60. Connolly develops the thesis that maps may have provided imagined pilgrimage by monastics. He cites Dom Jean LeClerq's study of imagined pilgrimages for which LeClerq coined the term *perigrinatio in stabilitate*; see Daniel K. Connolly, 'Imagined Pilgrimage in the Itinerary Maps of Matthew Paris', *The Art Bulletin*, 81, 1999, 598.

5 For discussion of pilgrimages to the Holy Land after 1095, see Kenneth Setton, *A History of the Crusades*, Philadelphia, 1958, IV: 36–68.

travel's vistas. Ironically, in spite of the fact that the crusades presented a larger geographical arena for *curiositas*, given the stakes, the Church nevertheless gave the crusader higher rewards and privileges than the pilgrim.[6]

That Jerusalem was placed at the center of the Hereford map, marking the *omphalos* or 'navel' of the world[7] indicated the continued authority and centrality of the crusades.[8] Juxtaposed against the plethora of worldly places, events and objects, the Holy Land was the focal point that reinforced the message of the frame – the eternal realm and its eternal rewards. In such a way, on the map, the inherent contradiction between curiosity and spirituality were set against one another in a visual hierarchy which imprinted the familiar memory of the Last Judgment above the more incoherent places and bits of information below. That the texts of the map were not in the language of the commoner, but rather in the languages of the upper classes to whom crusading exhortations were aimed, was also relevant.[9]

The map was a function of its time and place. England was heavily involved in the crusading effort and the map provided a pictorial vehicle for another crusading dialectic, the tension between the pressures of conversion brought on by the crusades and the ingrained belief in the exclusion of the 'other'.

Curiositas, the Crusades, and Redemption

Because the English strongly held that a crusade was defined as a holy war fought against non-Christians they had a long history of a single-minded involvement with the Holy Land as the destination of crusading. In spite of papal entreaties to extend the sphere of crusading outside the Holy Land, the English were relatively steadfast in their singular desire to reach Jerusalem and preserve it as Christian. Whereas the English played only a minor role in the reconquest of Spain, they were heavily involved in the

6 For example, greater privileges were given, and distinctions made, between crusade to Jerusalem as opposed to pilgrimage to Jerusalem; see Christopher Tyerman, 'Some English Evidence of Attitudes to Crusading', *Thirteenth Century England*, 1, 1986, 168–74, esp. 171.

7 The centrality of Jerusalem is a vast subject; for discussion, see Woodward, 'Medieval *Mappaemundi*', 286–370, esp. 340–2. The biblical references for its centrality are Psalm 74: 12 and Ezekiel 5: 5; later commentaries by Isidore of Seville popularized the idea of Jerusalem as the navel of all the land, an idea expanded upon by Rhabanus Maurus and Hugh of St Cher; see Friedman, *Monstrous Races*, 43–5. For discussion of the development of the centrality of Jerusalem on maps that predate the crusades, see Kenneth Nebenzahl, *Maps of the Bible Lands, Images of Terra Sancta through Two Millennia*, London, 1986; Robert North provides an outline of the development of pilgrim accounts that have relevance to maps; see Robert North, *A History of Biblical Map Making*, Wiesbaden, 1979, esp. 75–92.

8 For discussion of Jerusalem as center as a function of the crusades, see Woodward, 'Medieval *Mappaemundi*', 341. For discussion of the *omphalos*, see Germaine Aujac, 'The Foundations of Theoretical Cartography in Archaic and Classical Greece', in *The History of Cartography*, 1: *Cartography in Prehistoric, Ancient, and Medieval Europe and the Mediterranean*, ed. J. B. Harley and David Woodward, Chicago, 1987, 130–47, esp. 135. Also see Wright, *Geographical Lore*, 259–60. For the mission of the Apostles, see Isaiah 60–2.

9 Preaching and sermons relating to the crusades were generally in French and Latin, not in the vernacular; see Tyerman, *England and the Crusades*, 152–67.

quest to the east.[10] And although those who actually joined the crusades were largely from the aristocratic warrior class in England, the crusades were broadly supported monetarily through a complex system of taxes and revenues collected from a wide spectrum of society, suggesting popular awareness.[11] References to, and reminders of, the crusades and their promise of redemption were intensified in England following the news of the Fall of Acre and the responsive English expedition to the east by Otho de Grandson in 1291.[12] This was despite an apparent waning of English involvement between Henry III's taking of the cross in 1250[13] and Edward I's broken vows.[14] And so, also despite an instance in Hereford's annals that indicated a departure from the English dedication to the single-minded cause of Jerusalem,[15] the map's iconography would have resonated for its viewers. This type of map as object belonged within a larger context of artistic programs relating to the crusades, which were a function of the aspirations of those who commissioned the works as well as those who gazed upon them. Alone or combined within larger artistic programs, twelfth and thirteenth-century circular T-O mappae mundi with Jerusalem as center were here, for instance, artistic relatives to the wallpainting cycles that actualized the crusading aspirations of Henry III.[16]

10 Tyerman points to a number of instances that indicate divisions between the pope's intentions and English responses; for example in 1247 the bishop of Worcester, Walter Cantelupe, secured a papal guarantee not to divert efforts from crusades to the Holy Land. In 1251 this promise was repeated by Henry III. The attempt to fight against papal use of crusades for purposes other than the security of the Holy Land was reiterated by Matthew Paris (d. 1259); see Tyerman, *England and the Crusades*, 91.

11 Simon Lloyd, *English Society and the Crusade 1216–1307*, Oxford, 1988.

12 Edward I's efforts regarding crusades to the Holy Land were real but apart from the expedition of Otho de Grandson, Edward had little to show; see Tyerman, *England and the Crusades*, 230–40.

13 Henry III's crusading aim was possibly to refortify Latin strongholds in Syria as preliminary preparation for an assault on Jerusalem. According to Tyerman, propaganda for this campaign extended to the king's private apartments in which the siege of Antioch of 1098, made glamorous in the *Chanson d'Antioche* poem, was depicted in the Queen's Chamber at Westminster Castle, at Clarendon, and in the Camera Rosamundae at Winchester Castle. The legendary duel between Richard I and Saladin was depicted in the king's chamber at Clarendon, at Winchester Castle, at the Tower of London, and at Nottingham. Tiles portraying Richard decorated Westminster and Chertsey Castles. Apparently such crusading iconography was short-lived and confined to 1251–2; see Tyerman, *England and the Crusades*, 93. After 1252 Henry III seemed to lose his focus on the Holy Land because conflicting issues intervened; see Tyerman, *England and the Crusades*, 117–18.

14 In 1287 Edward I took the cross for the second time but circumstances prevented him from fulfilling his vow. In June 1294 proceeds of the 1291 sexennial crusade tithe were diverted for general purposes. For discussion of Edward I's situation regarding the crusade of 1291, see Tyerman, *England and the Crusades*, 230–40.

15 As opposed to Bishop Walter Cantelupe's stance against the proposed crusade to Sicily, the bishop of Hereford in February 1255 provided 4000 marks to aid in the diverted crusade; see Tyerman, *England and the Crusades*, 122. Similarly the potential loss of profit when vassals alienated monies and properties to the Church (mortmain) as preliminary to going on crusade created difficulty for Henry III. This was evidenced by his relations in 1256 with Henry of Bohun, Earl of Hereford, apparently a difficult vassal of the king; see Tyerman, *England and the Crusades*, 115.

16 For a list of wallpainting cycles relating to crusades commissioned by Henry III, see n. 13 above. Also note that the architecture of the chapel of the Holy Sepulcher in Winchester Cathedral was possibly associated with the crusade of Peter de Roches with Frederick II (1227–9). For discussion of wallpaintings, see Tristram, *Wall Painting: Thirteenth Century*, I: 162–6. In the case of the Hereford map, other than the

Fig. 7.1 Last Judgment (lower half). Joinville's Credo. Paris, Bibliothèque Nationale, MS lat. 11907, fs. 231–2. End of 13th century, Champagne, France

Stylistically, it is of interest that one of the closest models for the line drawings of the Last Judgment of the Hereford map is a set of illustrations meant to accompany Joinville's *Credo*, written in the vernacular specifically to provide crusaders with the visual and oral means to attain salvation upon death (Fig. 7.1).[17] The manuscript's style is so close to the style of the map's pictorial frame, and along with the parallel use of vernacular texts this suggests a connection between the two. Perhaps the *Credo* was available as a model.[18] That possibly being the case, the fact that the manuscript was so specifically attached to the crusades and crusaders bears consideration in thinking about the influence of the crusades upon the Hereford map.

There was also a localized reminder, specifically of the Hereford public's homage to knights of warfare, whether protecting their city or fighting abroad. Each person entering the city through the Bye Street Gate was welcomed by a pair of sculptured armored knights which adorned pendant niches on either side of the gate (Figs. 7.2, 7.3).[19] The Bye Street Gate was a key entrance into the walled city of Hereford, and the

images of Lincoln and Hereford Cathedrals, there is little to argue for specific references to contemporary events that tie the map to place. This is different from the Ebstorf map which has been shown to be closely tied to Ebstorf and to contemporary events; see Armin Wolf, 'News on the Ebstorf World Map: Date, Origin, Authorship', in *Géographie du monde au Moyen Age et à la Renaissance*, ed. Monique Pelletier, Paris, 1989, 51–68.

17 Paris, BN, MS lat. 11907, fs. 231–2, Champagne, France, end of the thirteenth century. The manuscript contains illustrations of the *Credo* with commentary. The red letters are reserved for the *Credo* and the black for commentary. They are inscription rather than book letters and are similar in style to the those of the outer circle of the Hereford map. According to de Laborde, the illustrations were probably meant as models for wallpaintings for the Maison-Dieu at Joinville following Joinville's return from the crusades in December 1263; see A. de Laborde and P. Lauer, 'Un projet de décoration murale', *Monuments et mémoires* (Fondation Eugène Piot), Paris, 1909, 61–84, esp. 68; Scheller, *Model Books*, cat. no. 12 (pp. 97–100). The *Credo* (written between August 1250 and April 1251) was meant to provide salvation to dying crusaders. Friedman stresses the close relationship between word and image, meant to be seen or read aloud as suggested by Joinville: *poez veoir ci après point et escrit les articles de nostre foi par letres et par ymages* ('you can see below the articles of our faith set out and written through letters and through images'). Two other known examples of the *Credo* are: (1) Paris, BN, MS 4509 nouv. acq. fonds. français, 1287 (probably a copy of the original); this manuscript has words and pictures, but the cycle is incomplete and the miniatures do not coincide with texts; (2) a thirteenth century Breviary for the service of Saint-Nicaise of Rheims now in the St Petersburg Public Library; see Lionel J. Friedman, *Text and Iconography for Joinville's 'Credo'* (The Medieval Academy of America, 68), Cambridge, MA, 1958, esp. 1–5. The *Credo* was one of the many types of tracts that was expressly meant to be used by the laity wherein the lay person was meant to use the book as a guide, an important parallel to the growing use of *exempla*; see Miri Rubin, *Corpus Christi*, 105. Also note on Fig. 7.8 the Virgin baring her breast.

18 The manuscript is described by Scheller as a model book; see Scheller, *Model Books*, cat. no. 12, 97–100.

19 I am indebted to Daniel Kletke for bringing this statuary to my attention. The sculptures are presently on anonymous loan to the Cloisters Museum in New York City, L1989.66a, b. According to records made available to me at the Hereford City Museum and Art Gallery, the sculptures were sold by Sir Charles Clore on 13 December, 1985 (Christie's London, Lots 67, 67A). After a complex attempt to keep the works in England, they were exported to America. An article relating to these statues is forthcoming. I am indebted to Anne Sanderson and Jonathon Cooter of the Hereford City Museum for relevant information. See Paul Williamson, 'Sculpture' in *The Age of Chivalry: Art in Plantagenet England 1200–1400*, ed. Jonathan Alexander and Paul Binski, London, 1987, 100, 106 (n. 14); David Nicolle, *Medieval Warfare Source Book I: Warfare in Western Christendom*, London, 1995, 137. I am indebted to Mary Shepard for these references.

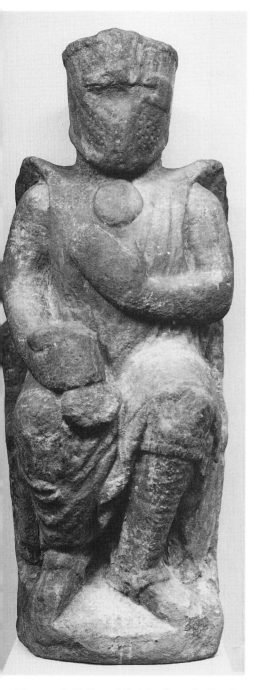 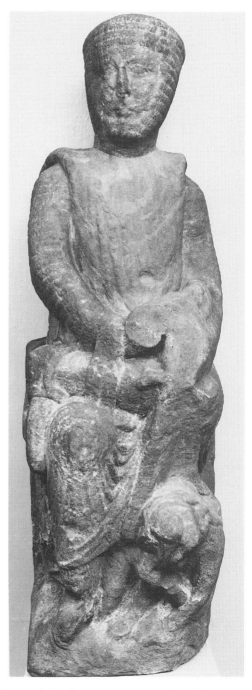

Fig. 7.2 (left) Seated Knight, from the Bye Street Gate, Hereford. Sandstone, *ca.* 1230–50. New York, The Metropolitan Museum of Art, anonymous loan (L1989.66 ab)

Fig. 7.3 (right) Seated Knight, from the Bye Street Gate, Hereford. Sandstone, *ca.* 1230–50. New York, The Metropolitan Museum of Art, anonymous loan (L1989.66 ab)

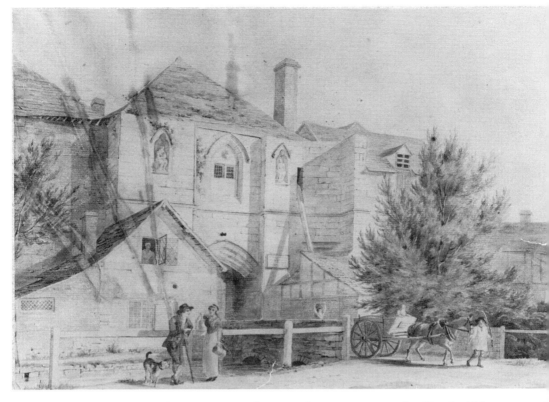

Fig. 7.4 Bye Street Gate by George Samuel. Watercolour, no. 1553. *ca.* 1800 Hereford Museum, Herefordshire Heritage Services, Herefordshire Council

original appearance of the gate before its dismantling in 1798 was preserved in a number of pain-ings, drawings, and prints (Fig. 7.4).[20]

Given the fame of Bishop Cantilupe's memory and the miraculous deeds attributed to him,[21] Hereford Cathedral by *ca.* 1300 was attracting numerous pilgrims to his tomb, which was probabl

[20] A defensive wall consisting of earthen banks punctuated by wood structures or gates surrounding Hereford was create as the result of the Royal Charter of the City of Hereford (9 October, 1189). Citizens were allowed to farm the rent their town, with the provision that they would help to enclose the city. The Pipe Rolls of 1190 refer to the constructio of four gates, presumably the Eign, Widemarsh, Bye, and St Owen Gates. Shoesmith suggests that the twelfth-centur enclosure served defensive ends but was moreover a symbol of the corporate identity of traders and craftsmen of Her ford. The later stone walls of the thirteenth century (*ca.* 1224–65) were more likely a response to increased Wels border raids and coincided with Henry III's visits to Hereford in the 1230s and 1240s. Hereford was considered a important garrison town in the wars waged against the Welsh; see Ron Shoesmith, *Hereford City Excavations: Excavatio on and Close to the Defences,* 2 (Council for British Archaelogy Research Report, 46), London, 1982, 17–21. For the full te of the Royal Charter, see *The Report on the Manuscripts of Hereford Corporation,* The Historical Manuscript Commissio 1892 (Thirteenth Report, Appendix, Part IV).

[21] In 1289 Bishop Swinfield (1283–1317) appealed to the pope to canonize Bishop Thomas Cantilupe; see Dew, *Cathedr Registers,* 31–2. The official account of the miracles relating to Cantilupe was written by six lawyers based on repor made by the papal commissioners sent to inquire into the life and miracles of Bishop Cantilupe from August to Novem ber 1307; see Bannister, *Cathedral Church,* 167–75.

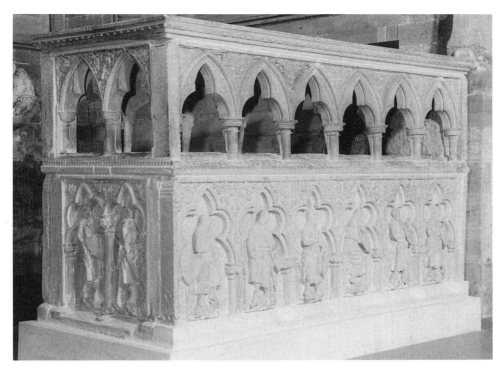

Fig. 7.5 The Tomb of Bishop Cantilupe. North Transept, Hereford Cathedral. *ca.* 1282–4
By kind permission of The Dean and Chapter of Hereford Cathedral and
the Hereford Mappa Mundi Trust

commissioned by Bishop Swinfield.[22] The tomb had the unique feature of sides decorated with a series of knights in various poses, similar to the Bye Street sculptures (Fig. 7.5).[23] The tomb was a central element of the overall architectural and decorative

22 According to Bannister, Cantilupe died in Florence. His remains were brought to Hereford and deposited in the Lady Chapel behind the high altar until they were moved to the north transept upon its completion in *ca.* 1287. In the presence of King Edward I, the remains were translated to the elaborate tomb. The stories of marvels of faith-healing proliferated to the point where pilgrims flocked to the Cathedral and almost all English bishops offered indulgences to those who visited Bishop Cantilupe's tomb where votive offerings covered the walls of the transept. Royalty came and money 'poured in'. Following Cantilupe's death, the gifts supported approximately three decades of elaboration to the fabric of the cathedral including the aisle of the north transept in which stood Cantilupe's tomb, built five years after his death. Additionally the central tower, aisles of the nave, and inner portion of the north porch were built; see Bannister, *Cathedral Church*, 71–2. In fact the tomb is presently close to its original 1287 site in the north transept. In 1349 it was moved to the Lady Chapel and remained there for most of the Middle Ages; see P. Lindley, 'Retrospective Effigies, the Past and Lies', in *Medieval Art, Architecture and Archaeology at Hereford*, ed. David Whitehead, London 1995, 118–19.

23 Stone dates the tomb to *ca.* 1282–4. He suggests that the overall plan may reflect a lost French model. He also notes that the sides of the free-standing tomb, which contain a series of knights, show the typically French manner of hanging the shields at the hip. The sculpture is related in style to English west-country sculpture, e.g. western effigies in Purbeck marble and freestone; see Lawrence Stone, *Sculpture in Britain*, Harmondsworth, 1955, 146. Tummers basically agrees with Stone and adds that the knights are also suggestive of west-country sculpture because the mail on the arms is characteristically depicted with seams

enhancement of the cathedral. For instance, under Bishop Swinfield's supervision the choir aisles were widened (*ca.* 1300) by rebuilding the outer walls to provide more space for the pilgrims to the shrine of St Thomas. At the same time the effigies of early bishops were put in place,[24] stained glass windows installed,[25] and sculptural decoration added to the north porch through which many pilgrims entered.[26] It is possible that it was also during this period of the extensive campaign to enhance the cathedral as a pilgrimage center that the map was placed within a wooden framework. This would have made it available for view to the many new visitors. Interestingly the wooden framework closely follows the basic, repetitive design of the arches that surmount the ten effigies all produced during a single campaign of *ca.* 1300, and more especially the design of the canopy above Bishop Swinfield's and Bishop Aquablanca's tombs.[27] Much as Hereford Cathedral with its new addition to house the map attracts

along the sleeves. He also notes similar attitudes between the tomb's knights and two seated knights, then on loan to the Victoria and Albert Museum, lent by Sir Charles Clore. At that date the seated figures were still believed to have originally come from Hereford Cathedral, although they have now been identified as belonging to the Bye Street Gate; see H. A. Tummers, *Early Secular Effigies in England*, Leiden, 1980, 29–30, esp. n. 143 (p. 155). Marshall argues that Cantilupe's tomb was placed against the east wall of the north transept in 1287 with a date of 1285–7 for the shrine; see G. Marshall, 'The Shrine of St Thomas de Cantilupe in Hereford Cathedral', *Transactions of the Woolhope Naturalists' Field Club*, 1930–2, 34–46. Reeves suggests that the lower part of the shrine that contains the knight 'weepers' dates to *ca.* 1274–82; see Pamela Wynn Reeves, 'English Stiff Leaf Sculpture', unpublished Ph.D. thesis, London University, 1952, 295 (n. I). Reeves is cited by Tummers; however, I was unable to gain access to the study.

24 Recent scholarship argues for a date of *ca.* 1300 under Swinfield's auspices for the widening of the choir aisles. According to Lindley, the reconstruction of the nave aisles is noted by the clerk of the works for 1290–1; see *Charters and Records of Hereford Cathedral*, ed. W. William Capes, Hereford, 1908, 163–5. The remodeling of the choir aisles (*ca.* 1300–10) was subsequently undertaken to contain tombs and retrospective effigies of ten bishops of Hereford who occupied the see from 1079 to 1219). This was in preparation for the intended translation of Cantilupe's relics to the Lady Chapel, planned to coincide with the papal commission's visit in 1307 to investigate Cantilupe's miracles in relation to the bid for his canonization which was finally successful in 1320 (P. H. Daly, 'The Process of Canonization in the thirteenth and early fourteenth centuries', in *St Thomas Cantilupe Bishop of Hereford*, ed. M. Jancey, Hereford, 1982, 125–35. See Lindley, 'Effigies', 111–21. Lindley's chronology takes into account the work of Morris; see Richard Morris, 'The Remodelling of the Hereford Aisles, *Journal of the British Archaeological Association*, 37, 1974, 21–39. The dating offered by these scholars convincingly challenges Bannister who suggests that the rebuilding of aisles of nave, choir, and the east transept dates to *ca.* 1320; see Bannister, *Cathedral Church*, 71–2.

25 The windows of the choir aisles are contemporary with the modernization necessary for widening the aisles to contain the tombs described above. At present the eastern window of the south-east choir aisle contains early fourteenth-century stained glass that may have originally belonged to this window. Three shields of arms are located in the tracery. Four figures are represented below from left to right: St Mary Magdalene with scroll, St Ethelbert with sword and church, St Augustine with crozier, and St George in armor and shield. The remains of more related glass, although more extensively restored, is located in the east window of the north-east transept. The pieces of glass were discovered in boxes and repaired by Warrington and placed in their present locations in 1864; see Morgan, *Cathedral Church Glass*, 11, 15. According to Havergal, Bishop Cantilupe was provincial Master of the Knights of the Templars; see Havergal, *Fasti*, 19. The inclusion of St George in armor and shield as warrior saint may be consciously related to commemoration of Bishop Cantilupe.

26 The archivolts of the north porch are of particular interest here. No research to my knowledge has been devoted to them. From a preliminary examination, they appear to include a variety of images, each made from a separate block. The images include strange races and beasts and are worthy of future attention.

27 Compare the wooden frame to those of the ten tombs in the choir aisles. One should also note the tomb

modern-day pilgrims and tourists, so too would the map in its new wooden framework have been of particular interest around 1300.[28] The visitors from afar no doubt gazed upon the map with attitudes of wider consideration than many of Hereford's inhabitants who were largely concerned with border skirmishes at the time. On the other hand, all viewers were to some extent touched by the crusades.

Conversion and Marginalization

For the average viewer, the map, with its inclusion of the strange races affixed to the rim of the worldly circle no doubt recalled dehumanized descriptions invented during centuries of warfare with the Moors of Spain and transferred onto the Moslems of the Holy Land. These peoples were conflated in the Christian mentality as dark, unclean, barbarous, and sexually perverse.[29] According to Tyerman, as a result of the eastern European Moslem invasion, English fear and paranoia was inflamed to the point where Bishop Grosseteste of Lincoln pronounced his willingness to preach the Gospel 'in the farthest regions of the Saracens, even to death'. And by 1241 stories of Mongol inhuman atrocities (the sudden appearance of Mongols in Europe fueled further fears) were published in every parish in England.[30] As reminders of the 'other', the people of Hereford needed only to recall the negative characteristics attached to their Jewish neighbors, who until their expulsion from England in 1290 lived enclosed within the city walls next to the Bye Street Gate.[31]

Monstrous traits of more distant folk, like the Plinian races, had already been transferred to some degree onto the Saracen enemies encountered during the reconquest of Spain. For instance in *The Song of Roland* on numerous occasions the Saracens were described as 'dog-headed'.[32] By the time of the crusades, in numerous manuscript

of Bishop Swinfield (d. 1317), which is located in the north-east transept. It is somewhat different in style from those of the choir aisles. Swinfield's tomb does not contain an effigy but rather a brass and it has a trefoil in the gable. The tomb of Bishop Aquablanca (1240–68) is located in the north-east transept and its gable is also similar to the wooden frame.

28 See Chapter 2.

29 For instance, in the sculptured tympanum of Leon, closely tied to the pilgrimage route to Santiago and more especially to the Christian expansion of the reconquest of Spain from the Moors we become aware of the implicit marginalization of the Moors justified through biblical commentary. In the tympanum Hagar, the mother of Abraham's bastard child Ishmael, is depicted as a whore with skirt raised. By the Middle Ages, Ishmael was considered the progenitor of the Moors, conceived of as a dark-skinned evil race; see John Williams, 'Generationes Abrahae: Reconquest Iconography in Leon', *Gesta*, 16/2, 1977, 3–14.

30 The dramatic rise of the Mongol Empire under Chingiz Khan and his successors presented a common threat to Muslims and Christians; see Tyerman, *England and the Crusades*, 95.

31 Bishop Swinfield was particularly harsh toward the numerous Jews of Hereford. In 1286 he excommunicated Christian guests, who after being forewarned attended or performed at a Jewish wedding. The next year all Jews throughout England were imprisoned and notified of expulsion, which was ultimately carried out in 1290. For several relevant documents, see Dew, *Cathedral Registers*, 26–8.

32 C. Meredith Jones, 'The Conventional Saracen of the Songs of Geste', *Speculum*, 17, 1942, 201–25; Matthew Bennett, 'First Crusaders' Images of Muslims: The Influence of Vernacular Poetry?', *Forum for Modern Language Studies*, 22, no. 2, 1986, 101–22.

pages describing the battles of the crusades, the Saracens were depicted as black. Jews were thought to perform an array of ritual slayings and blood rituals.[33] More to the point, during the period of the crusades, when distant travel to exotic places opened a Pandora's box of diverse cultures and peoples, the attributes of the monstrous races became shibboleths of the 'other'. They were considered separate from European Christians and their cultural norms.

However the mission of the crusades necessitated extending the definition of the 'other' beyond the bounds of the more familiar world. The possibility of conversion of the 'other' to Christianity obliged one to be aware that infidels were human. Whereas, for instance, the Fourth Lateran Council (1215) was concerned with the definition of Christianity, the Fifth Crusade (1217–29) sought to make the faith universal. This may account for the fact that later visual and verbal descriptions of Moslems and Jews did not deviate very far from the human. After all, these peoples were relatively familiar and their destinies and cultures were tied to the shared center, the Holy Land. To join the circle of redemption, they required conversion, a process already under way.[34] It was the more unfamiliar peoples who were considered as endowed with more monstrous properties that further stretched and challenged the ability of the Church to become universal.[35]

Christian nations encompassed the *oikoumene*, the portion of the earth inhabited by people of 'our kind'. Within the *oikoumene* were Jews and Moslems who constituted the first 'circle' to be brought within the body of Christ.[36] On the Hereford map, beyond the *oikoumene* in regions like Scythia and the land of Gog and Magog were located the barbaric tribes. At the very edges were the monstrous races – all of whom were brought into the circular container symbolizing the body of Christ, a concept made visually more explicit on the Ebstorf map. As noted, the strange races were represented by bodily distortions, described as partaking of unacceptable dietary practices, as inarticulate, and as otherwise aberrant from the European norm. Whereas Jews and Moslems were always shown clothed, nudity was a common characteristic of the more distant 'other' tropical peoples. For them, nakedness was conflated with bestiality and wild-

33 A vast literature pertaining to the Jews as 'other' is available; see J. Cohen, 'The Jews as the Killers of Christ in the Latin Tradition, From Augustine to the Friars', *Traditio*, 39, 1983, 1–27; B. Blumenkranz, *Les Auteurs chrétiens latins du Moyen Age sur les Juifs et le Judaisme*, Paris, 1963; B. Blumenkranz, 'Anti-Jewish Polemics and Legislation in the Middle Ages: Literary Fiction or Reality?', *Journal of Jewish Studies*, 15, 1964, 125–40; A. Funkenstein, 'Basic Types of Christian Anti-Jewish Polemics in the Later Middle Ages', *Viator*, 2, 1971, 373–81. For specific relationship between the crusades and anti-Semitism, see J. Riley-Smith, 'The First Crusade and the Persecution of the Jews', in *Persecution and Toleration* (Studies in Church History, 21), ed. W. J. Sheils, Oxford, 1984, 51–72; G. Langmuir, 'Anti-Judaism as the Necessary Preparation for Anti-Semitism', *Viator*, 2, 1971, 383–9; R. Chazan, *European Jewry and the First Crusade*, Berkeley, 1987; Naomi Reed Kline, 'The Typological Window of Orbais-l'Abbaye: The Context of Its Iconography', *Studies in Iconography*, 14, 1995, 83–130, esp. 94–102.

34 Benjamin Z. Kedar, *Crusade and Mission*, Princeton, 1984 (repr. 1988).

35 For discussion of developing discourse of papal–infidel relations beyond the pope's role vis-à-vis Moslems and Jews, see James Muldoon, *Popes, Lawyers and Infidels*, Philadelphia, 1979, 3–28.

36 For a relevant schematic diagram, see François Gagnon, 'Le Thème médiéval de l'homme sauvage dans les premières représentions des Indiens d'Amerique', in *Aspects de la marginalité*, ed. Guy-H. Allard *et al.*, Montreal, 1975, 82–99, esp. 86.

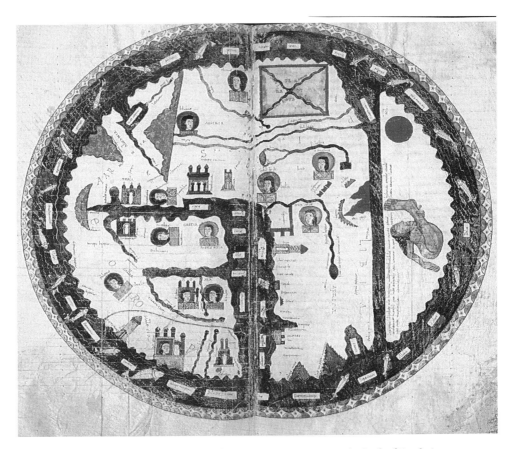

Fig. 7.6 World Map. Beatus of Liebana, *Commentary on the Book of Revelation*,
Cathedral of Burgo d'Osma, MS 1, fs. 35v–36. 1086
Illustration courtesy of the Fine Arts Library, Harvard College Library

ness, underscored by the frequent attribute of a club. These folks located on the edges were separated from images of cities and buildings, symbols of monumental architecture and culture. The seductive fascination they engendered underscored the driving need for their conversion. The allure, fear, and challenge of the edges of the world provided the medieval viewer with an imaginative pictorial rationale for the Church's objective of converting the entire world to Christianity.

Marginalization of the 'other' was not an invention of the crusades. If we consult the earlier history of map-making we find from the inception of zonal maps a method of providing separate zones for the marginalized or strange races beyond the ken of 'civilization' whether the *oikoumene* be the pagan or the Christian world. As early as the simplest zonal map based on Macrobius (*ca.* AD 400) the world was divided into five separate climatic zones.[37] Even though no monsters appear on Macrobian maps or in

[37] William of Conches (1080–1145), *De philosophia mundi*, in Sion College Bestiary. The map indicates five

his books, it was believed that climate largely accounted for the separation of peoples and their characters. It was believed that climate influenced the balance of the four humors and that excesses disturbed the mind and soul so that a direct relationship between savagery in man and savagery in nature was established.

The Pentecostal Mission

In effect the Hereford map combined the concept of zonal marginality with the theme of the Pentecostal mission of the Apostles, a subject that gained heightened meaning in respect to the crusades. The models for that conceptual fusion were a number of eleventh-century maps based on Beatus of Liebana's *Commentary on the Book of Revelation* in which Jerusalem was prominently shown near the center.[38] For instance, in the example in Fig. 7.6[39] the world is depicted as rectangular to suggest the four corners of the earth to which the Apostles were sent. Speaking in diverse tongues, the Apostles were to bring the unifying Christian faith to the alien races, as described in the miracle of Pentecost (Acts 2: 1–4), fulfilling Christ's mission to go to the four corners of the earth to convert and redeem all those who had been exiled as alien races (Mark 16: 15;[40] Matthew 28: 19[41]). In Beatus' words: 'And how this seed, over which the prophets labored and which the Apostles sowed, spread through the field of this world, the

climatic zones whose measurements in degrees from pole to pole are given in Macrobius' *In Somnium Scipionis expositio* ('Commentary on the Dream of Scipio'), *ca.* AD 400; see Woodward, 'Medieval Mappaemundi', 300.

38 Beatus of Liebana, *Commentary on the Book of Revelation*, Cathedral of Burgo d'Osma, MS 1, fs. 35v–36, 1086 (based on a prototype of 776–86). Also note that the furthest from Jerusalem in the most southern zone of the map shows the zone as inhabited by a member of the monstrous races (a sciapod as described in Pliny's *Natural History*, VII). For a list of illustrated Beatus manuscripts that contain maps to accompany Prol. bk. II, see John Williams, *The Illustrated Beatus*, 1 (Introduction), London, 1994, 28, 179–86. Also see Evelyn Edson, 'The Oldest World Maps: Classical Sources of Three VIIIth Century Mappaemundi', *Ancient World*, 24, 1993, 169–84, esp. 178–84.

39 Three Beatus maps indicate twelve heads of saints located in the countries of their missions (Cathedral of Burgo d'Osma, MS 1; Milan, Biblioteca Ambrosiana, MS F. sup.150; New York, Pierpont Morgan Library, MS 644); see LuisVasquez de Parga, 'Un mapa desconocido de la serie de los *Beatos*', in *Actas del simposio para el estudio de los codices del 'Commentario al Apocalipsis' de Beato de Liebana*, Madrid, 1978, 271–8. The article is cited by von den Brincken who notes that the Vercelli map marks tombs of Apostles with bell-towers, the Ebstorf map with chapels with tombs inside; see Anna-Dorothee von den Brincken, 'Monumental Legends on Medieval Manuscripts Maps', *Imago Mundi*, 42, 1990, 9–26, esp. 17. Note that the Hereford map shows St Thomas and suggests St Brigid (Caldara) but does not actually depict many saints. For discussion of the legend of St Thomas in India, see Wright, *Geographical Lore*, 275, 278. Also note on Fig. 7.6 the naked 'other' outside the *oikoumene*. The Morgan manuscript is published in facsimile; see John Williams and Barbara A. Shailor, *A Spanish Apocalypse: The Morgan Beatus Manuscript*, New York, 1991.

40 Mark 16: 15–18: 'And he said to them: "Go into all the world and preach the gospel to the whole creation. He who believes and is baptized will be saved: but he who does not believe will be condemned. And these signs will accompany those who believe: in my name they will cast out demons; they will speak in new tongues; they will pick up serpents, and if they drink any deadly thing, it will not hurt them; they will lay their hands on the sick, and they will recover." '

41 Matthew 28: 19: ' "Go therefore and make disciples of all nations; baptizing them in the name of the Father and of the Son and of the Holy Spirit." '

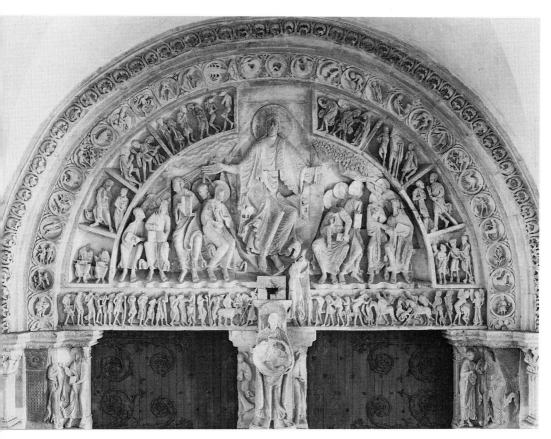

Fig. 7.7 The Mission to the Apostles. Tympanum, St Madeleine, Vezelay, France. 12th century
Photo Zodiaque

following picture more easily shows.' The Pentecostal command to the Apostles signified the potential redeemability of all people.

In the Beatus maps, as in the example of the sculptured tympanum of the church of St Madeleine at Vezelay (Fig. 7.7) the Pentecostal mission was explicitly shown to reach the furthest edges of the world where monstrous races existed.[42] Years ago Katzenellenbogen interpreted the iconography of the Vezelay tympanum as the Pentecostal mission of the Apostles. He noted that St Bernard delivered his call for the second crusade in front of this tympanum. Those present would have recognized parallels between the mission of the Apostles and the contemporary 'Mission of Crusaders'.[43] It should be noted, however, that although neither Urban II nor Bernard of

[42] The text accompanying the map from the *Commentary on the Apocalypse of Saint John* of Beatus of Liebana (the Silos Apocalypse), London, BL, MS Add. 11695, fs. 39v–40, 110g, includes the following text: 'outside the three parts of the world there is a fourth part, the furthest from the world, beyond the ocean, which is unknown to us on account of the heat of the sun. We are told that the Antipodeans, around whom revolve many fables, live within its confines'; see Woodward, 'Medieval *Mappaemundi*', 304, pl. 13.

[43] Adolf Katzenellenbogen, 'The Central Tympanum at Vézelay: Its Encyclopedic Meaning and Its Relation to the First Crusade', *The Art Bulletin*, 26, 1944, 141–51.

Clairvaux openly preached conversion, by the second crusade the distinction between crusade and mission to convert was blurred.[44]

As Katzenellenbogen showed, and as Friedman has elaborated upon subsequently, the mission of the Apostles and the crusades were interchangeably tied in the medieval imagination to the second coming of Christ. In an age in which crusaders returned with stories about distant lands couched within discourse of conversion and Christian domination, the subject of strange races took on exceptional meaning and intent. The map provided a vantage point for investigating the complexity of these relationships. The map's texts for the monstrous races were largely based on ancient sources presenting a non-moralizing tenor. Yet the images riveted salacious attention. It was left to the viewer to reconcile the factual authority of the classical writers with the contemporary Christian world view of these peoples. Visual memory which allowed for sifting and reorganizing information into a Christian framework came into play – hierarchies of zones, distances, and attributes were automatically computed. And finally the map's circle of inclusion reinforced the message of redemption for all peoples, those of the center as well as the outer edges. The frame's Last Judgment provided the Christian *nihil obstat* for the crusading mission to be rightfully considered a step toward the ultimate fulfillment of the mission of the Apostles.

Reading the Pentecostal Mission on the Hereford Map:
The Radius of Reconciliation

The Last Judgment surmounting the map marked the topmost point on the imaginary radius connecting the Garden of Eden (also known as the earthly paradise), the Tower of Babel, and the Crucifixion to Jerusalem at the center. The tower was depicted as the largest image on the map accompanied by the longest text,[45] in direct line with Jerusalem below and the earthly paradise above. Although the text related largely to Orosius' description of the city rather than the tower, the implication was obvious.[46]

[44] Kedar, *Crusade and Mission*, 60 ff.

[45] The text refers to the history of the city, its monumental size and strength of fortification. See n. 46 below.

[46] *Babilonia. a Nembroth gigante fundata. a nino et seramide reparata. campi planicie undique conspicua. natura loci letissima. castrorum facie. menibus paribus per quadrum disposita. Murorum latitudo L cubitorum. eius altitudo quater tanta. Ambitus urbis LXIIII miliaria circumplectitur. Murus coctile late atque interfuso bitumine compactus. Fossa extrinsecus. late patens uice ampnis circumfluit. A fronte murorum cente porte eree. Ipsa autem latitudo in consummacione pinnarum; utroque latere habitaculis eque dispositis; uicenas quadrigas in medio capit.* 'Babylon. Founded by Nembroth the giant, restored by Ninus and Seramis. Visible from everywhere because of the plain. The character of the place most pleasant. The form of the fortification arranged in a square with ramparts equal. The width of the walls 50 cubits. Its height four times as much. The circuit of the city encompasses 64 miles. The wall of brick extensive and compacted with pitch bonded in. A wide open moat outside flows around like a river. In front of the walls a hundred bronze gates. The actual width topped with battlements and chambers distributed equally on both sides accepts four-horse chariots in groups of twenty.' The Hereford's description of Babylon is closely based upon Orosius, II: 6 (trans. Deferrari, 53). Minor departures from Orosius' description are that the area of the circumference of the city is changed from 480 stades to 64 miles and the number of chariots that can fit though the gates from

The image of the huge tower, its pinnacle brazenly pointed toward its symbolic antithesis, Paradise,[47] a dragon peering from its walls, suggested the proud plan of its building campaign. According to Genesis (11: 1–9), the tower's size and intent caused God to humble the people who built it by confusing their language and scattering them over the entire earth, in essence creating the different racial types. If it was the responsibility of the crusaders to bring Christian unity to the east as a continuation of the Pentecostal mission of the Apostles, the prominence given to the Tower of Babel on the Hereford map may be regarded with particular interest.

Pentecost was typologically paired with the story of the Tower of Babel insofar as the God-given ability of the Apostles to speak in tongues at Pentecost was to enable them to bring all peoples together in Christian unity. Interestingly, in contemporary accounts of pilgrims, the fascination and implicit fearfulness of multiple languages spoken in the Holy Land were frequently commented upon.[48] One should also be reminded that it was the progeny of Nimrod, the proud founder of Babel, who connected his line with the line of Ishmael, considered the progenitor of the dark-skinned evil race of the Moors.[49]

The Tower of Babel stood between the earthly paradise, site of the Fall, and Jerusalem, the locus of God's Redemption. Babylon as the seat of the Antichrist (Revelation 17) was the antithesis of Jerusalem. Not surprising they are visually linked on the map – the city of the ungodly opposed to the city of the godly. Each is depicted as circular and marks an end of the radius. For the viewer, that connection visually reinforced the relationship between earthly paradise and heavenly Jerusalem. Jerusalem at the center was envisioned in its duality as the earthly historical Jerusalem and as the heavenly Jerusalem, where the New Covenant was to be fulfilled.[50] On the map's pictorial

an inexact number to twenty quadrigas or four-horse chariots. Interestingly the description avoids the moral lesson that Orosius finds inherent in the downfall of the Kingdom of Babylon as an example of God's censure for human intemperance; see trans. Deferrari, 44.

47 For a discussion of the symbolism of the Garden of Eden as a visual symbol for the heavenly paradise, see J. T. Rhodes and Clifford Davidson, 'The Garden of Paradise', in *The Iconography of Heaven*, ed. Clifford Davidson, 1994, 69–109. The Hereford depiction of the Garden of Eden, based on Genesis 2: 8–10, includes the tree, Adam and Eve, Eve reaching toward serpent, and the four rivers that flow from Paradise. The earthly paradise is shown surrounded by crenellated walls and an outer circle of fire.

48 According to Zeitler, the convergence of peoples of differing languages and cultures induced a heightened questioning of cultural norms suggestive of a 'crisis of cultural identity'. Her thesis is that cultural convergences at Jerusalem indicate that language was the defining characteristic of cultural and religious differences. She particularly noted pilgrimage accounts, such as John of Würzburg's (*ca.* 1170), that made special note of the different peoples and tongues spoken in Jerusalem; Barbara Zeitler, 'The Articulation of Cultural Identity in the Middle Ages' (paper presented at the International Medieval Congress, University of Leeds, 1996). For John of Würzburg's account, see John Wilkinson, *Jerusalem Pilgrimage 1099–1185*, London, 1988, 244–73, esp. 273.

49 See n. 29 above.

50 The relationship between Jerusalem and the heavenly Jerusalem is based upon the text of Revelation (21: 10) which describes Jerusalem as 'coming down out of heaven from God' with 'a great, high wall, with twelve gates' (21: 12). The measurements suggest a form that is equal in length, width, and height. Kühnel provides a thorough discussion of historical Hebrew Jerusalem and the Jewish theological roots of the heavenly Jerusalem. These ideas are considered in relation to Christian theological and political developments leading to clarification of the concept of 'New Jerusalem'; see Bianca Kühnel, *From the*

frame, the vision of Christ enveloped in a multicolored cloud relates to the description by Mark of Christ 'coming in clouds with great power and glory' (Mark 13: 26). The image provided the justification for further reading the symbolic image of Jerusalem on the map as a fulfillment of John's description of Jerusalem as 'coming down out of heaven from God' (Revelation 21: 10). According to Kühnel, in the Christian view, 'heavenly Jerusalem, [was] linked to but also separated from earthly Jerusalem by the cross of Christ' and 'the fate of Jerusalem – earthly and heavenly – in the New Testament [was] dependent on Christ: Jesus' death on the cross [which meant] the end of earthly Jerusalem; Jesus's *perousia* will bring the New Jerusalem from heaven'.[51] Numerous examples corroborate this point. For instance, in an account of Urban II's call for the first crusade of 1095, there is clear recognition of the psychological impact of the word 'Jerusalem'.

> Even the mere sound of the name Jerusalem must have had a glittering and magical splendour for the men of the eleventh century which we are no longer capable of feeling. It was a keyword which produced particular psychological reactions and conjured up particular eschatological notions. Men thought, of course, of the town in Palestine where Jesus Christ had suffered, died, been buried, and then had risen again. But, more than this, they saw in their mind's eye the heavenly city of Jerusalem with its gates of sapphire, its walls and squares bright with precious stones – as it had been described in the Book of Revelation (21: 10 ff.) and Tobit (13: 16–17). It was the center of a spiritual world just as the earthly Jerusalem was, in the words of Ezekiel (5: 5) 'in the midst of the nations and countries'. It was a meeting place for those who had been scattered, the goal of the great pilgrimage of peoples (Tobit 13: 14; Isaiah 2: 2), where God resides among his people; the place at the end of time to which the elect ascend; the resting place of the righteous; city of paradise and of the tree of life which heals all men. Since a good proportion of the crusaders would not have been capable of distinguishing between the earthly and the heavenly Jerusalem such images must have had a powerful effect upon them. They believed that they were marching directly to the city of eternal bliss.[52]

William of Tyre did not live to learn of the fall of Jerusalem in 1187, at which time the impact of the word 'Jerusalem' was revivified with renewed potency.

On the map Jerusalem's wheel radiates. Its crenellated walls appear to the modern viewer as gears prepared to turn. The four portals and four towers point inward as arrows to the circular form, probably meant to signify the dome of the Crusader Church of the Holy Sepulcher, believed to have enclosed the *omphalos* of the world.[53]

Earthly to the Heavenly Jerusalem (Römische Quartalschrift für christliche Altertumskunde und Kirchengeschichte, 42 Supplementheft), Rome, 1987, esp. 43–8; 49–59; Robert D. Russell, 'A Similitude of Paradise: The City as Image of the City', in *The Iconography of Heaven*, ed. Clifford Davidson, Kalamazoo, 1994, 146–61. Also see Laurence Hull Stookey, 'The Gothic Cathedral as the Heavenly Jerusalem: Liturgical and Theological Sources', *Gesta*, 8, 1969, 35–41.

51 Kühnel, *Earthly to Heavenly*, 56.

52 Hans Eberhard Mayer, *The Crusades*, trans. J. Gillingham, Oxford, 1988 (2nd edition), 11. The text is quoted by Jaroslav Folda, *The Art of the Crusaders in the Holy Land 1098–1107*, Cambridge, MA, 1995, 21.

53 For the centrality of the Constantinian Church of the Holy Sepulcher, see Kühnel, *Earthly to Heavenly*,

Jerusalem the Heavenly, in its circular form, was diverted from its literal biblical description (Revelation 21: 16) but once again had artistic precedents in illuminated Beatus Apocalypse manuscripts.[54] The Hereford map shared this common source for the circular form of Jerusalem with a related group of contemporary maps known as 'Situs Jerusalem' or 'crusader maps'.[55] For them, the circular forms of Jerusalem included specific details relating to the city plan and pilgrimage sites within Jerusalem (Figs. 7.8, 7.9). In that respect they differed from the Hereford map and its mappae mundi relatives which omitted most topographical details of the city.[56] However, the

81–8. For discussion of the symbolic import of the crusader Church of the Holy Sepulcher, see Nurith Kenaan-Kedar, 'Symbolic Meaning in Crusader Architecture', *Cahiers archéologiques*, 34, 1986, 109–17. For another valuable discussion of the relationship between the domed crossing above what was believed in the crusader period to be the exact location of the *omphalos*, see Folda, *Art of the Crusaders*, 213–14. Folda also lists several of the twelfth-century descriptions that ultimately refer to Psalm 74: 12 and less specifically in Ezekial 5: 5 and Isaiah 40: 12 ff.; see Folda, *Art of the Crusaders*, 213–14, 537 (n. 54). During the crusader period pilgrims associated the site of the *omphalos* (which was covered by the dome in the nave of the crusader Church of the Holy Sepulcher) with the appearance of Christ to Mary Magdalene. The larger dome covered the rotunda, which marked the site of Christ's resurrection.

54 Kühnel, *Earthly to Heavenly*, 142–5.

55 Although there are artistic precedents for Jerusalem portrayed as circular, its closest artistic analogs are the contemporary crusader maps of Jerusalem described below. This type of image came to be included in manuscripts describing the deeds of the crusaders. They are basically a large-scale city plan of Jerusalem superimposed upon a schematic image of the Holy Land. For general discussions of crusading maps of Jerusalem, see esp. Konrad Miller, *Die ältesten Weltkarten*, 3: *Die Kleineren Weltkarten*, Stuttgart, 1895–8, 61–8 in which the most complete list with inscriptions is given. Also see Franz Niehoff, 'Umbilicus mundi – Der Nabel der Welt', in *Ornamenta Ecclesiae*, ed. Anton Legner, 1985, III: 52–80, esp. 72–9; Zev Vilnay, *The Holy Land in Old Prints and Maps*, Jerusalem, 1963, 7–13; P. D. A. Harvey, 'Local and Regional Cartography in Medieval Europe', in *The History of Cartography*, 1: *Cartography in Ancient, and Medieval Europe and the Mediterranean*, ed. J. B. Harley and David Woodward, Chicago, 1987, esp. 473–6; Eran Laor, 'Maps of the Holy Land', *Ariel*, 45–6, 1978, 210–19; Kühnel, *Earthly to Heavenly*, 138–41. The five most commonly cited are the following:
(1) St Omer, f. 15v. See Miller, *Kleineren Weltkarten*, 62, no. 1, fig. 14.
(2) Brussels, Bibliothèque Royale, MS 9823–9824, f. 157, Collectar, second half of twelfth century. See Miller, *Kleineren Weltkarten*, 62, no. 2, fig. 15; (especially) Niehoff, 'Umbilicus mundi', 74–5, fig. H3 (p. 75); Vilnay, *Holy Land*, 10–11, fig. 15 (p. 10); Nebenzahl, *Maps of Bible Lands*, 32, who dates the map to *ca.* 1100; R. Röhricht, *Bibliotheca geographica Palaestinae*, Berlin, 1890, no. 86; Kühnel, *Earthly to Heavenly*, fig. 99.
(3) Stuttgart Public Library, MS Biblia Nr. 56. See Miller, *Kleineren Weltkarten*, 63–4, no. 5; Vilnay, *Holy Land*, 12–13, fig. p. 13 (p. 12); Kühnel, *Earthly to Heavenly*, fig. 100; R. Röhricht, 'Karten und Pläne zur Palästinakunde aus dem 7. bis 16. Jahrhundert', *Zeitschrift des deutschen Palästina-Vereins*, 15, 1892, 34–9, pls. 1, 2, 5.
(4) The Hague, Koninklije Bibliothek, MS 75, F5, f. 1, Psalter, St Bertin, late twelfth century. See Miller, *Kleineren Weltkarten*, 64, no. 7; Niehoff, 'Umbilicus mundi', 76–7, fig. H4 (p. 76); Vilnay, *Holy Land*, fig. 13 (p. 7); Kühnel, *Earthly to Heavenly*, fig. 101; Röhricht, 'Karten', 37, pl. 3 – for bibliography, see p. 221, n. 148; Walter Cahn, *Romanesque Manuscripts, The Twelfth Century* (A Survey of Manuscripts Illuminated in France, 2), cat. no. 138 (pp. 165–6), London, 1996; *ibid.* I: col. pl. XVI.
(5) Cambrai, Bibliothèque Municipale, MS 437, Collectar, Cambrai (?), *ca.* 1140–70. See Miller, *Kleineren Weltkarten*, 64, no. 9; Niehoff, 'Umbilicus mundi', 73–4, fig. H2 (p. 73); Vilnay, *Holy Land*, 8–9, fig. 14 (p. 8). This map is removed from the group in that Jerusalem is not enclosed within a circular frame.

56 For description of the sites included in the tour of the Holy Land, see Setton, *A History of the Crusades*, IV: 36–68. Also see Theoderich, *Guide to the Holy Land*, trans. Aubrey Stewart, New York, 1986 (2nd edition); Wilkinson, *Jerusalem Pilgrimage*; F. E. Peters, *Jerusalem: The Holy City in the Eyes of the Chroniclers, Visitors, Pilgrims, and Prophets from the Days of Abraham to the Beginnings of Modern Times*, Princeton, 1985.

Fig. 7.8 Map of Jerusalem. The Hague, Koninklijke Bibliotheek, MS 76 F 5, f. 1r. (?) St Bertin. *ca.* 1170–80

Fig. 7.9 Map of Jerusalem. Brussels, Royal Library of Belgium, MS 9823–9824, f. 157. Second half of 12th century

© Royal Library of Belgium

Hereford map, like its relatives, shared with the crusader maps the inclusion of key sites and objects of reverence central to itineraries of pilgrims and crusaders visiting the Holy Land.[57] In effect, although the two types of maps were related, mappae mundi operated more overtly on the symbolic level. Jerusalem was designated solely as the signifying center, punctuated by the Crucifixion at Calvary, its defining event.[58] In the Middle Ages, the typological relationship between the Crucifixion and the Fall was symbolized by the belief that the cross of Calvary was the Tree of Knowledge brought to life again.

For the crusaders there was a fascination with the mystical symbolism of the cross.[59] That on the Hereford map Calvary is immediately above the stark circular image of Jerusalem further suggests conflations not only with 'crusader maps' but also with contemporary line drawings of the Church of the Holy Sepulcher that represent the church as a series of concentric circles. In the Hereford map, the Holy Sepulcher and Jerusalem are in effect one and marked by the Crucifixion. In its simplification, the Hereford map distills the essence of the image on crusader maps which show the circular Church of the Holy Sepulcher marked by the cross at Calvary immediately above.[60] In discussing the crusader maps Kühnel suggests that they represented 'an

[57] Using the Hague MS 75 and Brussels MS 9823 examples as models, the following items surrounding Jerusalem are pictured: the Hague map: Bethpage, Mount of Olives/Ascension of the Lord, Gethsemane, Mount Excelsus, Jericho, Bethany, Church of St Mary/Tomb of St Mary, Brook Cedron, Valley of Jehoshaphat, Mount Joy, Fountain of Siloam, Aceldama, Coenaculum, Tomb of Rachel, Church of St Stephen, Mount Zion, Bethlehem. The Brussels map includes almost all the same examples (except Bethpage and Gethsemane). It also includes the Tomb of the Pilgrims, Nazareth, Mount Tabor, the region of the five cities (which includes Sodom and Gomorrah), the Dead Sea, the Jor and Dan issuing from Mount Lebanon, connecting to Lake Gennesaret, Sea of Tiberias, and Sea of Galilee. High mountains are pictured on the shore of the Dead Sea including Mount Seir and Mount Sinai. On the Hereford map, there is much less emphasis on pilgrimage sites. In comparing the Hereford map to the two above examples, the following sites are shared: Jerusalem, Calvary (Calvary is located within Jerusalem on the crusader maps), Bethlehem, Nazareth, Valley of Jehoshaphat, Jericho. It more closely resembles the Brussels map by its eastern inclusion of the Jordan, Mount Libanus (Lebanon) and the Dead Sea providing an eastern boundary. However, on the Hereford map the cities that border the Mediterranean, being of greater concern to crusaders, frame the Holy Land from north to south: Acaron (Ekron), Tholomaida (Ptolemais), Iope (Jaffa), Diospolis (Lydda), Iampnia (Jabne), Ascalon, Actua (Esdud), Gerara protecting the harbor and forming a series of fortress-like towers.

[58] On the Ebstorf map, however, Christ's resurrection is depicted within the central square image of Jerusalem, whereas in the Hereford map Jerusalem is depicted as circular and Christ crucified is depicted above Jerusalem. Folda suggests that the Hereford map's image with Christ surmounting Jerusalem at the center of the world may possibly be a reference to the Crucifixion mosaic in the Calvary Chapel of the Church of the Holy Sepulcher; see Folda, *Art of the Crusaders*, 546, n. 148.

[59] According to Tyerman, there were numerous descriptions of miracles relating to the location of the crucifixion by, for example, Roger of Wendover, William of Tyre as described by Matthew Paris, and Peter de Roches. In England important relics included the Holy Rood of Bromhold, the Host of Blood and the imprint of Christ's foot at Westminster; see Tyerman, *England and the Crusades*, 94.

[60] The interchangeability of the circular image of the rotunda of the Holy Sepulcher and Jerusalem has been noted by others, e.g. Kühnel, *Earthly to Heavenly*, 129–31; Niehoff, 'Umbilicus mundi', 77–8. The most familiar circular images of the Holy Sepulcher cited are from the four extant copies of ninth-century Arculf/Adamnan's *opus* based upon the seventh-century *loca sancta* description of the Holy Sepulcher by the Bishop of Gaul. Two examples are: (1) Vienna, Österreichische Nationalbibliothek, cod. 609, f. 4, thirteenth century (see Kühnel, *Earthly to Heavenly*, fig. 82; Niehoff, 'Umbilicus mundi', fig. H6 (p. 79);

amazing example of fusion between apocalyptic visions of Jerusalem and *loca sancta* realities, or heavenly-eternal exceptions and earthly landscapes, all so characteristic of the Christian attitude toward Jerusalem'.[61] The same comment even more aptly applies to the Hereford map.

Jerusalem was not only the worldly city at the hub of sacred history but as we have seen, it was at the same time the embodiment of the apocalyptic end of all history (Revelation 21).[62] It was a mystical goal that ended and transcended history. The confusion between the two was real and was made manifest on the Hereford map, by the scene of Christ in Last Judgment above the entire map.

Biblical 'Itineraries'

Although the map is a product of an age of crusading, it was too complex to see it only from that point of view. Crone has suggested that it alluded to other itineraries, trade routes and religious pilgrimages. For instance he points out the Hereford map included such centers as Santiago, Mont St Michel, Canterbury, and Rome, as well as Jerusalem.[63] To my mind, in addition to such fixed itineraries, it was also about wanderings, specifically biblical. Apart from numerous cities that are cited in the Bible, a limited number of biblical events and personages are specifically noted and some relate to this theme.[64] Immediately to the right of the earthly paradise, Adam and Eve were shown being expelled by a winged angel. Their displacement was reiterated by the relatively large space devoted to the subsequent wanderings of the Jews, whose path was described graphically and anecdotally by a looped line, connecting cities, the parted Red Sea, Moses with the Ten Commandments, and more. St Paul, who looked upon the Hebrews' wanderings as a judgment, may have influenced the selection of

Hermann, *Deutschen Handschriften*, 362–3, fig. 219); (2) Vienna, Österreichische Nationalbibliothek, cod. 458, Salzburg, mid-ninth century (see Niehoff, 'Umbilicus mundi', fig. H5 (p. 78)).

61 Kühnel, *Earthly to Heavenly*, 138–41.

62 See Norman Cohn, *The Pursuit of the Millennium*, New York, 1961, 40–52.

63 Crone suggests that the map included such itineraries as the Antonine Itinerary, Compostela pilgrimage, St Paul's journeys in part, the *Voie Regordane* and medieval trade routes including the wool trade route described by Francesco Pegolotti, a Florentine agent in his book *Pratica della mercatura*, compiled *ca.* 1290–1300; see Gerald R. Crone, 'New Light', 447–58; Gerald R. Crone, *The Hereford World Map*, London, 1949, 7, 10. Some of the details in the Holy Land were taken from itineraries made for use of pilgrims; see *ibid.* 10.

64 The Garden of Eden including the four rivers, and the Fall (Genesis 2: 8–14; 3: 1–7); expulsion from the Garden of Eden (Genesis 3: 24); Noah's Ark on the mountain of Ararat (Genesis 8: 4); Tower of Babel (Genesis 11: 1–9); Abraham at Ur (Genesis 11: 27–31); destruction of Sodom and Gomorrah, Lot's wife (Genesis 19: 1–25; 26); Abraham's Well of the Oath (Beersheba) (Genesis 21: 32, 46: 1); sojourn in Egypt, Joseph's storehouse (Genesis 41: 46–57); passsage of the Red Sea (Exodus 14: 21–9); Moses on the Mount while the Israelites worship the golden calf (Exodus 32: 1–8); Jericho marked as the city in which Moses completed his wanderings after leading the people of Israel all the way thither (Deuteronomy 32: 48–52).

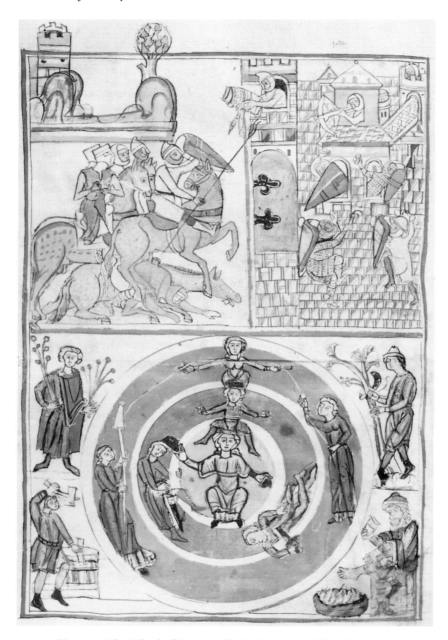

Fig. 7.10 The Wheel of Fortune. Flavius Josephus, *Bellum Judaicum*,
Munich, Bayerische Staatsbibliothek, MS Clm 17404,
f. 203v. 1226–41, Scheyern Abbey

Old Testament subjects.[65] The prominence given to the theme paralleled Paul's admonitions in which he compares the Christian life to the Hebrew experience in the wilderness as a warning to Christians (1 Corinthians 10: 11): 'Now these things happened to them as a warning, but they were written down for our instruction, upon whom the end of the ages has come.' In the Middle Ages, biblical exegesis and typological readings of biblical events were familiar to all groups of viewers, albeit learned through different means and understood with varying sophistication. Similarly chronicles of the crusades and world histories, based upon a Christian model of salvation, were familiar to most.[66] The literate viewer could rely on those interpretative treatises directly; the less knowledgeable learned the lessons of the Bible and 'history' indirectly through oral communication, usually distilled by the clergy.

In the age of the crusades, the edges of the world represented the limits of the Pentecostal mission of which the crusades were crucially important. Concomitant interest in the world beyond the *oikoumene* extended to the 'monstrous', which apparently paralleled twelfth and thirteenth century literary development of the 'marvelous' as defined by Le Goff as the natural form or 'secularization of the supernatural'[67] and was a function of the crusades and the courtly class.[68] At that time, the 'marvelous' made an appearance in high culture intimately associated with the idealized knight's quest for individual and collective identity. The knight tested by a series of marvels and monsters in combat became a literary trope. In that light, the crusading mandate to do battle with the 'other' as embodied by the strange, monstrous, and thus 'marvelous' was in effect a Christianization of the secular aspects of the chivalric mission.

On the one hand one could argue that for the Church, the marvelous, magnet of *curiositas*, could be tamed to its advantage. The idea is more overtly expressed by

65 I am grateful to Priscilla Smeed who suggested this interpretation to me. She also noted the Old Testament themes that relate to judgment and salvation as Noah's Ark, Sodom and Gomorrah, Joseph as a type for Christ, and others.

66 Stephen G. Nichols, Jr., *Romanesque Signs*, New Haven, 1983, esp. 1–14.

67 According to Le Goff, the 'marvelous' exists between two poles of supernatural occurrences: (1) miracle/divine supernatural (miraculous dependent only on God's saving grace, as for instance, the miracles of the saints); (2) magic/diabolical supernatural (magic, governed by Satan's destructive activity). According to Le Goff, based on examples from literature, hagiography, and other textual sources, from the fifth to the eleventh centuries, it appears the 'marvelous' was repressed. Le Goff attributes this to the need for the Church to counteract strong pagan threats during that time; see Jacques Le Goff, *The Medieval Imagination*, trans. Arthur Goldhammer, Chicago, 1988, 12. This is certainly corroborated by our knowledge of the history of maps wherein the element of the 'marvelous' is added to maps most obviously in the twelfth century.

68 Le Goff introduces Erich Köhler's view that 'courtly literature was bound up with the class interests of a rising but already threatened social stratum, namely the lower and middle ranks of the nobility, the knightly strata. It was the desire of this group to oppose the culture of the Church and its ally, the aristocracy, by erecting not a counterculture but an alternative culture that was more its own, hence more amenable to its wishes. It therefore drew upon an extant reservoir of culture, namely the oral culture of which the marvelous was an important component. That the marvelous plays such a large part in courtly romance is no accident. It is intimately associated with the idealized knight's quest for individual and collective identity. The knight is tested by a series of marvels. Marvels such as magical charms aid in his quest while others such as monsters must be combated.' See Le Goff, *Medieval Imagination*, 29, who cites Erich Köhler, *Ideal und Wirklichkeit in der höfischen Epik*, Tübingen, 1956.

Gervase of Tilbury who cited many 'mirabilia', in his *Otia imperialia* (*ca.* 1210) which was the source of much of the material on the Ebstorf map. Although he presented marvels as extreme or exceptional, they were not described as unnatural occurrences. He considered them true even if not sanctioned by the Bible. In his introduction he says 'we call marvels those phenomena that escape our understanding though they be natural'. They are presented as rarities rather than supernatural phenomena, events that render us impotent to explain as opposed to inexplicable events. Marvels took place on the fringes of this world, not in another world.[69]

In the context of the crusades, one can assume that, in addition to the desire to bring all people under the aegis of the Christian religion, there was also the desire to confront the 'marvels' of the world. Both were integral to the imagination of the stratum of society that was to make the journey. It was left to the individual viewer to make connections between the juxtaposition of the antique world and the familiar medieval designations (e.g. Fig. 7.10). On the Hereford Map, the Last Judgment imposed the Christian *nihil obstat* upon the monstrous and marvelous encompassed by the earth, and provided the context for crusading fervor.

[69] Gervase of Tilbury, *Le Livre des merveilles*, trans. Annie Duchesne, preface by Jacques Le Goff, Paris, 1992, 20. As described by Richardson, the first section shares many parallels with the Ebstorf and Hereford maps. The book begins with the Creation in nine chapters, followed by a description of the four monarchies of Adam, Noah, Alexander the Great, and Augustus Caesar, then follows geographical information beginning with the four rivers of Paradise. In the last four chapters of the first book he concerns himself with the history of mankind up to the Flood. The second book is concerned with history and includes a tract on the Holy Land. The third book is concerned with marvels. Richardson decries the paucity of research relating to Gervase of Tilbury; see H. G. Richardson, 'Gervase of Tilbury', *History*, 46, 1961, 102–14. Also see four works by James R. Caldwell: 'The Autograph Manuscript of Gervase of Tilbury', *Scriptorium*, 11, 1957, 87–98; 'Manuscripts of Gervase of Tilbury's *Otia imperialia*', *Scriptorium*, 16, 1962, 28–45; 'The Interrelationship of the Manuscripts of Gervase of Tilbury's *Otia imperialia*', *Scriptorium*, 16, 1962, 246–74; 'Gervase of Tilbury's Addenda to his *Otia imperialia*', *Mediaeval Studies*, 24, 1962, 95–126. It is largely agreed that Gervase's *Otia imperialia*, written by Gervase for Otto IV is closely associated with the Ebstorf map; see Joachim G. Leithäuser, *Mappae Mundi*, Würzburg, 1958, 89–90.

Part IV

The Hereford Map in Cartographic Context

8

A COMPARISON OF FRAMEWORKS

THIS STUDY HAS BEEN CONCERNED with placing the Hereford map within its artistic and intellectual context. The book would not be complete, however, without some discussion of the map's cartographic relatives. Because the subject is vast and has been extensively studied by others,[1] I limit my discussion to general introductory remarks followed by a brief comparison of the Hereford pictorial frame to the frames of four of its closest relatives (I stress the term pictorial frame here to avoid confusion with the Hereford map's wooden framework).

Pictorial Frames: General Remarks

The phenomenon of maps with numerous images and texts was largely a product of the eleventh to thirteenth centuries. Although the Hereford map supposedly was based upon the Roman map of Agrippa, evidence suggests that the model, apart from noting cities, lacked pictorial details. In terms of imagery, the history of western cartography showed little change between the Roman and Carolingian periods.[2] However, by the eleventh century, concomitant with the emergence of Romanesque imagery, the visual vocabulary of the more abundantly decorated Beatus maps emerged, soon after followed by a profusion of elaborately decorated T-O mappae mundi. These mappae mundi shared with other newly flourishing forms of medieval art a *horror vacui* wherein a seemingly endless array of images were packed into spaces that could hardly contain them. These maps were made in a range of sizes and artistic media and were clearly meant as cosmological images, made for educational and religious edification. The variety of sizes and presentations suggests a variety of intentions as well as audiences ranging from individuals who owned personal documents (mostly manuscripts) to maps exhibited for public viewing in both religious and secular contexts.

The various maps have often been shown to combine ideology with content. Although included in decorative schemes, manuscript collections, or exhibited singly, several maps have been shown to provide particular emphasis on their place of origin. This is particularly true of the Ebstorf map or the Henry of Mainz map (now known as the 'Sawley map') which suggest connection to place and patron. Sizes of countries are approximate, frequently reflecting a personal view of the world so that in the Ebstorf map Westphalia is particularly exaggerated as is England on the Hereford. In terms of geography the maps are not drawn to scale and so lengths and breadths are often given in inscriptions. There is little attempt to show coastlines in detail: for instance, islands

[1] For an extensive introduction to the subject, see Woodward, 'Medieval *Mappaemundi*', 286–370.
[2] Edson, 'Oldest World Maps' 169–84; Catherine Delano Smith, 'Geography or Christianity? Maps of the Holy Land before AD 1000', *The Journal of Theological Studies*, 42/1, 1991, 143–52.

are often represented by outlines of objects they were thought to resemble so that on the Hereford map Sardinia is shown in the shape of a footprint and Charybdis as a snail. The maps have been noted to be *retarditaire* in style; the images of the interiors generally of simple line drawings color-coded. In content, they provided a range of knowledge and lore from simple to learned. Compared to the more sophisticated inquiries of medieval scholars, travelers, and remarkably accurate marine charts soon to come into use, they linked the viewer to the past history of stored memory rather than the future of scientific inquiry.[3]

The frames reiterated the Christian implications of the maps in a manner akin to the earlier twelfth-century chronicles that took the Creation as their starting point.[4] As we have shown repeatedly, the Hereford map belongs within the greater tradition of medieval learning. The images and texts from the map belong to an endless network of other texts and images that were frequently placed side by side on pages of manuscripts that contained collections of revered material. I have spoken of the Hereford map as an encyclopedia; one may also refer to it as a 'universal chronicle' whose subject begins with the earth's creation. Goetz's description of a 'universal chronicle' may be used equally well for the map. 'It is characterized by its context within the history of salvation, manifested in the divine background, the division into ages (*aetates*) and kingdoms (*regna*), typological comparisons, a linear conception of history as a limited period, and a search for the position of the author's present age in the divine concept of salvation.' As Goetz also suggests, the choices of events and subjects were consciously made by the author to define the author's present in relationship to the Creation or Christ's incarnation. By stressing the main kingdoms, particularly the Roman Empire (and the Church), it revealed a sense of continuity, thus 'presenting only select sections which were stamped by the view of the contemporaries and the conviction that their own age was nearest to God'.[5] By the twelfth century, this type of material, in the form of chronological or geographical lists, was to be memorized. It would also be transferred onto map images so that the reader/viewer could situate details of history onto

[3] Crone suggests that a series of modern scholars have seen maps such as the Hereford map as not worthy of scholarly attention; see Crone, 'New Light', 1965, 447; Crone, *World Map by Richard of Haldingham*.

[4] Flint mentions Anselm of Laon (d. 1117), Hugh of St Victor, and Honorius of Autun who influenced a form of world chronicle which proceeds with the history of man from the Fall. In particular she cites the importance of the Universal Chronicle of Marianus Scotus of Mainz which was brought to Hereford by Bishop Robert of Hereford (1079–95); see Valerie I. J. Flint, 'World History in the Early Twelfth Century: the *Imago Mundi* of Honorius Augustodunensis', in V. I. J. Flint, *Ideas in the Medieval West*, London, 1988, 214.

[5] Hans Werner, 'On the Universality of Universal History', ed. Jean Philippe Genet, in *L'Historiographie médiévale en Europe*, Paris, 1991, 247–61, esp. 247; Gautier Dalché notes that Orosius, as compared to other universal chroniclers, emphasizes locations as well as deeds. He also suggests that Orosius was most likely the source for Hugh of St Victor's *Chronicon*, as already shown. This is particularly appropriate for our understanding of the Hereford map; see Patrick Gautier Dalché, 'L'Espace de l'histoire: le rôle de la géographie dans les chroniques universelles', in *L'Historiographie médiévale en Europe*, Paris, 1991, 287–300; Anna-Dorothee von den Brincken, 'Mappa mundi und Chronographia. Studien zur *imago mundi* des abendländischen Mittelalters', *Deutsches Archiv für Erforschung des Mittelalters*, 24, 1968, 118–86.

concrete images in an effort to follow the unfolding of the course of events in universal history in which all of mankind shared a common origin.[6]

Natural memory was often aided by learning systems, often systems that employed *loci* (places memorized as stimuli for the recollection of items methodically assigned thereto), as we have already seen in medieval versions of *Ad Herennium*.[7] Although one cannot argue for a clearly defined and organized system outside the geography itself, imbedded within maps are visual clues that help the viewer make extra-geographical connections and typological connections. For instance, in the Hereford map, a most obvious case is the circular world that encloses God's creations on earth juxtaposed against the smaller circle at the easternmost point that represents the Garden of Eden. The actual world compared to the ideal Garden are visually presented on a radius that leads us from the material world upward toward the spiritual realm. This visual relationship is expressed in various ways on other mappae mundi as well. One is prepared to 'read' the map in such a way, because for the medieval viewer the topmost image on the pictorial 'frame', in the case of the Hereford map, the Last Judgment, sets the stage for permitting the viewer to entertain Christian interpretations.

The selectivity of the images and texts chosen provides us with a visualization of a diverse world enclosed within the perimeter of the circle and beyond that the pictorial frame itself. The frames of the maps considered here remind the viewer that the earth began with Creation, and salvation, through Christ the *logos*. Biblical history connected to Christian salvation gave the apparently random images the continuity of history. The pictorial frames, differing to some degree from one map to another, provide the viewer with the cue to read the maps as symbolic constructs in which God's immanent meaning was encoded.[8] On the Hereford and Ebstorf maps and the Cornwall fragments, the particular emphasis on Caesar Augustus reinforces the conscious effort of the authors to make the material world of history mirror the scriptural. All three show the three notaries of Caesar who are responsible for taking the census of the descendants of Noah's three sons, each of whom inhabited a continent. In the case of the Hereford map the emperor wears the papal tiara, which reinforces the symbolism of the continuity with scriptural history.

A Comparison of Pictorial Frames

Separated from the general realm of mappae mundi are those maps that specifically are enclosed by pictorial frames of a cosmological nature and as such are 'related' to the Hereford map. I limit my discussion to the following medieval mappae mundi: the

6 Gautier Dalché suggests that by the first half of the twelfth century, as evidenced by the prologue of Hugh of St Victor's *Chronicon*, lists of geography and chronology were meant to be memorized. The concept was further developed by, for example, Gervase of Tilbury (thirteenth century) and later by Ranulf Higden (fourteenth century), whose writings are closely tied to mappae mundi developments; see Gautier Dalché, 'L'Espace', 289.

7 Yates, *Art of Memory*, 76.

8 For a discussion of the symbolic constructs in historical narrative, see Nichols, *Romanesque Signs*, esp. 1–14.

Henry of Mainz ('Sawley') map (late twelfth century),[9] the Duchy of Cornwall map (*ca.* 1260–85),[10] the Psalter map (*ca.* 1275–1300),[11] and the Ebstorf map.[12]

These maps were related by subject matter, textual information, and selected

9 Cambridge, Corpus Christi College, MS 66, p. 2. The map provides the frontispiece to Honorius of Autun's *Imago mundi* as part of a larger compendium including a compendium of texts and images described by Montague Rhodes James, *A Descriptive Catalogue of the Manuscripts in the Library of Corpus Christi College*, Cambridge, I: no. 66, 137–45. According to Harvey the map has been wrongly associated with Henry of Mainz. Harvey believes that the manuscript was probably written at Durham and the map was added as frontispiece when the manuscript was presented to the Cistercian house of Sawley in Yorkshire; see Harvey, *Mappa Mundi*, 22. For further discussion on this point, see Bernard Meehan, 'Durham Twelfth-Century Manuscripts in Cistercian Houses', in *Anglo-Norman Durham*, ed. D. Rollason, M. Harvey, and M. Prestwich, Woodbridge, 1994, 440, 442–6. The manuscript contains five illustrations: world map (p. 2), Fortune turning her wheel (p. 66), genealogical table with line of descent from Adam to Woden (p. 67), figure of Woden with busts of his seven sons (p. 69), six winged cherub with names of virtues (p. 100); see Kauffmann, *Romanesque Manuscripts*, cat. no. 102 with bibliography, 123; specifically for map, see Destombes, *Mappemondes*, no. 25.3 (p. 48); Miller, *Kleineren Weltkarten*, 21–9. For the image of the Wheel of Fortune, see Patch, *Goddess Fortuna*, pl. 5; Eric G. Millar, *English Illuminated Manuscripts from the Xth to the XIIIth Century*, 1926, pl. 54b.

10 A fragment of the map was discovered in the archives of the Duchy of Cornwall in the form of a wrapper for records relating to Ashridge College in Hertfordshire (founded in 1283 by Edmund, Duke of Cornwall, brother of King Henry III). Although only a corner of the map was found, extrapolating from the dimensions, it appears to have been slightly larger than the Hereford map. It was perhaps the earliest large mappa mundi produced in England, if, as suggested, it was presented to the College on its foundation by Edmund, Earl of Cornwall, whose father, Richard, Earl of Cornwall, was the brother of Henry III. Haslam suggests that it may be modeled after the mappa mundi at Westminster Palace commissioned by Henry III (*ca.* 1239, see Chapter 2; also see Graham Haslam, 'The Duchy of Cornwall Map Fragment', in *Géographie du monde au Moyen Age et à la Renaissance*, ed. Monique Pelletier, Paris, 1989, 33–44, 41 n. 19). If one accepts Haslam's provenance for the Cornwall map as English, *ca.* 1260–85, the Duchy of Cornwall map may have been a model for the Psalter and Hereford maps. Various relationships between the three maps support the thesis. For instance, the text regarding the three mythical surveyors on the Cornwall fragment is similar to that on the Hereford map, as are the descriptions of winds on the circumference. Similarly the figures depicted are close in style and subject matter to Hereford. According to Haslam, the Psalter map was an abbreviated intermediary. Haslam offers two suggestions as to authorship of the fragment: Gervase of Canterbury who produced a mappa mundi in 1262 (actually a list of religious houses), and Richard de Bello, the supposed 'author' of the Hereford map. According to Haslam, Earl Edmund owned a vast estate in Lincolnshire during the period of Richard de Bello's tenure at Lincoln Cathedral whereupon he commissioned Richard de Bello to make a map either for himself or for the Ashridge foundation.

11 The Psalter map in British Library MS Add. 28681 is one of three decorated pages that accompany the Psalter that is decorated with fully painted and historiated initials. The Psalter has been dated to post-1262 based upon calendric data and has been given a London/Westminster provenance. The three full-page illuminated pages (Mappa mundi, f. 9r; Mappa mundi, f. 9v; Virgin and Child, f. 190v) have been attributed to two different hands from the same workshop. Morgan suggests that the Psalter map (f. 9r) reflects a lost twelfth-century prototype, as too do the Ebstorf and Hereford maps, and the many copies of the fourteenth-century map of Ranulf Higden, the Psalter map being the closest to the prototype; see Morgan, *Early Gothic Manuscripts*, 4/2, cat. no. 114, 82–5 with lengthy bibliography on p. 85; Miller, *Kleineren Weltkarten*, 37–43; Tony Campbell, *Early Maps*, New York, 1982. Bagrow suggests *ca.* 1225, which considering more recent scholarship cited by Morgan appears too early; see Leo Bagrow, *History of Cartography*, Cambridge, MA, 1964, 45.

12 Morgan suggests that Gervase of Tilbury perhaps knew the twelfth-century prototype, which would explain links between the Ebstorf and Hereford maps; see Morgan, *Early Gothic Manuscripts*, 4/2, 84. The bibliography for the Ebstorf map is too extensive to cite here. For recent and extensive treatment and bibliographies, see Brigit Hahn-Woernle, *Die Ebstorfer Weltkarte*, Ebstorf, 1989; Hahn-Woernle, 'Ebstorfer Weltkarte und Fortuna'.

imagery. However, only circumstantial evidence suggests that they were directly linked.[13] Their relativity to one another was largely conceptual, yet each was enframed by a different device. Irrespective of their contents, the pictorial frames served as prompts to help viewers interpret the worldly matter from subtly different Christian vantage points suggested by images familiar from church settings.[14]

Our discussion of these pictorial frames takes us full circle insofar as the enframing cartographic tradition that burgeoned in the twelfth century again relates to cosmological themes earlier introduced. Clearly the maps 'spoke' to a varied audience, and were purveyors of a density of information and associations. Scholars have provided numerous links to authors of twelfth-century treatises that appear to have contributed to the conceptual underpinnings of the maps. Honorius of Autun[15] and Hugh of St Victor[16] are most commonly cited. More generally, the frames reflect the burgeoning number of treatises concerned with the theme of God as creator of the world.[17] Whereas the theme is imbedded in the Hereford map, it is more overtly stated in the others.

I begin the discussion with the Henry of Mainz map (Fig. 8.1). The map is a relatively close, although simpler, analog to the Hereford map. It includes sites and even images that are extremely close in conception to the Hereford.[18] The pictorial frame, however, is vastly different. The Henry of Mainz map has a simple enframement of four angels, one in each corner of the manuscript page. I suggest that within the context of an enframing device for a world map, the four angels were meant to represent the four corners of the world. The idea is based on the Jewish conviction that God sent four

13 See discussions on individual maps in text and footnotes above.
14 Hints of these symbolic developments that stress theology over geographic accuracy are noted in a limited number of examples predating the twelfth and thirteenth centuries; see Smith, 'Geography or Christianity?', 143–52.
15 For seminal work on Honorius of Autun's *Clavis physicae*, see Marie Thérèse d'Alverny, 'Le Cosmos symbolique du XIIe siècle', *Archives d'histoire doctrinale et littéraire du Moyen Age*, 28, 1953, 31–81. For introduction to Honorius of Autun's *Imago Mundi*, see V. I. J. Flint, 'Honorius Augustodunensis. *Imago Mundi*', *Archives d'Histoire doctrinale et littéraire du Moyen Age* 49, 1982, 7–153; V. I. J. Flint, 'World History'.
16 For seminal work, see Grover A. Zinn, Jr. 'Mandala Symbolism and Use in the Mysticism of Hugh of St Victor', *History of Religions*, 12, 1972–3, 317–41. Zinn's suggestion of Hugh of St Victor as an important source for cosmological iconography is more specifically applied to the cosmological pictorial frames of mappae mundi by Lecoq who creates a visualization of selections taken from Hugh of St Victor's *Mystical Ark of Noah*. The visualizations do not however actually closely parallel any known mappa mundi; see Danielle Lecoq, 'La *mappemonde* du *De arca Noe mystica* de Hugues de Saint-Victor (1128–1129)', in *Géographie du monde au Moyen Age et à la Renaisssance*, ed. Monique Pelletier, Paris, 1989, 9–31; Gautier Dalché, *La 'Descriptio mappe mundi'*; Kupfer, 'Medieval World Maps', esp. 269–71; Barber, 'Evesham Map', 13–33, esp. nn. 73, 74.
17 For an excellent overview of the imagery of the Creation in medieval art, see Johannes Zahlten, *Creatio mundi*, Stuttgart, 1979. Note the burgeoning of treatises relating to the Creation from the twelfth century to the fourteenth as shown on the chart; see Zahlten, *Creatio mundi*, 223.
18 Note for instance, similarities of images such as basilisk (*basiliscus*), Temple of Jove (*templum iovis*), Lake Caleas (*caleas lac*), Paradise (*paradis*), Joseph's barns in Egypt (*horrea ioseph*). For numerous shared texts and items, see Miller, *Kleineren Weltkarten*, 21–9.

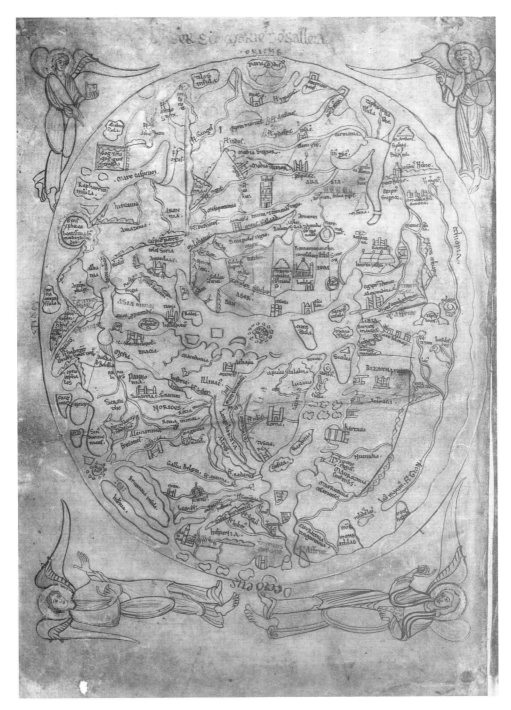

Fig. 8.1 The Sawley Map (previously known as Henry of Mainz World Map). Cambridge, Corpus Christi College, MS 66, p. 2. Late 12th century, England

By kind permission of The Master and Fellows of Corpus Christi College, Cambridge

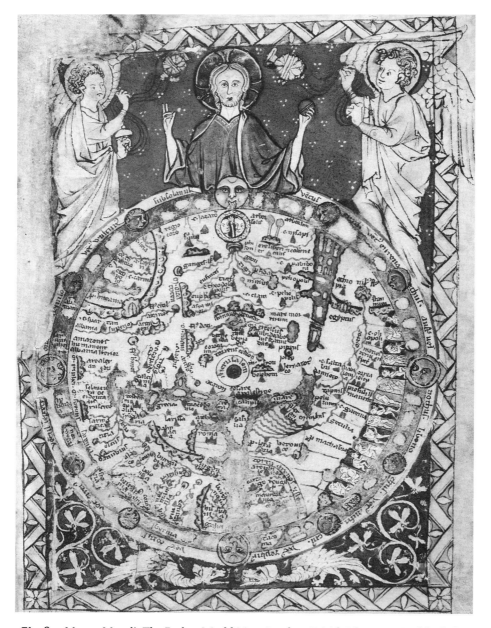

Fig. 8.2 Mappa Mundi. The Psalter World Map, London, British Library, MS Add. 28681, f. 9. Mid-13th century, England

By kind permission of the British Library

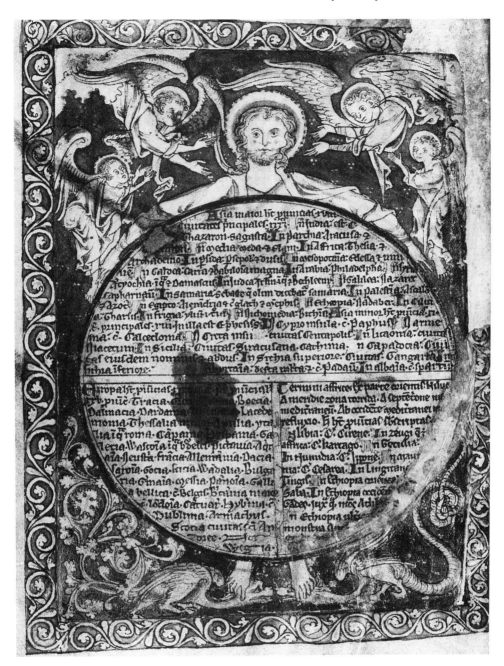

Fig. 8.3 Mappa Mundi. The Psalter World Map, London, British Library, MS Add. 28681, f. 9v. Mid-13th century, England

By kind permission of the British Library

angels to the four corners of the earth to form the body of Adam,[19] who early on was viewed as a microcosm of the earth.[20] Interestingly Zosima, the fourth-century alchemist, actually depicted on the Hereford map, was partially responsible for perpetuating the Jewish legend.

The association of the name Adam with the four elements and the four cardinal points was adopted by Christians in the Middle Ages following St Augustine's identification of the letters of the name ADAM with the Greek names of the four cardinal points.[21] These inter-relationships were particularly captured in insular and Anglo-Saxon works, as for example in the microcosmic scheme of Byrhtferth wherein ADAM figures centrally within a complex cosmological pictorial frame (Fig. 1.9).

For Augustine, Adam's representation of the world prefigured that his progeny would inhabit the entire earth, the earth would be shattered by sin, and would be made whole again at the parousia. It is conceivable then that the pictorial frame of angels surrounding the Henry of Mainz map not only signifies the story of Creation but the apocalypse as well. The Henry of Mainz map is redolent with references to Creation and the significance of giving names.[22]

Eschatology also plays a significant role in the Psalter map. The well-known Psalter map was painted on the recto of folio 9 (Fig. 8.2) whereas another map, less known, was painted on the verso (Fig. 8.3) . The Psalter map provides a particularly interesting comparison to the Hereford. Bound in a small psalter easily held in one hand, the maps introduce the words of the psalmist: 'Yet God my King is from of old, working salvation in the midst of the earth' (Psalm 74: 12). The first image is a small T-O map that, albeit extremely abbreviated, shares a number of similarities with the interior subject matter of the Hereford map.[23] The second map, divided into three sections, consists of a textual listing of geographical locations by continent.

Let us consider the relationship of their two pictorial frames illuminated back to back. On the recto surrounded by two censing angels, Christ's upper body surmounts the map, his right hand raised in blessing, his left holding an orb divided into sections like a T-O map. Christ's legs are not depicted. Two crouching wyverns are shown below

[19] Louis Ginzberg, *Legends of the Jews*, 7 vols. Philadelphia, esp. V: 4–5, 71; Louis Ginzberg, 'Adam', in *The Jewish Encyclopedia*, ed. Isidore Singer, New York, 1909 (13th edition), I: 173–81. The legend and additional bibliography is also given by d'Alverny, 'L'Homme comme symbole', esp. 137, 165. The angels were previously identified as the Four Angels of Revelation (7: 1); see Lecoq, 'Mappemonde', 1989, 22.

[20] D'Alverny, 'L'Homme comme symbole', 123–95.

[21] According to d'Alverny, Augustine refers to the concept in three texts: *Enarratio in Psalmos*, in Psalm 95: 15; *In Ioannis Evangelium*, tract. 9, 14; *ibid*. tract. 10, 12; see d'Alverny, 'L'Homme comme symbole', 165, n. 86. The idea, according to d'Alverny, was not invented by Augustine but had ancient Greek and Jewish roots; for citations, see d'Alverny, 'L'Homme comme symbole', 165–6, n. 88. However, St Augustine was partially responsible for the concept of Adam as microcosm of the earth for it was from Adam that all nations would spring; see d'Alverny, 'L'Homme comme symbole', 167.

[22] The Creation theme as central to our understanding of transmission of themes and images relating to maps was earlier noted, specifically with reference to the manuscript illuminations of Adam naming the animals. Muratova suggests that the robed Adam in these images represents the New Adam, the Adam who is understood to be redeemed by the Christ of the New Testament; see Muratova's answers to d'Alverny, in d'Alverny, 'L'Homme comme symbole'.

[23] Note the large proportion of parallels; see Miller, *Kleineren Weltkarten*, 21–9.

the earth recalling the wooden enframement for the Hereford map where two similar dragons, suggesting evil, perhaps allusions to hell, were also to be seen painted at the foot of the map on the wooden frame.

On the verso Christ is depicted once again, this time holding the earth in the form of the T-O map of the world. His feet stand firmly below the earth; he is shown trampling the crouching dragons below. Here it is clear that good triumphs over evil.

Clearly the outstretched arms of Christ belonged within the larger tradition of macro–microcosmic imagery, a subject to which we have already alluded.[24] The Psalter map contained the depiction of Christ as the New Adam shown holding the world within his arms, physically enveloping the earth as his body – a symbol of the Eucharist.

As Miri Rubin has made clear, in the Middle Ages the symbolic meaning of the Eucharist was 'over determined', suggesting that it was widely understood on multiple levels. However, by the late thirteenth century although theologians continued to debate and disagree about the Eucharist and the meaning of 'transubstantiation', the pastoral design was fixed. For the general public, the Eucharist held the 'promise of being one with God in a bodily sense'.[25] The circular map as Christ's body was furthermore visually and symbolically linked to the eucharistic host, the circular wafer that symbolically and corporally was believed to contain the body of Christ. In the years following the decrees of the Fourth Lateran Council in 1215 and the arrival of the institution of the Feast of Corpus Christi to England in 1318,[26] a theological debate raged regarding meaning and formalization of the rite of the Eucharist. Whereas the Eucharist had been practiced and understood by different parties in varying ways, the debates regarding the formalization of universal practice and meaning of the Eucharist continued. However, through *exempla* and other teaching methods, by the thirteenth century in England, the Eucharist was made available to lay people in a relatively formalized way.[27] The host, circular in shape and often stamped with the cross, became particularly codified in meaning and ritual during this time.[28] By association with the

24 Morgan cites relationships to: (1) Hildegard of Bingen (Lucca Biblioteca Statale, MS 1942, f. 9) in which God holds a system of concentric circles with man at the center; and (2) the late fourteenth-century fresco by Piero di Puccio in the Camposanta, Pisa, that depicts God holding concentric circles with the world at the center. Also see the Aberdeen (Morgan *Early Gothic Manuscripts*, 4/1, cat. no. 17, fig. 58) and Ashmore Bestiaries (Morgan *Early Gothic Manuscripts*, 4/1, cat. no. 19) wherein God as creator stands against the concentric spheres of the universe. For general introduction, see Gerhart B. Ladner, 'Ad imaginem Dei', *The Image of Man in Medieval Art*, Latrobe, PA, 1965; d'Alverny, 'L'Homme comme symbole'. For the possible relationship to Dante, see John B. Friedman, 'Medieval Cartography and *Inferno* XXXIV: Lucifer's Three Faces Reconsidered', *Traditio*, 39, 1983, 447–56.

25 Rubin, *Corpus Christi*, esp. 26–34.

26 Rubin, *Corpus Christi*, 199–204. Note that evidence shows that by the mid-fourteenth century there were elaborate Corpus Christi reenactments and processions in Hereford; see Rubin, *Corpus Christi*, 245.

27 Rubin, *Corpus Christi*; Miri Rubin, 'What did the Eucharist mean to Thirteenth-Century Villagers?', *Thirteenth Century England*, 4, Woodbridge, 1991, 47–55. Also see Marion Gibbs and Jane Lang, *Bishops and Reform 1215–1272*, Oxford, 1934.

28 The host was codified as white, round, thin, and usually inscribed with a cross and the initials IHS and, from the twelfth century on, a crucifixion scenes or the lamb of God; see Rubin, *Corpus Christi*, 39, 42; Josef A. Jungmann, *The Mass of the Roman Rite:Its Origins and Development*, trans. Francis A. Brunner, New

circle, Hugh of St Victor's insistence that the 'Eucharist was granted as a sign of God to demonstrate his omnipotence, his lack of limitation, his freedom from the laws of nature' becomes a paradigm for the image of the map as the body of Christ.[29]

Miri Rubin has considered the implications of this specifically in England, where she suggests that for lay people everywhere during the thirteenth century, the idea of consuming the body and blood of Christ held a strange and somewhat morbid fascination.[30] It became the focus of intense interest, and by the thirteenth century the elevation of the Host during the Mass was frequently accompanied by the ringing of bells.[31] Obviously the ritual was symbolically multivalent, and thus for the general population an *exemplum* such as the one by Jacques de Vitry (*ca.* 1160/70–1240) held additional associative meaning: 'Just as through partaking in Adam we are all dead, so by partaking in Christ we all recover life.'[32] The connections between Adam and Christ in terms of the cycle of creation and redemption were constantly reinforced in word and image.[33]

On the Psalter map Christ as the New Adam surmounted and incorporated within himself the world of all creation. In that role the Psalter maps' pictorial frames were visualizations of the aim of the Pentecostal mission in which the monstrous races were included within the body of the Church. In spite of their deformities and heretical ways, concentric circles of unbelievers were ultimately included in the *oikoumene*. In the age of the crusades, the edges of the world were incorporated into the body of Christ, an indication of the extension of the meaning of the Pentecostal mission. God symbolically incorporated all the marvels and monstrous people within the body of the

York, 1955 (3rd edition), 381–2. For authors of eucharistic tracts e.g. Hugh of St Victor, see Rubin, *Corpus Christi*, 52. For a discussion of the elevation of the host, see Rubin, *Corpus Christi*, 55–60. For teaching and reception of the Eucharist, see Rubin, *Corpus Christi*, 83–155.

29 Rubin, *Corpus Christi*, 34. Rubin discusses Hugh of St Victor in the context of the drive toward uniformity in ritual. She notes that eucharistic tracts were often part of larger works on the seven sacraments written by almost every Parisian master including Hugh of St Victor; see Rubin, *Corpus Christi*, 51–2. Rubin also cites a genre of tracts for the laity on the seven sacraments as for instance Joinville's *Credo* (1250–1) which was written in the vernacular and illustrated; see Rubin, *Corpus Christi*, 105. For discussion of Joinville's *Credo*, see Chapter 7.

30 Caroline Bynum has added a dimension to our understanding of this phenomenon and its particular attraction for women during the Middle Ages; see Caroline Bynum, *Holy Feast and Holy Fast*, Berkeley, 1987. Tyerman notes the close connection between the crusades and Mass with its concentration on the body of Christ. He notes that the Bishop of Oporto's sermon to the crusaders in 1147 was integrated into a celebration of the Eucharist. He also points out that those early thirteenth-century sermons included meditations on Christ's presence in the Mass. As part of crusading, in the thirteenth century there were special prayers, processions, and celebrations of the Eucharist specifically designed to inspire enthusiasm toward the crusades and the cause of the Holy Land; see Tyerman, *England and the Crusades*, 159–60.

31 Rubin cites a number of statutes that described the ringing of bells including one by William of Cantilupe, Bishop of Worcester in 1240; see Rubin, *Corpus Christi*, 59–60.

32 *Et sicut per gustum in Adam omnes mortui sumus, ita per gustum in Christo omnes vitam recuperamus. The Exempla or Illustrative Stories from the 'Sermones vulgares' of Jacques de Vitry*, ed. T. F. Crane, London, 1890. The text of the *exempla* here quoted is cited by Rubin, *Corpus Christi*, 26.

33 Interestingly, at Chalivoy-Milon the image of God creating Adam and Eve is included on the map. Kupfer suggests that the mid-twelfth century wallpainting of a mappa mundi at Chalivoy-Milon may have been a prototype for the Hereford map, a suggestion that corroborates Crone's theory of unspecified French influences; see Marcia Kupfer, 'The Lost *Mappamundi* at Chalivoy-Milon', *Speculum*, 66, 1991, 540–71.

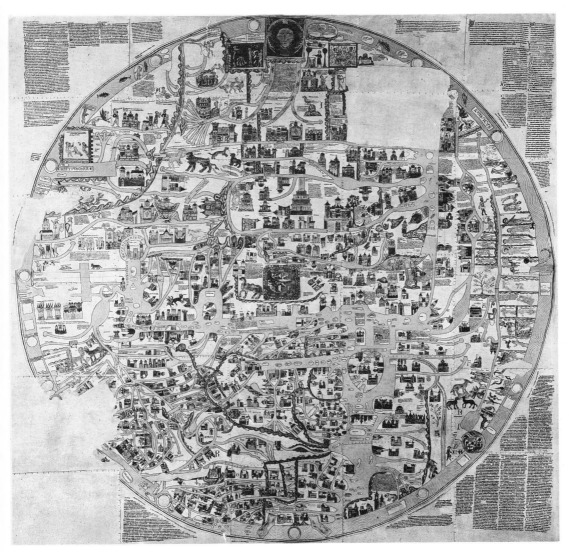

Fig. 8.4 Ebstorf World Map. Mid-13th century, Kloster Ebstorf, Germany (destroyed in 1943, 20th century replica)

Church and Christ thus stood at the beginning and end in space and time. The crusading emphasis is reinforced by the particular concentration on the area surrounding Jerusalem that echoes site-specific maps of Jerusalem (Fig. 7.9).[34]

The motif of the map as encompassed by Christ's body was re-employed in the Ebstorf map (Fig. 8.4) as well as in other examples so that we may assume that it was commonly understood and implied.[35] In returning to our original premise of the circle as the container for cosmological concepts, I conclude by noting how imbedded was the theme of the circle with its specific connotations in relation to the Creation in medieval cosmological theories and images. Theories relating to the earth's microcosmic position in the cosmos abounded. The magnificent floor mosaic commissioned by Henry III placed in front of the high altar at Westminster Cathedral was in effect a visualization of the cosmos as described by John Sacrobosco in *De sphaera*.[36] Whereas the text that accompanied the floor mosaic refers to the *primum mobile*, a close look at a contemporary manuscript page that depicts the same subject provides a better pictorial parallel to the pictorial frames of maps and their subliminal message of Creation (Fig. 8.5). Surrounded by the winds and elements is the greater circle of the body of Christ defined as MUNDUS. Christ is clearly shown here as creator. He is the world: all of the universe's components are contained within his body.

The last of the pictorial frames to be considered is that of the Duchy of Cornwall map (Fig. 8.9). Haslam has presented a compelling circumstantial argument for the Duchy of Cornwall map being related to the Hereford map. He suggests that Richard de Bello may have commissioned both.[37] Clearly, the Duchy of Cornwall map, although extremely fragmentary, does appear to be similar to the Hereford map in size,

34 Note the following items surrounding Jerusalem on the Psalter map that are also found for example on the crusading map of Jerusalem in Brussels, Bibliothèque Royale, MS 9823–9824: Jerusalem, Mount Sion (*m[ons] sion*), Bethlehem (*Be[t]lehem*), Brook Kidron (*torrens cedron*), Jericho (*ierico*), The River Jordan flows with two sources marked Jor (*ior*) and Dan (*dan*). The Jor is erroneously shown as issuing from the foot of Mount Lebanon. The Jordan enters Lake Tiberias (note the fish in it). Above the lake is written *Genesar*, its Talmudic name. From the lake the Jordan runs down to the Dead Sea [*mare mortuum*]. At the effluence of Jordan from Lake Tiberias is a mountain with the following legend: *mons excelsus ubi diabolus statuit* [*sic*] *D[omi]n[u]m*. The legend closely resembles that in the Brussels manuscript. The legend on the Psalter map, which refers to the mountain where Satan tempted Christ, is according to Vilnay an allusion to the Mount of Forty, in Arabic, *Djebel Karantal*, which rises next to Jericho and overlooks the Jordan and the Dead Sea; see Vilnay, *Holy Land*, 14.

35 In the Ebstorf map this idea is especially made clear by special prominence given to the tombs of the Apostles, for instance Andrew and Bartholomew, who were responsible for converting the heathens beyond the *oikoumene*.

36 The text for the floor mosaic in translation is: 'The sphere shows the archetype, this globe shows the macrocosm. In the year of Christ one thousand, twice one hundred, twelve with sixty, taking away four, King Henry III, the city, Odoricus, and the abbot joined together these porphyry stones'; see Steven H. Wander, 'The Westminster Abbey Sanctuary Pavement', *Traditio*, 1978, 137–56.

37 The connection is through Lincoln. Haslam makes a compelling case for the Duchy map to have been expressly made for the Augustinian house that had connections to Henry III through his brother the Duke of Cornwall. Apparently the Duke had vast landholdings in Lincolnshire; see Haslam, 'Duchy of Cornwall', 44.

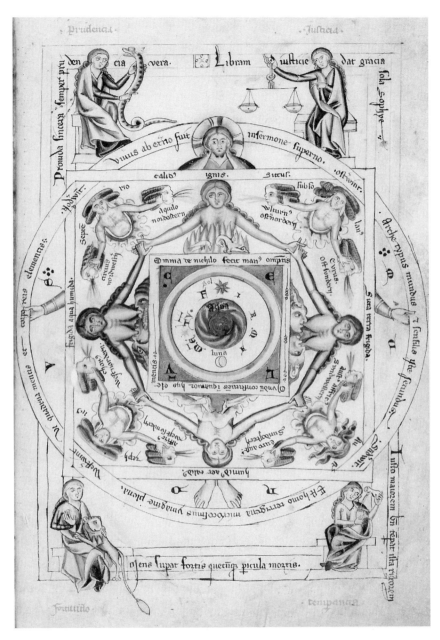

Fig. 8.5 Christ as Creator. Munich, Bayerische Staatsbibliothek, MS Clm, lat. 2655, f. 105r.

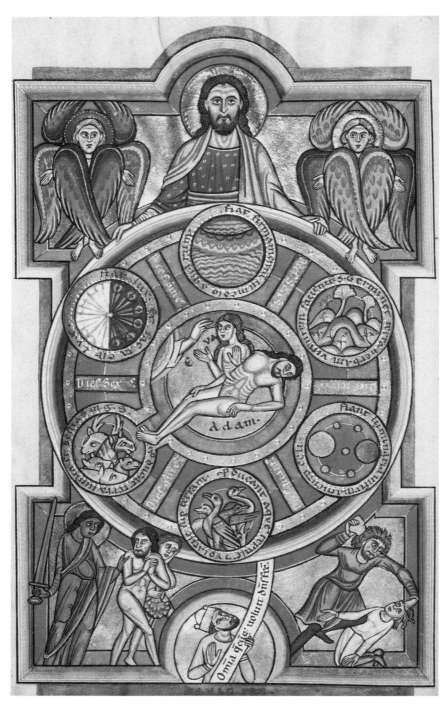

Fig. 8.6 The Creation. Stammheim Missal, The J. Paul Getty Museum,
Los Angeles, MS 64, f. 10v

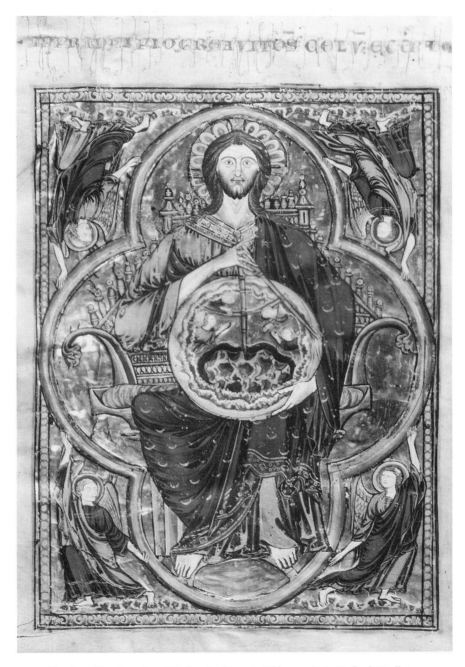

Fig. 8.7 The Creation (God as Architect). *Bible moralisée*, Oxford, Bodleian Library, MS Bodl. 270b, f. 1v. 13th century, France

© The Bodleian Library, University of Oxford

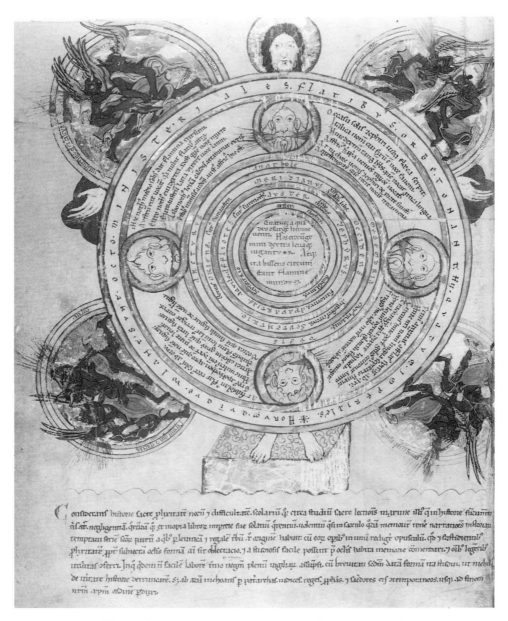

Fig. 8.8 Wind *Rota*. Petrus Pictaviensis, *Epitome historiae sacrae*, Vienna, Österreichische Nationalbibliothek, MS Cod. 378, f. 1

Fig. 8.9 Duchy of Cornwall World Map (fragment). Duchy of Cornwall Library and Archive, Maps and Plans 1. Late 13th century, England

imagery, and textual information.[38] Although we only have a small section of the lower right hand corner of the Duchy of Cornwall map in which a section of Africa is described, there is enough information to make substantial comparisons.

The text in the right lower corner of the Cornwall map mirrors the subject matter of the Hereford's lower left corner. Both refer to the survey of the world by Nicodoxus, Polyclitus, and Thodocus. On the Cornwall map geographical items are listed followed by the text. 'In this true little book, as in the brief former table, the certain causes of heaven, the situation of lands, and the breadth of the seas are annotated, so that the reader in that way may glance at them, and the brief compendium makes known the etymologies and causes of them.' Whereas in the Hereford map it was suggested that the map was an 'histoire', the text on the Cornwall map explicitly indicates that the map was accompanied by a small book, perhaps indeed a history, which included charts.

Returning to the comparison of the imagery of the pictorial frames, what remains of the Duchy of Cornwall map are four roundels plus the vestiges of a fifth along the bottom right corner. The pairs of roundels each appear to represent a conversation between a personification of an hour of the *Opus Dei* and an Age of Man. The extant roundels begin with the figure of *senectus*, followed by the pair *vespa–decrepita*, and end with the pair *angelus–homo mortuus*. Thus the angelus or compline ends the series with death. I would suggest that originally this bottom register contained sixteen roundels, two for each of the eight hours of the *Opus Dei*. The roundels provide evidence that the pictorial frame contained images and ideas that were familiar and available to the laity in a variety of other artistic forms as well; for example these paired images are known to have also existed in wallpaintings and manuscripts.[39] They are versions of the recurring theme of the Wheel of Life.

In the final analysis, the Hereford map was most likely one of a number of large-sized maps that were well known to the medieval viewer. It was probably partially made in Lincoln and brought to Hereford by Richard de Bello, then most likely placed in a wooden framework as part of the general refurbishment relating to the installation of Bishop Cantilupe's tomb. Presumably the map, in an exemplar form,

[38] The Duchy of Cornwall map was possibly the earliest large mappa mundi produced in England. Haslam dates the fragment to 1260–85. The circular world originally measured approximately 164 cm., which makes it somewhat larger than the Hereford map. Carbon dating (which is not reliable for precise values) places the mean value at *ca.* 1165–1215; see Haslam, 'Duchy of Cornwall', 36.

[39] Closely related to the Ages of Man on the Cornwall fragment are wallpaintings from a private residence of the Thorpe family, Longthorpe Tower near Peterborough, *ca.* 1330, which include a similar series; see Sears, *Ages of Man*, 137–8, fig. 78. A related manuscript example is a richly decorated Book of Hours (New York, Pierpont Morgan Library, MS G, fs. 19r, 29r, 50r, 58v, 64r, 68r, 72r, 81r). The book was originally owned by one of the daughters of Robert de Lisle, dated to *ca.* 1320–30, York. Following the canonical hours, in large opening initials are represented the stage of life. In each, a woman and man are shown in dialogue with texts in French. The woman is shown as scroll-bearer and question-poser; see Sears, *Ages of Man*, 138, figs. 79–80. See John Plummer, *The Glazier Collection of Illuminated Manuscripts*, New York, 1968, 29–30 (no. 37), pl. 35 (f. 58v). Haslam describes the roundels as containing words that describe middle age to maturity, extreme old age (*decrepita etas*), Purgatory and finally angelic release; see Haslam, 'Duchy of Cornwall', 43.

once the personal belonging of the first canon Richard de Bello, was given, in its final form, to the cathedral by the second. The map as finally framed became the centerpiece of a triptych whose side panels depicted the Annunciation to the Virgin. In style, the ensemble was similar to the Westminster painted panel executed for Henry III,[40] believed to have surrounded the reliquary of St Edward. However it is unlikely that the Hereford map served as an altarpiece.

Much evidence points to the centrality of Henry III's commissions of painted works of arts to embellish his living quarters. Henry III, perhaps in consultation with Gervase, who had visited him in 1229, commissioned wall maps for audience chambers in Winchester and Westminster. The Psalter map, produced in London in the early 1260s, may be a reduced copy of the map from Westminster. Matthew Paris suggests that the Westminster map was frequently copied, and although the original was destroyed in *ca.* 1265 scholars have suggested that it may have possibly accounted for similarities to several of the English examples considered here such as the Psalter map, the Duchy of Cornwall fragment, and the Hereford map.[41]

Although the survey has concentrated on English examples, its connection with Gervase of Tilbury, an Englishman, provides some justification for including a discussion of the pictorial frame of the Ebstorf map here as well. Here in large scale the extraordinary image of the world as the body of Christ is made explicit.[42] Additionally the theme of redemption is also made more explicit insofar as in the center of the map, above Jerusalem, Christ is shown rising from the grave with banner in hand, a fulfillment of Isaiah's prophecy. On this map, the concept of Christ as redeemer is particularly emphasized, as he is shown seated at the beginning and end of time and space. Encompassing the earth on his cross nimbus we find the alpha and omega and the words 'primus et novissimus'.

In our brief survey of the pictorial frames of these selected maps, we find the recurrent necessity to present the world as a compendium of shifting time and space ordered by a fixed geography. It is surmounted, however, by symbols of strict order that relate Creation to eternal time following the Resurrection and Last Judgment. Whereas the Psalter and Henry of Mainz maps suggest the Creation, the Ebstorf emphasizes the Resurrection, and the Hereford, the Last Judgment.[43] The circle, at once the symbol of Creation, becomes the container of the ephemeral and the supporter of the eternal.

40 The relationship between the Westminster Retable and the Hereford map is considered in depth in Chapter 2, esp. n. 62.

41 Matthew Paris refers to three world maps (part I, no. 88, MS 26 f. vii v). Also see Lewis, *Matthew Paris*, 372.

42 It is interesting that the Ebstorf map, a map that has been shown to reflect contemporary events in Germany, may have originally belonged to a convent and been illuminated by its sisters. In a nearby convent, Hildegard of Bingen created images in word and picture that also capture the mystical power of the concept of the body of Christ and imagery of man as microcosm of the world, albeit one hundred years earlier.

43 The theme of pictorial frames has also been discussed by Barber and Brown, in relation to the Aslake map (fourteenth century); see Peter Barber and Michelle P. Brown, 'The Aslake World Map', *Imago Mundi*, 44, 1992, 24–44, esp. 28; Barber, 'Evesham Map', 23.

CONCLUSION

Universal Chronicles

AS WE HAVE SHOWN repeatedly, the Hereford map belongs within the greater tradition of medieval learning as it was disseminated in its many forms. The images and texts from the map belong to an endless network of other images and texts placed side by side on pages of manuscripts containing collections of revered material. I have written of the Hereford map as an compendium of information – one may also refer to it as a 'universal chronicle' whose subject begins with the earth's creation.

Creation

The schemes that we are concerned with here were simplified visions of cosmological concepts that were passed on through authoritative texts and diagrams. They do not generally presume to reflect more contemporary theories relating to the structure and operation of the world. Rather these images are derivative in their authority. Because much of twelfth and thirteenth-century scholarly natural philosophy continued to concern itself with reconciling Aristotelian theories of the cosmos with Christian theology, the diagrams retained didactic value. Several aspects of Aristotle's work however remained fundamentally impossible to resolve, especially the concept of an eternal world, an idea which was diametrically opposed to the central Christian tenets of Creation and Last Judgment. By 1277, this key issue was condemned, along with two hundred and nineteen other Aristotelian tenets, and hence an authoritarian restriction on cosmological teachings was introduced.[1] And thus the diagrams continued to have relevance insofar as they provided the appropriate construct.

[1] The Condemnation of 1270 by the Bishop of Paris, Etienne Tempier, denounced thirteen propositions that contained Averroist Aristotelian teachings; this was followed by the encompassing Condemnation of 7 March, 1277, by Bishop Tempier. For details see Grant, 'Cosmology', 268–70; Wallace, in *Science in the Middle Ages*, ed. Lindberg, 91–119; for extensive discussion of the effects of the Condemnations on later medieval science, see Duhem, *Medieval Cosmology*.

BIBLIOGRAPHY

Aharoni, Yohanan, and Michael Avi-Yonah, *The Macmillan Bible Atlas*, New York, 1968.

Albertus Magnus, *De animalibus, libri XXII–XXVI*, 2 vols., ed. Hermann Stadler, Münster, 1916–21.

Alexander, Jonathan, and Paul Binski, ed., *The Age of Chivalry: Art in Plantagenet England 1200–1400*, London, 1987.

Alexander, J. J. G., and Elzbieta Temple, *Illuminated Manuscripts in the Oxford College Libraries, the University Archives, and the Taylor Institution*, Oxford, 1984.

d'Alverny, Marie Thérèse 'Le Cosmos symbolique du XIIe siècle', *Archives d'histoire doctrinale et littéraire du Moyen Age*, 28, 1953, 31–81.

d'Alverny, Marie-Thérèse, 'L'Homme comme symbole. Le microcosme', in *Simboli e Simbologia nell'alto Medioevo* (Settimane di Studio del Centro Italiano di Studi sull'alto Medioevo, 23), Spoleto, 1976, 123–95.

d'Alverny, Marie-Thérèse, 'Les Pérégrinations de l'âme dans l'autre monde', *Archives d'histoire doctrinale et littéraire du Moyen Age*, 13, 1940–2, 239–99.

Anderson, Andrew Runni, *Alexander's Gate, Gog and Magog, and the Inclosed Nations*, Cambridge, MA, 1932.

Arano, Luisa Cogliati, 'Il manoscritto C.246 inf. della Biblioteca Ambrosiana, Solino', in *La miniatura italiana in età romanica e gotica* (Storia della miniatura, Studi e documenti, 5), Florence, 1979, 239–58.

Aristotle, *De Anima; On the Soul; Parva Naturalia, On Breath*, trans. W. S. Hett, Cambridge, MA, 1935.

Arrian, *The Campaigns of Alexander*, trans. Aubrey de Sélincourt, Harmondsworth, 1958.

Artz, Frederick B., *The Mind of the Middle Ages A.D. 200–1500*, Chicago, 1980 (3rd edition, revised).

Auerbach, Eric, *Scenes from the Drama of European Literature*, New York, 1959.

Augustine, *The City of God against the Pagans*, trans. William M. Green, 7 vols., Cambridge, MA, 1957–72.

Aujac, Germaine, 'The Foundations of Theoretical Cartography in Archaic and Classical Greece' (prepared by the editors from materials supplied by the author), in *The History of Cartography*, 1: *Cartography in Prehistoric, Ancient, and Medieval Europe and the Mediterranean*, ed. J. B. Harley and David Woodward, Chicago, 1987, 130–47.

Bacon, Roger, *Opus maius*, ed. John Henry Bridges, Oxford, 1897.

Bagrow, Leo, *History of Cartography*, trans. D. L. Paisley, rev. R. A. Skelton, Cambridge, MA, 1964.

Bailey, Martin, 'The *Mappa Mundi* Triptych: The Full Story of the Hereford Cathedral Panels', *Apollo*, 137, no. 376 (n.s.), June 1993, 374–8.

Bailey, Martin, in *The Observer*, November 5, 1989.

Baltrusaitis, Jurgis, 'L'Image du monde céleste du IXe au XIIe siècle', *Gazette des beaux-arts*, 20, 1938, 137–148.

Baltrusaitis, Jurgis, 'Cercles astrologiques et cosmographiques à la fin du Moyen Age', *Gazette des beaux-arts*, 21, 1939, 65–84.

Bannister, Arthur Thomas, *The Cathedral Church of Hereford: Its History and Constitution*, London, 1924.

Bannister, Arthur Thomas, *Registrum Ade de Orleton, Episcopi Herefordensis, A.D. 1317–1327*, Hereford, 1907.

Barber, Peter, and Michelle P. Brown, 'The Aslake World Map', *Imago Mundi*, 44, 1992, 24–44.

Barber, Peter, 'The Evesham World Map: A Late Medieval English View of God and the World', *Imago Mundi*, 47, 1995, 13–33.

Barber, Richard, *Bestiary: Being an English Version of the Bodleian Library, Oxford 764 with All the Original Miniatures Reproduced in Facsimile*, Woodbridge, 1993.

Beer, Ellen J., *Die Glasmalereien der Schweiz vom 12. bis zum Beginn des 14. Jahrhunderts* (Corpus Vitrearum Medii Aevi, Schweiz, 1), Basel, 1956.

Beer, Ellen J., *Die Rose der Kathedrale von Lausanne*, Bern, 1952.

Beer, Ellen J., 'Nouvelles réflexions sur l'image du monde dans la cathédrale de Lausanne', *La Revue de l'art*, 10, 1970, 58–62.

Bennett, Matthew, 'First Crusaders' Images of Muslims: The Influence of Vernacular Poetry?', *Forum for Modern Language Studies*, 22, no. 2, 1986, 101–22.

Beretz, Elaine, 'Fortune Denied: The Theology against Chance at Saint-Etienne, Beauvais (France)', Ph.D. thesis, Yale University, 1989.

Bevan, W. L., and H. W. Phillott, *Medieval Geography: An Essay in Illustration of the Hereford Mappa Mundi*, London, 1874.

Binski, Paul, *The Painted Chamber at Westminster*, London, 1986.

Binski, Paul, *Westminster Abbey and the Plantagenets*, New Haven, 1995, 152–67.

Binski, Paul, 'What was the Westminster Retable?', *Journal of the British Archaeological Association*, 40, 1987, 153–74.

Birch, W. de G., *Catalogue of Seals in the Department of Manuscripts in the British Museum*, London, 1887–98.

Blumenkranz, B., 'Anti-Jewish Polemics and Legislation in the Middle Ages: Literary Fiction or Reality?', *Journal of Jewish Studies*, 15, 1964, 125–40.

Blumenkranz, B., *Les Auteurs chrétiens latins du Moyen Age sur les Juifs et le Judaisme*, Paris, 1963.

Bober, Harry, 'An Illustrated Medieval School-Book of Bede's *De natura rerum*', *The Journal of the Walters Art Gallery*, 19–20, 1956–7, 64–97.

Bober, Harry, '*In Principio*: Creation Before Time', in *De Artibus Opuscula XL, Essays in Honor of Erwin Panofsky*, ed. Millard Meiss, 1961, I: 13–28.

Boethius, *The Consolation of Philosophy*, trans. H. F. Stewart, London, 1918.

Borenius, Tancred, 'The Cycle of Images in the Palaces and Castles of Henry III', *Journal of the Warburg and Courtauld Institutes*, 6, 1943, 40–50.

Borenius, Tancred, and E. W. Tristram, *English Medieval Painting*, Paris, 1927.

Brehaut, Ernest, *An Encyclopedist of the Dark Ages, Isidore of Seville*, New York, 1964 (repr.).

Brincken, Anna-Dorothee von den, 'Mappa mundi und Chronographia. Studien zur *imago mundi* des abendländischen Mittelalters', *Deutsches Archiv für Erforschung des Mittelalters*, 24, 1968, 118–86.

Brincken, Anna-Dorothee von den, 'Monumental Legends on Medieval Manuscripts Maps', *Imago Mundi*, 42, 1990, 9–26.

Brincken, Anna-Dorothee von den, 'Zur Universalkartographie des Mittelalters', in *Miscellanea medievalia*, 7 (Methoden in Wissenschaft und Kunst des Mittelalters), Berlin, 1970, 249–78.

Brown, Carleton, ed., *Religious Lyrics of the XIVth Century*, Oxford, 1924.

Brown, Carleton, ed., *English Lyrics of the XIIIth Century*, Oxford, 1932 (repr. 1950).

Bruck, Robert, *Die Malereien in den Handschriften des Königreichs Sachsen*, Dresden, 1906.

Brunetto Latini, *Le Trésor* I, ed. Francis J. Carmody, Los Angeles, 1948.

Buchthal, Hugo, *Miniature Painting in the Latin Kingdom of Jerusalem*, Oxford, 1957.

Bunt, G. H. V., 'Alexander and the Universal Chronicle: Scholars and Translators', in *The Medieval Alexander Legend and Romance Epic, Essays in Honour of David J. A. Ross*, ed. Peter Noble, Lucie Polak, and Claire Isoz, New York, 1982, 1–10.

Butturff, Douglas R., 'The Monsters and the Scholar: An Edition and Critical Study of the *Liber monstrorum*', Ph.D. thesis, University of Illinois at Urbana, 1968.

Bynum, Carolyn Walker, *Holy Feast and Holy Fast*, Berkeley, 1987.

Cahier, Charles, and Arthur Martin, *Mélanges d'archéologie, d'histoire et de littérature*, 4 vols., Paris, 1847–9.

Cahn, Walter, *Romanesque Manuscripts, The Twelfth Century* (A Survey of Manuscripts Illuminated in France), 2 vols., London, 1996.

Caiger-Smith, A., *English Medieval Mural Paintings*, Oxford, 1963.

Caldwell, James R., 'The Autograph Manuscript of Gervase of Tilbury', *Scriptorium*, 11, 1957, 87–98.

Caldwell, James R. 'Gervase of Tilbury's Addenda to his *Otia imperialia*', *Mediaeval Studies*, 24, 1962, 95–126.

Caldwell, James R., 'The Interrelationship of the Manuscripts of Gervase of Tilbury's *Otia imperialia*', *Scriptorium*, 16, 1962, 246–74.

Caldwell, James R., 'Manuscripts of Gervase of Tilbury's *Otia imperialia*', *Scriptorium*, 16, 1962, 28–45.

Calendar of Liberate Rolls: Henry III, Public Record Office, Texts and Calendars, 6 vols., London, 1916–1963.

Camille, Michael, 'Illustrations in Harley MS 3487 and the Perception of Aristotle's *Libri naturales* in Thirteenth-Century England', in *England in the Thirteenth Century* (Proceedings of the 1984 Harlaxton Symposium), ed. W. M. Ormrod, Woodbridge, 1986, 31–43.

Camille, Michael, *Images on the Edge, The Margins of Medieval Art*, Cambridge, MA, 1992.

Campbell, Mary, *The Witness and the Other World*, Ithaca, 1988.

Campbell, Tony, *Early Maps*, New York, 1982.

Capes, William, ed., *Charters and Records of Hereford Cathedral*, Hereford, 1908.

Carmina Burana (facsimile edition), ed. Bernhard Bischoff, Munich, 1967.

Carruthers, Mary J., *A Book of Memory: A Study of Memory in Medieval Culture*, Cambridge, 1992 (repr.).

Carruthers, Mary J., *The Craft of Thought: Meditation, Rhetoric, and the Making of Images, 400–1200*, Cambridge, 1998.

Carter, John, *Specimens of Ancient Sculpture and Painting*, London, 1780.

Cary, George, *The Medieval Alexander*, Cambridge, MA, 1956.

Caviness, Madeline Harrison, 'Images of Divine Order and the Third Mode of Seeing', *Gesta*, 22, 1983, 99–120.

Caviness, Madeline Harrison, *The Early Stained Glass of Canterbury Cathedral, circa 1175–1220*, Princeton, 1977.

Caviness, Madeline Harrison, *The Windows of Christ Church Cathedral, Canterbury* (Corpus Vitrearum Medii Aevi, Great Britain, 2), London, 1981.

Chazan, R., *European Jewry and the First Crusade*, Berkeley, 1987.

Chenu, M. D., 'Le Cosmos symbolique du XII siècle', *Archives d'histoire doctrinale et littéraire au Moyen Age*, 28, 1953, 31–81.

Clanchy, M. T., *From Memory to Written Record*, Cambridge, MA, 1979.

Clarke, Willene B., 'The Illustrated Medieval Aviary and the Lay-Brotherhood', *Gesta*, 21/1, 1982, 63–74.

LeClerc, Joseph Victor, 'L'Image du monde, et autres enseignements', *Histoire littéraire de la France*, 23, 1856, 287–335.

Cohen, J., 'The Jews as the Killers of Christ in the Latin Tradition, from Augustine to the Friars', *Traditio*, 39, 1983, 1–27.

Cohen, Jeffrey Jerome, 'The Limits of Knowing: Monsters and the Regulation of Medieval Popular Culture', *Medieval Folklore*, 3, 1994, 1–37.

Cohn, Norman, *The Pursuit of the Millennium*, New York, 1961.

Connolly, Daniel K., 'Imagined Pilgrimage in the Itinerary Maps of Matthew Paris', *The Art Bulletin*, 81, 1999, 598–622.

Cosmas Indicopleustes, *Topographie chrétienne*, ed. Wanda Wolska-Conus, Paris, 1962.

Courcelle, Pierre, *La Consolation de Philosophie dans la tradition littéraire*, Paris, 1967.

Cowen, Painton, *Rose Windows*, London, 1979.

Crone, Gerald R., 'New Light on the Hereford Map', *The Geographical Journal*, 131/4, 1965, 447–62.

Crone, Gerald R., *The World Map by Richard of Haldingham in Hereford Cathedral, circa A.D. 1285*, London, 1954.

Crone, Gerald, *The Hereford World Map*, London, 1949.

Crosby, Sumner McK., *The Royal Abbey of Saint-Denis*, edited and completed by Pamela Z. Blum, New Haven, 1987.

Cummins, John, *The Hound and the Hawk*, London, 1988.

Daly, P. H., 'The Process of Canonization in the Thirteenth and Early Fourteenth Centuries', in *St. Thomas Cantilupe Bishop of Hereford*, ed. M. Jancey, Hereford, 1982, 125–35

Denholm-Young, N., 'The *Mappa Mundi* of Richard of Haldingham at Hereford', *Speculum*, 32, 1957, 307–14.

Destombes, M., 'The Mappamundi of the Poem *Alexandreidos* by Gauthier de Châtillon (*ca.* A.D. 1180)', *Imago Mundi* 19, 1965, 10–12.

Destombes, Marcel, ed., *Mappemondes AD 1200–1500: Catalog preparé par la Commission des Cartes Anciennes de l'Union Géographique Internationale*, Amsterdam, 1964.

Dew, E. N., *Extracts from the Cathedral Registers of Hereford: Hereford Cathedral Registers 1275–1525*, Hereford, 1932.

Dilke, O. A. W., 'Maps in the Service of the State: Roman Cartography to the end of the Augustan Era', in *The History of Cartography*, 1: *Cartography in Prehistoric, Ancient, and Medieval Europe and the Mediterranean*, ed. J. B. Harley and David Woodward, Chicago, 1987.

Dingley, Thomas, *History from Marble: Compiled in the Reign of Charles II* (Camden Society old series 94, 97, facsimile), ed. John Nichols, Westminster, 1867–8.

Dow, Helen J., 'The Rose Window', *Journal of the Warburg and Courtauld Institutes*, 20, 1957, 248–97.

Druce, George C., 'The Elephant in Medieval Legend and Art', *Archeological Journal*, 76, 1919, 1–73.

Druce, George C., 'The Medieval Bestiaries, and Their Influence on Ecclesiastical Decorative Art, I', *The Journal of the British Archaeological Association*, n.s. 25, 1919, 40–82.

Druce, George C., 'The Medieval Bestiaries, and Their Influence on Ecclesiastical Decorative Art, II', *The Journal of the British Archaeological Association*, n.s. 26, 1920, 34–79.

Duhem, Pierre Maurice, *Medieval Cosmology*, ed. and trans. Roger Ariew, Chicago, 1985.

Edson, Evelyn, *Mapping Time and Space: How Medieval Mapmakers Viewed Their World* (Studies in Map History, 1), London, 1997.

Edson, Evelyn, 'The Oldest World Maps: Classical Sources of Three VIIIth Century *Mappaemundi*', *Ancient World*, 24, 1993, 169–84.

Egbert, Donald Drew, *The Tickhill Psalter and Related Manuscripts*, New York, 1940.

Einhorn, Jürgen W., *Spiritualis unicornis* (Munstersche Mittelalter-Schriften, 13), Munich, 1936.

Eschapasse, Maurice, *Notre-Dame d'Amiens*, Paris, 1960.

Faral, Edmond, 'Une Source latine de l'Histoire d'Alexandre *La Lettre sur les merveilles de l'Inde*', *Romania*, 43, 1914, 199–215, 353–70.

Flint, Valerie I. J., 'The Hereford Map: Its Author(s), Two Scenes and a Border', *Transactions of the Royal Historical Society*, Sixth Series, 8, 1998, 19–44.

Flint, Valerie I. J., 'Honorius Augustodnensis, *Imago mundi*', *Archives d'histoire doctrinale et littéraire du Moyen Age*, 49, 1982, 7–53.

Flint, Valerie I. J., 'World History in the Early Twelfth Century: the *Imago mundi* of Honorius Augustodunensis', in V. I. J. Flint, *Ideas in the Medieval West*, London, 1988, 211–38.

Folda, Jaroslav, *The Art of the Crusaders in the Holy Land 1098–1107*, Cambridge, MA, 1995.

Frankis, John, 'The Social Context of Vernacular Writing in Thirteenth Century England', in *Thirteenth Century England* (Proceedings of the Newcastle upon Tyne Conference), ed. P. R. Coss and S. D. Lloyd, Woodbridge, 1985, I: 175–84.

Friedman, John B., 'The Architect's Compass in Creation Miniatures of the Later Middle Ages', *Traditio* 30, 1974, 419–29.

Friedman, John B., 'The Marvels-of-the-East Tradition in Anglo-Saxon Art', in *Sources of Anglo-Saxon Culture* (Studies in Medieval Culture, 20), ed. P. E. Szarmach and V. D. Oggins, Kalamazoo, 1986, 319–41.

Friedman, John B., 'Medieval Cartography and *Inferno* XXXIV: Lucifer's Three Faces Reconsidered', *Traditio*, 39, 1983, 447–56.

Friedman, John B., *The Monstrous Races in Medieval Art and Thought*, Cambridge, MA, 1981.

Friedman, Lionel J., *Text and Iconography for Joinville's 'Credo'* (The Medieval Academy of America, 68), Cambridge, MA, 1958.

Funkenstein, A., 'Basic Types of Christian Anti-Jewish Polemics in the Later Middle Ages', *Viator*, 2, 1971, 373–81.

Furnivall, Frederick J., ed., *Hymns to the Virgin & Christ, The Parliament of Devils and other Religious Poems*, London, 1867.

Gagnon, François, 'Le Thème médiéval de l'homme sauvage dans les premières représentions des Indiens d'Amerique', in *Aspects de la Marginalité au Moyen Age*, ed. Guy-H. Allard, *et al.*, Montreal, 1975, 82–99.

Gautier Dalché, Patrick, 'L'Espace de l'histoire: le rôle de la géographie dans les chroniques universelles', in *L'Historiographie médiévale en Europe*, Paris, 1991, 287–300.

George, Wilma, *Animals and Maps*, Berkeley, 1969.

Gervase of Tilbury, *Le Livre des merveilles*, trans. Annie Duchesne, preface by Jacques Le Goff, Paris, 1992.

Gesta Romanorum, ed. Hermann Oesterley, Berlin, 1872.

Gibb, Paul Allen, 'Wonders of the East: A Critical Edition and Commentary', Ph.D. thesis, Duke University, 1977.

Gibbs, Marion, and Jane Lang, *Bishops and Reform 1215–1272*, Oxford, 1934.

Ginzberg, Louis, 'Adam', in *The Jewish Encyclopedia*, ed. Isidore Singer, New York, 1909, I: 173–81.

Ginzberg, Louis, *Legends of the Jews*, Philadelphia, 7 vols., Philadelphia, 1909.

Glenn, John, 'Notes on the *Mappa Mundi* in Hereford Cathedral', in *England in the Thirteenth Century* (Proceedings of the 1984 Harlaxton Symposium, Harlaxton 1985), ed. W. M. Ormrod, Woodbridge, 1986, 60–3.

Goetz, Hans Werner, 'On the Universality of Universal History', in *L'Historiographie médiévale en Europe*, ed. Jean Philippe Genet, Paris, 1991, 247–61.

Goff, Jacques Le, *The Medieval Imagination*, trans. Arthur Goldhammer, Chicago, 1988.

Gough, Richard, *British Topography. Or, An Historical Account of What Has Been Done for Illustrating the Topographical Antiquities of Great Britain and Ireland*, London, 1780.

Gough, Richard, notebook entry, Oxford, Bodl. Lib., MS Top Gen. e 19. f. 88.

Grant, Edward, 'Cosmology', in *Science in the Middle Ages*, ed. David Lindberg, Chicago, 1978, 265–302.

Grant, Edward, ed., *A Source Book in Medieval Science*, Cambridge, MA, 1974.

Haase, Gustav, *Untersuchung über die Reime in der Image du Monde des Walther von Metz*, Halle, 1879.

Hahn-Woernle, Birgit, *Die Ebstorfer Weltkarte*, Ebstorf, 1989.

Hahn-Woernle, Birgit, 'Die Ebstorfer Weltkarte und Fortuna Rotis-Vorstellungen', in *Ein Weltbild vor Columbus*, ed. Hartmut Kugler and Eckhard Michael (Die Ebstorfer Weltkarte Interdisziplinäres Colloquium, 1988), Weinheim, 1991, 185–99.

Hamer, Eileen Robertson, 'Patronage and Iconography in Romanesque England: The Herefordshire School', Ph.D. thesis, University of Chicago, 1992.

Hamilton, George L., 'Quelques notes sur l'histoire de la légende d'Alexandre le Grand en Angleterre au Moyen Age', in *Mélanges de philologie et d'histoire offerts à M. Antoine Thomas*, Geneva, 1973, 195–202.

Harley, J. B., and David Woodward, ed., *The History of Cartography*, 1: *Cartography in Prehistoric, Ancient, and Medieval Europe and the Mediterranean*, Chicago, 1987.

Harvey, P. D. A., 'Local and Regional Cartography in Medieval Europe', in *The History of Cartography*, 1: *Cartography in Prehistoric, Ancient, and Medieval Europe and the Mediterranean*, ed. J. B. Harley and David Woodward, Chicago, 1987.

Harvey, P. D. A., *Mappa Mundi; The Hereford World Map*, Toronto, 1996.

Harvey, P. D. A., and Andrew McGuinness, *A Guide to British Medieval Seals*, London, 1996.

Haslam, Graham, 'The Duchy of Cornwall Map Fragment', in *Géographie du monde au Moyen Age et à la Renaisssance*, ed. Monique Pelletier, Paris, 1989, 33–44.

Hassall, William Owen, *The Holkham Bible Picture Book*, London, 1954.

Hassig, Debra, *Medieval Bestiaries: Text, Image, Ideology*, Cambridge, 1995.

Hatto, A. T., 'The Elephants in the Strassburg *Alexander*', in *The Medieval Alexander Legend and Romance Epic, Essays in Honour of David J. A. Ross*, ed. Peter Noble, Lucie Polak, and Claire Isoz, New York, 1982, 85–105.

Havergal, Francis T., *Fasti Herefordenses & Other Antiquarian Memorials of Hereford*, Edinburgh, 1869.

Hearn, M. F., *Romanesque Sculpture: The Revival of Monumental Stone Sculpture in the Eleventh and Twelfth Centuries*, Ithaca, NY, 1981.

Heath-Whyte, R. W., *A Guide to the Medieval Wall Paintings of St. Mary-the-Virgin Church*, Chalgrove, 1985.

Henderson, George, 'Romance and Politics on some Medieval English Seals', *Art History*, 1, no. 1, 1978, 26–42.

Hermann, Julius Hermann, *Die deutschen romanischen Handschriften*, Leipzig, 1926.

Herrad of Hohenbourg, *Hortus Deliciarum*, ed. Rosalie Green, Michael Evans, Christine Bischoff, Michael Curschmann, *et al.*, 2 vols., London, 1979.

Herrade de Landsberg, *Hortus Deliciarum*, ed. A. Straub and G. Keller, Strasbourg, 1901.

Hilka, Alfons, *Roman d'Alexandre* (Romanische Forschungen, 29), 1911.

Hillaby, Joe, 'Leominster and Hereford: The Origins of the Diocese', in *Medieval Art, Architecture and Archaeology at Hereford*, ed. David Whitehead, London, 1995, 1–14.

Hillaby, Joe, and Reg Boulton, *The Sculpture Capitals of Leominster Priory*, Leominster, 1993.

Honorius Augustodunensis, *Imago mundi*, in *Patrologia latina*, CLXXII: 123–4.

Hrabanus Maurus, *De universo*, in *Patrologia latina*, CXI: 195–9.

Hugh of Saint-Victor, *La 'Descriptio mappa mundi' de Hugues de Saint-Victor*, ed. Patrick Gautier Dalché, Paris, 1988.

Husband, Timothy, *The Wild Man, Medieval Myth and Symbolism*, New York, 1980.

Illich, Ivan, *In the Vineyard of the Text: A Commentary to Hugh's 'Didascalicon'*, Chicago, 1993.

Isidore of Seville, *Etymologiae*, ed. W. M. Lindsay, 2 vols., Oxford, 1911.

Isidore of Seville, *Traité de la nature*, ed. Jacques Fontaine, Bordeaux, 1960.

Ives, Samuel A., and Helmut Lehmann-Haupt, *An English 13th Century Bestiary: A New Discovery in the Technique of Medieval Illustration*, New York, 1942.

Jacobus de Voragine, *The Golden Legend*, trans. Granger Ryan and Helmut Ripperger, New York, 1969 (repr.).

Jacques de Vitry, *The Exempla or Illustrative Stories from the 'Sermones vulgares' of Jacques de Vitry*, ed. T. F. Crane, London, 1890.

Jacques de Vitry, *Historia Hierosolymitana*, ed. W. A. Hinnebusch, Fribourg, 1972.

James, Montague Rhodes, *The Bestiary*, Oxford, 1928.

James, Montague Rhodes, *A Descriptive Catalogue of the Manuscripts in the Library of Corpus Christi College*, I, Cambridge, 1912.

James, Montague Rhodes, *Marvels of the East*, Oxford, 1929.

James, Montague Rhodes, 'Pictor in Carmine', *Archaeologia*, 94, 1951, 141–66.

James, Montague Rhodes, *The Romance of Alexander: A Collotype Facsimile of MS Bodley 264*, Oxford, 1933.

James, Montague Rhodes, *The Verses Formerly Inscribed on Twelve Windows in the Choir of Canterbury Cathedral* (Cambridge Antiquarian Society, Octavo, 38), Cambridge, 1901.

Jeffrey, David L., *The Early English Lyric and Franciscan Spirituality*, Lincoln, NE, 1975.

Jeffrey, David L., and Brian Levy, *The Anglo-Norman Lyric. An Anthology*, Toronto, 1990.

John of Sacrobosco, *The Sphere of Sacrobosco and Its Commentators*, ed. and trans. Lynn Thorndike, Chicago, 1949.

Jones, C. Meredith, 'The Conventional Saracen of the Songs of Geste', *Speculum*, 17, 1942, 201–25.

Jourdain and Duvall, 'Roues Symboliques de N.-D. d'Amiens et de St. Etienne de Beauvais, *Bulletin Monumental*, 2, 1845, 59–64.

Jungmann, Josef A., *The Mass of the Roman Rite: Its Origins and Development*, trans. Francis A. Brunner, New York, 1955 (3rd edition).

Katzenellenbogen, Adolf, 'The Central Tympanum at Vézelay: Its Encyclopedic Meaning and Its Relation to the First Crusade', *The Art Bulletin*, 26, 1944, 141–51.

Kauffmann, Claus Michael, *Romanesque Manuscripts 1066–1190* (A Survey of Manuscripts Illuminated in the British Isles, 3), London, 1975.

Kedar, Benjamin Z., *Crusade and Mission*, Princeton, 1984 (repr. 1988).

Kenaan-Kedar, Nurith, 'Symbolic Meaning in Crusader Architecture', *Cahiers archéologiques*, 34, 1986, 109–17.

Kent, Thomas, *The Anglo-Norman Alexander ('Le Roman de toute chevalerie')* (Anglo-Norman Text Society, 29–33), ed. Brian Foster, London, 1976–7.

Ker, N. R., *Medieval Libraries of Great Britain. A List of Surviving Books*, London, 1964.

Kibre, Pearl, and Nancy G. Siraisi, 'The Institutional Setting: The Universities', in *Science in the Middle Ages*, ed. David C. Lindberg, Chicago, 1976, 120–44.

Kirschbaum, Engelbert, Gunter Bandmann, *et al.* ed., *Lexikon der christlichen Ikonographie*, 8 vols., Rome, 1968–76.

Kitzinger, Ernst, 'World Map and Fortune's Wheel: A Medieval Mosaic Floor in Turin', *Proceedings of the American Philosophical Society*, 117, 1973, 344–73.

Klibansky, Raymond, *The Continuity of the Platonic Tradition during the Middle Ages*, London, 1939.

Kline, Naomi Reed, 'The Typological Window of Orbais-l'Abbaye: The Context of Its Iconography', *Studies in Iconography*, 14, 1995, 83–130.

Klingender, Francis Donald, *Animals in Art and Thought to the End of Middle Ages*, Cambridge, MA, 1971.

Köhler, Eric, *Ideal und Wirklichkeit in der hofischen Epik*, Tübingen, 1956.

Kratz, Dennis M., trans., *The Romances of Alexander*, New York, 1991.

Kugler, Hartmut, and Eckhard Michael, *Ein Weltbild vor Columbus* (Die Ebstorfer Weltkarte Interdisziplinäres Colloquium, 1988), Weinheim, 1991.

Kuhn, Thomas S., *The Structure of Scientific Revolutions*, Chicago, 1970 (2nd edition).

Kühnel, Bianca, *From the Earthly to the Heavenly Jerusalem* (Römische Quartalschrift für christliche Altertumskunde und Kirchengeschichte, 42, Supplementheft), Rome, 1987.

Künstle, Karl, *Ikonographie der christlichen Kunst*, 2 vols., Freiburg, 1928.

Kupfer, Marcia, 'Medieval World Maps: Embedded Images, Interpretive Frames', *Word and Image*, 10, no. 3, 1994, 262–88.

Kupfer, Marcia, 'The Lost *Mappamundi* at Chalivoy-Milon', *Speculum*, 66, 1991, 540–71.

Kupfer, Marcia, 'The Lost Wheel Map of Ambrogio Lorenzetti', *The Art Bulletin*, 78, 1996, 286–310.

Laborde, A. de, *La Bible moralisée illustrée, conservée à Oxford, Paris et Londres*, 5 vols., Paris, 1911–27.

Laborde, A. de, and P. Lauer, 'Un projet de decoration murale', *Monuments et mémoires* (Fondation Eugène Piot), Paris, 1909, 61–84.

Ladner, Gerhart B. *'Ad imaginem Dei' The Image of Man in Medieval Art*, Latrobe, PA, 1965.

Langlois, C. V., *La Connaissance de la nature et du monde*, Paris, 1927, 166–80.

Langmuir, G., 'Anti-Judaism as the Necessary Preparation for Anti-Semitism', *Viator*, 2, 1971, 383–9.

Laor, Eran, 'Maps of the Holy Land', *Ariel*, 45–6, 1978, 210–19.

Lascelles, M. M., 'Alexander and the Earthly Paradise in Medieval English Writing', *Medium Ævum*, 5, nos 1, 2, 1936, 31–47, 79–104.

Le Berrurier, Diane O., *The Pictorial Sources of Mythological and Scientific Illustrations in Hrabanus Maurus' 'De rerum naturis'*, New York, 1978.

Lecoq, Danielle, 'L'Image d'Alexandre à travers les mappemondes médievales (XIIe–XIIIe)', *Geografia Antiqua*, 2, 1993, 63–103.

Lecoq, Danielle, 'La *Mappemonde* du *De arca Noe mystica* de Hugues de Saint-Victor (1128–1129)', in *Géographie du Monde au Moyen Age et à la Renaisssance*, ed. Monique Pelletier, Paris, 1989, 9–31.

Legge, M. Dominica, *Anglo-Norman Literature and Its Background*, Oxford, 1963.

Lehmann-Haupt, Helmut, ed., *The Göttingen Model Book: A Facsimile Edition and Translations of a Fifteenth-Century Illuminators' Manual*, Columbia, 1972.

Leithäuser, Joachim G, *Mappae Mundi*, Würzburg, 1958.

Lethaby, W. R., 'English Primitives: The Painted Chamber and the Early Masters of the Westminster School', *Burlington Magazine*, 7, 1905, 257–69.

Lethaby, W. R., 'English Primitives – VIII', *Burlington Magazine*, 33, 1918, 3–8.

Letts, Malcolm, *The Pictures in the Hereford Mappa Mundi*, Hereford, 1975 (7th edition).

Lewis, Suzanne, *The Art of Matthew Paris in the 'Chronica majora'*, Berkeley, 1987.

Lewis, Suzanne, *Reading Images*, Cambridge, 1995.

Liber monstrorum de diversis generibus, ed. Moriz Haupt, in *Opuscula* II, Leipzig, 1876.

Lindberg, David C., *The Beginnings of Western Science*, Chicago, 1992.

Lindberg, David C., ed., *Science in the Middle Ages*, Chicago, 1978.

Lindley, P., 'Retrospective Effigies, the Past and Lies', in *Medieval Art, Architecture and Archaeology at Hereford*, ed. David Whitehead, London 1995, 111–21.

Lloyd, Simon, *English Society and the Crusade 1216–1307*, Oxford, 1988.

Long, E. T., 'The Stanningfield Doom', *Burlington Magazine*, 70, 1937, 128.

Madden, Frederick, 'On Knowledge Possessed by Europeans of the Elephant in the Thirteenth Century', in *The Graphic and Historical Illustrator*, ed. Edward Wedlock Brayley, London, 1834, 335–6, 352.

Mandeville's Travels: Texts and Translations, trans. Malcolm H. Letts, 2 vols., London, 1953.

Manitius, Max, *Geschichte der lateinischen Literatur des Mittelalters*, 3 vols., Munich, 1911–31.

Marshall, G., 'The Shrine of St. Thomas de Cantilupe in Hereford Cathedral', *Transactions of the Woolhope Naturalists' Field Club*, 1930–2, 34–46.

Martianus Capella, *De nuptiis Philologiae et Mercurii*, ed. Adolfus Dick, Stuttgart, 1969.

Martin, Henry, *Catalogue des manuscrits de la Bibliothèque de l'Arsenal*, 9 vols., Paris, 1885–92.

Matthew Paris, *The Illustrated Chronicles of Matthew Paris*, trans. and ed. Richard Vaughan, Gloucestershire, 1993.

Mayer, Hans Eberhard, *The Crusades*, trans. J. Gillingham, Oxford, 1988 (2nd edition).

Maynard, Stephen T. J., 'A Study of the Wall Paintings of St Mary's, Chalgrove', MA thesis, Centre for Medieval Studies, University of York, 1986.

McCrindle, J. W., *The Invasion of India by Alexander the Great as Described by Arrian, Q. Curtius, Diodoros, Plutarch and Justin*, Westminster, 1896.

McCulloch, Florence, *Medieval Latin and French Bestiaries*, Chapel Hill, 1962.

McGurk, Patrick, *et al.*, ed., *An Eleventh-Century Anglo-Saxon Illustrated Miscellany: British Library Cotton Tiberius B.V. part I*, Copenhagen, 1983.

McMunn, Meradith, 'Bestiary Influences in Two Thirteenth-Century Romances', in *Beasts and Birds in the Middle Ages*, ed. Willene B. Clark and Meradith T. McMunn, Philadephia, 1989, 134–50.

Meehan, Bernard, 'Durham Twelfth-Century Manuscripts in Cistercian Houses', in *Anglo-Norman Durham*, ed. D. Rollason, M. Harvey, and M. Prestwich, Woodbridge, 1994, 439–49.

Mermier, Guy R., 'The Phoenix: Its Nature and Its Place in the Tradition of the *Physiologus*', in *Beasts and Birds of the Middle Ages*, ed. Willene B. Clark and Meradith T. McMunn, Philadelphia, 1989, 69–87.

Meyer, Paul, *Alexandre le Grand dans la littérature française du Moyen Age*, 2 vols., Geneva, 1886.

Michael, Ian, 'Typological Problems in Medieval Alexander Literature: The Enclosure of Gog and Magog', in *The Medieval Alexander Legend and Romance Epic, Essays in Honour of David J. A. Ross*, ed. Peter Noble, Lucie Polak, and Claire Isoz, New York, 1982, 131–47.

Millar, Eric G., *English Illuminated Manuscripts from the Xth to the XIIIth Century*, Brussels, 1926.

Millar, Eric G., *A Thirteenth Century Bestiary in the Library of Alnwick Castle*, Oxford, 1958.

Miller, Konrad, *Mappaemundi: Die ältesten Weltkarten*, 6 vols., Stuttgart 1895–1898: III: *Die Kleineren Weltkarten*; IV: *Die Herefordkarte*; VI: *Rekonstruierte Karten*.

Moir, A. L., *The World Map in Hereford Cathedral*, Hereford, 1975 (7th edition).

Morgan, F. C., *Hereford Cathedral Church Glass*, Hereford, 1979.

Morgan, Nigel, *Early Gothic Manuscripts, 1190–1250* (Survey of Manuscripts Illuminated in the British Isles, 4), 2 vols., London, 1982.

Morgan, Nigel, 'The Hereford Mappa Mundi – Art Historical Aspects' (paper presented at the Hereford Mappa Mundi Conference, Hereford, 27 June – 1 July, 1999).

Morgan, Nigel, 'Texts and Images of Marian Devotion in Thirteenth-Century England', in *England in the Thirteenth Century* (Proceedings of the 1989 Harlaxton Symposium), Stamford, 1991, 69–103.

Morris, Richard, 'The Remodelling of the Hereford Aisles', *Journal of the British Archaeological Association*, 37, 1974, 21–39.

Morson, John, 'The English Cistercians and the Bestiary', *Bulletin of the John Rylands Library*, 39, 1956, 146–70.

Muldoon, James, *Popes, Lawyers and Infidels*, Philadelphia, 1979.

Muratova, Xenia, 'Bestiaries: An Aspect of Medieval Patronage', in *Art and Patronage in the English Romanesque*, ed. Sarah Macready and F. H. Thompson, London, 1986, 118–44.

Muratova, Xenia, 'Adam donne leurs noms aux animaux', *Studi Medievali*, 18/2, 1977, 367–94.

Muratova, Xenia, *Le Bestiaire*, Paris, 1988.

Muratova, Xenia, 'Les Cycles des bestiaires dans le décor sculpté des églises du XIIe siècle dans le Yorkshire, et leur relation avec les manuscrits des Bestiaires enluminés', in *Atti del V Colloquio della Società Internazionale per lo studio dell' epica animale, della favola e del fabliau*, Turin and Saint-Vincent, 1983, 337–54.

Muratova, Xenia, 'Workshop Methods in English Late Twelfth-Century Illumination and the Production of Luxury Bestiaries', in *Beasts and Birds of the Middle Ages*, ed. Willene B. Clark and Meradith T. McMunn, Philadelphia, 1989, 53–68.

Murdoch, John E., *Album of Science: Antiquity and the Middle Ages*, New York, 1984.

Mynors, R. A. B., and Rodney M. Thomson, *Catalogue of the Manuscripts of Hereford Cathedral Library*, Cambridge, 1993.

Nebenzahl, Kenneth, *Maps of the Bible Lands, Images of Terra Sancta through Two Millennia*, London, 1986.

Nicolet, Claude, and Patrick Gautier Dalché, 'Les *Quatre sages* de Jules César et la *Mesure du monde* selon Julius Honorius: réalité antique et tradition médiévale', *Journal des savants*, October–November 1986, 157–218.

Nichols, Stephen G., Jr., *Romanesque Signs*, New Haven, 1983.

Nicolle, David, *Medieval Warfare Source Book I: Warfare in Western Christendom*, London, 1995.

Niehoff, Franz, 'Umbilicus mundi – Der Nabel der Welt', in *Ornamenta Ecclesiae*, 3, ed. Anton Legner, Cologne, 1985, III: 52–80.

North, Robert, *A History of Biblical Map Making*, Wiesbaden, 1979.

Ong, Walter J., *Orality and Literacy: The Technologizing of the Word*, London, 1982.

Orosius, Paulus, *The Seven Books against the Pagans*, trans. Roy Deferrari, Washington, 1964.

Owst, G. T., *Literature and Pulpit in Medieval England: A Neglected Chapter in the History of English Letters and of the English People*, Cambridge, 1933.

Pacht, Otto, and J. J. G. Alexander, *Illuminated Manuscripts in the Bodleian Library, Oxford*, 3 vols., Oxford, 1966–73.

Parkes, M. B., *Scribes, Scripts and Readers*, London, 1991.

Parkes, Malcolm, 'The Mappa Mundi at Hereford: Report on the Handwriting and Copying of the Text' (paper presented at the Hereford Mappa Mundi Conference, Hereford, 27 June – 1 July, 1999).

Patch, Howard R., *The Goddess Fortuna in Medieval Literature*, Cambridge, MA, 1927.

Peters, F. E., *Jerusalem: The Holy City in the Eyes of the Chroniclers, Visitors, Pilgrims, and Prophets from the Days of Abraham to the Beginnings of Modern Times*, Princeton, 1985.

Pevsner, Nikolaus, *Herefordshire. The Buildings of England*, Harmondsworth, 1963.

Physiologus, trans. Michael J. Curley, Austin, 1979.

Pickering, F. P., '*Augustinus oder Boethius? Geschichtsschreibung und epische Dicthtung im Mittelalter*', Part 1 (Philologische Studien und Quellen, 39), Berlin, 1967.

Pickering, F. P., ed., *The Anglo-Norman Text of the 'Holkham Bible Picture Book'*, Oxford, 1971.

Pickering, F. P., *Literature and Art in the Middle Ages*, London, 1970.

Platelle, H., 'Le Miracle au moyen-âge d'après un ouvrage nouveau', *Mélanges des sciences religieuses*, 42, 1985, 177–84.

Pliny the Elder, *Natural History*, trans. H. Rackham, Cambridge, MA, 1940.

Plummer, John, *The Glazier Collection of Illuminated Manuscripts*, New York, 1968.

Pritchard, Telfryn, R., trans., *The History of Alexander's Battles ('Historia de preliis' – the J¹ Version)*, Toronto, 1992.

Pseudo-Callisthenes, *The Romance of Alexander the Great by Pseudo-Callisthenes*, trans. Albert Mugrich Wolohojian, New York, 1969.

Pseudo-Hugh of St Victor, *De bestiis*, in *Patrologia latina*, CLXXVII.

Quintus Curtius, *Res gesta Alexandri Magni*, trans. John C. Rolfe, 2 vols., Cambridge, MA, 1946.

Randall, Lillian M. C., 'Exempla and Their Influence on Gothic Marginal Art', *The Art Bulletin*, 39, 1957, 97–107.

Randall, Lillian M. C., *Images in the Margins of Gothic Manuscripts*, Berkeley, 1966.

Reeves, Pamela Wynn, 'English Stiff Leaf Sculpture', Ph.D. thesis, London University, 1952.

The Report on the Manuscripts of Hereford Corporation (The Historical Manuscript Commission, Thirteenth Report, Appendix, Part IV), 1892.

Rhodes, J. T., and Clifford Davidson, 'The Garden of Paradise', in *The Iconography of Heaven*, ed. Clifford Davidson, 1994, 69–109.

Richardson, H. G., 'Gervase of Tilbury', *History*, 46, 1961, 102–14.

Riley-Smith, J., 'The First Crusade and the Persecution of the Jews', in *Persecution and Toleration* (Studies in Church History, 21), ed. W. J. Sheils, Oxford, 1984, 51–72.

Röhricht, R., *Bibliotheca geographica Palaestinae*, Berlin, 1890.

Röhricht, R., 'Karten und Pläne zur Palästinakunde aus dem 7. bis 16. Jahrhundert', *Zeitschrift des deutschen Palästina-Vereins*, 15, 1892, 34–9.

Rooney, Anne, *Hunting in Middle English Literature*, Cambridge, 1993.

Ross, David John Athole, *Alexander Historiatus: A Guide to Medieval Illustrated Alexander Literature*, Frankfurt-am-Main, 1988 (reprinted from Warburg Institute, London, 1963).

Ross, David John Athole, 'Alexander in the *Liber Floridus* of Lambert of St. Omer', in D. J. A. Ross,

Studies in the Alexander Romance, London, 1985, 152–5 (article reprinted from *Medium Ævum*, 31, 1962).

Ross, David John Athole, 'A Check-List of Three Alexander Texts: The Julius Valerius *Epitome*, the *Epistola ad Aristotelem* and the *Collatio cum Dindimo*', in D. J. A. Ross, *Studies in the Alexander Romance*, London, 1985, 83–8.

Ross, David John Athole, 'An Exemplum of Alexander the Great', in D. J. A. Ross, *Studies in the Alexander Romance*, London, 1985, 264–5.

Ross, David John Athole, 'The History of Macedon in the *Histoire ancienne jusqu'à César*', in Ross, *Studies in the Alexander Romance*, London, 1985, 198–248.

Ross, David John Athole, 'Illustrated Manuscripts of Orosius', *Scriptorium*, 9, 1955, 35–56 plus plates.

Ross, David John Athole, *Illustrated Medieval Alexander-Books in Germany and the Netherlands*, Cambridge, 1971.

Ross, David John Athole, 'A Lost Painting in Henry III's Palace at Westminster', *Journal of the Warburg and Courtauld Institutes*, 16, 1953, 160.

Rouse, E. Clive, *Medieval Wall Paintings*, Buckinghamshire, 1991

Rouse, E. Clive, and A. Baker, 'The Wall Paintings at Longthorpe Tower near Peterborough, Northants', *Archaeologia*, 96, 1955, 1–57.

Rowland, Beryl, 'The Art of Memory and the Bestiary', in *Beasts and Birds of the Middle Ages*, ed. Willene Clark and Meradith T. McMunn, 12–25.

Roy, Bruno, 'En marge du monde connu: les races de monstres', in *Aspects de la marginalité au Moyen Age*, ed. Guy-H. Allard, Montreal, 1975, 70–80.

Royal Commission on Historical Monuments, Herefordshire, I, III, 1931.

Rubin, Miri, 'What did the Eucharist mean to Thirteenth-Century Villagers?', *Thirteenth Century England*, 4, Woodbridge, 1991, 47–55.

Rubin, Miri, *Corpus Christi: The Eucharist in Late Medieval Culture*, Cambridge, 1991.

Rudolf of Ems, *Weltchronik*, ed. Gustav Ehrismann, Dublin, 1967 (repr.).

Russell, Robert D., 'A Similitude of Paradise: The City as Image of the City', in *The Iconography of Heaven*, ed. Clifford Davidson, Kalamazoo, 1994, 146–61.

Russell, Jeffrey Burton, *Inventing the Flat Earth: Columbus and Modern Historians*, New York, 1991.

Sandler, Lucy Freeman, *Gothic Manuscripts 1285–1385* (A Survey of Manuscripts Illuminated in the British Isles, 5), 2 vols., London, 1986.

Sandler, Lucy Freeman, *The Psalter of Robert de Lisle*, Oxford, 1983.

Sands, Harold, 'Extracts from the Documentary History of the Tower of London', *Archaeological Journal*, 69, 1912, 161–74.

Scheller, Robert Walter Hans Peter, *A Survey of Medieval Model Books*, Haarlem, 1963.

Schilling, Michael, '*Rota Fortunae*: Beziehungen zwischen Bild und Text in mittelalterlichen Handscriften', in *Deutsche Literatur des späten Mittelalters* (Hamburger Colloquium, 1973), ed. Wolfgang Harms and L. Peter Johnson, Berlin, 1975, 293–313.

Sears, Elizabeth, *The Ages of Man: Medieval Interpretations of the Life Cycle*, Princeton, 1986.

Secomska, Krystyna, 'The Miniature Cycle in the Sandomierz *Pantheon* and the Medieval Iconography of Alexander's Indian Campaign', *The Journal of the Warburg and Courtauld Institute*, 38, 1975, 53–71.

Secomska, Krystyna, *Legenda Aleksandra Wielkiego w 'Pantheonie' sandomierskim: miniatury w kodeksiw z 1335 roku*, Wroclaw, Poland, 1977.

Setton, Kenneth M., *A History of the Crusades*, 6 vols., Philadelphia, 1958.

Shoesmith, Ronald, *Hereford City Excavations: Excavations on and Close to the Defences* (Council for British Archaeology Research Report, 46), London, 1982.

Slassarev, V., *Prester John. The Letter and the Legend*, Minneapolis, 1959.

Smith, Catherine Delano, 'Geography or Christianity? Maps of the Holy Land Before AD 1000', *The Journal of Theological Studies*, 42/1, 1991, 143–52.

Smith, Catherine Delano, 'Cartographic Signs on European Maps and their Explanations before 1700', *Imago Mundi*, 37, 1985, 9–29.

Solinus, *Collectanea rerum memorabilium*, ed. T. Mommsen, Berlin, 1864.

Sorabji, Richard, *Aristotle on Memory*, Providence, 1972.

Stahl, William H., *Roman Science*, Madison, 1962.

Stanton, Anne Rudloff, 'The *Queen Mary Psalter*: Narrative and Devotion in Gothic England', Ph.D. thesis, University of Texas at Austin, 1992.

Stock, Brian, *The Implications of Literacy: Written Language and Models of Interpretation in the Eleventh and Twelfth Centuries*, Princeton, 1983.

Stoddard, Whitney, *The West Portals of Saint-Denis and Chartres*, Cambridge, MA, 1952.

Stone, Lawrence, *Sculpture in Britain*, Harmondsworth, 1955.

Stookey, Laurence Hull, 'The Gothic Cathedral as the Heavenly Jerusalem: Liturgical and Theological Sources', *Gesta*, 8, 1969, 35–41.

Tattersall, Jill, 'Sphere or Disc? Allusions to the Shape of the Earth in some Twelfth-Century and Thirteenth-Century Vernacular French Works', *Modern Language Review*, 76, 1981, 31–46.

Temple, Elzbieta, *Anglo-Saxon Manuscripts 900–1066* (A Survey of Manuscripts Illuminated in the British Isles, 2), New York, 1976.

Theoderich, *Guide to the Holy Land*, trans. Aubrey Stewart, New York, 1986 (2nd edition).

Thomson, Rodney M., *Catalogue of the Manuscripts of Lincoln Cathedral Chapter Library*, Woodbridge, 1989.

Thorndike, Lynn, *A History of Magic and Experimental Science*, 2 vols., New York, 1923.

Thurlby, Malcolm, 'Hereford Cathedral: The Romanesque Fabric', in *Medieval, Art, Architecture and Archaeology at Hereford*, ed. David Whitehead, London, 1995, 15–28.

Tristram, E. W. 'An English Mid-Fourteenth Century Picture', *The Burlington Magazine*, 83, 1943, 160–5.

Tristram, E. W., *English Medieval Wall Painting, The Twelfth Century*, Oxford, 1944.

Tristram, E. W., *English Medieval Wall Painting, The Thirteenth Century*, 2 vols., Oxford, 1950.

Tristram, E. W., *English Medieval Wall Painting, The Fourteenth Century*, London, 1955.

Tudor-Craig, Pamela, 'The Painted Chamber at Westminster', *The Archaeological Journal*, 114, 1957, 92–105.

Tummers, H. A., *Early Secular Effigies in England*, Leiden, 1980.

Turner, T. Hudson, *Some Account of Domestic Architecture in England*, Oxford, 1851.

Turville-Petre, Thorlac, ed., *Alliterative Poetry of the Later Middle Ages: An Anthology*, London, 1989.

Twiti, William, *The Art of Hunting, 1327* (Cynegetica Anglica, I, Stockholm Studies in English, 37), ed. Bror Danielsson, 1977.

Tyerman, Christopher, *England and the Crusades 1095–1588*, Chicago, 1988.

Tyerman, Christopher, 'Some English Evidence of Attitudes to Crusading', *Thirteenth Century England*, 1, 1986, 168–74.

Vasquez de Parga, Luis, 'Un mapa desconocido de la serie de los *Beatos*', in *Actas del simposio para el estudio de los codices del 'Commentario al Apocalipsis' de Beato de Liebana*, Madrid, 1978, 271–8.

Vermeerhen, P. J. H., *Über den Kodex 507 der Österreichen Nationalbibliothek*, The Hague, 1956.

Vernet, A., 'Un remaniement de la *Philosophia* de Guillaume de Conches', *Scriptorium*, 1, 1946–7, 243–59.

Vilnay, Zev, *The Holy Land in Old Prints and Maps*, Jerusalem, 1963.

Wagner, David L., *The Seven Liberal Arts in the Middle Ages*, Bloomington, 1983.

Wallace, William A., 'The Philosophical Setting of Medieval Science', in *Science in the Middle Ages*, ed. David C. Lindberg, Chicago, 1976, 91–119.

Wander, Steven H., 'The Westminster Abbey Sanctuary Pavement', *Traditio*, 1978, 137–56.

Warner, George, *Queen Mary's Psalter*, London, 1912.

Webster's New Geographical Dictionary, Springfield, 1988.

Werner, Hans, 'On the Universality of Universal History', in *L'Historiographie médiévale en Europe*, ed. Jean Philippe Genet, Paris, 1991, 247–61.

Wilkinson, John, *Jerusalem Pilgrimage 1099–1185*, London, 1988.

Williams, E. Carleton, 'Mural Paintings of the Three Living and the Three Dead in England', *Journal of the British Archaeological Association*, 3rd series, 7, 1942, 31–40.

Williams, John, and Barbara A. Shailor, *A Spanish Apocalypse: The Morgan Beatus Manuscript*, New York, 1991.

Williams, John, 'Generationes Abrahae: Reconquest Iconography in Leon', *Gesta*, 16/2, 1977, 3–14.

Williams, John, *The Illustrated Beatus*, I (Introduction), London, 1994.

Williamson, Paul, 'Sculpture' in *The Age of Chivalry: Art in Plantagenet England 1200–1400*, ed. Jonathan Alexander and Paul Binski, London, 1987, 98–106.

Wiseman, Peter, 'Julius Caesar and the Hereford World Map', *History Today*, November 1987, 53–7.

Wittkower, Rudolf, 'Marvels of the East', *Journal of the Warburg and Courtauld Institutes*, 5, 1942, 159–97.

Wolf, Armin, 'News on the Ebstorf World Map: Date, Origin, Authorship', in *Géographie du monde au Moyen Age et à la Renaissance*, ed. Monique Pelletier, Paris, 1989, 51–68.

Woodward, David, 'Reality, Symbolism of Time, and Space in Medieval World Maps', *Annals of the Association of American Geographers*, 75, 1985, 510–21.

Woodward, David, 'Medieval *Mappaemundi*', in *The History of Cartography*, 1: *Cartography in Prehistoric, Ancient, and Medieval Europe and the Mediterranean*, ed. J. B. Harley and David Woodward, Chicago, 1987, 286–370.

Woolley, Reginald Maxwell, *Catalogue of the Manuscripts of Lincoln Cathedral Chapter Library*, Oxford, 1927.

Wright, John K., *Geographical Lore of the Time of the Crusades: A Study of the History of Medieval Science and Tradition in Western Europe*, New York, 1925.

Wuttke, Heinrich, *Die Aechtheit des Auszugs aus der Kosmographie des Aithikos*, Leipzig, 1854.

Wuttke, Heinrich, *Die Kosmographie des Istrier Aithicus*, Leipzig, 1853.

Wyon, Alfred Benjamin, *The Great Seals of England*, London, 1887.

Yapp, William Brunsdon, *Birds in Medieval Manuscripts*, London, 1981.

Yates, Francis A., *The Art of Memory*, Chicago, 1966.

Yates, Wilfred Nigel, 'The Dean and Chapter of Hereford 1240–1320', Ph.D. thesis, University of Hull, 1969.

Zacher, Christian K., *Curiosity and Pilgrimage: The Literature of Discovery in Fourteenth-Century England*, Baltimore, 1976.

Zahlten, Johannes, *Creatio mundi*, Stuttgart, 1979.

Zarnecki, George, 'Regional Schools of English Sculpture in the Twelfth Century', Ph.D. thesis, Courtauld Institute, London University, 1950.

Zarnecki, George, Janet Holt, and Tristam Holland, ed., *English Romanesque Art, 1066–1200*, London, 1984.

Zeitler, Barbara, 'The Articulation of Cultural Identity in the Middle Ages' (paper presented at the International Medieval Congress, University of Leeds, 1996).

Zinn, Grover A., Jr., 'Mandala Symbolism and Use in the Mysticism of Hugh of St Victor', *History of Religions*, 12, 1972–3, 317–41.

The following title appeared after the present book was in proof:

Westrem, Scott D., *The Hereford Map: a transcription and translation of the legends with commentary* (Terrarum Orbis I), Turnhout, 2001.

INDEX